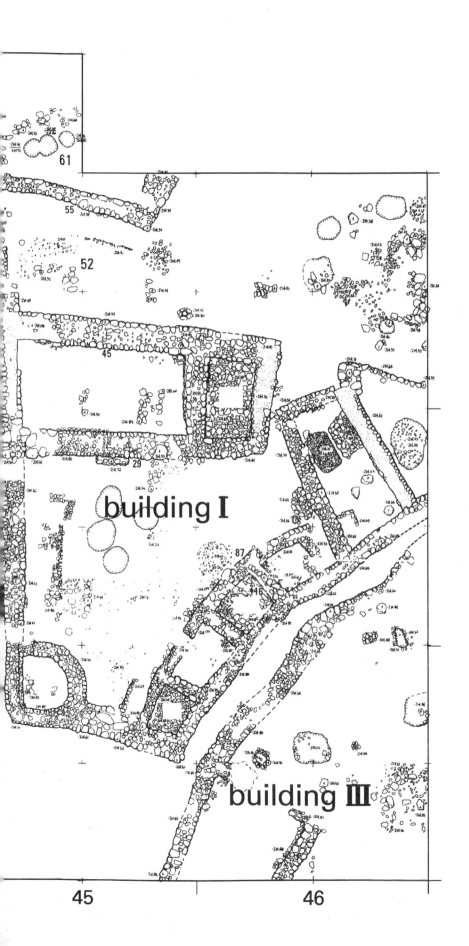

# SHA'AR HAGOLAN
## VOLUME 1

## NEOLITHIC ART IN CONTEXT

*Yosef Garfinkel and Michele A. Miller*

with contributions by

*Susan E. Allen, Nira Alperson, Nachum Applbaum, Yaakov H. Applbaum, David Ben-Shlomo,
Anat Cohen-Weinberger, Anna Eirikh-Rose, Brian Hesse, Sonya Itkis, Naomi Korn,
Zinovi Matskevich, Daphna Zuckerman*

Oxbow Books

*Published by*
Oxbow Books, Park End Place, Oxford OX1 1HN

ISBN 1 84217 057 0

A CIP record for this book is available from the British Library

*This book is available direct from*
Oxbow Books, Park End Place, Oxford OX1 1HN
(Phone: 01865-241249; Fax: 01865-794449)

*and*

The David Brown Book Company
PO Box 511, Oakville, CT 06779, USA
(Phone: 860-945-9329; Fax: 860-945-9468)

*or from our website*

www.oxbowbooks.com

*Printed in Great Britain by*
The Short Run Press
Exeter

*To*

*Curtiss T. and Mary G. Brennan*

# FOREWORD

Publication of the results of archaeological excavation is a complicated task involving the cooperation of a large number of people. As a result, all too often excavation reports appear only decades after the end of a field project, if at all. At the core of this problem is no doubt the standard format of the classic "final excavation report" itself, a monumental publication, written not only at the end of the dig, but also after completion of the various analyses of the excavated finds. In the case of large scale, multi-season projects, enormous quantities of diverse data are unearthed each year. Add to this the fact that under the modern interdisciplinary approach, a large number of specialists are involved in the analysis of resultant data, and the difficulties of coordinating the publication of different analyses becomes clear. For these reasons, it has become increasingly common to publish a series of less comprehensive preliminary articles, each presenting an abstract of the main achievements, unique discoveries and selected artifacts of the excavation up to a given date. Comprehensive results of a dig and analyses of the resultant data may remain unavailable for a period of 20 to 30 years or longer.

Our long term project faces the same problems. While the results of previous excavations at Sha'ar Hagolan were published in a series of short reports in *Hadashot Arkheologiyot (Excavations and Surveys in Israel)*, the *Israel Exploration Journal*, and in a variety of separate papers presented at meetings and in journals, we have yet to present a more extensive report detailing the great wealth of findings from this important site. Current excavations at Sha'ar Hagolan began in 1989, and so far eight excavation seasons have taken place. We plan to continue this fieldwork for another five seasons. One school of thought would have us wait until we have completed our research before presenting a more comprehensive report. This would mean ignoring the great richness of material that has already been processed, drawn, photographed, and, at least preliminarily, analyzed, which may already be of value and interest to the archaeological community

and the public at large. Therefore, we have chosen to publish this comprehensive interim report presenting various materials according to their present state of analysis. The chapters of this report present more complete analyses of material from our first four field seasons (1989, 1990, 1996, 1997), the survey carried out in 1998, as well as additional information regarding the field-work conducted and subsequent finds unearthed in 1998 and 1999. We may find, as our research progresses, that we no longer support some of the preliminary conclusions presented in this volume – however, it would be negligent not to offer some sort of interpretation at this point.

The chapters in this report were submitted during the spring of 2000. In the meantime, during the editing process, two other excavation seasons took place during the summers of 2000–2001. The results of these latest seasons are not included in this report. With the ongoing progress of fieldwork, as well as the analysis of various aspects of the site, we are expecting a second (and perhaps even a third) volume of similar interim perspective before the end of the fieldwork at Sha'ar Hagolan.

As at any large-scale archaeological project, hundreds of people were involved with the fieldwork and the analysis of the resultant material. In the introduction we present a detailed account of the many staff and scholars for whose commitment to and involvement in the exploration of Sha'ar Hagolan we are deeply grateful. We would like to thank David Brown and his staff at Oxbow, Oxford, for taking upon themselves the publication and distribution of this book. We hope to continue with this fruitful cooperation in the next volumes as well. The text was prepared for publication by A. Paris, with generous support from the Jerusalem Center for Anthropological Studies, Dr. Edgar E. Siskin, Director. Last, but not least, it is a great pleasure for us to dedicate this book to Curtiss T. and Mary G. Brennan, loyal friends and supporters of the Sha'ar Hagolan project. Without their deep interest, the great significance of Sha'ar Hagolan would still lay buried.

Yosef Garfinkel and Michele A. Miller

# Contents

# LIST OF FIGURES

Field photographs were taken by Y. Garfinkel. Studio photographs were taken mainly by G. Laron; others by D. Harris, I. Sztulman, and the Israel Antiquities Authority. Maps and plans were prepared by J. Rosenberg. Artifact drawings: pottery by M. Sarig; figurines by D. Ladiray; flint by J. Moskovitch.

# 1

# INTRODUCTION

*Yosef Garfinkel and Michele A. Miller*

This monograph presents the revolutionary results of ten years of excavation and research in the Neolithic village of Sha'ar Hagolan, Jordan Valley, Israel (Fig. 1.1). Sha'ar Hagolan is dated to the Pottery Neolithic period, and is the type-site for the Yarmukian culture, which occupied large parts of the Mediterranean climatic zones of Israel, Jordan and Lebanon during the sixth millennium BC. Recent excavations at the site have opened new horizons to our understanding of the Yarmukian culture, specifically, but also have more far-reaching implications for the entire Neolithic period, as well as for the history of architecture and village planning, art and cult, and other aspects of the development of material culture in the ancient Near East. What was previously considered to be an era of decline has proved to have been a time of cultural evolution in the Levant.

## I. PROBLEMS AND LIMITATIONS

The Pottery Neolithic of the Southern Levant has traditionally been a neglected period of study that fell between two disciplines: prehistoric archaeology on the one hand and biblical archaeology on the other. For the prehistorians, it is considered too late, with large quantities of pottery perceived as a nuisance by those who would rather concentrate their study on flint industries. For the biblical archaeologists, it is simply too early, too far removed from and unrelated to David, Solomon, and other persons and events recounted in the Bible. The vacuum of modern research has been taken to reflect the actual circumstances of the period, or in the words of Bar-Yosef, "Part of the blame for the fragmentary data may be placed on the character of the remains themselves" (1992: 31). Thus, modern research has created a

false impression concerning most aspects of this period, as we summarize below:

**1. Site size, architecture and settlement pattern.** Already in the first account of her excavations at Jericho, Kenyon termed the chapter on the Pottery Neolithic period: "A Retrogression," and stated that the "newcomers brought with them the use of pottery, but in every other respect they were much more primitive than their predecessors" (1957: 77). In her summary on the archaeology of the Holy Land, she emphasized two points, which were time and again repeated by most scholars dealing with this period (Kenyon 1960: 58–68):

a. The Pottery Neolithic marks a sharp decline in comparison with the earlier Pre-Pottery Neolithic periods: "This way of life was undoubtedly a retrogression as far as Palestine, as represented by Jericho, was concerned. Nothing on the scale of the Pre-Pottery Neolithic A and B towns of Jericho is found. For some reason, the light of progress seems to flicker out. It is possible that the town-dwellers had become decadent, and fell victims to more barbarous elements" (1960: 67–68).

b. The Pottery Neolithic of the southern Levant marks a sharp decline in comparison with the other, contemporary cultures of the ancient Near East.

In Kirkbride's summary of the period, published in 1971, the Pottery Neolithic period was described as: "The pit dwelling settlements of these people who, until Wadi Rahah and late Jericho VIII, appeared to have no solid architecture point to a semi-nomadic way of life in Palestine." She adds that the southern Levant just faintly mirrored the flourishing northern cultures.

Recently, in a discussion on settlement development

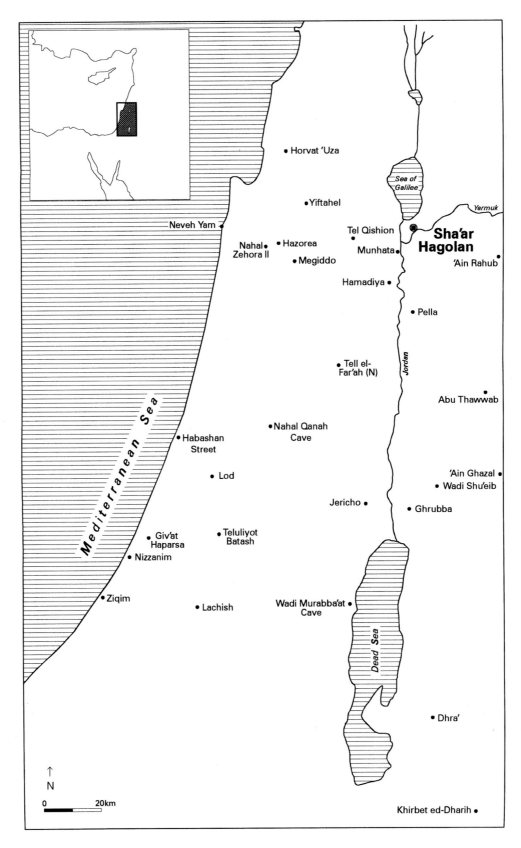

FIG. 1.1. The distribution of Pottery Neolithic sites in the southern Levant

from late prehistory until the Iron Age, the following description of the Pottery Neolithic Period was presented:

> At the beginning of the sixth millennium B.C.E. a major breakdown of the Early Neolithic culture occurred in the southern Levant while prosperity continued in the northern parts of the Near East. The collapse is evident from the disintegration of all major settlements and the erection of small villages. The dominant dwelling form in this period is the circular house; in most cases these were only circular pits that formed the lower part of huts. In other instances only remains of floors, fireplaces and shallow pits pointed to the existence of huts or tents constructed from organic, perishable materials. Interestingly, this decline in settlement architecture is concomitant with the first appearance of pottery in the history of ancient Israel.
>
> The transition of the pattern of settlement from large villages of multiroomed rectangular houses in the PPNB to the small hamlets of pits and huts in the Pottery Neolithic Period clearly indicates that the process of social change in Israel is non unilineal evolution. It appears that the climatic crisis at the beginning of the period forced the communities to abandon previous sites and led to their dispersion into smaller groups of polygynous families that preferred the circular hut, as did their ancestors of the PPNA in the eighth millennium B.C.E. (Herzog 1997: 27–29).

In another recent discussion of the period, Bar-Yosef wrote:

> The emerging picture of the spatial distribution of Pottery Neolithic 'cultures', such as the Yarmoukian… conveys a well-spread population, small villages, hamlets, [and] temporary campsites…
>
> The overall picture does not change with the dominant Wadi Rabah culture of the next phase. The 'grandeur' of the PPNB days are over. The main economic powers at this time are in the northern Levant, Anatolia, and northern Mesopotamia. Although there was no gap in the population history, the people of the southern Levant definitely became 'marginal' to the powerful social organizations further north (Bar Yosef 1998: 170–171).

Thus we see that according to the accepted scholarly consensus up to this time, the population of the Pottery Neolithic period was supposedly organized in small, semi-nomadic groups that inhabited each site only part of the year, and dwelled in pit-buildings or circular huts (Perrot 1968; Kirkbride 1971; Bar-Yosef 1992: 31–38).

**2. Chronology.** The basic sequence of the Neolithic period in the southern Levant was formulated by Kenyon following her extensive excavations at Jericho in the 1950s (1960). She suggested two pre-pottery phases designated Pre-Pottery Neolithic A (PPNA) and Pre-Pottery Neolithic B (PPNB). These were followed by a settlement gap, which lasted a few centuries. Later, two successive

pottery phases developed, the Pottery Neolithic A (PNA) and the Pottery Neolithic B (PNB). The earlier part of this sequence, the Pre-Pottery, was accepted without any serious criticism. Jericho also produced quite a number of radiometric dates for the two earlier Neolithic settlements. The two later Neolithic settlements at Jericho, however, provided no radiometric dates at all. This situation produced much speculation as to the relative, as well as the absolute, chronology of the later sequence of the Neolithic period in the southern Levant. Kenyon placed Sha'ar Hagolan as chronologically parallel with PNB Jericho (1960: 65–66). However, other dating has been suggested as well (see review, Garfinkel 1999a, Table 1). Recently, in order to solve the chronological debate, some 20 samples of organic materials from three Neolithic sites, including Sha'ar Hagolan, were submitted for dating to the Oxford accelerator unit (Garfinkel 1999b). This is the first time that systematic dates for the post Pre-Pottery Neolithic B Levant were achieved, thus clearly helping to solve some of the chronological problems of the period under discussion.

**3. Economy.** One of the implications of the above mentioned common understanding of the Pottery Neolithic period was that the population was semi-nomadic pastoralists, and their main subsistence strategy was based on herding sheep and goats (Perrot 1968; Kirkbride 1971; Bar-Yosef 1992: 31–38). As discussed in this monograph, our recent excavations at Sha'ar Hagolan have enabled us to test this hypothesis and suggest revised interpretations of Yarmukian economy.

**4. Art Objects.** The largest assemblage of prehistoric art ever found at one site in Israel, including figurines of both clay and stone as well as more enigmatic stone carved objects, is from Sha'ar Hagolan. For comparison, from all Natufian and other Neolithic phases, some 100 anthropomorphic figurines have been found (Yizraeli-Noy 1999), while over 200 items are known to us from Sha'ar Hagolan. This wealth of symbolic expression at a single site raises many questions: What are these objects? Why were they made? Who made them? Who used them? Do the anthropomorphic figures represent humans or divinities? Why are there so many of these objects? Why have the greatest number of them been discovered at one site, Sha'ar Hagolan? Despite much scholarly speculation, these questions remained unanswered as most of these objects had been collected from the site surface thereby providing us with little information concerning their function and use. As we are dealing with a pre-historic human community that left behind no written texts, the context in which the art objects are found is our major source of information for analysis and inter-

pretation. Only with the recent excavations at Sha'ar Hagolan have sufficient numbers of these objects been found in secure stratigraphic contexts, which has enabled greater understanding of their use and function in Yarmukian society.

**5. Yarmukian Material Culture.** The term "Yarmukian" seems to be well defined, with its characteristic flint, pottery and art objects (Stekelis 1951, 1972; Garfinkel 1993; Kafafi 1993). Nevertheless, not long ago, the Pre-Pottery Neolithic site of Ashkelon was related to the Yarmukian (Perrot and Gopher 1996). Recently, five radiocarbon samples from Ashkelon placed the site some 500 years earlier then the Yarmukian (Garfinkel 1999b). This case clearly indicates that there are still problems with the categorization of Yarmukian material culture, and that various find categories, particularly lithics, require further classification and analysis.

## II. THE YARMUKIAN IN CONTEXT

The Pottery Neolithic is characterized by a mosaic of regional cultures which simultaneously populated different parts of the Levant (Garfinkel 1999a):

1. The Yarmukian culture is known at sites located in the Mediterranean zone of the southern Levant. The significant sites of this culture are: Sha'ar Hagolan, Munhata, Hamadiya, Megiddo, Habashan Street, Abu Thawwab, 'Ain Ghazal, and Byblos (néolithique ancien)

2. The Jericho IX culture lies mainly to the south of the territory of the Yarmukian culture, in the Judean Lowlands, on the fringe of the Mediterranean zone, and in desert regions on the shores of the Dead Sea and south of it. The following sites have yielded significant finds of this culture: Jericho (Garstang's Layer IX, Kenyon's PNA), Teluliyot Batash, Lod, Khirbet ed-Dharih, Dra' and Ghrubba.

3. Nizzanim culture was found at sites in the southern coastal plain, south of the Yarmukian sites and west of the Jericho IX sites, including Giv'at Haparsa, Nizzanim and Ziqim.

4. North of the area of the Yarmukian culture, we lack clear information on parallels. However, it should be noted that the Cardium Combed Ware found in the néolithique ancien at Byblos, has been reported at two additional northern sites: Tell Ramad and Kefar Gil'adi. This may reflect a local tradition in Lebanon and Syria.

5. North of Byblos, Pottery Neolithic sites are known in the 'Amuq area, Tell Sukas and Ugarit. At these sites, red and black slipped and burnished pottery of a type referred to as Dark Faced Burnished Ware (DFBW) was in use.

6. Sites are known in the desert areas which have no pottery at all. These may be related to the Pottery Neolithic period on the basis of radiometric dates and similar small flint arrowheads.

Many researchers have regarded the various groups surveyed above as a chronologically significant development and much effort has gone into attempts to establish the order of their appearance, from early to late. On the base of typological and geographical analysis it seems that these are regional cultures, which existed simultaneously, each within a defined territory. Some overlap may be observed between these units; however, the main sites of each culture are clustered in distinct regions. An examination of the material culture in the different regions reveals considerable unity in flint tool and pottery forms.

Regional differences are manifest mainly in the decorative style of pottery and art objects. At Yarmukian sites, pottery decoration is mainly engraved, while at Jericho IX it is primarily painted and burnished. In each region the decoration is characteristic and easily identifiable, thus revealing the distinctiveness of each cultural entity. The Yarmukian sites are exceptional in the richness of their art objects, including stylized anthropomorphic clay and pebble figurines and grooved stone artifacts. This wealth and variety is unknown in other Pottery Neolithic cultures in the Levant.

A feature common to these Pottery Neolithic cultures is a decline in the amount of obsidian and exotic objects, which has been proposed as an indication of the weakening of long-distance connections in the Levant. During this period there seems to have been a tendency for human groups to live in relative isolation, with a resultant strengthening of the unique character of each region.

## III. THE SHA'AR HAGOLAN PROJECT

Mapping the distribution of Pottery Neolithic sites in the southern Levant creates quite a dense settlement array (Fig. 1.1, see review of the specific sites in Garfinkel 1999a). However, a closer examination reveals that at most of these sites only very limited fieldwork was carried out in the levels corresponding to the Pottery Neolithic period. Only at Munhata was a large horizontal exposure conducted, where several stages of the Neolithic period have been uncovered (Perrot 1968). The Sha'ar Hagolan excavation project thus presents a new research strategy for the period:

**1. Excavation of a primarily single-period site**. In this way all our efforts are focused on the Yarmukian settlement without having to excavate and study other levels. At the same time, Yarmukian material tends to be in a better state of preservation at Sha'ar Hagolan than when it is found beneath the layers of later cultures.

**2. Plans for a project of long duration.** While excavations at biblical sites often last for decades, due to various factors most excavations at prehistoric sites in the Levant continue for only a few years, at most. Five seasons of work on a rather small scale were conducted during three years (1949, 1950, 1952) at Sha'ar Hagolan under the direction of M. Stekelis. Six seasons of renewed excavations have already taken place over the last 10 years (1989–1990, 1996–1999). In addition, we plan on five more full field seasons, as well as several short study seasons at Sha'ar Hagolan.

**3. Extensive excavation and research team.** The considerable size of the expedition at Sha'ar Hagolan is similar to that of historical excavations. In the past several seasons we have worked with approximately 15 field staff and nearly 100 volunteers (Figs. 1.2, 1.3). In addition, a large international team of specialists is dedicated to the study of the cultural material recovered from Sha'ar Hagolan.

**4. Large horizontal exposure.** Our excavations focus on the uppermost layers at the site, allowing us to expose a large area relatively rapidly (Fig. 1.4). In this endeavor we have been helped by the shallow nature of the Yarmukian deposits at Sha'ar Hagolan (both because of the lack of overlying deposits and because of recent removal of the top alluvium in the creation of fishponds). Most of these deposits lie close to the present ground surface. By the end of the 1999 season, c. 1,800 sq. m. have been opened.

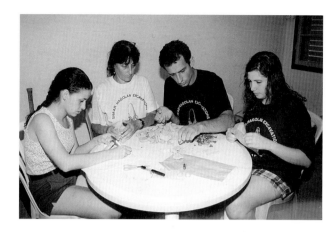

Fig. 1.3. Staff members sorting finds during afternoon hours

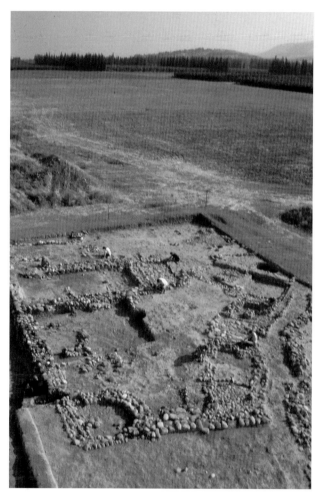

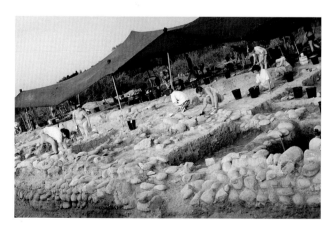

Fig. 1.2. The site during excavations

Fig. 1.4. The Jordan Valley and the excavation of Sha'ar Hagolan

**5. Employment of intensive recovery methods and scientific analytical techniques.** While excavating a prehistoric site with many of the characteristics of a historical site, such as large size, extensive architecture and the presence of large quantities of pottery as well as other cultural material, we have employed recovery methods and analytical techniques more often employed during the excavation of smaller, prehistoric sites. This includes the sieving of all excavated sediment, horizontal and vertical plotting of the find-spot of all "special" finds such as figurines, groundstone, arrowheads, and whole pots, flotation of a 10% sample of each excavation unit (and 100% of select features), micro-morphological analysis of suspected hearth sediments, and magnetic survey for detection of subsurface remains.

These extensive efforts have already completely altered our understanding of the Yarmukian period, and have proven beyond doubt that common theories about this culture, as reflected in the above citations, are fundamentally incorrect. A new history for the Levant in the sixth millennium BC, and its contributions to the Neolithic of the Near East, must be written. This collection of 19 articles, presented by various members of the Sha'ar Hagolan expedition, is the first publication of these new and revolutionary results. The articles are organized in four main parts. Part I presents the site, the intensive surface survey, the magnetometric survey, the excavations and the architecture. Part II presents various studies of material culture recovered from the site. Three articles examine the pottery, which was introduced into the Southern Levant during this period. Two other articles present the lithic industry. Part III presents the art objects; we use the term art in this context quite deliberately. Sha'ar Hagolan produced the richest assemblage of prehistoric art ever uncovered at one site in Israel, and the largest in the Levant for that period. During our excavations 64 new anthropomorphic figurines were found, 48 of them in one structure. Part IV includes subsistence data, written by our botanical and zoological experts. These indicate that the Yarmukians had a mixed economy, and were not specialized shepherds, as heretofore proposed.

While excavations at Sha'ar Hagolan are far from complete, we have felt it necessary to present preliminary data from our excavations in this comprehensive format because of the importance of these results and their significance for further research in the later prehistory of the Near East. Furthermore, we hope these results will stimulate new interest in this exciting period in the course of cultural development in the Levant.

## IV. ACKNOWLEDGMENTS

The excavations at Sha'ar Hagolan are conducted on behalf of the Institute of Archaeology at the Hebrew University of Jerusalem. During the first six seasons of excavations, the archaeological expedition to Sha'ar Hagolan was sponsored by various agencies; part of them are listed here, in chronological order.

1989: The Israel National Council for Research and Development.

1990: The Irene Sala CARE Foundation.

1996: The Faculty of Humanities at the Hebrew University of Jerusalem and the Jewish National Fund (technical assistance).

1997: The Faculty of Humanities and the Philip and Muriel Berman Center for Biblical Archaeology, both at the Hebrew University of Jerusalem.

1998: The Curtiss T. and Mary G. Brennan Foundation.

1999: The Curtiss T. and Mary G. Brennan Foundation, Jewish National Fund (technical assistance) and the Philip and Muriel Berman Center for Biblical Archaeology at the Hebrew University of Jerusalem.

The Israel Science Foundation founded by the Israel Academy of Sciences and Humanities also sponsored the study and analysis of various aspects of the excavated material, in the years 1998–2000. The study and analysis of art objects has been supported by a grant from the Robert H. and Clarice Smith Center of Art History at the Hebrew University of Jerusalem. Over the years we also received an abundance of kind and necessary assistance from the members of Kibbutz Sha'ar Hagolan. The expedition is accommodated in the kibbutz guesthouse, and received technical help in preparing this large area for excavation, as well in the overhead photography of the entire excavated area. Of special help, to mention just a few, were Eitan and Shachar Everi, Uzi Choen and Nurit Kaziri.

The extensive fieldwork required the assistance of many area supervisors and specialists. The following archaeologists acted in such capacity, listed here in chronological and alphabetic order:

1997: A. Eirikh-Rose, N. Koren, K. J. Lev-Tov, S. Lousi, M. A. Miller, K. Wallach and K. Harbord. The camp manager was A. Harris

1998: N. Alferson, D. Ben Shlomo, H. Clark, D. Dag, K. Dunwoody, A. Eirikh-Rose, K. J. Lev-Tov, Z. Matskevich, J. Rose and K. Wallach. The camp manager was A. Harris.

1999: D. Ben Shlomo, H. Clark, D. Dag, A. Eirikh-Rose, R. Favis, Z. Matskevich, E. Musselman, D. Rookis, U. Rubenstein and K. Wallach. The camp manager was I. Broder

The team analyzing material from Sha'ar Hagolan includes Prof. B. Hesse (archaeozoologist), S. Allen (archaeobotanist), J. Rosenberg (surveyor), S. Itkis (magnetic survey), D. Zuckerman (potter, experimental pottery workshop), M. Lavi and O. Cohen (conservation), R. Uni (pottery restoration), G. Laron (studio photography), N. Alperson and Z. Matskevich (flint analysis), A. Eirikh-Rose (pottery analysis), A. Cohen-Weinberger (petrography), D. Ben-Shlomo (stratigraphy and architecture), N. Korn (figurines), N. and Y. Applbaum (Computer Tomography Imaging), and T. L. Arpin (Geoarchaeology).

Last but not least, we would like to express our respect and admiration for the dozens of volunteers from all over the world who joined us on our excavation, including the groups from Kolping Jugendgemeinschaftsdienste in Cologne, Germany. They contributed their time and energy in the extremely hot climate of the Jordan Valley. Without their efforts, this project would have been an impossible undertaking.

## BIBLIOGRAPHY

Bar Yosef, O. 1992. The Neolithic Period. In Ben-Tor, A. (ed.) *The Archaeology of Ancient Israel*, pp.10–39. Hew Haven: Yale University Press.

Bar Yosef, O. 1998. Jordan Prehistory: A View from the West. In Henry, D.O. (ed.) *The Prehistoric Archaeology of Jordan*, pp. 162–178 (B.A.R. International Series 705). Oxford: British Archaeological Reports.

Garfinkel, Y. 1993. The Yarmukian Culture in Israel. *Paléorient* 19: 115–134.

Garfinkel, Y. 1999a. *Neolithic and Chalcolithic Pottery of the Southern Levant* (Qedem 39). Jerusalem: Institute of Archaeology, Hebrew University.

Garfinkel, Y. 1999b. Radiometric Dates from Eighth Millennium B.P. Israel. *Bulletin of the American Schools of Oriental Research* 314: 1–13.

Herzog, Z. 1997. *Archaeology of the City* (Monograph Series of the Institute of Archaeology, No. 13). Tel Aviv: Tel Aviv University.

Kafafi, Z. 1993. The Yarmoukians in Jordan. *Paléorient* 19: 101–114.

Kenyon, K.M. 1957. *Digging Up Jericho*. London: Benn.

Kenyon, K.M. 1960. *Archaeology in the Holy Land*. London: E. Benn.

Kirkbride, D. 1971. A Commentary on the Pottery Neolithic of Palestine. *Harvard Theological Review* 64: 281–289.

Perrot, J. 1968. La Préhistoire Palestinienne. In Cazelles, H. and Feuillet, A. (eds.) *Supplément au Dictionnaire de la Bible*, pp. 286–446. Paris: Letouzy and Ané.

Perrot, J. and Gopher, A. 1996. A Late Neolithic Site near Ashkelon. *Israel Exploration Journal* 46: 145–166.

Stekelis, M. 1951. A New Neolithic Industry: The Yarmukian of Palestine. *Israel Exploration Journal* 1: 1–19.

Stekelis, M. 1972. *The Yarmukian Culture of the Neolithic Period*. Jerusalem: Magnes Press.

Yizraeli-Noy, T. 1999. *The Human Figure in Prehistoric Art in the Land of Israel*. Jerusalem: Israel Museum and Israel Exploration Society.

# PART I

# THE SITE, EXCAVATIONS AND ARCHITECTURE

# THE ARCHAEOLOGY OF SHA'AR HAGOLAN

## Yosef Garfinkel and Michele A. Miller

## I. LOCATION AND SETTING

Sha'ar Hagolan is an 8,000-year-old Neolithic village located in the central Jordan Valley, 1.5 km. south of the Sea of Galilee, at an elevation of c. 210 m. below sea level (Israel map reference 20690–23150/20750–23200). This geographical unit, called Kinnerot Valley, contains Lake Kinneret (the Sea of Galilee) and the triangular-shaped region to the south, between the Jordan and the Yarmuk Rivers. The site lies on the northwestern bank of the Yarmuk River, near the meeting point of three modern states: Israel, Jordan and Syria. The Golan Heights and Mount Gilead border this part of the rift valley to the east and the Hills of Galilee to the west. The mountains reach a maximum elevation of 200–300 m. above sea level. The area is rich in water and fertile land. The Neolithic period remains at Sha'ar Hagolan extend over a broad area of approximately 20 hectares, making it one of the largest known Neolithic settlements in the Near East (see M. A. Miller, Chapter 3 in this volume). Some parts of this area were later reoccupied by a Middle Bronze I site, dated to the late third millennium BC, as explored by Eisenberg (1993) in a single season of excavation in the year 1980. The renewed excavations, however, concentrate on the Neolithic village, and only very meager Middle Bronze I remains have been encountered.

Karmon has provided a detailed geographical description of the area, including the following information on its climatic conditions:

> The climate of the area is dominated by its topographic position below sea level. Summer temperatures are much higher than in the coastal plain, due to the lower elevation and the lack of the moderating influence of the Mediterranean Sea. The sea breeze which reaches the area around noon, arrives as a dry wind, warmed adiabatically, and instead of bringing cooling relief keeps temperatures high until evening.
>
> Daily maximum temperatures reach 37–38° C on the average and are maintained for many hours, and absolute maximum temperatures of 48–50° C have been recorded. On the other hand, in winter the minimum very rarely falls below the freezing point, because of the temperating influence of the lake. Another important fact is the short spring (i.e. a quick transition from winter temperatures to summer heat). This rise of temperature is accelerated by the occurrence of Sharav conditions in the transitional season...
>
> Regarding rainfall, ...the southern part of the area receives 375 mm and the northern section 475 mm; thus the area lies in a region where unirrigated agriculture is still possible. A special feature of the rainfall regime is heavy thunderstorms and cloudbursts which occur especially at the end of the rainy season, when the instability of the air is increased by the warming up of the valley. These cloudbursts cause severe flooding which has many times wrought heavy damages especially in Tiberias. (Karmon 1971: 170)

The location on the bank of the Yarmuk River must have provided numerous advantages to the inhabitants of the site, such as the following:

1. Permanent stable water supplies for humans and animals.
2. Mud and clay deposits for various needs, including building construction and pottery.
3. Marsh vegetation which is suitable for basketry and mat industries.
4. Supplies of basalt river pebbles for various constructions, such as the rounded pebbles used for wall foundations and flat pebbles used for paving.
5. Limestone pebbles used for the schematic anthropomorphic figurines.

6. Flint pebbles which were the most commonly utilized material for the lithic industry.
7. Availability of aquatic fauna. However, so far no fish bones have been found in the excavation.

Most Neolithic sites in the Jordan Valley are situated similarly to Sha'ar Hagolan, adjacent to a tributary which approaches the valley from one side (Fig. 2.1). The same geographical pattern can be seen at Gesher (Pre-Pottery Neolithic A), Tel 'Ali (Pre-Pottery Neolithic B, Pre-Pottery Neolithic C), Munhata (PPNB, Yarmukian) and Hamadiya/'Ain Soda (Yarmukian). These sites are thus seated in the delta area, where the river leaves the mountain and reaches the Jordan Valley (Tzori 1958: 51). The traditional explanation for this pattern is its advantages for agriculture and the cultivation of land (Prausnitz 1959). Or in the words of Bar-Yosef:

Alluvial fans or wadi terraces provided suitable locations for simple farming techniques, as they could easily be cleared of their natural vegetation. Yearly inundation assured the continued fertility of the soil, and the steady and well-distributed rainfall assured the success of the crops. This may explain why Neolithic agricultural villages were located in the lowlands. (Bar-Yosef 1992: 15)

In addition, river valleys also provided the most convenient transportation routes between different regions. These sites therefore also appear to have been situated at crossroads between the north-south route created by the Jordan Valley and the east-west routes created by its tributaries. This may be an important factor as we consider the place of Sha'ar Hagolan in regional trade networks.

## II. History of Research

Modern interest in the ancient Neolithic site of Sha'ar Hagolan can be summarized into three main phases: discovery and intensive surface survey by the local farmers; the first excavations by Stekelis; and the renewed excavations by the current expedition.

**1. The Local Farmers' Activities.** The site was discovered by members of the local farming community (Kibbutz) of Sha'ar Hagolan, during the construction of fishponds in the late 1930s. A collection of finds including pestles and grindstones, stone bowls, flint tools, pottery and figurines, was assembled and stored in crates under beds in the kibbutz. As this was a pioneering era, the kibbutz members lived in tents or small huts. During Israel's War of Independence in 1948, the kibbutz came under severe attack, and was burned and abandoned for several days. The black color of one of the figurines is a result of that fire.

Since the 1930s, members of Kibbutz Sha'ar Hagolan have taken great interest in the antiquities in their fields. Ploughing, tree-planting, installation of underground water pipes and maintenance of now disused fishponds exposed a variety of finds. For approximately 60 years, archaeological surveys were systematically carried out in search of antiquities. This was an activity of school children, individuals and families during afternoon leisure hours and weekends. Sha'ar Hagolan would appear to be one of the most intensively surveyed archaeological sites in the Near East.

The members of Kibbutz Sha'ar Hagolan were aware of the importance of the site and of the finds which they collected there. In 1952, they officially opened an exhibit of their antiquities collection in a bomb shelter. This became Israel's first museum of prehistory. This early

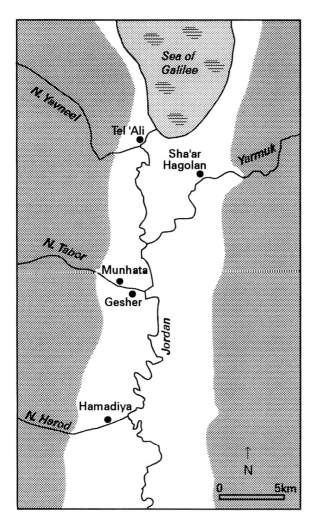

FIG. 2.1. The location of Neolithic sites in the Central Jordan Valley

museum is mentioned by the famous anthropologist Robert Ardrey in his book—*The Territorial Imperative* (1967):

> You may visit a kibbutz called Sha'ar Hagolan, near the Sea of Galilee and within gunshot of the Jordan border. You may inspect the Neolithic antiquities which in their spare time the members have dug from their fields and which they display in a convenient bomb shelter; and you will have no need to examine the beaver to confirm the enhancement of energy in a territorial defender. (1967)

During the 1970s, a large structure was specially erected which houses the museum to this day. German reparation money received by members of Kibbutz Sha'ar Hagolan who had survived the Holocaust was donated for this purpose.

Surface finds were regularly brought to the museum. The late Yehuda Roth, founder, curator and local expert until his death in the early 1990s, had no formal training in archaeology, but became extremely knowledgeable, even serving as archaeology correspondent for the daily newspaper of the kibbutz movement. Roth was a dominant figure who did not hesitate to appropriate objects from kibbutz members for the museum. Thus, a large local collection of art objects was assembled, preventing these artifacts from being dispersed among hundreds of different people.

**2. Stekelis Excavations.** Sha'ar Hagolan became known in archaeological research following the work of the late Prof. Moshe Stekelis of the Hebrew University of Jerusalem. In the mid-1940s he surveyed the area and later he conducted five excavation seasons at the site between the years 1949–1952. In his preliminary publications on Sha'ar Hagolan, Stekelis pointed out the most characteristic aspects of this material culture, which he named Yarmukian, after the nearby river. These trademarks of the Yarmukian culture are pottery decorated with incised herringbone patterns, sickle-blades with coarse denticulation, and a rich assemblage of art objects (1951, 1952). He published the final excavation report in Hebrew in 1966 and in English in 1972.

Stekelis' excavations were carried out in four different locations (Areas A–D), all of them several hundred meters from the Yarmuk River bank (Fig. 2.2). He also documented the sections of an anti-tank trench dug in this region during the Second World War and outcrop on the bank of the Yarmuk River. The following results were reported:

**Area A.** A test pit of 9 × 2 m (18 sq.m.), dug to a depth of 2 m. The Neolithic layer was only 30 cm. thick, 0.8 to 1.1 m. below the ground surface, and includes flint implements and many pottery sherds.

**Area B**: A test pit of 5 × 2 m (10 sq.m.), dug to a depth of 2 m. The Neolithic layer was only 20 cm. thick, 1.2 to 1.4 m below the ground surface, and includes a few flint implements and some charred animal bones.

**Area C**: Water pipes laid in this area disturbed the archaeological deposits in this location.

**Area D**: Five squares of 5 × 5 m. were opened, and the total excavated area was 125 sq.m. The dig went down to a depth of 2.4 m. below the ground surface.

As the current expedition has not yet reached such depth, we are presenting here the section from Stekelis' sounding in Area D. Here, seven different layers of varying thickness were found (Fig. 2.3):

*Layer A* (0–0.6 m.). Black alluvial soil mixed with boulders and recent sherds. At the bottom, 1 sq.m. of plastered floor with two Byzantine sherds were found.

*Layer B* (0.6–0.8 m.). Black earth mixed with basalt boulders and sherds of the Early Bronze Age. A well-built Middle Bronze Age I house, with two to three courses of the walls are mentioned, as well as pottery.

*Layer C* (0.8–0.9 m.). Bed of gravel containing freshwater shells and poorly preserved, undateable structures.

*Layer D* (0.9–1.2 m.). Bed of coarse sand and gravel mixed with rolled flint chips. This layer is archaeologically sterile.

*Layer E* (1.2–1.6 m.). The upper half consists of sand and gravel, the lower of loamy clay. This layer is archaeologically sterile.

*Layer F* (1.6–2 m.). A clay layer of the Neolithic period (Yarmukian) with remains of a hut, burial, hearths, large number of flint implements, animal bones, incised river pebbles and a figurine.

*Layer G* (2–2.4 m.). A layer of consolidated basalt and flint gravel, the bottom of which was not reached during excavation. Cores and flakes of Levallois technique of the Middle Paleolithic were found in the gravel.

Stekelis did not find clear architectural remains in his excavations and concluded that "the Neolithic settlers of Sha'ar Hagolan apparently lived in circular huts, half sunk below ground level" (1972: 42).

A major problem with Stekelis' report is the presentation of the excavated material together with the surface finds collected by the local farmers. Not only did he not distinguish between the two, but he also created the impression that the report was solely dedicated to excavations: "we brought to light a large and diversified assemblage, which is presented in this report" (1972: 3). That the report includes surface finds is nowhere men-

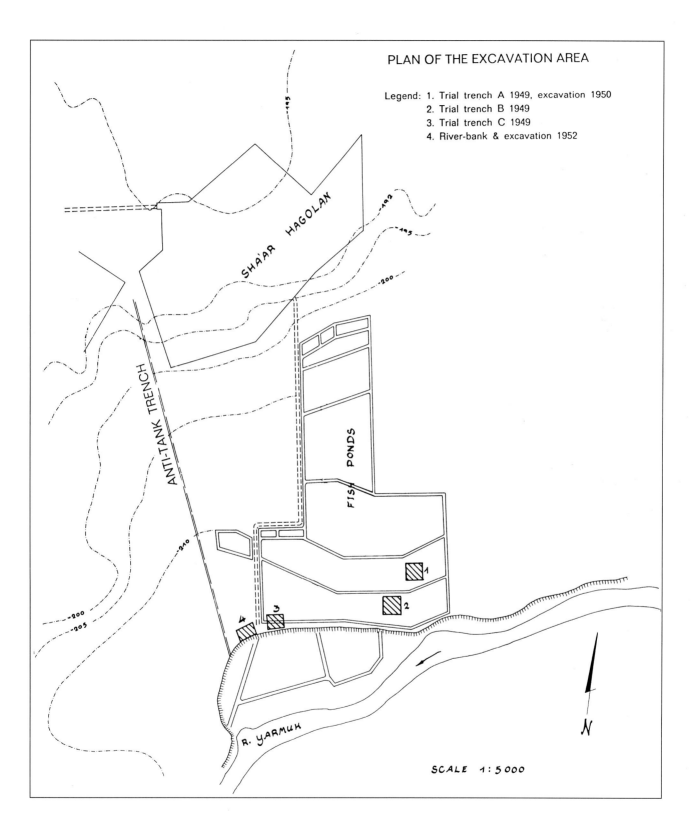

PLAN OF THE EXCAVATION AREA

Legend: 1. Trial trench A 1949, excavation 1950
         2. Trial trench B 1949
         3. Trial trench C 1949
         4. River-bank & excavation 1952

SCALE 1:5000

FIG. 2.2. The location of Stekelis Excavations at Sha'ar Hagolan (Stekelis 1972, Pl. 3)

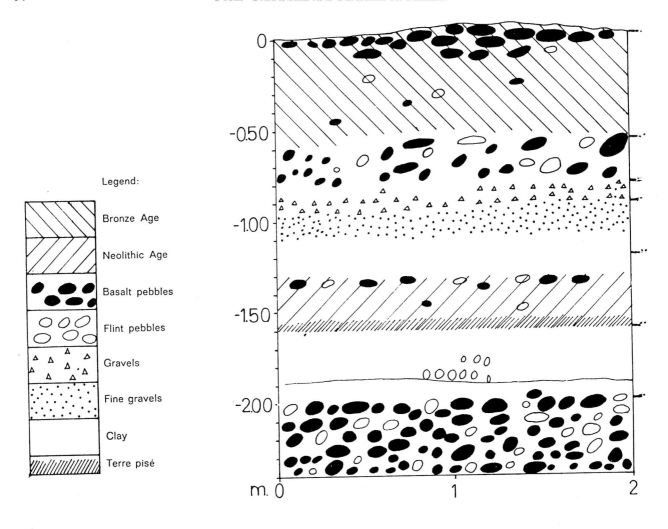

Legend:

Bronze Age

Neolithic Age

Basalt pebbles

Flint pebbles

Gravels

Fine gravels

Clay

Terre pisé

FIG. 2.3. The southern wall of Area D, 1952 excavations (Stekelis 1972, Pl. 7)

tioned. However, Stekelis himself, in earlier publications of the same objects, related certain items to the specific local individuals who had discovered them (Stekelis 1951, 1952). Unfortunately, one result of this compression of the data is that the report is essentially useless for contextual analyses of the finds.

**3. The Renewed Excavations.** In 1989 the excavations at Sha'ar Hagolan were renewed, 37 years after Stekelis completed his explorations at the site (Fig. 2.4). The new excavations are directed by Y. Garfinkel on behalf of the Institute of Archaeology of the Hebrew University of Jerusalem, joined by M. Miller as co-director since the 1998 season.

**The 1989 Season.** The first renewed excavation season lasted three weeks, from the third till the 26th of May, 1989. At the time, the area of the site was under intensive

cultivation, including fishponds and various groves, including banana, olive, avocado, mango and date. Thus, the possible locations for excavation were severely limited. In cooperation with Kibbutz Sha'ar Hagolan, soundings were carried out in three places with a small mechanical digger. Cultural remains were encountered in an area located at the end of the terrace abutting the flood line of the Yarmuk River, at 214 m. below sea level. Here, it was only possible to excavate limited test pits within an olive grove located between two fishponds (Fig. 2.5). Following Stekelis' system, this location was named Area E.

The excavation area extended over c. 50 sq.m. (two 5 × 5 m. squares), to a depth of 0.5–0.6 m. below the present surface. The following stratigraphy was established:

1. Surface stratum (depth 0.1–0.4 m.) – dark brown clayey soil used for agricultural cultivation.

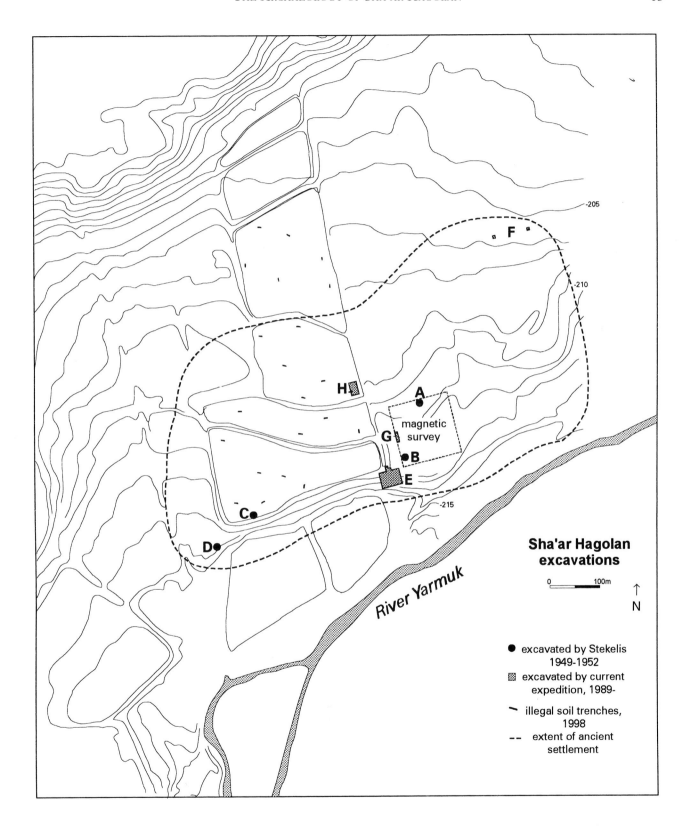

FIG. 2.4. The location of the renewed excavation areas at Sha'ar Hagolan

FIG. 2.5. The beginning of the excavation of Area E in 1989

FIG. 2.6. The first room uncovered in Area E in 1989

2. Settlement level with building remains, including walls, stone paving and installations (Fig. 2.6). The finds included flint tools and pottery characteristic of the Yarmukian culture of the Pottery Neolithic period.
3. The 2-m.-deep mechanically-dug section did not reach virgin soil. This is a thick archaeological deposit with several phases. However, only the upper level has been excavated.

In the excavated area, parts of two Neolithic constructions were exposed. In the east, 4 m. of a massive stone wall, running north-south, was exposed. Four courses of this wall were visible in the section made by the mechanical digger. In the west, one small rectangular room (now Room C in Building Complex II) was completely uncovered, with an additional wall running into the unexcavated area, and a basalt mortar nearby. From the topsoil above this room came the largest pebble

figurine ever found at Sha'ar Hagolan. It was a great surprise to find such remains at that time, since such elaborate construction was not known from previously excavated Pottery Neolithic sites. This trial season clearly demonstrated that the site of Sha'ar Hagolan contains *in situ* archaeological deposits and well-preserved architecture.

**The 1990 Season.** The second season lasted three weeks, from 18 September to 6 October 1990. The excavated area was extended by c. 100 sq.m. Work continued in the east, where the massive stone wall was located the previous year. By the end of the season the wall, 1 m. wide and 60 cm. high, was unearthed to a length of 8 m. It forms a 90-degree angle with an another massive wall, of which a 6-m.-long stretch was exposed (Fig. 2.7). In the corner between these walls, two floor levels were cleared. On the lower floor was found a large basalt grinding slab. To the west, work continued in the rectangular room and various installations were unearthed.

By the end of the season we had cleared all the area available for excavation. A fishpond ramp prevented expansion of the excavation to the north, olive trees to the east and west, and a dirt road and the cliff of the Yarmuk terrace to the south. It seemed that no further excavations could take place at Sha'ar Hagolan. Instead, over the next five years Garfinkel concentrated on analysis of the excavated material, which he presented as a doctoral thesis (Garfinkel 1992a), and on systematic documentation of the large collection of anthropomorphic pebble figurines found in the local museum and various other locations. Meanwhile, during the 1990s water became increasingly expensive in Israel. This had great effect on the agricultural activities and land use in Kibbutz Sha'ar Hagolan, in which fishponds were abandoned and groves of various fruit-trees were uprooted.

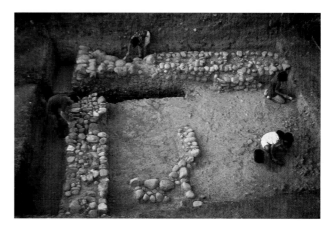

FIG. 2.7. A corner in monumental Building Complex I at the end of the 1990 excavation season.

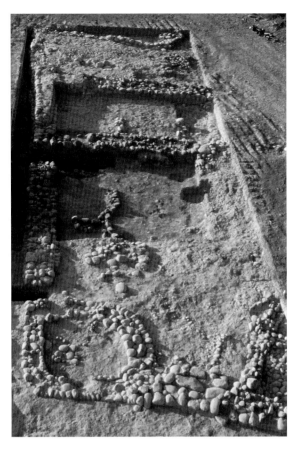

FIG. 2.8. Area E at the end of the 1996 excavation season

This made it possible to initiate a large-scale excavation project by the mid-1990s, which we plan to continue for ten seasons. Eight seasons have been conducted so far, and another is planned for June–July 2002.

**The 1996 Season.** Prior to the excavation the expedition received assistance from the Jewish National Fund to clear the surroundings of Area E from the overburden of fishpond ramps, remains of dead trees and agricultural topsoil. In three working days, utilizing heavy machinery, a few thousand cubic meters were cleared.

The third season lasted four weeks, from 2–31 July. The excavated area was extended to c. 350 sq.m. Work continued mainly in the east part of Area E, where large parts of Building Complex I were exposed to a length of 25 m. By the end of the excavation, most of the walls still extended into the unexcavated area (Fig. 2.8).

**The 1997 Season.** The fourth season of excavation lasted for seven weeks, from 16 June to 31 July. The exposed area of Area E was doubled, from c. 350 to c. 700 sq.m. Complex I was completely uncovered and found to be composed of one triangle-like courtyard with eight rooms surrounding it (Fig. 2.9). In it, some fragments of a large clay statue were found.

East of Building Complex I, a curved alley was found, and east of it the edge of Complex III. The uncovered area exposed one large open courtyard and part of a room of this complex. Many installations were found on

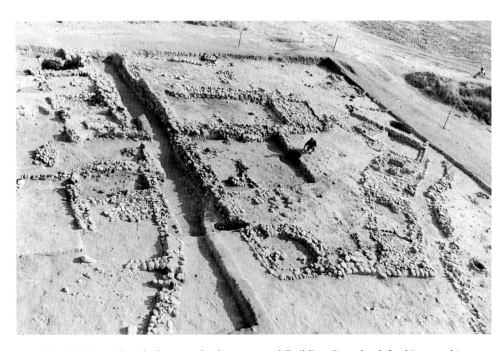

FIG. 2.9. Area E with the completely uncovered Building Complex I (looking north)

the courtyard floor. No further work has taken place in Complex III since the 1997 season.

West of Complex I a 3-m.-wide straight street was uncovered. At the other side of the street, the edge of Complex II was slowly revealed by further excavation. Even at this early stage, it appeared to be especially rich: the limited excavated contained a greater density of finds than Complex I. The finds from this season included a pottery jar (from which a full profile could be restored), 12 stone weights, an incised basalt pebble, a clay cylinder pointed at both ends, zoomorphic clay figurine fragments, numerous pottery sherds, many with elaborate decoration, and a large quantity of lithics.

**The 1998 Season.** The fifth season of excavation took place between 5 July and 14 August. Area E was extended by c. 475 sq.m. to include a total of approximately 1,175 sq.m. Large parts of Complex II were exposed (Fig. 2.10), and extremely rich assemblages of flint, pottery, and over 40 figurines were collected. Results of this season also revealed the destructive power of the nearby Yarmuk River, as the southern area of Complex II appeared to have been eroded by the river at some time in the past. Approximately 500 m. northeast of Area E, a new area of the site was examined (Area F). Excavation in this area consisted of two small test squares some 30 m. apart. In both, broad, massive Yarmukian stone walls were found.

Several surveys were also carried out during this season. M. A. Miller conducted an intensive archaeological survey of the area surrounding the excavation and Yarmukian remains were found to extend over an area of c. 20 hectares. Consecutively, S. Itkis conducted a magnetometric survey that covered an area exceeding 1.2 hectares, adjacent to Area E. During these explorations, we noted that in the southwestern part of the site some twenty trenches had been illegally dug by local farmers to

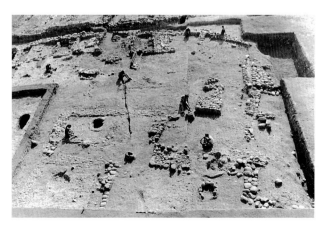

FIG. 2.10. Building Complex II in Area E at the end of the 1998 excavation season (looking east)

obtain soil samples for agricultural purposes. Walls and occupational levels were observed in some of these, while others were sterile. We mapped these trenches, drew sections and collected finds from their back-dirt.

During this season we also constructed a mechanism for the flotation of archaeological sediments in order to recover seeds and other botanical remains. S. Allen and J. Hansen of Boston University supervised the construction and operation of this installation, which has continued in use during subsequent seasons (see S.E. Allen, Chapter 17 in this volume).

**The 1999 Season.** The sixth season lasted from 20 June to 30 July. Excavation was carried out in three separate locations at the site; two of them excavated for the first time (Areas G and H). In Area E, in order to enlarge the horizontal exposure, it was necessary to remove other parts of the fishpond ramps using heavy mechanical equipment. This enabled us to open an additional 125 sq.m., enlarging the exposure in this location to c. 1,300 sq.m. The goal was to follow the main street, which runs north-south and separates Complex I and Complex II. For the first time, the surface of the street was clearly defined, while several new rooms were found to line either side of the street as we moved further north.

Area G was opened in order to verify and correlate results of the magnometric survey conducted in the previous season with excavated remains. The location of a trench of 20 × 5 m. (100 sq.m.) was chosen according to the magnometric specialist as the area with the strongest magnometric values. The excavation revealed poor Middle Bronze I remains and below them, Yarmukian horizons with various floors, installations, sherds and flint. However, no clear architecture was unearthed in this area. After excavating down 70 cm., the excavated area was re-measured with the same magnometric equipment, and strong anomalies were found still further down. We have concluded that more work is needed in Area G, which is the only location in which the renewed excavation has penetrated into the lower parts of the site stratigraphy.

Area H lies c. 200 m. northwest of Area E, in the southeastern corner of a large field that once served as a fishpond. Fifteen squares (375 sq.m.) were excavated and several phases of Yarmukians architectural remains were found in the entire area. The same type of construction activities, as discovered before in Areas E and F, were found, including wide stone wall socles, mudbrick superstructure, various enigmatic installations and stone paving. A few more seasons are needed in order to verify the stratigraphy of this area as well as to uncover the plan of two complete structures.

Another activity conducted during the 1999 season

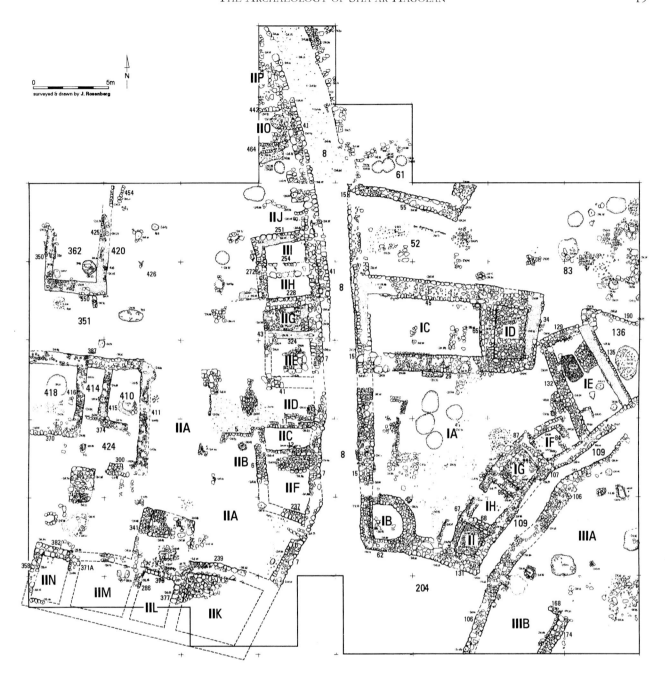

FIG. 2.11. Plan of Area E at the end of the 1999 season

was an experimental pottery workshop. This enabled us to examine various aspects of Neolithic pottery production (see D. Zuckerman, Chapter 9 in this volume).

**The Upcoming Seasons**. While in the first seasons our work focused on individual households, we will look with interest at the community level of Yarmukian habitation at Sha'ar Hagolan during future seasons. We hope to compare various areas of the ancient village, by excava-

ting in three different parts of the site, and hopefully uncover two complete structures in each. Each structure will be carefully examined, including an analysis of its size, construction and plan, as well as the types and density of the finds (pottery, flint, animal bones, exotic minerals and art objects) found within it. Then the results of this analysis from each structure will be compared.

In keeping with these goals, the next seasons will be devoted to the complete exposure of Complex II in Area

Table 2.1. The expansion of the excavated area at Sha'ar Hagolan over the years (in sq.m.)

|        | Area E |        | Area F | Area G | Area H | Total (cumulative total) |        |
|--------|--------|--------|--------|--------|--------|--------|--------|
| 1989   | 50     |        |        |        |        | 50     | (50)   |
| 1990   | 50     | (100)  |        |        |        | 50     | (100)  |
| 1996   | 250    | (350)  |        |        |        | 250    | (350)  |
| 1997   | 350    | (700)  |        |        |        | 350    | (700)  |
| 1998   | 475    | (1175) | 50     |        |        | 525    | (1225) |
| 1999   | 125    | (1300) |        | 100    | 375    | 600    | (1825) |
| Total  | 1300   |        | 50     | 100    | 375    | 1825   |        |

E, the excavation of two complete structures in Area H, as well as sampling in another remote area of the site. This next area will be in the north-west extremity, some 500 m. away from Area E, where we have done little previous excavation. Our biggest problem in executing this plan is the large size of the structures at Sha'ar Hagolan. Each of the complexes uncovered so far is a few hundred sq.m. in size. After excavating over 1,800 sq.m., only one (!) complete building has been entirely uncovered. Thus, in order to expose six similar complete structures, the excavated area must be enlarged to c. 4,000 sq.m. (0.4 hectare). Since the site is 20 hectares, uncovering 0.4 hectare will enable us to sample approximately 2% of the village area.

## III. Digging and Recording Methodology

**1. Fieldwork.** The site is located in a hot area, where the average temperature during the excavation season is usually between 35–40° C and the summer sun is unusually strong. We alleviate these difficult conditions by starting the workday at sunrise, excavating and sieving in shaded areas, drinking frequently, and having three breaks during fieldwork – coffee (7: 00–7: 15 AM), breakfast (9: 00–9: 30 AM) and fresh fruit (11: 00–11: 15 AM). We also set aside a longer period of time from 1–4: 30 PM each day for lunch and rest, after which the entire excavation team is engaged in laboratory work until our evening meal. Volunteers wash the finds that have been excavated earlier that day, and are thus able to see more clearly the material that they have uncovered. They may likewise join staff in other activities, such as sorting and packing the cleaned finds according to raw material (flint, pottery, animal bones, stone objects, sediment samples, etc.), flotation, or more specialized analysis of various finds. One goal of this process is to initiate the preliminary

analysis of all materials during the excavation season, rather than waiting until the materials are transported to a distant museum or laboratory and analyzed during the off-season. In this manner, we are able to formulate preliminary hypotheses about the site, which we draw upon in making daily decisions in the field. At the same time, this method serves to engage volunteers in a range of activities, and to expose them to the range of finds from the site, thus fostering closer cooperation and ties to our research goals among the entire excavation team.

**2. The Grid.** In the first season of excavations, a 1 × 1 m. grid was laid on the site topsoil and the excavation followed the method commonly utilized at prehistoric sites. All the excavated sediment was sieved. When we reached the Neolithic layer and it became apparent that we had uncovered massive architecture, it was clear that another excavation methodology was needed, more similar to that practiced in the excavation of large biblical sites. A new grid system was therefore created based upon squares measuring 10 × 10 m.; the north-south gridlines are designated by uppercase letters and the east-west gridlines are designated by Arabic numbers. Each of these large squares was further subdivided into four 5x 5 m. squares, designated by lowercase letters (a-d). These squares, for example, are referred to as G44b, H45c, etc. A staff member and three volunteers are assigned to the excavation of each of these 5 × 5 m. squares.

**3. Topsoil Removal.** The removal of overburden sediment (usually the plow-zone) is carried out in accordance with the nature and thickness of the deposit. Modern fishpond ramps are cleared by heavy machinery, which are able to remove 2–3 cu.m. in a single bucketload. The regular alluvial topsoil is cleared with the help of a light mechanical digger, which removes only a few centimeters in each pass. This is done in specific squares, before the excavation, according to the excavation grid. As the topsoil sediment is dark and the archaeological layer at

Sha'ar Hagolan is whitish, it is easy to differentiate between the two.

**4. Features and Basket Numbers**. The excavation is carried out within each square in accordance with the sediments encountered. The first unit is always topsoil. As the Neolithic layer is reached, various archaeological features begin to appear, such as walls, floors, pits, installations, fill, debris, and the like. Each of these is registered as a separate locus, and each gets a distinct identification number. These numbers started from the first season of excavation, and have continued from then on. Another running series of numbers is assigned to "baskets," our daily technical excavation units. All the sediment that has been removed from a specific locus, or part of a locus on a specific day gets a distinct basket number. Every day a new basket number is given, and sometimes two or three baskets are assigned to a single locus within one day, if the area is particularly rich in finds or if we would like to have more accurate, specific control (eg., distinguishing between the left and right halves of a room). From 1989 till 1997 we worked only in Area E, and we had only one system of numbers. From 1998, each of the new excavation areas, Area F, Area G and Area H, has its own independent system of numbers for locus and baskets. The given number in each location bears the area letter (F1 or H1, etc.). When a number bears no letter it indicates that it originated from Area E.

In summary, the basket is a technical unit reflecting the process of the modern excavation, while the locus is an authentic unit reflecting the activities of the ancient inhabitants. Using this two-fold system has enabled us to refine our excavation strategy and keep track of materials according to the changing character of the cultural material we encounter.

**5. Recording**. Recording is conducted at two levels: the basket and the locus. A special form is filled out for every basket. If an area supervisor excavates four different loci on a given day and in one of these has two baskets, he/she must complete five basket forms for that day. Information recorded on these forms includes a drawing of the basket area within the square in relation to relevant features, top and bottom elevations, sediment color (taken with a Munsell chart), sediment description, and a description of the density and types of finds. "Special finds," such as complete pots, stone bowls and weights, incised cobbles or figurine fragments, are given a Special Find number, and their locations are recorded in further detail (vertical, horizontal, and elevation) and drawn onto the plan. Once a certain feature has been completely uncovered, a locus form is filled out, summarizing the data necessary to fully describe the feature and its location, and drawing it in further detail. A third form is

used during find-sorting to record the number and type of finds recovered in each basket. All three forms are typed into our computer database to facilitate later analyses. Ideally, this work is done daily during the course of excavation. In reality, however, some of this data entry extends past the end of the season.

**6. Sieving**. All the Neolithic sediment is collected into 10 liter buckets and sieved through a 2 × 2 mm. mesh. Sieving involves a heavy investment in labor, requiring over 50% of our work time. Yet the method is necessary to recover quantitatively reliable assemblages of flint, obsidian, seashell and other small objects. By excavating in larger squares, recording the find-spot of all special finds and the density of all finds, and sieving all sediments, the Sha'ar Hagolan dig successfully combines excavation traditions of both biblical and prehistoric archaeology.

**7. Flotation.** In its first year of operation, 1998, our flotation system proceced c. 3,500 liters of sediment, while in 1999 c. 1,000 liters were processed. This change reflects a modification of our sampling method, once we pinpointed those sediments most likely to contain botanical remains. The flotation system enables us to recover seeds and other botanical remains in the "flot" or light fraction, as well as a variety of minute finds, including microfauna, in the heavy fraction.

## IV. THE FIELD OBSERVATIONS

**1. Area E**. This is the main excavation area of the renewed project and c. 1,300 sq.m. have been exposed over the years (Fig. 2.1). This portion of the prehistoric village includes two streets and three monumental structures. One structure has been completely uncovered, large parts of a second have been excavated, while a small segment of a third has been unearthed so far. A brief description of the area is presented here, while more detailed analysis of all the architectural components is presented in the section on Yarmukian architecture and village planning (see Y. Garfinkel and D. Ben-Shlomo, Chapter 6 in this volume).

**Complex I.** This c. 230 sq.m. complex is composed of one roughly triangular courtyard surrounded by eight rooms (Fig. 2.9). The building had one entrance that opened directly into the courtyard. A series of small, roofed rooms surrounded the courtyard and opened onto it. One room was circular and the others were either rectangular or square. Three were paved with flat basalt river pebbles. The finds in this monumental structure include numerous flint artifacts, pottery sherds, animal bones, a few figurine fragments, some obsidian artifacts

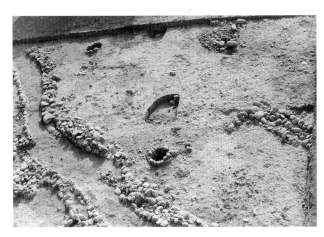

FIG. 2.12. The western extremities of Building Complex III and the small alley in Area E

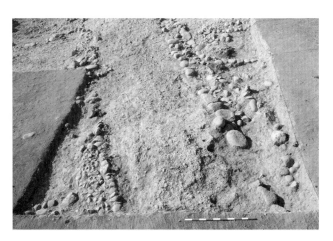

FIG. 2.14. A close-up of the main street in Area E

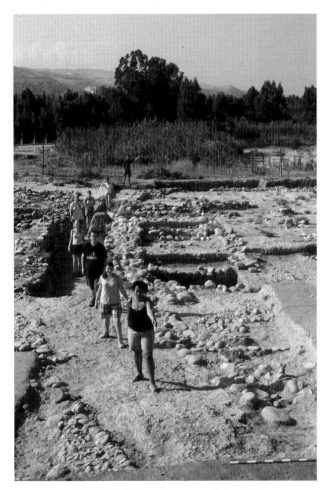

FIG. 2.13. The main street of Area E

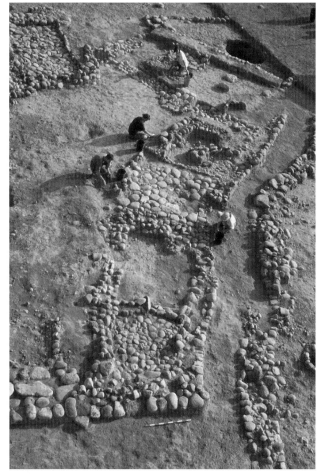

FIG. 2.15. The small alley in Area E

and seashells. An unusual large clay statue was uncovered in the courtyard near the eastern wall.

**Complex II.** This structure has been exposed to a length of 40 m. and to a width of 20 m., but still extends into the unexcavated area (Fig. 2.10). Its total size must be larger then 800 sq.m. It thus appears to be the largest known Neolithic structure in the Ancient Near East. The well-preserved eastern side of the structure consists of a row of small rooms. The southern side was partly eroded by the Yarmuk River; however, remaining portions indicate that there, too, was a row of rooms. At the center of the structure is a large, open area, apparently a central courtyard. The northern and western parts are to be excavated in the coming seasons. This monumental structure proved extremely rich in finds, which include numerous flint artifacts, pottery sherds, animal bones, some 48 figurines or figurine fragments, obsidian and seashells. Further data on the figurine distribution is given below (see D. Ben-Shlomo and Y. Garfinkel, Chapter 14 in this volume).

**Complex III.** Only the western extremity of this monumental structure has been uncovered. Here a large, open area with various installations was exposed (Fig. 2.12).

**The Streets.** Two passageways were excavated at Sha'ar Hagolan. One is a 3-m.-wide straight street, separating Complex I and Complex II. It has so far been exposed to a length of 45 m. (Figs. 2.13–2.14). The other is a curved alley, 1 m. wide, separating Complex I and Complex III (Fig. 2.15). The alley has thus far been exposed to a length of 15 m. These finds appear to reflect a hierarchical system consisting of broad, straight streets and narrow, curved alleys.

## 2. Area F

Area F is located 500 m. northeast of Area E, in one of the banana groves of Kibbutz Masada. After deep plowing, rich concentrations of Yarmukian artifacts were found on the surface. In 1998, some 50 sq.m. were opened in three test pits in order to obtain a better understanding of this remote area at the northeastern part of the site:

a. Square VV84d is located at the far edge of the Banana grove and yielded no finds at all, with only topsoil and sterile virgin soil. It seems to be beyond the settlement area.
b. Square WW80d is located in the center of the banana grove (Figs. 2.16–2.17). Two wide stone walls (F12 and F17), forming an L-shape in the corner of a room, were found. Inside the room, running to the wall, were found remains of a plaster (?) floor F20 (level -209.97).

c. Square WW74d is also located in the middle of the banana grove (Fig. 2.16, 2.18). The excavation concentrated upon its western half and under the topsoil two stone walls were discovered, creating a corner. Wall F6 is massive (1.2 m wide) and has a north-south orientation while wall F13 is smaller and runs east-west. Plaster Floor F15 (level -210.09) is associated with the northern side of wall F13.

Although only a small area was excavated in Area F, architecture associated with Yarmukian finds was clearly exposed. There are remains of at least two large structures, presenting the same type of architecture better known in Area E. Unfortunately, soon after excavation, Area F was planted with bananas, which are scheduled to remain in the field until the year 2009.

**3. Area G.** This is a 5 × 20 m. (100 sq.m.) trench located c. 100 m. northeast of Area E (Fig. 2.19–2.20). The aim of work here is to verify the results of the magnometric survey and to obtain a deep section into the lower parts of the site. So far, the northern part of Area G has been excavated to a depth of 1.5 m. below current topsoil. The following stratigraphic results were noted:

a. Topsoil.
b. A Middle Bronze Age surface, pottery and typical Canaanite flint implements (sickleblades).
c. Four phases of Yarmukian occupation. These include plaster floor fragments, pits and various installations – some plastered. Feature G29 in the southern part of the trench is a wall fragment constructed of river stones, possibly associated with Floor G22 (level -214.21).

Area G appears to have been an open area between structures in the Neolithic village of Sha'ar Hagolan. This is the only area at the site where work is concentrating on unearthing successive phases of Yarmukian remains.

**4. Area H.** Area H is located about 200 m. northwest of Area E (Figs. 2.21–2.22). Two main phases of modern agricultural use can be distinguished here. First, from the late 1930s till the beginning of the early 1990s, it was covered by a fishpond. During the 1990s, after the fishpond ceased functioning, it was used for seasonal cereal cultivation, while in the northern part, eucalyptus trees were planted. Yarmukian pottery was discovered here when the trees were planted. In the 1999 season the area was tested for the first time and 15 5 × 5 m. squares were opened (375 sq.m.) In the southern part of Area H, the remains are relatively close to the current site surface, and sometimes one can see stones protruding from the

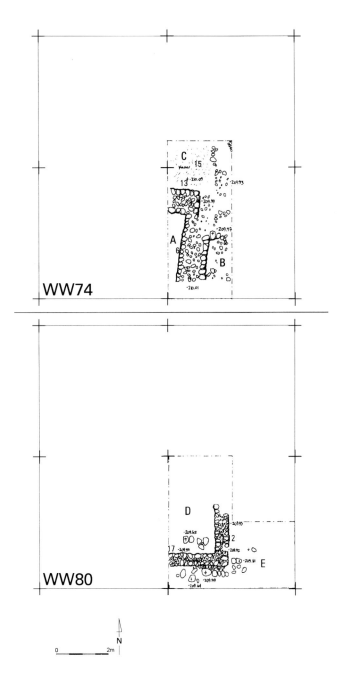

WW74

WW80

N

0    2m

FIG. 2.16. Plan of Area F at the end of the 1998 season

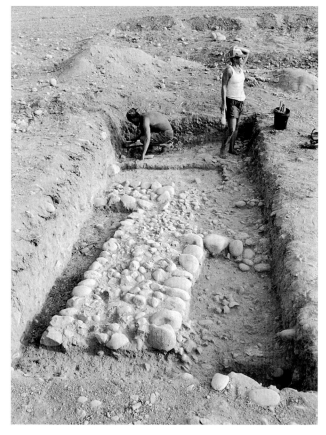

FIG. 2.17. Square WW80d in Area F

FIG. 2.18. Square WW74d in Area F

ground. In this location, the uppermost archaeological remains have been severely disturbed by agricultural activities. In the northern part of Area H, the Yarmukian phase lies about 60–80 cm. below the site surface and is better preserved. The basic stratigraphic sequence so far uncovered includes the following stages:

a. Topsoil. A dark clay layer, that had accumulated at the bottom of the fishpond. This sediment includes modern, as well as a few Neolithic, Middle Bronze I, Byzantine and Islamic artifacts. The Neolithic material from this sediment also included two pebble figurines.

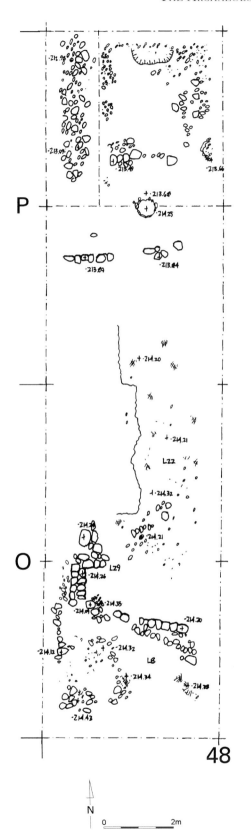

FIG. 2.19. General plan of Area G at the end of the 1999 season

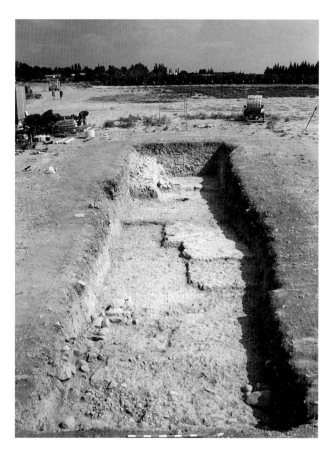

FIG. 2.20. Area G at the end of the 1999 excavation season (looking north)

b. A rounded pit covered with flat stones was uncovered, with an iron blade found within. This isolated pit is probably associated with the Byzantine or Islamic sherds discovered in the topsoil, and may point to the use of these fields for farming in the historic period.

c. Middle Bronze I. No architectural remains were found of this settlement, but Pit 205 contained typical MB I pottery.

d. The Yarmukian occupation. At least two phases exist in the excavated area. The upper one is badly damaged, while the lower one is in a better state of preservation. After only one season of excavation more questions have been raised about these remains than solved; thus, only a preliminary account of the Yarmukian remains is presented here.

Figures 2.21–2.22 present the results of the 1999 excavations in Area H. At this stage of the work, we cannot determine exactly how the various rooms and open areas were organized into structures. Thus, the various spaces were tentatively marked by letters, from A to I. The Yarmukian architecture in Area H is similar in

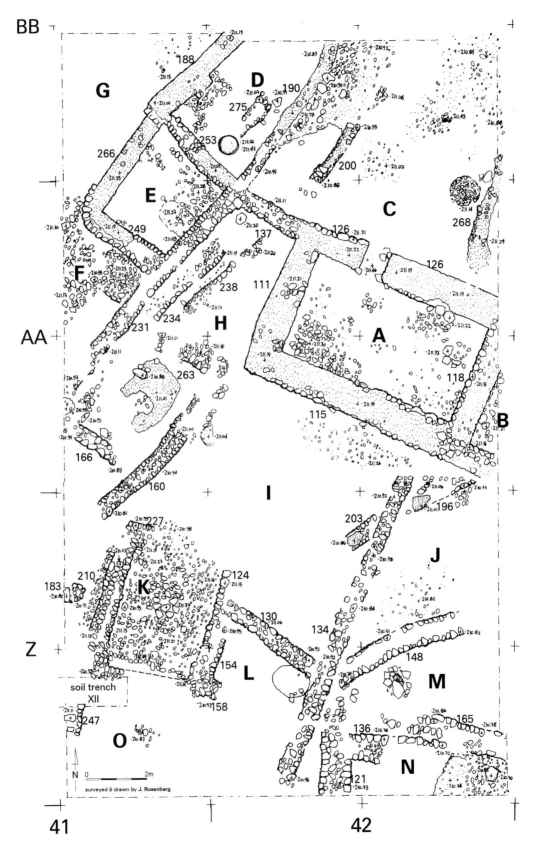

Fig. 2.21. Plan of Area H at the end of the 1999 season

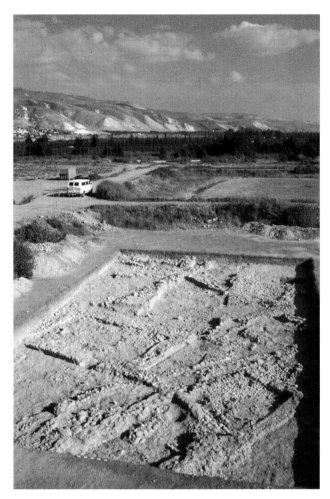

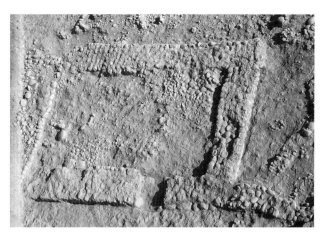

FIG. 2.23. Room A in Area H at the end of the 1999 excavation season (looking south)

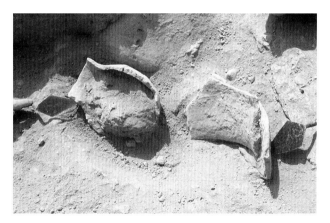

FIG. 2.22. Photograph of Area H at the end of the 1999 season

FIG. 2.24. Concentration of pottery at the entrance to Room A in Area H

construction to that of Area E, including walls with stone foundations and mudbrick superstructure, but here the mudbrick is often better preserved. The major architectural units in Area H are:

**Room A**. The most dominant architectural unit in Area H is a rectangular room confined by walls H126 (north), H118 (east), H115 (south) and H111 (west) (Fig. 2.23). The walls are made of rounded, plano-convex, whitish mudbricks, have stone foundations, and are massive, up to 1.2 m. thick. The room measures 5.8 × 3.3 (internal); 7.8 × 5.4 (external) and has an internal area of nearly 20 sq.m. One entrance, in the northeastern long side, has been identified. This entrance faces courtyard C. Large fragments of pottery vessels were found on the entrance surface (Fig. 2.24). Inside the room, stone paving has been preserved in some places, especially near the corners (paving H128 and H264, level -211.22–211.30) as well as installation H149 which is rounded and made of large

stones. It is possible that wall H115 continues eastwards into the balk and thus connects this room to other units.

**Room B.** This area is adjacent to and to the east of Room A. Only a small corner has been excavated so far, as most of the room lies beyond the excavated area. It seems to have a stone paving.

**Courtyard C.** It is defined by Room A and wall H137 on the south, wall H190 on the west and wall H268 (most of which is in the balk) on the east. It is about 7 m. wide and continues north to the unexcavated area. Two occupation levels were found, one on top of the other, including paved areas, hearth, and a wall. The upper surface is at level -210.85–210.98 while the lower is at level -211.13 (some 20–25 cm. lower). The lower surface was rich in artifacts and many large fragments of pottery vessels were found on it (Fig. 2.25). "Hearth" H146, near wall H268, is a round area lined with big flat sherds and stones.

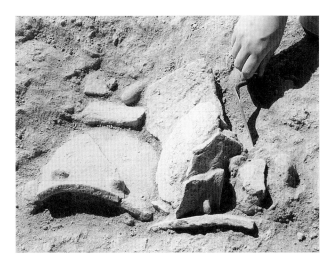

FIG. 2.25. Concentration of pottery sherds on the lower floor of courtyard C in Area H

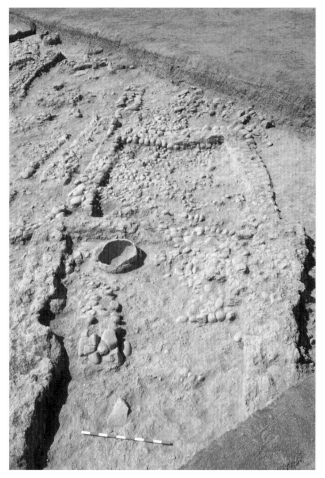

FIG. 2.26. Room D in Area H and the large pithos

Installation H200 is a peculiar feature. It is long and narrow (2.2 × 0.5 m.), and is constructed of two parallel lines of vertically-standing flat pebbles, carefully placed. There are three flat stones placed on the southern edge and some stones marking the northern edge. The inner part is filled with earth. It seems to be a bench or a flimsy partition wall subdividing the western part of Area C.

**Room D**. Consists of a rectangular room, 3 m. wide, enclosed on three sides by walls (walls H190, H253 and H188), while the fourth wall (in the north) apparently remains in the as yet unexcavated area. The most distinct feature here is a large pithos, about 0.6 m. in diameter, placed in the southeastern corner (Figs. 2.26-2.27). The lower part of the vessel was sunk below floor level. It contained no finds and was probably used for grain storage. An entrance to this room has not yet been discerned.

**Room E**. A squared room, defined by walls H266, H253, H231 and H249. It measures 3 × 2.8 m., having an area of c. 8 sq.m. Two floors were found here, the lower well-built of flat stone paving; the upper less carefully constructed.

**Courtyard F**. This unit is defined from the north and east by walls H249 and H231. It seems to be an open area, but further excavation to the west is required in order to confirm this. In the southeastern corner is a square installation with a well constructed pavement of flat pebbles (paving H272, level -211.25).

**Courtyard G**. A relatively large, open area bordered in the east by walls H266 and H188.

FIG. 2.27. A close-up of the large pithos in Area H

**Room H.** A partly closed area, bordered by wall H231 in the west, wall H137 in the north and wall H111 in the east. Two walls in a fragmentary state of preservation (walls H166 and H160) may relate to it and thus may have closed it from the south. Features in this area include mud surface H260 (-211.01), stones H263 and two rows of stones (H234 and H238).

**Open Area I.** A large open area bordered in the west by Room H, in the north by Room A, in the east by wall H134 and in the south by wall H130 and Room K. The southern part of this area was very rich in angular fieldstones. We could not, however, recognize any specific paving. Other features in this area were wall fragment H203 and mud surface H216 (level -211.04).

**Open Area J.** An open area created by Room B in the north, wall H134 in the west and wall H148 in the south. It continues into the unexcavated area to the east.

**Room K.** A rectangular room defined by wall H124 in the east and wall H210 in the west. The north and south walls have not yet been discerned, though Stones H227 might be remains of that wall. The stone walls have two phases built one on top of the other. The room would measure approximately 4 × 3 m. Two levels of floors were found: paving H273 is the lower floor (level −211.37), well constructed with flat river pebbles; floor H176 above it was characterized by a concentration of stones (level -211.16). Round stone installation H183 is probably a hearth.

**Room L.** A rectangular room bordered by wall H134 in the east, wall H130 in the north, wall H154 in the west and wall fragment H158 in the south.

**Open Area M.** The area left between units J and N.

**Room N.** This space is defined by massive walls H121 and H136. These walls create the northwest corner of a room, most of which lies to the south of the excavated area. The eastern part of the area is paved with Floor H107/H147 (level -210.78–210.85). This unit is very close to the topsoil and seems to belong to a later Yarmukian phase. It also has a different orientation then the other walls in this area.

**Open Area O.** This space is located in the southwest corner of Area H. It seems to be badly damaged, as the southern walls of Room K and L have not been preserved.

Though our understanding of Area H is still preliminary, it seems that we are dealing here, as in Area E, with courtyard houses. This is evident mainly in the northern part, where fragments of two such structures may have been found.

## V. CHRONOLOGY

Until recently, the chronology of the Yarmukian culture, and of the sixth-fifth millennia BC in general, was quite problematic (Garfinkel 1999a). Some scholars tended to place the Yarmukians within Pottery Neolithic B Jericho, which implies a fifth millennium BC dating. Others placed it immediately after the Pre-Pottery Neolithic B of the seventh millennium BC. In order to solve this problem, a series of samples were submitted for radiometric dating.

Preservation of organic material was very poor at Sha'ar Hagolan, and only tiny fragments of charcoal were found. It was therefore not possible to conduct any botanical identification of the wood. At first, seven samples of small charcoal chunks were submitted to the Oxford accelerator unit in 1998. The laboratory was not able to process one sample, and the remaining six produced the results presented below. Later, two emmer wheat (*Triticum dicoccum*) seeds from flotation (see S.E. Allen, Chapter 17 in this volume) were submitted for Accelerator Mass Spectrometry (AMS) dating, one of which failed.

| | | | |
|---|---|---|---|
| Sha'ar Hagolan 1 (Basket 120/1, Loc. 3) | OxA-7884 | 6980±100 | $d^{13}C$ -23.5 0 (charcoal) |
| Sha'ar Hagolan 2 (Basket 120/2, Loc. 3) | OxA-7917 | 7410±50 | $d^{13}C$ -25.8 0 (charcoal) |
| Sha'ar Hagolan 3 (Basket 128, Loc. 3) | OxA-7918 | 7465±50 | $d^{13}C$ -23.8 0 (charcoal) |
| Sha'ar Hagolan 4 (Basket 133, Loc. 16) | OxA-7919 | 7495±50 | $d^{13}C$ -25.1 0 (charcoal) |
| Sha'ar Hagolan 5 (Basket 170, Loc. 32) | failed | | |
| Sha'ar Hagolan 6 (Basket 242, Loc. 58) | OxA-7920 | 7245±50 | $d^{13}C$ -24.7 0 (charcoal) |
| Sha'ar Hagolan 7 (Basket 328, Loc. 15) | OxA-7885 | 7270±80 | $d^{13}C$ -25.0 0 (charcoal) |
| Sha'ar Hagolan 8 (Basket 900, Loc. 251) | failed | | |
| Sha'ar Hagolan 9 (Basket 852, Loc. 210) | OxA-9417 | 7285± 45 | $d^{13}C$ -23.5 0 (emmer wheat seed) |

Table 2.2. Yarmukian radiometric dates from the southern Levant

| Site | Composition | Date bp | Sample No. | Reference | Notes |
|---|---|---|---|---|---|
| Sha'ar Hagolan 4 | charcoal | 7495±50 | OxA-7919 | Garfinkel 1999a | |
| 'Ain Rahub | charcoal | 7480±90 | GrN 14539 | Muheisen *et al.* 1988 | |
| Sha'ar Hagolan 3 | charcoal | 7465±50 | OxA-7918 | Garfinkel 1999a | |
| Sha'ar Hagolan 2 | charcoal | 7410±50 | OxA-7917 | Garfinkel 1999a | |
| Munhata (Layer 2b) | charcoal | 7370±400 | M 1792 | Garfinkel 1992b:91 | |
| Byblos (N. ancien) | charcoal | 7360±80 | GrN 1544 | Dunand 1973:34 | replacing 7000±80 |
| Munhata (Layer 2b) | charcoal | 7330±70 | Ly 4927 | Garfinkel 1992b:91 | |
| Sha'ar Hagolan 9 | seed | 7285±45 | OxA-9417 | | |
| Sha'ar Hagolan 7 | charcoal | 7270±80 | OxA-7885 | Garfinkel 1999a | |
| Sha'ar Hagolan 6 | charcoal | 7245±50 | OxA-7920 | Garfinkel 1999a | |
| Nahal Qanah Cave | charcoal | 7054±78 | RT 1544 | Gopher & Tsuk 1996:206 | |
| Nahal Qanah Cave | charcoal | 6980±180 | RT 861D | Gopher & Tsuk 1996:206 | |
| Sha'ar Hagolan 1 | charcoal | 6980±100 | OxA-7884 | Garfinkel 1999a | |
| Byblos (N. ancien) | charcoal | 6650±200 | W 627 | Dunand 1973:34 | too late |
| 'Ain Ghazal | charcoal | 2880±95 | AA 5204 | Rollefson *et al.* 1992 | too late |

## VI. Material Culture

A wealth of artifacts has been unearthed at Sha'ar Hagolan.

**1. Flint.** Flint artifacts are the most common finds at Sha'ar Hagolan. The source of the flint was river pebbles carried from their source by the Yarmuk River and collected by the inhabitants of Sha'ar Hagolan. Hundreds of thousands of flints have been gathered over the years by the systematic sieving of all the earth removed during the excavations. The article by Alperson and Garfinkel (Chapter 10 in this volume) presents 34,528 flint artifacts from the first three seasons (1989, 1990 and 1996). The flint from the 1997 season, c. 34,000 artifacts, has been analyzed by Matskevich. Only one aspect of his work is presented here – the implications of conjoinable pieces to our understanding of Yarmukian flint-knapping technology.

**2. Pottery.** The systematic production of pottery vessels was the greatest technological innovation of the Yarmukian people. This is the earliest known use of pottery in Israel. Pottery vessels provided an excellent solution to basic household activities: food preparation, cooking, food serving and storage. It is not surprising that from the moment pottery vessels were introduced, they began to appear in every village and constitute one of the most common finds in archaeological excavations. Eirikh-Rose and Garfinkel present the pottery assemblage unearthed during the first five seasons (1989–1998) in detail in this volume. It consists of 34,232 sherds, the largest Yarmukian assemblage unearthed to date. The size of the other published assemblages is 15,890 sherds from Munhata (Garfinkel 1992b) and 7,910 sherds from Abu Tawwab

(Obeidat 1995: 19). Petrographic analysis of pottery from Sha'ar Hagolan was carried out by Y. Goren (1992) and A. Cohen-Weinberger (see Chapter 8 in this volume). An experimental workshop was conducted at the site during the 1999 excavation season (see D. Zuckerman, Chapter 9 in this volume). In addition, S. Weiner and D. Ben-Shlomo conducted experiments to determine the pigments used by the potters.

From the technological point of view, the following features characterize Yarmukian pottery:

1. All the pottery is handmade rather than wheel-made. The use of coils can sometimes be discerned in the sections of sherds.
2. Fine vessels with a smooth surface and elaborate decoration appear side by side with undecorated coarse vessels that have thick walls and rough surfaces.
3. Sometimes the surface was smoothed with grass or straw, leaving an imprint in the pottery.
4. Some bases bear circular mat impressions, indicating that potters used mats as their working surfaces.
5. Petrographic studies have shown that the vessels were made of clay derived from the immediate vicinity of the site.
6. Potters preferred clays with high carbonate content which gave vessels a light color. This is a clear continuation of the plaster pyrotechnology tradition of the preceding period.

The Yarmukian pottery vessels vary in shape and size, and can thus be classified into six main groups based on general vessel shape and size: small open vessels, medium-sized open vessels, large open vessels, small closed vessels, medium-sized closed vessels and large open vessels.

THE ARCHAEOLOGY OF SHA'AR HAGOLAN

According to their shape and size the vessels could have served the Yarmukian inhabitants of the site for a large number of functions related to a household's daily activities: grain storage, fluid storage, cooking, serving (table ware) and vessels for spices and cosmetics. In addition to pottery vessels and art objects (see below), other artifacts were made of clay:

**a. Clay whorls** – rounded objects, bi-conical in cross-section and pierced at the center, usually interpreted as spindle whorls (Fig. 2.28).

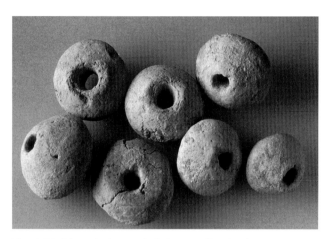

FIG. 2.28. Bi-conical, rounded clay spindle whorls (average size 3–4 cm.)

**b. Clay rods** – cylindrical objects with pointed tips and straight or pointed bases (see below, Fig. 2.35). They were carefully made and sometimes burnished. These were made of special light grey to white paste that seems to contain a high percentage of chalky matrix. The clay is rather dense and well-levigated. Some scholars interpret these objects as cultic, representing male sex organs.

To summarize, the Yarmukian potters demonstrate varied and impressive craftsmanship. They were capable of producing both very small containers and very large storage vessels. They developed a very distinct style of decoration, which includes incised lines framing a herringbone pattern. Pottery vessels met the need for household storage, cooking and serving utensils.

**3. Groundstone Objects.** Stone implements made of basalt and limestone were an important component of Yarmukian household equipment, as attested by the relatively large numbers found. The stone artifacts can be classified into three main functional groups (see Y. Garfinkel, Chapter 12 in this volume): food processing and serving implements, weights and tools.

To summarize, the Yarmukians utilized a wide range of raw materials for their household objects. They probably also fashioned objects of wood, basketry, and other perishable materials, which have disintegrated and were not preserved. We have only indirect evidence for these in the imprints of straw mats on the bases of pottery. On the other hand, objects of clay, flint, basalt and limestone have been preserved in large quantity and attest to the great effort and care invested by the Yarmukians in their material culture.

## VII. EXCHANGE NETWORKS

Objects found at late prehistoric sites in Israel that reflect long distance trade include obsidian, greenstone and seashell. Stekelis did not mention any such exotic raw materials from his excavations at Sha'ar Hagolan. Nor do the publications of other Yarmukian sites. Therefore, little was known about Yarmukian trade. This picture has been changed with the discovery of obsidian and seashell in the new excavations at Sha'ar Hagolan.

**Seashell:** A small number of seashells have been discovered at Sha'ar Hagolan, and these are associated with the monumental buildings. Scientific classification of species has not been completed, although species of cowrie, columbella and cockle have all been noted (Fig. 2.29). Most of these shells appear to have come from the Mediterranean Sea, located some 60 km. west of Sha'ar Hagolan.

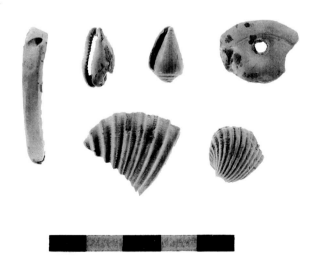

FIG. 2.29. A selection of seashells (some worked)

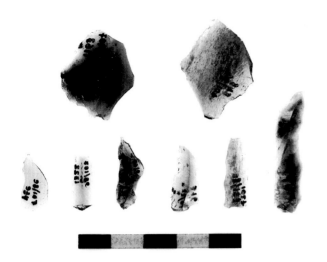

FIG. 2.30. Obsidian artifacts

**Obsidian:** The closest geological sources of obsidian are located in the northern part of the Near East, in Anatolia and Armenia. Thus, the nearest source of natural obsidian to Sha'ar Hagolan is approximately 700 km. to the north. About 10 obsidian artifacts have been found in the monumental buildings at Sha'ar Hagolan (Fig. 2.30). These are small, ranging in weight from 0.5 to 2 g. They are gray, transparent, and very sharp.

Though only a few small pieces of obsidian and several seashells were discovered, these provide clear evidence of long distance trade and exchange networks developed by the Yarmukian people with neighboring communities. The seashell indicates local connections, while the obsidian indicates contact over long distances. As obsidian passed from hand to hand, oral communications would, likewise, have been transmitted. We thus know that the Yarmukian people did not live in total isolation, but maintained direct and indirect contacts with neighboring regions.

## VIII. ART OBJECTS

The Neolithic village of Sha'ar Hagolan is the largest prehistoric art center in Israel and is one of the most outstanding sites in the ancient Near East. Because of worldwide interest in this art assemblage, the Metropolitan Museum of Art in New York City has devoted a special display to Sha'ar Hagolan. Some 30 objects are on exhibit for 5 years, from 19 October 1999. In Jerusalem in 1999, the Bible Lands Museum held the exhibition: "The Yarmukians – Neolithic Art from Sha'ar Hagolan." including the publication of an elaborate and colorful catalogue (Garfinkel 1999b). In late 2000, the Musée du

Louvre in Paris will present 10 artifacts from Sha'ar Hagolan for 5 years.

The variety of art objects known from Sha'ar Hagolan includes: 1. a clay statue; 2. seated cowrie-eyed figurines; 3. clay pillar figurines; 4. cylindrical clay figurines; 5. various clay figures; 6. anthropomorphic pebble figurines; 7. various stone figures; 8. seals; 9. basalt pebbles engraved in geometric designs; and, 10. zoomorphic figurines. The renewed excavations have contributed to a better understanding of the Sha'ar Hagolan art in the following respects:

1. For the first time, complete anthropomorphic clay figurines were found at the site.
2. New types of anthropomorphic figurines, never before found at Yarmukian sites, have been unearthed. Garfinkel, Korn and Miller present most of this assemblage in Chapter 13 in this volume.
3. The discovery of zoomorphic figurines, never before found at Sha'ar Hagolan.
4. The items came from excavated contexts of rooms and courtyards, inside houses. The spatial distribution of the anthropomorphic figurines is presented by Ben-Shlomo and Garfinkel (Chapter 14 in this volume).

In Complex II, 48 anthropomorphic figurines or figurine fragments have been found, while only 9 have been found in Complex I. Complex II produced the largest collection of figurines ever found in one structure in the Neolithic Near East.

In addition to the anthropomorphic figurines, the new excavations revealed two further aspects of symbolic expression:

**a. Zoomorphic Figurines**. These were not reported by Stekelis nor collected from the site surface by the local farmers. In the new excavations, approximately 10 such clay figures have been found, adding a new dimension to the Yarmukian artistic tradition. However, most of the zoomorphic figurines are just small, broken fragments. Two items are in a better state of preservation and thus are presented here. These are four legged animals, modeled so schematically that precise zoological identification is not possible. One of them may be a sheep/goat (Fig. 2.31); the other has a ridge along its back and might be a pig (Fig. 2.32). Similar schematic zoomorphic representations were found in Perrot's excavations in Munhata (Garfinkel 1995). At both sites, the anthropomorphic figurines are dominant and the zoomorphic less common. In PNA Jericho, a few schematic zoomorphic figurines have been found (Holland 1982: 554).

**b. Basalt Pebbles Engraved in Geometric Designs**. A geometrically decorated pebble was found in each of the

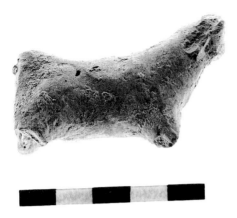

FIG. 2.31. Zoomorphic clay figurine

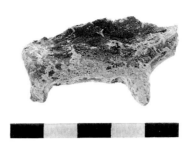

FIG. 2.32. Zoomorphic clay figurine

two structures of Area E. In Complex I, two flat basalt river pebbles were found facing each other. One was incised with the intersecting line pattern and the other was undecorated (Fig. 2.33). In Complex II, one small basalt river pebble was found on the structure floor. One side has 11 incised straight lines (Fig. 2.34). The other side has a central groove. Nearby, a burnished clay rod was found (Fig. 2.35). Various hypotheses have been suggested concerning the function of these geometrically decorated artifacts in Yarmukian contexts: as part of a fertility cult, in textile dyeing, as part of a rain cult, in initiation rites or as brands used to mark ownership of animals (Garfinkel 1993). We offer no alternative explanation at this time, but it is worth noting that similar geometric patterns appear on contemporary rounded pebbles from Ugarit in Syria and from Cyprus. In addition, these geometric patterns were engraved on early stamp seals from Lebanon, Syria

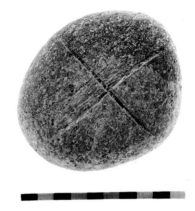

FIG. 2.33. Engraved basalt pebble from Building Complex I

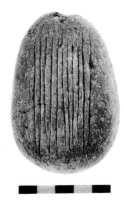

FIG. 2.34. Engraved basalt pebble from Building Complex II

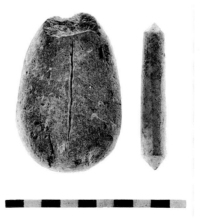

FIG. 2.35. The other side of the engraved basalt pebble from Building II, and the clay rod discovered nearby

and Mesopotamia. The widespread geographical distribution of the geometric patterns may indicate some shared knowledge associated with counting, calendrics, and the development of early mathematics.

## IX. DISCUSSION

The Yarmukian village at Sha'ar Hagolan was the largest settlement of the Neolithic period in Israel, and one of the largest in the entire Near East. At this village, massive building activities took place and monumental courtyard structures were constructed. Evidence for these was unearthed in three different parts of the village: Area E, Area F and Area H. One completely excavated complex is c. 230 sq.m. in size and another has been only partially exposed, but already covers an area of c. 800 sq.m. Contrary to the commonly held view that the Yarmukians were pit dwellers, the new discoveries clearly demonstrate that the Yarmukians conducted massive construction operations on a scale not previously known.

The Yarmukian monumental buildings were carefully organized. Although the excavated area is too limited to obtain a coherent plan of the street network, the evidence uncovered so far does provide some valuable information. There appears to be a differentiation between wide, straight streets and narrow, curved alleys. No other Neolithic site in Israel has yet revealed similar evidence of settlement planning.

Since the renewal of excavations at Sha'ar Hagolan just over a decade ago, a variety of new and revolutionary evidence concerning the Yarmukians has accumulated every summer. This has altered our understanding not only of the Yarmukians, but also of the Neolithic period in general.

## BIBLIOGRAPHY

Ardrey, R. 1967. *The Territorial Imperative. A Personal Inquiry into the Animal Origins of Property and Nations*. London: Collins.

Bar-Yosef, O. 1992. The Neolithic Period. In Ben-Tor, A. (ed.) *The Archaeology of Ancient Israel*, pp. 10–39. Hew Haven: Yale University Press.

Dunand, M. 1973. *Fouilles de Byblos* Vol. V. Paris: Maisonneuve.

Eisenberg, E. 1993. Sha'ar Hagolan, The Middle Bronze I Site. In Stern, E. (ed.) *The New Encyclopedia of Archaeological Excavations in the Holy Land*, Vol. IV, pp. 1342–1343. Jerusalem: Israel Exploration Society.

Garfinkel, Y. 1992a. The Material Culture of the Central Jordan Valley in the Pottery Neolithic and Early Chalcolithic Periods. Unpublished Ph.D. dissertation. Jerusalem: The Hebrew University (Hebrew).

Garfinkel, Y. 1992b. *The Sha'ar Hagolan and Wadi Rabah Pottery Assemblages from Munhata (Israel)*. (Cahiers du Centre de Recherche Français de Jérusalem 6). Paris. Association Paléorient.

Garfinkel, Y. 1993. The Yarmukian Culture in Israel. *Paléorient* 19: 115–134.

Garfinkel, Y. 1997. Sha'ar Hagolan 1997 (Notes and News). *Israel Exploration Journal* 47: 271–273.

Garfinkel, Y. 1999a. Radiometric Dates from Eighth Millennium B.P. Israel. *Bulletin of the American Schools of Oriental Research* 315: 1–13.

Garfinkel, Y. 1999b. *The Yarmukians, Neolithic Art from Sha'ar Hagolan*. Jerusalem: Bible Lands Museum.

Garfinkel, Y. and Miller, M. 1999. Sha'ar Hagolan 1998 (Notes and News). *Israel Exploration Journal* 49: 136–138.

Gopher, A. and Tsuk, T. 1996 *The Nahal Qanah Cave. Earliest Gold in the Southern Levant* (Monograph Series of the Institute of Archaeology, No. 12). Tel Aviv: Tel Aviv University.

Herzog, Z. 1997. *Archaeology of the City* (Monograph Series of the Institute of Archaeology, No. 13). Tel Aviv: Tel Aviv University

Holland, T.A. 1982. Figurines and Miscellaneous Objects. In Kenyon, K.M. and Holland, T.A (eds.) *Excavations at Jericho*, Vol. IV, pp. 551–563. London: British School of Archaeology in Jerusalem.

Kafafi, Z. 1985. Late Neolithic Architecture of Jebel Abu Tawwab, Jordan. *Paléorient* 11: 125–128.

Kafafi, Z. 1993. The Yarmoukians in Jordan. *Paléorient* 19: 101–114.

Karmon, Y. 1971. *Israel: A Regional Geography*. London: Willy.

Kenyon, K.M. 1981. *Excavations at Jericho*, Vol. III. London: British School of Archaeology in Jerusalem.

Kirkbride, D.1971. A Commentary on the Pottery Neolithic of Palestine. *Harvard Theological Review* 64: 281–289.

Muheisen, M., Gebel, H.G., Hannes, C. and Neef, R. 1988. Excavations at 'Ain Rahub, a Final Natufian and Yarmoukian Site near Irbid (1985). In Garrard, A.N. and Gebel, H.G. (eds.) *The Prehistory of Jordan, the State of Research in 1986* (B.A.R. International Series 396) pp. 473–502. Oxford: British Archaeological Reports.

Obeidat, D. 1995. *Die neolithische Keramik aus Abu Thawwab, Jordanien* (Studies in Early Near Eastern Production, Subsistence and Environment 2). Berlin: *ex oriente*.

Perrot, J. 1968. La Préhistoire Palestinienne. In Cazelles H. and Feuillet A. (eds.) *Supplément au Dictionnaire de la Bible*, pp. 286–446. Paris: Letouzy and Ané.

Prausnitz, M. 1959. The First Agricultural Settlements in Galilee. *Israel Exploration Journal* 9: 166–174.

Rollefson, G.O., Simmons, A.H. and Kafafi, Z. 1992 Neolithic Cultures at 'Ain Ghazal, Jordan. *Journal of Field Archaeology* 19: 443–470.

Stekelis, M. 1951. A New Neolithic Industry: The Yarmukian of Palestine. *Israel Exploration Journal* 1: 1–19.

Stekelis, M. 1952. Two More Yarmukian Figurines. *Israel Exploration Journal* 2: 216–217.

Stekelis, M. 1972. *The Yarmukian Culture of the Neolithic Period*. Jerusalem: Magnes Press.

Tzori, N. 1958. Neolithic and Chalcolithic Sites in the Valley of Beth-Shan. *Palestine Exploration Quarterly* 90: 44–51.

# The Spatial Distribution of Ancient Human Occupation: Results of an intensive Surface Survey and Test Excavations

*Michele A. Miller*

## I. Introduction

**1. Goals and Objectives of the Survey Project.** The primary goal of the explorations of the Neolithic remains at Sha'ar Hagolan is to address the place of these first pottery-making peoples in the development of civilization in the Levant. While excavations at the site have led to many important discoveries, several important questions could best be determined by intensive surface survey followed by test excavations.

The first question we have aimed to answer with the survey is a determination of the extent of Neolithic habitation at Sha'ar Hagolan. Although prior to this survey our present excavations were confined to one area of the site adjacent to the bank of the Yarmuk River, evidence had already indicated that Yarmukian occupation was distributed over a much larger area. Previous exploration at the site by M. Stekelis found Yarmukian material in several squares ranging over an area of several hundred square meters. From his work at Sha'ar Hagolan, Stekelis estimated the size of the Neolithic site to be 200–300 dunams, i.e., 20–30 hectares (Stekelis 1972: 2). Corroborating his research is the fact that Yarmukian material, including many of the famous Sha'ar Hagolan pebble figurines, were found by members of Kibbutz Sha'ar Hagolan during plowing and other agricultural activities in various, separate fields.[1] Despite these indications that Sha'ar Hagolan was an exceptionally large site for the Neolithic period, the exact area of the site remained unknown.

A second objective of the surface survey was to determine whether occupation was evenly distributed over the entire area of the site. While Stekelis found Yarmukian cultural material in all the squares he exposed, he failed to uncover substantial architectural features of the type we have found in more recent excavations. Thus, we hoped that the survey would clarify the relationship of the monumental complexes uncovered by our present excavations with the small round pit-dwellings described by Stekelis. This relationship could be that between the core and periphery of a single large town, between a communal and/or ritual center and domestic buildings, or between elite and common domestic structures. A surface survey, combined with excavation of test squares, was thought to be the best means of determining the nature of this spatial and occupational relationship.

A final objective of this survey was to document the use of the region through time and record changes in its relative importance in the history of civilization in the Levant. Most important was to determine the relation of the Yarmukian phases at Sha'ar Hagolan with the Middle Bronze Age I (hereafter MB I), also known as Early Bronze Age IV, settlement excavated in the nearby area by E. Eisenberg. Was there evidence for continued occupation from the Yarmukian into MB I? Moreover, we hoped to determine if the area of Bronze Age occupation indicated by the survey would correspond with that estimated by Eisenberg.

**2. A Window of Opportunity.** Several factors pointed to a need to conduct a surface survey during the 1998 season. First, was the need to determine the distribution of Yarmukian occupation as we planned our future

---

[1] The area in which the majority of both the Yarmukian and Bronze Age occupational remains are found is part of Kibbutz Sha'ar Hagolan, though some Yarmukian remains to the north and east also lie beneath fields currently under cultivation by Kibbutz Masada.

excavation strategy. We hoped that the survey would point to specific areas of the site deserving more intense investigation. More importantly, recent changes in agricultural practices of the kibbutzim which own most of the land on which the site lies pose an imminent threat to any remaining cultural remains. As the kibbutzim remove old groves of trees, new occupation areas have become exposed. Many of these sites will be destroyed without documentation, as these fields will be more heavily plowed in planned future agricultural activities. Furthermore, some of these fields will undoubtedly be replanted with other orchard crops, such as mango or avocado, and thus will become unavailable for exploration for many years to come.

For the next few seasons a window of opportunity has been opened for intensive archaeological exploration, and it is our hope to take advantage of this short time when cultural remains are still visible on the surface. Even prior to this survey, large river cobbles of the type used for prehistoric dwellings, along with massive quantities of MB I pottery, were found churned up in a newly plowed area near the current excavations. While the members of Kibbutz Sha'ar Hagolan are generally very favorable to archaeological investigations (it is noteworthy that a small museum dedicated to the site has been erected at the kibbutz) it is likely that they will continue to destroy unexplored sites without being aware of their existence. We thus hoped that the survey would indicate specific areas of the site not only for our own investigation, but also deserving further protection.

## II. SURVEY STRATEGY AND METHODOLOGY

It became apparent early in the planning process that most well-known surface survey strategies would not be appropriate to our objectives and restrictions.[2] The Sha'ar Hagolan survey objectives were rather unusual; rather than looking for new archaeological sites in a relatively large region, we hoped to determine the distribution of ancient human remains in a fairly restricted area (c. 1.5 sq. km.). And whereas many surface surveys aim to discover sites of many periods, we were basically interested in determining the extent of occupation during a single period, the Yarmukian, and only secondarily to verify the extent of later remains (primarily of MB I). Finally, while many published surveys were conducted over many seasons, we intended for this survey to be completed in a

single four-week season. Thus, it was necessary to establish a survey strategy based on the particular objectives and characteristics of the Sha'ar Hagolan project.

In light of these particular requirements we felt the need to conduct a uniquely fine-grained, intensive survey, allowing total coverage of the survey area. The basic units of the survey were transects of approximately 50 m. by 200 m. These transects were walked in two opposing passes (i.e. walked in opposite directions), c. 200 m. in length. In almost all cases, transects were fit into the configurations of existing fields, for greater consistency of ground cover within a transect, and to enable us to more easily locate the transect on area maps (Fig. 3.1).

Seven surveyors walked in a line along each pass, approximately 3.5 m. apart. Thus, unlike many surveys in which participants walk five to ten meters apart, at Sha'ar Hagolan we were able to cover the survey area more precisely and see a greater percentage of the cultural material on the ground surface. In fact, on several occasions we walked an extra pass over a previously surveyed area as a check and found that most of the cultural material had been removed. Each surveyor was given a marked bag (A–G for the first pass, H–N for the second) in which all cultural material found during the pass was placed. Surveyors were instructed to pick up all cultural material, of every period but modern, including chipped stone, pottery, and groundstone. Architectural features, or other material too large to be removed, were noted on the survey forms and maps, drawn (when appropriate) and photographed.

One of the primary difficulties encountered by the survey was the intensive agricultural use of the landscape. We found that the current type of agricultural use of a particular field had a profound effect on the visibility of cultural remains on the surface. Whenever possible we followed the kibbutz farm schedule in order to survey fields after they had been newly plowed. Meticulous records, meanwhile, helped us to compensate during analysis for the wide variation in visibility caused by differences in ground cover. Record forms kept on each transect contained data on the type of groundcover and the estimated visibility of the ground surface. Any other details about the landscape, such as slope, previous land use, etc., were also noted on these forms. Finds were washed in the afternoon, after which we counted the number of finds of each type (pottery, lithic, etc.) from every bag and noted their estimated date. This information was also recorded on the appropriate transect forms.

---

[2] In fact, it is acknowledged that there are almost as many survey strategies as areas under archaeological investigation. This survey combined 'total coverage' methods commonly used to distinguish the distribution density of artifacts in a single site or over a limited area (see for instance, Binford *et al.*, 1970) with more extensive reconnaissance-survey methods used to explore settlement patterns, as developed by Gordon Willey (1953; 1983). For more on survey methods, see Alcock 1951; Cowgill *et al.* 1984; King 1978; Wells 1990; Wright *et al.* 1990.

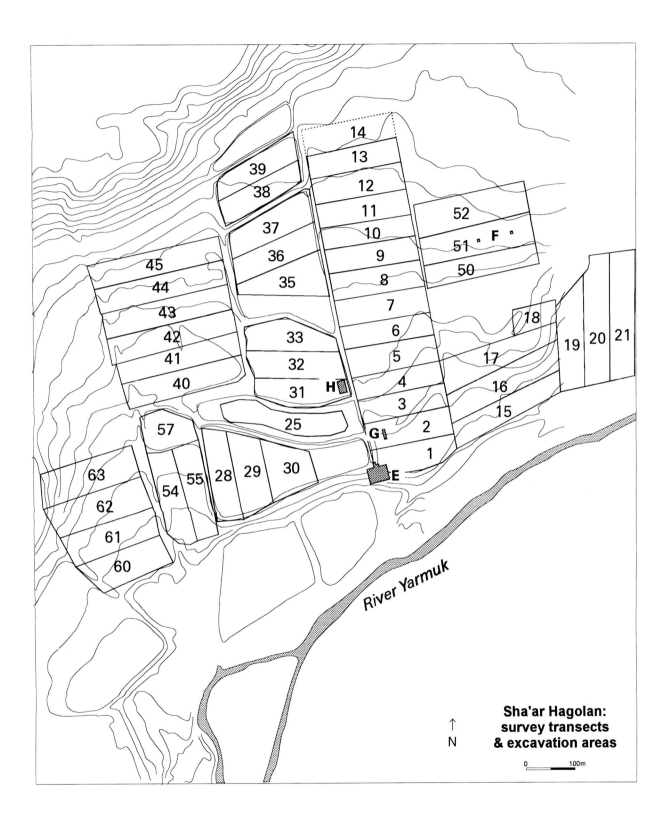

FIG. 3.1. The survey map of Sha'ar Hagolan

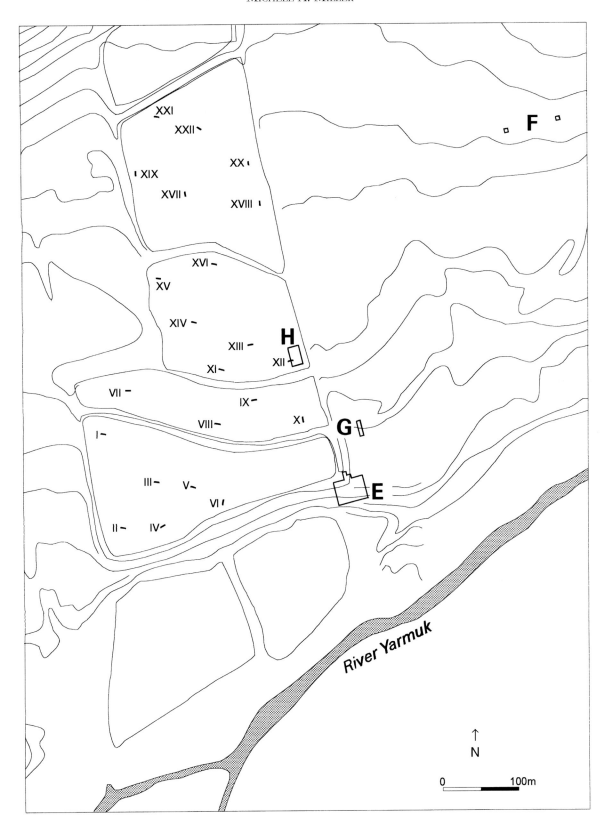

FIG. 3.2. The location of the soil-sample trenches

As we conducted the survey, we noted numerous deep trenches created by back-hoe in several of the fields surrounding our excavations. These were soil-test trenches dug by the kibbutz in order to determine the composition of the soil in fields that had been used previously as fishponds (Fig. 3.2). Unfortunately these trenches pose a serious threat to archaeological remains in the region, as not only do they disturb *in situ* deposits, but they mark the preparation of these fields for more intensive and potentially damaging agricultural practices. On the other hand, the trenches provided us with a valuable glimpse into the sediment beneath the present ground surface. Often the surface of these fields was covered with a deep layer (sometimes measuring over c. 10 cm.) of sterile gray clay that was deposited by the fishponds. Thus, while cultural material was often not visible on the surface of these fields, or visible only along the edge, the trenches enabled us to determine the cultural material beneath this thick clay layer.

Study of the soil-test trenches was incorporated into the surface survey. Each trench was given a number (in Roman numerals to distinguish them from the transect numbers) and was marked on survey maps, as located by the staff surveyor/architect, who also drew a section of one balk from each trench. Then the survey team examined all the loose sediment that had been dumped by the backhoe in mounds around each trench. The walls of the trench were also examined for cultural material, and in particular, for evidence of architectural features which may have been disturbed by the back-hoe. These were noted on the sections (Fig. 3.3). All portable cultural material was collected and marked for later analysis.

## III. Survey Results

**1. Neolithic Occupation.** The 1998 survey provided significant data for the analysis of human occupation during the prehistoric era in the region of Kibbutz Sha'ar Hagolan. Over 3,500 pottery sherds and more than 13,000 worked lithics were collected during the course of the survey. This included 721 Yarmukian pottery sherds, 78 diagnostic (mostly Yarmukian) lithics, 792 MB I pottery sherds and 923 historic pottery sherds; the remaining material was not diagnostic and could not be assigned a date (see Table 3.1). The first important conclusion that can be drawn from the results of this survey is the extent of Neolithic occupation in this region. As indicated by variations in the density of Neolithic material, the Yarmukian site of Sha'ar Hagolan extended at least 700 m. north

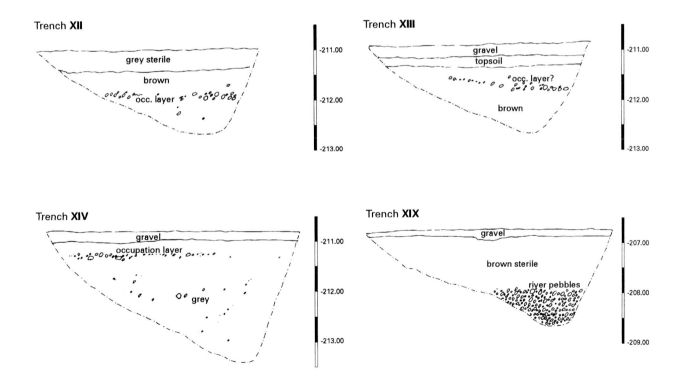

Fig. 3.3. The sections of four soil-sample Trenches XII, XIII, XIV and XIX

MICHELE A. MILLER

TABLE 3.1. Surface survey results. Key: VP = very poor, P = poor, F = fair, G = Good, E = excellent

| Transect Number | Undiag. Pottery | Yarmukian Pottery | MB I Pottery | Historic Pottery | Undiag. Lithics | Yarmukian Lithics | Total Lithics | Other Material | Terrain | Visibility | Slope |
|---|---|---|---|---|---|---|---|---|---|---|---|
| 1 | 19 | 3 | 6 | 20 | 530 | 0 | 530 | 0 | cut grass | G | L |
| 2 | 23 | 2 | 3 | 16 | 488 | 0 | 488 | 1 | grass cover | F/G | L |
| 3 | 11 | 0 | 0 | 3 | 244 | 0 | 244 | 1 | grass cover | F/G | M |
| 4 | 4 | 2 | 0 | 1 | 205 | 4 | 209 | 0 | dischar. | G | L |
| 5 | 0 | 15 | 2 | 2 | 214 | 0 | 214 | 0 | dischar. | G | L |
| 6 | 4 | 10 | 0 | 2 | 230 | 8 | 238 | 1 | dischar. | G | L |
| 7 | 0 | 9 | 1 | 5 | 210 | 2 | 212 | 0 | dischar. | G | L |
| 8 | 24 | 2 | 2 | 20 | 541 | 1 | 542 | 0 | plowed | E | L |
| 9 | 5 | 0 | 1 | 5 | 687 | 2 | 689 | 0 | plowed | E | L |
| 10 | 5 | 0 | 0 | 8 | 630 | 10 | 640 | 0 | plowed | E | L |
| 11 | 1 | 2 | 1 | 1 | 510 | 2 | 512 | 0 | plowed | E | L |
| 12 | 0 | 0 | 0 | 4 | 205 | 0 | 205 | 0 | plowed | E | L |
| 13 | 0 | 0 | 0 | 12 | 275 | 0 | 275 | 0 | plowed | E | L |
| 14 | 0 | 0 | 0 | 4 | 170 | 2 | 172 | 0 | plowed | E | L |
| 15 | 11 | 0 | 1 | 5 | 137 | 0 | 137 | 0 | date | P | L |
| 16 | 7 | 0 | 0 | 1 | 224 | 1 | 225 | 1 | date | VP | L |
| 17 | 5 | 12 | 2 | 9 | 351 | 2 | 353 | 0 | date | F | |
| 18 | 8 | 10 | 0 | 1 | 27 | 2 | 29 | 0 | date/new | E | L |
| 19 | 0 | 0 | 0 | 7 | 186 | 0 | 186 | 0 | banana | P | L |
| 20 | 2 | 0 | 1 | 12 | 65 | 0 | 65 | 0 | banana | VP | L |
| 25 | 6 | 12 | 17 | 1 | 60 | 0 | 60 | 2 | | | |
| 28 | 1 | 0 | 7 | 4 | 73 | 2 | 75 | 0 | cut grass | F | L |
| 29 | 0 | 2 | 3 | 3 | 63 | 1 | 64 | 0 | cut grass | F | L |
| 30 | 0 | 0 | 12 | 8 | 77 | 0 | 77 | 0 | cut grass | F | L |
| 31 | 5 | 11 | 9 | 6 | 95 | 0 | 95 | 0 | cut grass | G | L |
| 32 | 12 | 13 | 34 | 2 | 117 | 0 | 117 | 0 | cut grass | G | L |
| 33 | 11 | 5 | 71 | 8 | 95 | 0 | 95 | 0 | cut grass | G | L |
| 35 | 0 | 2 | 1 | 0 | 61 | 2 | 63 | 0 | cut grass | F/G | L |
| 36 | 1 | 0 | 0 | 4 | 84 | 0 | 84 | 0 | cut grass | F/G | L |
| 37 | 1 | 2 | 1 | 2 | 98 | 0 | 98 | 0 | cut grass | F/G | L |
| 38 | 1 | 0 | 0 | 1 | 9 | 0 | 9 | 0 | cut grass | P & G | L |
| 39 | 3 | 0 | 0 | 2 | 10 | 0 | 10 | 0 | cut grass | P | L |
| 40 | 147 | 11 | 338 | 12 | 1351 | 12 | 1363 | 1 | avocado | F/G | L |
| 41 | 187 | 14 | 18 | 15 | 883 | 1 | 884 | 1 | avocado | F/G | L |
| 42 | 15 | 0 | 90 | 35 | 667 | 4 | 671 | 0 | avocado | F/G | L |
| 43 | 54 | 0 | 0 | 20 | 356 | 0 | 356 | 0 | avocado | F/G | L |
| 44 | 16 | 1 | 2 | 6 | 90 | 0 | 90 | 0 | avocado | F/G | L |
| 50 | 14 | 73 | 0 | 21 | 269 | 9 | 278 | 2 | plowed | E | L |
| 51 | 0 | 251 | 0 | 9 | 383 | 3 | 386 | 3 | plowed | E | L |
| 52 | 5 | 216 | 2 | 8 | 351 | 4 | 355 | 6 | plowed | E | L |
| 55 | 53 | 32 | 70 | 120 | 743 | 2 | 745 | 1 | avocado | F/G | L |
| 56 | 58 | 6 | 19 | 91 | 441 | 0 | 441 | 0 | avocado | F/G | L |
| 57 | 0 | 0 | 0 | 1 | 2 | 0 | 2 | 0 | eucalyptus | F/G | L |
| 60 | 151 | 0 | 10 | 124 | 236 | 1 | 237 | 0 | avocado | F/G | L |
| 61 | 120 | 2 | 6 | 147 | 167 | 1 | 168 | 1 | avocado | F/G | L |
| 62 | 32 | 0 | 34 | 107 | 140 | 0 | 140 | 0 | avocado | F/G | L |
| 63 | 83 | 1 | 28 | 28 | 94 | 0 | 94 | 0 | avocado | F/G | L |
| Totals | 1105 | 721 | 792 | 923 | 13,144 | 78 | 13,222 | 21 | | | |

of Area E at the bank of the Yarmuk River, and at least 1 km. to the east and west. Therefore, the Neolithic occupation in this region spread over more than a twenty hectare area, making Sha'ar Hagolan not only a site of unusual size for such an early period, but the largest Neolithic site yet known in the Levant.

It is possible that the site might be even larger. Excavations in Area E during the 1998 season determined that at one time the Yarmuk River cut into the southern part of excavated buildings; sediment currently in this area is modern fill. Therefore, cultural remains of earlier periods would not be visible in the area immediately to the south of the excavations. It would have been interesting to survey in the area still further to the south, which would once have lain south of the river course, but this area currently lies in the no-man's land on the opposite side of the Israel-Jordan border and was thus not available to us.

Not all of the area in which Neolithic remains were found was necessarily occupied contemporaneously, or in the same manner. In fact, the survey results give strong indications of several nodes of more intense Neolithic occupation, determined to have contained architectural features, surrounded by land which may have been less intensely occupied with fewer or no permanent structures. One of these possible nodes was revealed by the soil-test trenches (see Table 3.2) in an area of about 200–250 m. due east of the current excavations (transects 28–30). Several trenches in this area (trenches I–VI) contained a rich accumulation of Yarmukian material (and also some Bronze Age pottery sherds). One trench (IV) contained a large basalt mortar of a form typical to the Yarmukian occupation at Sha'ar Hagolan. The backhoe seems to have disturbed some sort of architectural features in a second, neighboring trench (V), as indicated by a line of large basalt stones of the type commonly used in Yarmukian architecture. Several large, flat stones, including a squared, flat limestone block with a rounded

TABLE 3.2. Finds from soil-test trenches

| Trench | Transect | Undiag. Pottery | Yarm. Pottery | MB I Pottery | Undiag. Lithics | Diag. Lithics | Other finds |
|--------|----------|-----------------|---------------|--------------|-----------------|---------------|-------------|
| I | 28 | 0 | 3 | 0 | 85 | 9 | 3 bone |
| II | 28 | 0 | 0 | 0 | 29 | 7 | 4 bone |
| III | 29 | 1 | 14 | 1 | 90 | 2 | 2 bone |
| IV | 29 | 0 | 6 | 0 | 23 | 8 | 3 bones, 1 limestone bowl, 1 mortar |
| V | 30 | 0 | 2 | 25 | 123 | 6 | 11 bones |
| VI | 30 | 0 | 0 | 25 | 49 | 4 | 8 bone, 1 spindle-whorl |
| VII | 25 | 12 | 34 | 3 | 77 | 1 | 1 bone, 1 mortar |
| VIII | 25 | 42 | 74 | 33 | 21 | 1 | 3 bone |
| IX | 25 | 0 | 6 | 0 | 14 | 2 | 2 bone |
| X | 25 | 3 | 6 | 0 | 49 | 4 | 9 bone, 1 groundstone |
| XI | 31 | 5 | 5 | 0 | 6 | 1 | 1 stone weight |
| XII | 31 | 3 | 3 | 0 | 31 | 0 | 1 bone |
| XIII | 31 | 1 | 6 | 4 | 28 | 0 | 1 bone |
| XIV | 32 | 0 | 9 | 0 | 10 | 0 | 1 bone, 1 stone bowl fragment |
| XV | 33 | 0 | 0 | 0 | 8 | 0 | |
| XVI | 33 | 4 | 15 | 0 | 22 | 0 | 1 bone, 3 stone bowl fragments |
| XVII | 35 | 0 | 0 | 0 | 7 | 0 | |
| XVIII | 35 | 0 | 0 | 0 | 11 | 0 | |
| XIX | 36 | 9 | 8 | 8 | 4 | 0 | |
| XX | 36 | 0 | 0 | 0 | 0 | 0 | |
| XXI | 37 | 0 | 0 | 0 | 0 | 0 | |
| XXII | 37 | 9 | 8 | 8 | 22 | 0 | |
| XXIII | 38 | 1 | 0 | 0 | 2 | 0 | |
| XXIV | 38 | 1 | 0 | 0 | 4 | 0 | |
| XXV | 39 | 0 | 0 | 0 | 0 | 0 | |
| XXVI | 39 | 0 | 0 | 0 | 1 | 1 | |
| XXVII | 39 | 0 | 0 | 0 | 0 | 0 | |

shallow impression in the center, were recovered amongst the debris heaped around the trench by the back-hoe. A similar block is found in the midst of the carefully paved area in Building Complex I, which was uncovered during the 1997 season excavations. This evidence strongly indicates that the disturbed feature is a paved area, rather than a wall; possibly, the trench has disturbed another large, paved room of an unknown building complex.

We cannot yet ascertain whether this area of Yarmukian occupation is separate from the area currently under excavation (Area E), or is a continuation of the same occupation zone further to the east. Currently, the field between the two areas is covered in dense overgrowth, which could not be penetrated for survey. Intriguingly, according the kibbutz farm manager, the field was left unplowed because it was too difficult to use the farm equipment due to a dense concentration of stones found there. Y. Garfinkel, who investigated this area in previous seasons before the vegetation had grown so thick, found what he believed to be the remains of several stone walls on the ground surface. These, however, he believed to date from the Bronze Age, and this zone may be the Area A examined by Eisenberg (see below). On the other hand, if the architectural features revealed by the soil trenches and Area E are linked, total area covered by these Yarmukian building complexes would be immense –

perhaps unparalleled in any other site of the Neolithic period.

Another area with a high concentration of Yarmukian artifacts was discovered during the survey approximately 450 m. to the northeast of the main excavation area, and later designated Area F (see Fig. 2.4 below). This area had recently been deeply plowed, and newly disturbed soil contained large basalt stones of a type frequently found in Yarmukian architecture. The disturbed sediment was a distinct white clay also found in the areas under current excavation at Sha'ar Hagolan. The survey of transects 50–52 in this area revealed over 500 Yarmukian pottery sherds, including several of extremely thick open jars (pithoi) of very wide diameter, several with painted and incised decoration characteristic of the Yarmukian (including the typical herringbone pattern), and numerous lug handles. Over one thousand flaked stone artifacts were found in these same transects, including numerous retouched blades, several of the distinctive Yarmukian sickle-blades with large denticulation, and two bifacial knives characteristic of the Levantine Neolithic. Other cultural material found in this area included a stone weight, a fragment of a stone bowl, and numerous large stone mortars and millstones. Altogether the large basalt building stones, white clay sediment, and accumulation of cultural material indicated that the area might contain

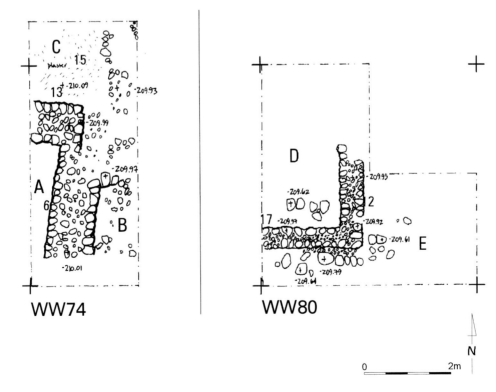

FIG. 3.4. The architecture of Area F

occupational features from the Yarmukian period similar to those found in the main excavations. We therefore decided to excavate test squares in Area F in order to check this hypothesis, and to determine the extent of damage to architectural remains caused by prior agricultural activities (see below).

**2. Middle Bronze Age I Occupation.** MB I period occupation in the area of Sha'ar Hagolan had previously been documented by the explorations of E. Eisenberg (1993: 1342–3) who briefly examined architectural remains revealed during the cleaning of the kibbutz fishponds in the 1980s. Eisenberg also examined cultural material found in neighboring fields, and estimated that the MB I occupation in the area was approximately 20 hectares, a substantial settlement. Later, the site explored by Eisenberg was re-submerged in the fishpond, and not further studied. Some MB I remains have also been found during recent excavations at Sha'ar Hagolan, but these consist mostly of layers mixed with earlier material. No clear MB I architectural material has yet been uncovered in the new excavations.

The 1998 surface survey clarified the extent of MB I cultural material at Sha'ar Hagolan and re-located what we believe to be the areas examined by Eisenberg. In general, we found MB I material primarily in the area to the west of our Yarmukian Area E, particularly in the fishponds just to the west and northwest, within the soil trenches in this area, and in the avocado groves further to the west. Although found in a low density 'background' scatter over a large area, MB I material was more densely concentrated in only a very restricted area. In part this may be because much of the Bronze Age site lies primarily beneath the dried fishponds and thus would be difficult to detect due to the thick layer of clay, which covers the original sediment in this area. However, even in areas where it predominated over material of other periods, Bronze Age material was often found in association with Yarmukian remains. This mixing of Neolithic and MB I finds was also noted in the excavation of Eisenberg's Area A (Eisenberg 1993: 1342).

Eisenberg explored two separate areas of Bronze Age occupation at Sha'ar Hagolan, both of which contained substantial architectural remains, including several buildings consisting of multiple rooms, attested by preserved stone wall socles. In the first of these, which he referred to as Area A, Eisenberg uncovered c. 900 sq. m. of building remains near an older bank of the Yarmuk River. It is probable that this is the same area currently hidden by dense undergrowth that lies between our current main excavations (Yarmukian Area E) and the Yarmukian remains revealed by soil-test trenches to the west. Interestingly, a relatively high number of Bronze Age sherds (12)

compared to Yarmukian sherds (0) were found in transect 30, just to the west of this area, as well as within the trenches (V and VI) located just beyond the undergrowth.

The highest concentration of MB I material was found in the unused fishpond c. 250 m. north of this dense undergrowth, in transects 32, 33, and in the avocado fields directly to the west of this area, transects 40–42. Surface remains in transects 32 and 33 include several displaced large basalt stones, which may once have formed walls. The area surrounding these remains has been cordoned off by the Israel Antiquities Authority, and it is possible to distinguish an old sign on the fencing which reads "Antiquities." It is likely these remains, now badly disturbed, once formed the buildings of Area B examined by Eisenberg (1993: 1343). It is interesting, however, that the soil trenches (XIV, XV, and XVI) located in transect 32 and 33, which lie just west of the probable Bronze Age walls contained only a few Yarmukian and no Bronze Age sherds. In fact, this observation was confirmed by more recent excavations in Area H, which have uncovered extensive Yarmukian remains with only minor MB I disturbance. Either the area between Eisenberg's areas A and B was not occupied during the MB I, or the majority of Bronze Age remains in this area were exposed and perhaps removed in the massive earth-moving necessary for the construction of the fishponds. The Yarmukian remains, being deeper, were much less disturbed by this activity.

The total area of significant MB I material revealed by the survey was about 650 by 250 m. (c. 16 hectares) and therefore slightly smaller than Eisenberg's estimate. Although it appears that a portion of the MB I settlement was disturbed by much more recent land use in the area, it now seems that the extent of Bronze Age occupation at Sha'ar Hagolan was less than that of the earlier Yarmukian period. It is likely that a very different settlement pattern existed during the two periods.

**3. Other Periods.** Some material of various other, almost exclusively historic, periods was found during the survey. As these local wares have not been closely studied, it was not possible for us to determine the exact dates of these sherds – most appear to be Byzantine or later. Interestingly, such historic-period sherds were found in a small, but even concentration over much of the area under survey, varying in density primarily depending upon how visible the ground surface was beneath the overlying cover or vegetation.

The detection of historic period material at Sha'ar Hagolan supplies a valuable lesson about the efficacy and certitude of surface survey in an area under dense modern occupation and use. Numerous local inhabitants of the area had reported to us about an area where they

had frequently found pottery sherds in the past. The oldest residents of the kibbutz reported that the area, now under date palm cultivation, had once been the site of a small Arab farm, called Abu Nimel. It was deserted during the 1948 war, and then the area came under intense and varied use. As the area lies adjacent to the border it is the site of a military defensive embankment. Land mines were subsequently laid in this area, and warning signs still can be found, though recently, as Israeli relations with Jordan improved, they have been removed. Presently, the embankment is being used by Kibbutz Masada as a dumping ground for the stones and other debris removed from neighboring fields during plowing.

Much of this area was also prepared for the cultivation of date palms, which required extensive grading and the further dumping of soil collected from other fields during the course of plowing and planting. The result of this activity is that very few prehistoric or historic pottery sherds or other cultural material were found in this area. These results have important repercussions for our analysis of survey data. We must apply caution to the equation of lack of cultural material found on the surface to the non-existence of a site beneath the surface. The results of surface survey – both positive and negative evidence – must be backed up with other techniques, such as remote sensing and excavation, which enable us to see what lies beneath the ground surface.

## IV. PILOT PROJECT: GEOPHYSICAL SURVEY AT SHAʿAR HAGOLAN

As we conducted a field survey in the 1998 season, we simultaneously initiated a pilot project to test the effectiveness of remote sensing techniques to locate Yarmukian structures at Shaʿar Hagolan (see S. Itkis, Chapter 4 in this volume). Along with more traditional techniques, such as the surface survey and excavation, we hope that the use of geophysical prospection will enable us to differentiate areas with significant architectural remains from those perhaps used for other purposes. The area immediately north of our Area E excavations was chosen for this project, as two of the small squares excavated by Stekelis which contained Yarmukian material (but no architecture) were found in this area. S. Itkis carried out a magnetic survey of 1.25 hectares in this area. The same area was also walked as part of the surface survey and found to have a significant density of cultural material, mostly lithics, but also some Yarmukian pottery sherds.

Detailed maps generated by the magnetometer indicated areas of extreme anomalies in this field. A test trench of 20 × 5 meters (Area G) was excavated at the location with the strongest magnetic values in order to verify and correlate results of the magnetic survey with excavated remains. To date, the excavations in this area, conducted only in the last season, have not provided conclusive evidence on which to base a discussion of Yarmukian occupational patterns.

## V. RESULTS OF PRELIMINARY EXCAVATIONS IN AREA F

As indicated above, the concentration of Yarmukian materials on the surface in a newly plowed field c. 450 m. to the northeast of the main excavations, referred to as Area F, indicated that the area had been intensively occupied during the Yarmukian period. The presence on the ground surface in this area of large millstones, mortars, and basalt stones of the type typically used in Yarmukian architecture at Shaʿar Hagolan, aroused concern that previous agricultural activities, including deep plowing, may have disturbed any architectural features beneath the ground surface. Moreover, the area was scheduled for further, deeper plowing in preparation for the planting of bananas, and therefore any cultural material was under immediate threat. Upon discovering the density of Yarmukian remains in this field during the survey, we immediately initiated negotiations with Kibbutz Masada which controls the field, and received permission to excavate until the end of the season, only two weeks away. We excavated small test-squares in three separate areas of the field; one on the eastern edge of the field, another in the center of the area of greatest density of finds, and a third approximately half-way between the two other squares.

Although we had hoped that in the square placed along the edge of the plowed field we would uncover deposits undisturbed by recent agricultural activity, this did not appear to be the case. The uppermost level of this square was a loose, mixed sediment, apparently disturbed by previous plowing. Interesting material found within this 'plow zone' included a complete, finely-worked, steep-sided limestone bowl and several large pottery sherds with characteristic Yarmukian incised decoration. The nature of the mixed sediment, however, indicated that these materials were brought in from other areas of the field through plowing and other agricultural activities, and were not indicative of cultural deposits within the undisturbed sediment below. In fact, deeper soundings in this area along the eastern edge of the field, including a trench dug down nearly two meters, revealed only sterile soil.

Test trenches in other areas of the field were more encouraging. A small square, measuring 2.5 m. by 5.0 m. and designated WW74d according to our site grid, was

opened in the center of the area found to have the densest concentration of surface finds (Figs. 2.18, 3.4). While here, too, upper levels were greatly disturbed by plowing, in lower levels the cultural deposits appear to have remained intact. At a depth of c. 0.5 m. below the ground surface (c. 210 m. below sea level) we uncovered a substantial wall, running approximately north–south. Only the foundation of the wall, which was built in a characteristic Yarmukian pattern of rounded basalt cobbles, nearly one meter in width, was preserved. Toward the north end of the trench this wall appears to form a corner with another, smaller east–west wall. On the other side of the corner our excavations revealed the remains of a hard-packed floor, perhaps made up of plaster or fine, white clay. This floor was highly fragmentary, and primarily appeared in patches that when cleared seemed to form a surface contiguous with the stones of both walls. Such preserved plastered floors have not yet been encountered within the architectural features of Area E, although there is some evidence for them in the trench excavated in Area G.

Architectural features were also found at a similar depth in a 2.5 m. by 5.0 m. trench designated WW80d, which was excavated during the final week of the 1998 season (Figs. 2.17, 3.4). A wall of rounded basalt stones, approximately 0.25 m. wide and 3 m. long, running in a north–south direction, was uncovered in this trench. This wall forms a corner with an east–west wall of similar width, also made up of stone cobbles, in the southern area of the square. An east–west line of large, flat basalt stones lying adjacent and to the south of this corner, but at a slightly higher elevation, may either be an upper bench or a later buttress to the wall. Small areas of plastered flooring were also preserved in this square. Finds in both squares include abundant Yarmukian pottery sherds and lithics, although no figurines were found in this area.

have cautioned about the underlying difficulties of surface survey in a region of intense agricultural development. I have already described how current agricultural practices may have obscured a recent historic site. In a similar vein, I recently noted that the Yarmukian remains, which were so abundant on the surface in Area F during our 1998 season, were completely covered and invisible during the 1999 season, after the sediment in the area had been prepared and compacted for the planting of bananas. Thus it is entirely possible, if not probable, that there are areas of Sha'ar Hagolan which were occupied in the past but were not noted by this survey.

In addition, we have proposed that the Yarmukian occupation appears to cover this area unevenly, with several nodes of more dense occupation, including substantial architectural features, and other areas without significant remains. Preliminary results from the survey, however, do not indicate the association between these different areas, and whether there are functional or chronological differences between various nodes of Yarmukian occupation. Presently, A. Eirikh-Rose and Z. Matskevich are conducting more in-depth analyses of the pottery and lithics, respectively, recovered from the survey, with the goal of exploring any differences in Yarmukian artifact types across the entire survey area. In addition, they will be comparing the pottery and lithics found on survey with those from our excavations. With the excavation of several new areas of the site in the year 1999, we now also have the opportunity to compare artifacts from several different areas of the site. We thus hope to clarify the relationship not only between various nodes of Yarmukian occupation, but between these nodes and the areas which seem to lack more substantial architecture that lie between them. By exploring these questions we look forward to a greater understanding of this impressive culture and its role in the dawn of civilization in the Levant.

## VI. PRELIMINARY CONCLUSIONS AND FUTURE DIRECTIONS

While the survey has pointed to several very important hypotheses about Yarmukian and Bronze Age occupation at Sha'ar Hagolan, it is important to remember that these are only preliminary results which need to be backed up by future research. For instance, the total area of Yarmukian occupation at Sha'ar Hagolan described above must be considered only a minimum, and may, in fact, be much larger. It is quite possible that more Yarmukian material will one day be found further to the south, on the other side of the Yarmuk River, and even further to the east, where today an impenetrable banana grove makes the detection of any surface remains impossible. Moreover, I

## BIBLIOGRAPHY

Alcock, L. 1951. A Technique of Surface Collecting. *Antiquity* 98: 75–76.

Binford, L.R., Binford, S.R., Whallon, R. and Hardin, M.A. 1970. *Archaeology at Hatchery West*. Memoir no. 24. Washington, D.C.: Society for American Archaeology.

Cowgill, G.L., Altschul, J.H. and Sload, R.S. 1984. Spatial Analysis of Teotihuacan: A Mesoamerican Metropolis. In Hietala, H. J. (ed.) *Intrasite Spatial Analysis in Archaeology*, pp.154–195. Cambridge: Cambridge University Press.

Eisenberg, E. 1993. Sha'ar Hagolan: The Middle Bronze Age I Site. In Stern, E. (ed.) *The New Encyclopedia of Archaeological Excavations in the Holy Land*, Vol. IV, pp. 1342–1343. Jerusalem: Israel Exploration Society.

King, T.F. 1978. *The Archaeological Survey: Methods and Uses*. Washington, D.C.: U.S. Department of the Interior, Heritage Conservation and Recreation Service.

Wells, B., Runnels, C. and Zangger, E. 1990. The Berbati-Limnes Archaeological Survey: The 1988 Season. *Opuscula Atheniensia* 18: 207–238.

Willey, G. R. 1953. *Prehistoric Settlement Patterns in the Virú Valley, Peru*. Bureau of American Ethnology, Bulletin 155. Washington, D.C.: Smithsonian Institution.

Willey, G. R. 1983. Settlement Patterns and Archaeology: Some Comments. In Vogt, E.Z. and Leventhal, R.M. (eds.) *Prehistoric Settlement Patterns: Essays in Honor of Gordon R. Willey*, pp. 445–462. Albuquerque and Cambridge: University of New Mexico Press, and Harvard University, Peabody Museum of Archaeology an Ethnology.

Wright, J.C., Cherry, J.F, Davis, J.L, Mantzourani, E. and Sutton, S.B. 1990. The Nemea Valley Archaeological Project: A Preliminary Report. *Hesperia* 59: 579–659.

Stekelis, M. 1972. *The Yarmukian Culture of the Neolithic Period*. Jerusalem: Magnes Press.

# 4

# MAGNETIC INVESTIGATIONS

## Sonya Itkis

## I. INTRODUCTION

Geophysical prospection has been well established as a means of locating and mapping archaeological sites. Geophysical techniques are based on well-known physical principles (Aitken 1974). In the case of the study of archaeological sites, geophysical techniques involve indirect measurements, resulting from subsurface disturbances associated with past cultural activities. Geophysical imaging of archaeological remains is nowadays utilized to document site boundaries and protect sites from destruction. Among geophysical methods applied to archaeological studies, the fastest and most commonly used one is magnetic survey. In recent years, with the growing sophistication of geophysical exploration techniques, improved accuracy and reliability, the use of this method has increased significantly (Boucher 1996; Heimmer and De Vore 1995). The method has been proven at various prehistoric sites in Israel (Itkis and Eppelbaum 1999).

Magnetometry is based on the magnetic contrast between archaeological remains and the soil surrounding them. The greater the contrast, the higher the chance of discovering buried archaeological remains. Differentiation of magnetic properties ranges from a few units to several thousands units SI $\times 10^{-5(1)}$. The shape, size, magnetic properties and depth of an object, produces magnetic anomalies of varying magnitudes and configurations.

## II. FIELD INVESTIGATIONS

A survey was carried out at Sha‘ar Hagolan in order to estimate the archaeological importance of a large area within a ploughed field, approximately, 100 × 120 m.

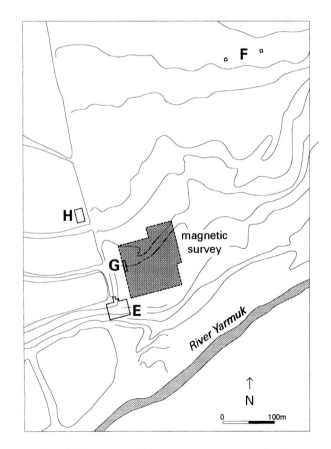

FIG. 4.1. Location of the magnetic survey at the site

(11.600 sq.m. or 1.16 hectares), located just 10 m. from the northeastern corner of Area E (Fig. 4.1). The aim of the survey was to reveal magnetic anomalies within this area that might be interpreted as architectural remains or

---

[1] SI = International System for various physical values

other archaeological features and define the limits of the site.

**Equipment:** MM-60 quanta magnetometer, manufactured by Geologorazvedka, St. Petersburg, Russia, was used for field investigations. Magnetic variations of the earth's magnetic field were registered using an MMP-203 proton magnetometer (also manufactured by Geologorazvedka, St. Petersburg, Russia) as a base station. To provide the required accuracy in mapping, the measurements of magnetic variations were synchronized with field magnetic measurements and were taken every 30 seconds. The accuracy of mapping estimated by 7.8% control measurements is ±0.67 nT.

The survey followed the standard procedure. Measurements were taken at 1 m. intervals in 27 grid squares measuring 20 × 20 m. and in 4 rectangles of 10 × 20 m. as shown in Fig. 4.2.

Prior to magnetic study, two tests were undertaken:

1. A detailed magnetic profile running north–south. Measurements were taken at 0.5 m. intervals. The study was carried out above basalt walls as well as paved floors in order to establish the range of values of magnetic anomalies produced by archaeological remains at the site (Fig. 4.3).
2. A study of magnetic properties (magnetic susceptibility) of soil and basalt building material of excavated walls in order to estimate magnetic contrast. The results of the study are shown in Table 4.1.

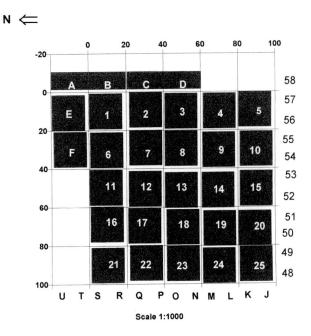

Fig. 4.2. The magnetic survey grids

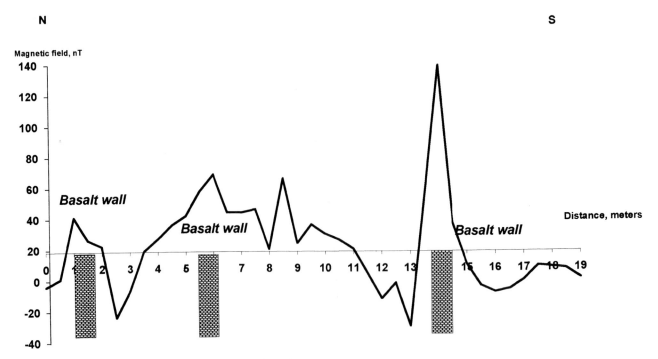

Fig. 4.3. Test magnetic profile of NS direction above excavated features, Area E

TABLE 4.1. Magnetic susceptibility of archaeological features and soil.

| Material | Number of samples | Magnetic susceptibility, $10^{-5}$ SI unit | | |
| | | minimum | maximum | average |
| --- | --- | --- | --- | --- |
| Soil | 47 | 142 | 177 | 212 |
| Basalts–1 | 34 | 166 | 2,710 | 784 |
| Basalts–2 | 23 | 62 | 151 | 84 |

The area examined is characterized by high contamination with modern iron objects of various sizes and forms: parts of a water-pipe system, small pieces of wire and tin, rods and other iron scrap. In the southern grids (5, 10, 15, 20, 25) strong influence of an iron fence disturbed the data obtained. To minimize the influence of iron objects within the area examined, a special method of eliminating the high frequency component from the magnetic data was applied.

The interpretation of the data obtained involved the application of special methods developed for quantitative interpretation of magnetic anomalies under complex conditions. A new, advanced package of computer programs COSCAD (Complex Of Spectral and Correlation Analysis of Data), developed by the Russian Geological Academy (Petrov 1999) was utilized for the first time in Israel to analyze complicated magnetic anomalies and to roughly estimate the depth and size of objects creating magnetic anomalies.

## III. RESULTS

A total Magnetic Field Map at a scale of 1:400 was constructed for the entire area (Fig. 4.4). All data (more than 12,000 measurements) were reduced to common level using a square matrix. After careful analysis of structure and intensity of magnetic anomalies and estimation of the depth and size of the objects causing the anomalies, the borders of ten Anomaly Zones presented on the map were established. These usually include a combination of several magnetic anomalies, located within a specified area and characterized by similar characteristics of magnetic anomalies: configuration, intensity and direction.

The great number of different magnetic anomalies presented on 31 detailed maps (scale 1:100) was interpreted in order to estimate the position and depth of remains. To optimally present an interesting structure, discovered in the western part of the area investigated

(grids 17–18 and 22–23) (Fig. 4.5) and near the eastern border (grids C–D) (Fig. 4.6), Magnetic Image Maps were constructed to a scale of 1:200. On the basis of preliminary study of the building materials and their magnetic properties, as well as those of soil within excavated area, several key points were established:

1. Walls were constructed of several different types of basalt, from the point of view of their magnetic properties (see Table 4.1). We have roughly divided the measured basalt samples into two groups: Basalt–1, "magnetic" group, magnetic susceptibility values 200–2,700 units SI $\times$ $10^{-5}$, and Basalt–2, non-magnetic samples, magnetic susceptibility values are less than 200 units SI $\times$ $10^{-5}$. It must, however, be stated that within the Basalt–1 group there are at least, three subgroups with different magnetic characteristics: 25% with magnetic susceptibility values of 1,000–2,700 units SI $\times$ $10^{-5}$, 50% samples with magnetic susceptibility values 500–1,000 units SI $\times$ $10^{-5}$ and 25% characterized by magnetic susceptibility values of 200–500 units SI $\times$ $10^{-5}$.
2. Soil is more magnetic or equal to Basalt–2 groups, but its magnetic properties are considerably less (3–5 times) than those of the Basalt–1 group.
3. The basalt remains at the site create the most significant magnetic anomalies and may be easily identified.

Basalt remains produce strong positive magnetic anomalies. Judging by the results of the test profile (Fig. 4.2), the intensity of the anomaly above a wall may range from 20 to 50 nT.[2]

On the magnetic maps we can clearly see three types of magnetic anomalies:

1. *Small positive magnetic anomalies*, characterized by round or oval shape configurations, with a diameter of approximately 3–5 m. or more and a magnetic intensity of 5–10 or 15–20 nT. On the basis of previous work, carried out at the Early Bronze Age site of Ashkelon Marina and confirmed by excavation, these anomalies may be interpreted as refuse pits filled with magnetic soil. The enhancement of soil magnetic susceptibility on archaeological sites occurs because of repeated heating as well as the accumulation of organic debris. Both these processes are associated with human habitation (Tite and Mullins 1971; Dalan and Banerjee 1996). Another interpretation of anomalies of this type is that they are basalt pavements. In both these cases, the cause of the anomaly's appearance is strong magnetic contrast between archaeological remains and soil. The two possible interpretations illustrate the well-known geophysical problem of

---

[2] Nanotesla (nT)=unit of magnetic anomaly magnitude.

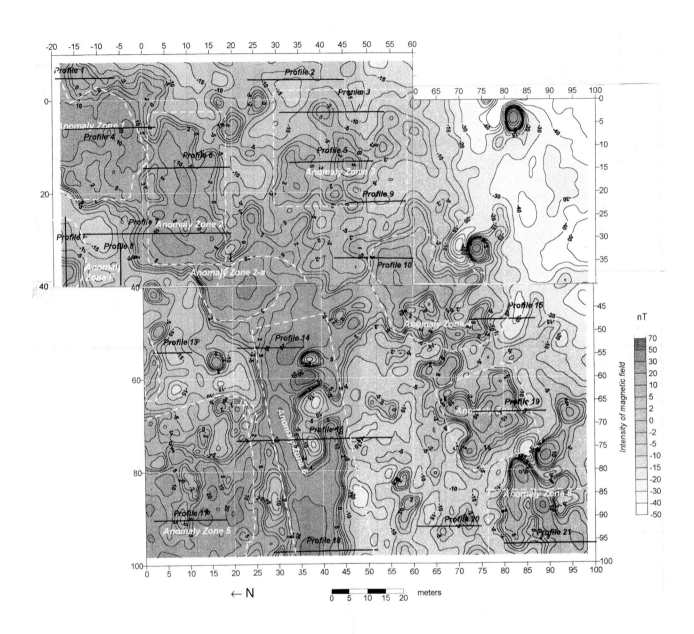

FIG. 4.4. Total magnetic field map with elements of interpretation; smoothing data by square matrix 4 x 4 m.

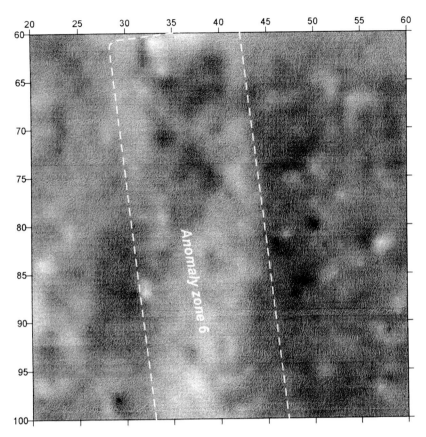

FIG. 4.5. Image magnetic map of anomaly zone 6, grids 17, 18, 22, 23

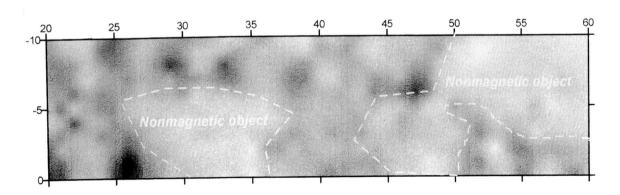

FIG. 4.6. Image magnetic map, grids C and D

ambiguous interpretation. For an unequivocal solution, further investigation is necessary.

2. *Elongated linear positive magnetic anomalies.* As usual, these appear on maps as c. 7–10 m. or longer strips of various widths. The amplitude value of anomalies reached 10–20 nT. These anomalies often have distinct borders traced by so-called gradient zones or places where magnetic contours are situated are extremely close one to another. Such anomalies may be produced by basalt walls.

3. *Local negative magnetic anomalies.* These have oval or triangular configurations and range in size from 7–10 m. or 10–20 m. The amplitude values of such anomalies are about 7–10 nT, sometimes reaching as high as 20–25 nT. These anomalies usually have distinct borders appearing as gradient zones on the map. According to previous results confirmed by test excavation at Kibbutz Beth-Govrin, such an anomaly may indicate the location of architectural remains below the surface, such as fragments of paved floors or walls. Negative magnetic anomalies appear above the feature due to considerable contrast between non-magnetic or slightly magnetic building material (limestone, mud brick or even non-magnetic Basalt–2) and magnetic soil (Itkis and Eppelbaum 1999).

4. *Intensive (± 50–200 nT) magnetic anomalies of dipole types.* Such anomalies are widely known in the literature and may be produced by two different kinds of object: fired installations (kiln, hearth or fire place) or a large concentration of modern iron scrap. In our case, the latter is likely as the survey was carried out in an area used for agriculture over an extended period. Some anomalies, undoubtedly, were produced by iron scrap concentrations.

As mentioned above, various combinations of magnetic anomalies were shown on the Magnetic Field Map as Anomaly Zones. In the area investigated, ten significant Anomaly Zones have been recognized (Fig. 4.4).

**Anomaly Zone 1.** Located in the northeast corner of the area investigated and includes survey grids A and E. Within the Zone 1 a few anomalies that may be archaeological features were revealed. They are as follows:

1. A few "spot" anomalies near northern border, Grid A (-10, 0; -20, -15), calculated depth – 40–50 cm.
2. Two rectangular structures, approximately, 6 × 8 m., also located near the northern border, Grid E (the first, rectangular, 6–12, -14, 0 and the second, located just to the south, 3–9; -19–14). The orientation of these structures is NE–SW, their calculated depth, 70–80 cm.

**Anomaly Zone 2.** Situated to the southwest of Anomaly Zone 1, within magnetic grids 1 and 6. On the whole, Anomaly Zone 2 may be considered as single structure,

located at a depth of 70–80 cm. The size of the zone is about 20 × 40 m. (The long side extends east–west). Here mainly elongated anomalies extending east–west have been detected. For example, a long anomaly located along picket 9 between 13–24 (estimated depth 30–40 cm.). Some of these single anomalies formed structures of rectangular or square configuration and may be considered as building units. Their size is about 8 × 12 m. The intensity of magnetic anomalies is 20–30 nT, estimated depth about 60–70 cm.; for separate, more intensive parts of anomalies, depth values of c. 30–40 cm. were obtained.

**Anomaly Zone 3.** This zone includes six "spot" anomalies of oval or triangular configurations. The features causing these anomalies are located deeper than those described above. For example, one of the triangular anomalies located in the interval of profiles 12–17, pickets 43–49, is characterized by the following values: the depth of the upper edge of object is about 1 m.; the lower edge is located at a depth of 2.5–2.7 m. A similar structure was revealed just to the south (7–13, 51–57). It should be noted that all anomalies within Zone 3 appear to be produced by deeply located objects.

Besides Anomaly Zones 1–3, there are a few "unusual" anomalies revealed throughout eastern part of the surveyed area. They all are strong, intensive, negative anomalies of 10–25 nT running along the eastern border of the area investigated (grids A, B, C, D). According to our criteria, these anomalies might be due to the presence of "negative" magnetic masses. All non-magnetic blocks, according to the result of calculations, are located in the depth interval between 1.2–1.5 m., i.e., below the "positive" magnetic blocks described above.

**Anomaly Zone F.** Appears to be a fragment of larger zone that may be revealed to the north and to the west of the surveyed area. There are three parts of elongated anomalies within this zone: one anomaly orientated north–south (16–17, -20–14) and two anomalies orientated east–west, (15–20, -19 and 15–20, -16). This group of anomalies may be regarded as a single structure. The depth of these features is 40–50 cm.

**Anomaly Zone 2–A.** Located southwest of Anomaly Zone 2. The Zone has a rectangular shape and measures 16 × 10 m. The depth of the object that produced magnetic anomalies is about 1 m., while its upper edge is located at a depth of 40–50 cm. As we can see on the detailed maps, the zone looks like a combination of a few single anomalies of "spot", triangular and rectangular configurations.

**Anomaly Zone 4.** Covers an area measuring approximately 30 × 30 m. with an additional "appendix" of about 10 × 20 m. This zone is composed primarily of

structures with an east–west orientation with "spot" configurations along their axes. A long structure located in grids 8 and 13 may be interpreted as a massive wall with upper parts at a depth of 50–60 cm. and lower parts located at least 1.5 m. below the surface The other long structure is also oriented east–west (4–44, 60–62). The calculated depth of the anomaly is 1.10–1.20 m. with its upper edge located at a depth of 80 cm. Two additional square units (18–26, 64–73 and 45–54, 68–76) with upper parts located at a depth of 40–50 cm. and a large triangular unit (35–45, 65–76) were revealed within Zone 4.

**Anomaly Zone 5.** This large zone, approximately 20 × 40 m. is situated within southwestern grids 16 and 21. Here a few rectangular units may be distinguished: two of them are located near the northern border and have a west–northwest orientation. The third rectangular structure is situated near the western border. Just to the west we can see on the map the edge of the other unit of similar configuration extending beyond the survey area. According to the calculations, the upper parts of these structures are located at a depth of 40–50 cm., while their geometric centers are at a depth of 1.2–1.5 m. The zone undoubtedly extends beyond the surveyed area, to the north as well as to the west.

**Anomaly Zone 6.** The most interesting feature within the entire area of investigation. The zone appears as an elongated rectangle (50 × 20 m.) running from east to west within grids 12–13, 17–18, 21–22 (Fig. 4.5). The zone may be divided into three large parts. The first is situated in the eastern section of the zone and has an almost square configuration. Only the influence of a huge iron object in the southwestern corner disturbs its regular shape. It measures 12 × 12 m., the intensity is greater than 35 nT. The model of the feature may be a horizontal plate located at a depth of 80 cm., with a few elevated portions at a depth of 30–40 cm. The next section (28–45, 65–85) appears on the map like the magnetic image of a building unit. We can clearly see two elongated anomalies with distinct borders limited by gradient zones. Their width is c. 4–5 m. and the depth is 50–70 cm. In the center of the structure is a strong negative anomaly. The feature is at a depth of c. 1 m. The last (western) portion of the zone appears as a wide strip running west beyond the limits of the area investigated. This portion has been interpreted as having been produced by a massive, deep plate. Its upper edge is situated at a depth of 50–60 cm., the center of mass is at a depth of about 2 m. and the lower edge may lie at a depth of c. 3.5–4 m. It should be noted that the intensely positive structure described above is surrounded by vast zones of negative magnetic field. One of these, located to the south (82–100, 44–55) may be regarded as having

been produced by a deep feature, the lower extent of which lies below the border of the "positive" magnetic mass described above.

**Anomaly Zone 7.** It is located mainly within grid 19 and has a square configuration with east–northeast – west–southwest orientation. The area is characterized by a high degree of iron contamination, like the southern portion of the investigation area (grids 5, 10, 15, 20, 25) in general. Most of the magnetic anomalies here seem to be produced by iron objects, but kilns may also produce them. Testing with a metal detector could resolve this.

**Anomaly Zone 8.** Located in the southwestern corner of the area investigated, mainly within grid 25. Here, because of severe iron contamination, it is very difficult to extract useful information. Undoubtedly, this anomaly zone continues beyond the limit of the area investigated. An intensive rectangular anomaly (96–100, 88–94) which runs to the west, may be interpreted as a pavement located at a depth of about 80 cm. An elongated anomaly (88–100, 96–98) may be interpreted as a wall orientated east–west, with upper edge at a depth of 30–40 m.

## IV. CONCLUSIONS

The present investigation was the first attempt to use geophysical testing methods on the large and important prehistoric site of Sha'ar Hagolan. The method may be regarded as a comprehensive and significant one for estimating the size and limits of the site. Careful analysis of the magnetic data allow the recognition of 10 large anomalous zones within the area investigated. Examination of the literature for comparative material and prior use of this technique enable us to make inferences concerning the possible sources of magnetic anomalies. These may be basalt objects of different sizes, at various depths and in diverse configurations (walls, paved floors), refuse pits and construction using non-magnetic material. Excavation provides definitive confirmation of the results of these investigations and clarifies uncertain identifications.

The main result of the study is a map showing dense and persistent distribution of magnetic anomalies in practically all parts of the area investigated. Most of anomalies revealed near the limits of the test area, it should be emphasized, extend into the adjacent areas. This, together with archaeological reconnaissance, may provide confirmation that the limits of the site have not yet been reached.

Magnetometry may be considered as a prospective method for the preliminary estimation of site area as well as a means for discovering and tracing archaeological

remains. Nonetheless, the results must be analyzed in close collaboration with the archaeological team working at the site and may be improved by excavating probes to check conclusions. As the data bank of archaeological features reflected in magnetic fields grows, and standard models for the interpretation of future magnetic surveys are developed, the utility of this survey technique will be greatly increased.

BIBLIOGRAPHY

Aitken, M.J. 1974. *Physics and Archaeology.* Oxford: Clarendon Press.

Boucher, A. R. 1996. Archaeological Feedback in Geophysics. *Archaeological Prospection* 3: 129–140.

Dalan, R.A. and Banerjee, S.K. 1996. Soil Magnetism, an Approach for Examining Archaeological Landscapes. *Geophysical Research Letters* 23: 185–188

Heimmer, D.H. and De Vore, S.L. 1995. *Near-Surface, High Resolution Geophysical Methods for Cultural Resource Management and Archaeological Investigations.* Denver: National Park Service (second edition).

Itkis, S.E. and Eppelbaum, L.V. 1999. First Results of Magnetic Prospecting Application at the Prehistoric Sites of Israel. *Mitekufat Haeven (Journal of the Israel Prehistoric Society)* 28: 177–187.

Petrov, A.V. 1999. *"Coscad" Software for Potential Field Interpretation.* Moscow: Mining Academy, Russia.

Tite, M.S. and Mullins, C.E. 1971. Enhancement of the Magnetic Susceptibility of Soils on Archaeological Sites. *Archaeometry* 13: 209–219.

# 5

# ARCHITECTURE AND VILLAGE PLANNING IN AREA E

### *Yosef Garfinkel and David Ben-Shlomo*

## I. INTRODUCTION

For many years it was assumed that the Yarmukian Pottery Neolithic culture of the Southern Levant, dated to the sixth millennium BC, did not build permanent houses. Stekelis, the archaeologist who defined the Yarmukian culture following his excavations at Sha'ar Hagolan, did not discover evidence of permanent architecture at the site, and so he concluded that: "the Neolithic settlers of Sha'ar Hagolan apparently lived in circular huts, half sunk below ground level" (1972: 42). A similar settlement pattern has been reported from other Yarmukian sites, like Munhata, Hamadiya, Megiddo and Habashan Street in Tel Aviv (see review in Garfinkel 1993: 115). At these sites a large number of rounded pits have been reported, and sometimes meager, rounded, architectural remains. The large number of pits dug by the Yarmukians created the false impression in the early days of research that this population was semi-nomadic and pastoral, inhabiting the sites only part of the year (Perrot 1968; Kirkbride 1971; Bar-Yosef 1992: 37). In a recent discussion on urban development from late prehistory until the First Temple Period, the Yarmukian era was described by Herzog as: "a major breakdown... The collapse is evident from the disintegration of all major settlements and the erection of small villages. The dominant dwelling form in this period is the circular house, in most cases these were only circular pits that formed the lower part of huts" (1997: 27–29). This picture, however, must now be completely altered. In our new excavations at Sha'ar Hagolan, monumental building complexes with rectangular rooms were uncovered in various parts of the site (areas E, F, H). The structures identified so far are large courtyard houses. When a larger area was uncovered, in Area E, streets were found between the houses. This architectural plan shows an advanced concept of space division, including roofed rooms, enclosed open courtyards, open areas and formalized passageways. The village seems to be densely built with well-planned streets between the houses. The aim of this article is to present, in detail, the new evidence regarding the Yarmukian construction activities at Sha'ar Hagolan and to place the new data in the broader context of architectural developments in the Neolithic Near East.

## II. STRATIGRAPHY

In most of the excavated areas at Sha'ar Hagolan there is a topsoil layer that includes fishpond sediment mixed with Byzantine and Islamic material of the late first millennium AD. In some places, under this, a Middle Bronze I layer dated to the late third millennium BC is found. A large part of this village was excavated by Eisenberg in the early 1980s (1993), but in our excavations the Middle Bronze I activities are limited to a few pits, installations or surface finds with no architecture. Below these lay the extensive remains of the Pottery Neolithic village of Sha'ar Hagolan, radiometrically dated to the sixth millennium BC (Garfinkel 1999). In some places these remains lay only a few centimeters below the current surface. This situation is apparently due to the construction of fishponds over large parts of the site during the late 1930s, which completely altered the original topography. The thickness of the Neolithic occupation in the excavated areas is unknown to us, as virgin soil has not yet been reached.

Our excavations concentrated upon exposing the uppermost Yarmukian layer, which in itself shows constructional sub-phases. Under this layer at least one

earlier stratum of Yarmukian construction activity exists, as attested whenever excavations penetrated beneath the walls and floors of the upper layer. We do not yet have a complete stratigraphical sequence for the site, however, according to the latest results in Area G, Yarmukian settlement strata may be c. 3 m. thick in some places.

## III. Building Techniques

Yarmukian buildings are constructed of local basalt (rarely limestone) river pebbles, and mudbricks. If wood or other perishable materials were used, no evidence of them remains. Many of the walls have a stone foundation built from medium and large rounded and flat pebbles, laid on each other, up to 0.5 m. high (Fig. 5.1). The walls were founded on the contemporary surface rather than in dug trenches. A mudbrick superstructure was placed on top of the stone socle, probably adding another 1.3–1.5 m. to the height of the wall. The mudbrick walls are not well preserved, and so far none has been found exceeding several courses, 0.2–0.4 m. high (Fig. 5.2). The width of the walls varies according to architectural function. Massive surrounding walls are 0.8–1.2 m. thick, while partition walls and installations consist of a single row of stones. Installations for storage (silos) are characterized by a floor of flat river pebbles and an outer wall constructed of the same type of flat pebbles placed "standing" on their narrow side. Our usage of the term "standing stones" does not refer to objects of cultic significance (as it does in biblical archaeology), but to a construction technique.

Stones used for building are usually rounded or flat basalt (occasional limestone) pebbles, abundant on the bank of the nearby Yarmuk River. The mudbricks are made of grayish-white clay of the local Lisan Formation, typical of the Jordan Valley. The bricks have many organic inclusions and are made in rounded shapes. The most common are plano-convex "loaf shaped" round bricks, about 12 cm. in diameter (Fig. 5.3). Similar bricks were found at Jericho in the contemporary Pottery Neolithic A settlement: "The bricks are peculiar to the Pottery Neolithic period. They are best described as bun-shaped, being plano-convex and approximately round in plan (Kenyon 1981: 94, Pl. 75c).

Various types of floors were found at Sha'ar Hagolan. Complete rooms or smaller installations are paved with large, flat and closely placed basalt river pebbles (Fig. 5.4). Sometimes two such layers were found one on top of the other. In entrances, thresholds were constructed with large, flat river pebbles. Some of the open areas have patches of cobbled surfaces of small, angular stones. Mud plaster floors are partially conserved in several areas.

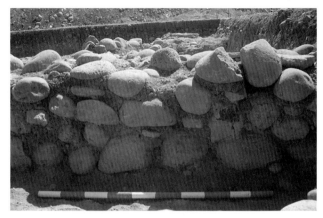

Fig. 5.1. Close-up of a stone wall

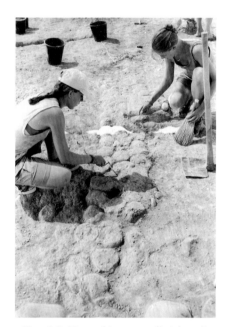

Fig. 5.2. Unearthing a mudbrick wall

Fig. 5.3. A typical plano-convex mudbrick

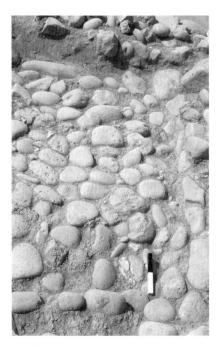

FIG. 5.4. A stone paved room

Lime plaster floors, as known in the Pre-Pottery Neolithic B period, were not found, but in Area F a small area was paved with crushed white lime.

There is no definitive evidence of columns or postholes. In one case, a buttress was built against a wall, probably to strength it. It is possible the flat chunks of mud plaster found in rooms were part of the roofing.

## IV. The Architecture in Area E

Area E is located near the northern bank of the Yarmuk River. The work here started in 1989 and some 50 sq.m. were excavated that year. The area was enlarged from season to season as we followed the Neolithic architecture, and by the end of the 1999 season some 1,300 sq.m. had been exposed (Garfinkel 1997; Garfinkel and Miller 1999). Further work is planed for this area in future seasons. The large horizontal exposure in Area E is one of the main achievements of the renewed excavation at Sha'ar Hagolan. Three buildings or complexes, together with various open areas, were found. The plan of Building Complex I, which has been completely uncovered, is quite clear. Building Complexes II and III, on the other hand, have not been fully exposed, and therefore, various aspects of their plans are not yet clear.

### 1. Building Complex I (Figs. 5.5–5.7)

Complex I is defined by Street 8 from the west, Alley 109 from the southeast and "Piazza" 204 from the south. The northern boundaries are less clear, as the north and northeast walls (15 and 107) continue beyond the limits of the building into the unexcavated area. Hence, it is not yet clear whether Open Areas 52, 83 and 136 and Wall 55 are part of Building Complex I, or part of yet another architectural complex.

Building Complex I comprises eight closed rooms enclosing an open courtyard. The rooms are designated on the plan by the letters: B, C, D, E, F, G, H and I, and

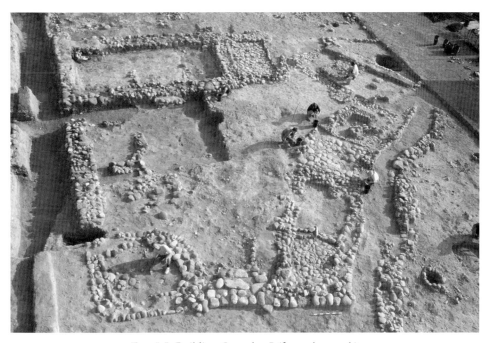

FIG. 5.5. Building Complex I (from the south)

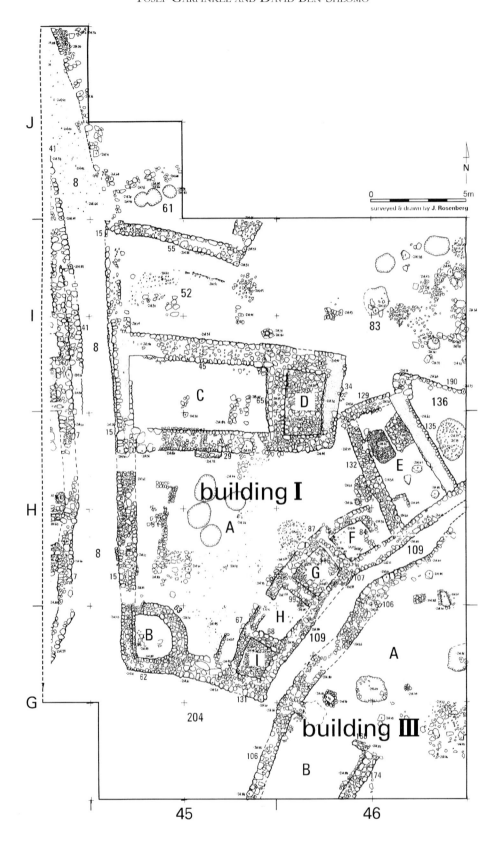

building I

building III

FIG. 5.6. Plan of Building Complexes I and III

FIG. 5.7. Artist's reconstruction of Building Complex I (drawing by O. Michaelov)

FIG. 5.8. Pits in the courtyard of Building Complex I

the courtyard by the letter A. The only entrance to the building is located at the south side of the courtyard, where a paved threshold is found between rooms B and I. The building has the shape of an asymmetrical pentagon with two right angles and a narrower southern side. The outer walls of the rooms are all connected to each other and separate this building from the rest of the village. The measurements of Building Complex I are approximately 17.3 × 15.8 m., and its total size is 233 sq.m. The net inner usable area, calculated without the walls, is 152.5 sq.m. The following units were found here:

**Courtyard A**. It is a nearly triangular, or trapezoidal (right angled) open area enclosed by eight rooms (rooms B to I) and Wall 15 in the west. The courtyard measures 11.6 × 10.53 m., having an area of 92 sq.m., which is 60.5% of the net area of the complex.

Features within this courtyard include:

1. Stone walls 19a–b, 39 and 48, in the west, form some kind of installation or semi-enclosed room, but this is definitely not a substantial construction, like the "real" rooms of the building.
2. Pits 22, 25, 33 and 38 are rounded, quite shallow pits, dug in the middle of the courtyard (Fig. 5.8).
3. Pavement 49 (level -214.71) is of large flat stones and is adjacent to Wall 29.
4. Stones 71 create a small niche near Room I.
5. Loci 53 and 115 are probably floor levels rich in small

stones, bones and material finds (levels -214.71–214.85). These are located near the main entrance in the south and near Room G.
6. In the northwest, the excavation penetrated into an earlier phase of the building (level -215.14). Basalt Ground Stone 45a is a large flat slab, found sunk into the lower floor.
7. All the entrances to the rooms face the courtyard, while the main entrance to the building is located at the southern end, between rooms B and I.

**Room B**. This is a circular room, 2.13 m. in diameter, having a net area of 3.5 sq.m. It is bounded by Round Wall 63 in north and east, Wall 62 in the south and Wall 15 in the west (Fig. 5.9). The entrance to the room is from the northwest corner, facing courtyard A. In it, a rounded installation (hearth?) was found, built with flat basalt river pebbles. The irregular form of Room B may imply that it was a silo or a storage room.

**Room C**. This is a rectangular room (Fig. 5.10), confined by walls 15, 45, 65 and 29 (west, north, east, and south, respectively). Its internal size is 7.2 × 3.6 m., having an area of 25 sq.m. The entrance to this room is from the southwest corner, facing Courtyard A. The upper floor of the room has been removed, and below, two partition walls of an earlier phase have been partly exposed.

**Room D**. This is a rectangular room on the east side of Room C (Fig. 5.10). It is confined by walls 65, 92, 94 and 29, measures 3.4 × 1.9 m. and has an area of 6.35 sq.m. Its floor is completely paved with large, flat, basalt river pebbles (Locus 97, levels -214.59–214.61). We could not locate any entrance to this room. The phenomenon of two adjacent rooms, one unpaved with an entrance and the other paved but without an entrance, recurs in three places in Building Complex I. This pattern must have functional meaning: the unpaved unit was the living area while the paved unit was a storage place.

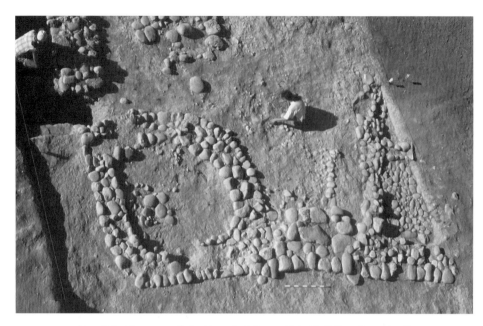

FIG. 5.9. Close-up of the Rounded Room B in Building Complex I

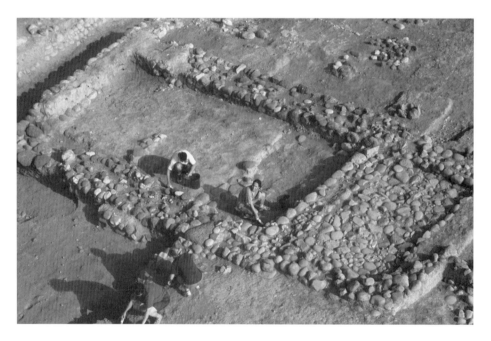

FIG. 5.10. Close-up of Rooms C and D in Building Complex I

**Room E**. A rectangular room measuring 6.0 × 2.73 m., with an area of 13.5 sq.m. (Fig. 5.11). Its axis creates an approximate 150° angle with Room D. It is confined by Wall 132 on the southwest, Wall 129 on the northwest, Wall 135 on the northeast and Wall 107 on the southeast.

The entrance to the room, from Courtyard A, is near the center of Wall 132, making it a typical broad room.

Pavement 127 is a threshold built of flat river pebbles, that slopes upward to the room. The floor of this room was higher than the floor of the courtyard. Stone Circle 123 was found adjacent to the entrance and might be associated with the door, or other closing device.

A few installations were found in this room:

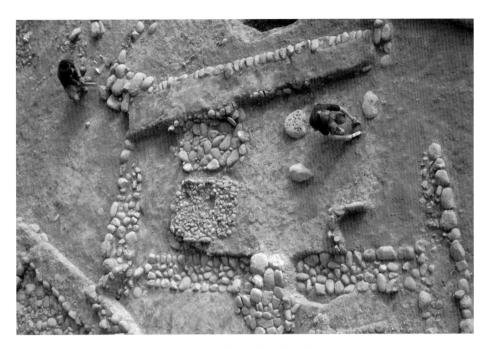

FIG. 5.11. Close up of Room E in Building Complex I

1. Silo 154 is a paved area of flat basalt river pebbles. A few standing stones were found on its periphery (level -214.73). An earlier, similar pavement can be seen below the upper pavement.

2. Silo 171 is adjacent to Silo 154 and is the same size. Its pavement was constructed differently, with smaller, angular cobblestones (level -214.72). An earlier pavement, of flat basalt river pebbles, can be seen below the upper cobblestones. Both silos occupy the entire northwest half of the room, while the rest of the floor is of beaten earth. The difference in their pavements may reflect a different function or a different period of construction, but their absolute height is the same.

3. Installation 155 is an L-shaped stone boundary joining Wall 132 and creating a niche in the south corner of the room.

4. A small basalt mortar, broken, resting on its side, was found in this room.

**Room F.** This is a squared room, confined by wall 116 on the southwest, Wall 87 on the northwest, Wall 84 on the northeast and Wall 107 on the southeast. It measures 1.67 × 1.6 m., having an area of 2.8 sq.m. Wall 84 does not reach Wall 107, thus creating an opening at the eastern corner of the room. This also creates a narrow corridor between walls 84 and 132 leading to an indirect access to Room F from Courtyard A. Installation 98 (level -214.55) is located at the middle of the room and consists of a

circle of flat basalt river pebbles, possibly a hearth.

**Room G.** This is a squared room, confined by walls 99, 87, 116 and 107. It measures 1.73 × 1.67 m., having an area of 3.2 sq.m. The floor is paved with flat basalt river pebbles of various sizes (levels -214.64–214.73). We could not locate any entrance to this room.

**Room H.** A rectangular room, confined by walls 68, 118 (a continuation of Wall 87), 99 and 107. The entrance to the room is from Courtyard A, through the center of Wall 118. It measures 2.47 × 2.13 m., having an area of 3.7 sq.m. A rounded concentration of small, angular stones near the eastern corner is possibly the remains of a hearth. Two large basalt mortars were found upside-down in the room.

**Room I.** A rectangular room located at the southeast corner of the building. It is confined by walls 131, 67 (a continuation of Wall 118), 68 and 107. The room measures 1.93 × 1.47 m., having an area of 2.4 sq.m. It is fully paved with medium sized, flat basalt river pebbles (level -214.78), and has no discernible entrance.

## 2. North of Building Complex I

This is an open area, which is either a free space between structures, or an open courtyard of another building, which lays beyond the excavated area. Only further excavations may clarify its exact function. The following units were identified here:

**Area 52**. This space is confine by rooms C and D in the south, Wall 15 in the west and Wall 55 in the north. It is connected to Open Area 83 in the east. Several installations were found here:

1. Mortar 150. This is a basalt mortar, found sunken below the upper floor level, encircled by smaller stones. One of these stones was a broken mortar fragment.
2. Stone Wall 55. A wall fragment that does not relate to any other feature and probably represents a somewhat later phase.
3. Stones 50. An area paved with flat basalt river pebbles.
4. Stones 60 and 119. Two concentrations of angular stones.
5. Stones 73. A thin straight line composed of small angular stones.

**Area 83**. This space is located east of Area 52, north of Room E, and beyond the excavated area to the north and east. It includes several components:

1. Stone Concentrations 170, 182, 189. Some of these are constructed with large flat river pebbles while others consist of smaller stones.
2. Pits 105, 152, 158, 165, 186, 188. These are six shallow pits dug in the east part of the area. In one of them, a complete clay figurine was found.

**Area 136**. This triangle-like space is confined by Wall 107 in the south, walls 135 and 175 in the west and Wall 190 (a single row of stones) in the north. The eastern part of

Area 136 was not exposed, as it is located outside the excavation area. The nature of this space is not yet clear and it may have been either roofed or open. Pit 140 occupies most of this area. It is large, deep and filled with thousands of small and medium-sized river pebbles.

**Area 61/455**. This is the space north of Wall 55 and east of Wall 462 (the northen continuation of Wall 15). Pits 440, 443 and 444 form a group of three small, shallow, rounded depressions dug in this area.

### 3. Building Complex II (Figs. 5.12–5.13)

Building Complex II, similar to Complex I, is a "courtyard house" type, comprising a series of rooms enclosing a large courtyard. By the end of the 1999 season, Complex II was exposed to a length of 40 m. and a width of 20 m. Thus, its total area must be greater than 800 sq.m. In the east, it is defined by Street 8 and massive walls 7 and 41. Wall 41 is the original construction, representing a lower phase of the building, while Wall 7 was built on top of it with a slightly different orientation. These walls run for at least 40 m. and continue north beyond the excavated area.

The southern part of the building runs up to the recent terrace of the Yarmuk River. The edge itself is missing, and has been eroded by the river (Fig. 5.14). However, a partially preserved series of four small rooms (K, L, M, N) indicate the exact edge of the courtyard. A small fragment, Wall 430, which is located in the south part of Room N, enables us to reconstruct the edge of the building. Continuing this line and intersecting it with Wall 7,

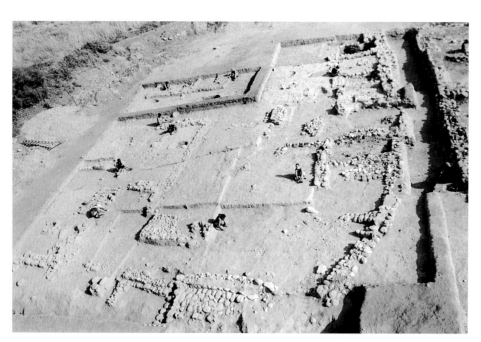

FIG. 5.12. Building Complex II (from the south)

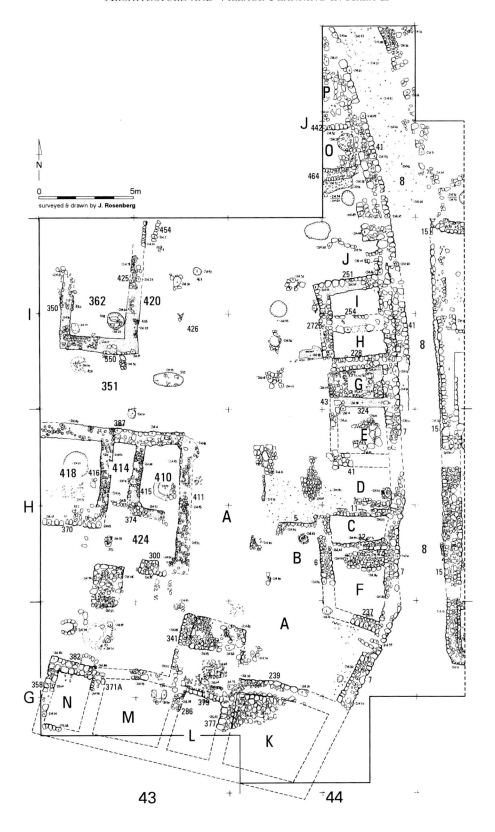

FIG. 5.13. Plan of Building Complex II

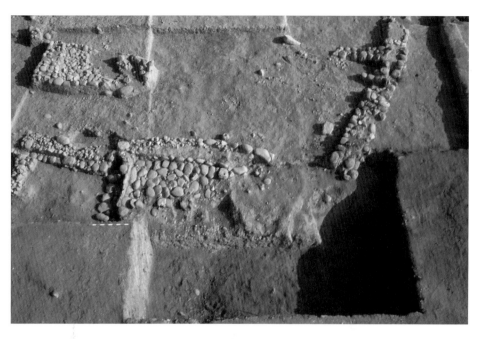

Fig. 5.14. The south side of Building Complex II (looking north); the southesast corner and parts of the rooms have been eroded

one may reconstruct the southeast corner of the building.

The other three corners of the building have not yet been exposed. Wall 7/41 continues to the north into the unexcavated area, while to the west, no closing wall has yet been found. The entrance to the building has not been identified yet either. The following units have been identified so far in this building:

**Courtyard A**. This large area measures at least 25 × 15 m. As the building is not yet fully exposed, the shape of the courtyard remains unclear. A large number of installations were found at different levels, indicating that they are not all contemporaneous. We shall survey the features from north to south:

1. Pits 281, 279, 285, 266, 265. These are shallow, small pits, scattered near the east side of the courtyard.
2. Installation 335 is a circle of large stones (level -214.52).
3. Floor 267 is a patch of packed mud (level -214.65).
4. Stone Pavement 230. A pavement of flat river pebbles with standing stones around its periphery, adjacent to Wall 272 (level -214.26–214.38).
5. Pavements 13, 21, 30. There are several paved areas near Room D. Two of them are of large and medium pebbles: Pavement 13 (level -214.64) and Pavement 30 (level -214.45–214.48). Pavement 21 is of small angular stones (level -214.80).
6. Wall 36. A line of standing stones forming a partition. Its function is not clear.
7. Open Area 2 (Unit B). This is an open area within the

courtyard, defined by Wall 5 in the north and Wall 6 in the east. A basalt mortar was found here, sunk into the floor, encircled with smaller stones. Inside the mortar, a natural basalt pebble was found *in situ*, indicating that it functioned as a pestle (Fig. 5.15). This location was a specific activity area in the building, where grinding work took place.
8. Pits 202, 212 and 222. These are shallow pits in the southeast corner of the courtyard.
9. Pavement 349. A paved area north of Room L, near Wall 341. This pavement consists of large pebbles, and slopes downward to the south. Two layers can be recognized, but only the upper one has been fully exposed (level -214.55).

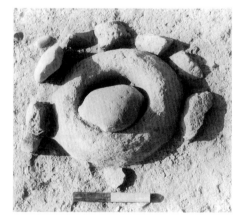

Fig. 5.15. A basalt mortar with pestle still *in situ*

10. Pits 428, 378, 401, 380 and 314. These are located in the western part of the excavated area. It seems that at the upper phase of Building Complex II, Courtyard A continued westward to the edge of the excavated area.
11. Installation 400. A round construction of mudbrick, partially lined with stones (level 214.72).
12. Installation 386. A grinding stone encircled by small stones (-214.71).
13. Installation 372. A deep fixed mortar with stones around it (Fig. 5.10).
14. Installation 315. A partial circle of stones in the southwest of the corner.
15. Installation 384. A circle of stones adjacent to Wall 382.
16. Grinding stone 318.
17. Burial 316. Only a very fragmentary skull and a few other bones were found.
18. Mud floor 322. A patch of packed mud floor area (level -214.51).
19. Stone pavements 353 and 319. Rectangular areas paved with flat basalt river pebbles.
20. Surface 385. An area rich in finds, including small stones, bones and pottery sherds (levels -214.34–214.42).

**Room P.** This room is located at the northern edge of the excavated area, and has been only partially exposed. It is confined by Wall 41 in the east and Wall 442 in the south. Pavement 458 is the floor of this room, constructed with flat pebbles (levels -214.25–214.36).

**Room O.** This is a rectangular space confined by walls 442, 41 and 464. Its western part has not yet been excavated. The room is 1.8 m. wide. Inside, near Wall 41, a circular installation of stones and plaster was found.

**Room J.** This room is defined by walls 464, 41 and 251 (Fig. 5.16). Features of this space include Installation 347, which is composed of a row of standing stones, pits 264 and 441 and Pavement 326 (levels -214.72–214.77).

In this area we dug a test pit 0.5 m. deep into the earlier site sediment (Locus 280, levels -214.96–215.34). The cultural material from this test pit is typically Yarmukian, including a well-preserved female figurine. We noted that the material from the sounding is in a better state of preservation than that found near the site surface. The figurine and the pottery were still covered with well-preserved red slip and the animal bones are in good condition and without the heavy concretions that are typical of the bones of the upper layer.

**Rooms H and I.** These two units are described together, as they were originally built as one room, confined by Wall 272 in the west, Wall 251 in the north, Wall 7 in the

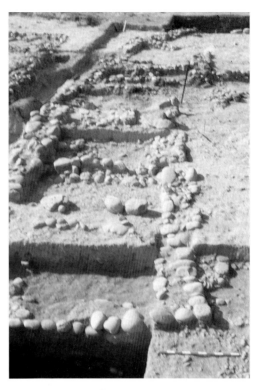

Fig. 5.16. The east side of Building Complex II (looking south)

east and wall 228 in the south. Later, Inner Wall 254 was built, dividing the original room into two rooms: H and I (Figs. 5.16-5.17). The original room (H/I) is rectangular and measures 3.4 × 2.73 m., having an area of 8.7 sq.m. The division created Room I in the north (measuring 2.53 × 1.07 m., net area 3.1 sq.m.) and Room H in the south (measuring 2.73 × 1.27 m., net area 3.15 sq.m.). The room has a partially preserved stone and mud pavement, and the location of the entrance is not clear.

**Room G.** A rectangular room adjacent to Room H, confined by walls 43 (or 256), 228, 7 and 324 (Fig. 5.18). Some mudbrick courses were preserved on its stone foundations. It measures 2.53 × 1.67 m., having an area of 3.75 sq.m. Cobble Pavement 346 is the floor of this room (level -214.68). In this case angular stones were chosen for the pavement, and not the typical flat river pebbles. We could not identify any entrance to this room. A burial was found in the northeastern corner of the room, under the floor, including the skull and some of the long bones.

**Room E.** Adjacent to Room G, nearly square in shape and confined by walls 43, 324, 7 and 4. The room measures 2.5 × 2.5 m., having an area of 6 sq.m. Most of the room is covered with Pavement 40, which was constructed with exceptionally large pebbles (level -214.43).

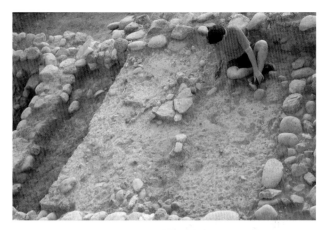

Fig. 5.17. Rooms H and I in Building Complex II

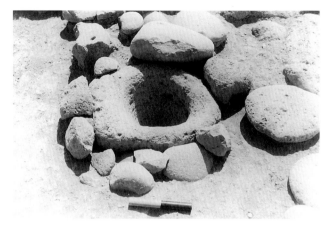

Fig. 5.19. A basalt mortar *in situ* in Room D, Building Complex II

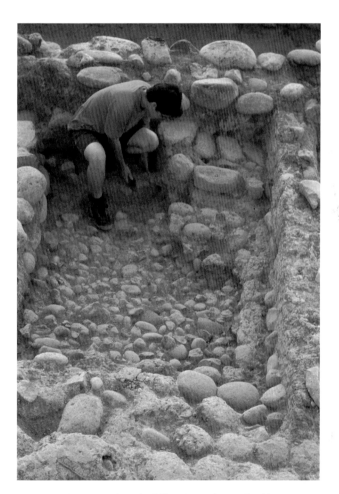

Fig. 5.18. Room G in Building Complex II (looking east)

**Unit D**. This space has a rectangular shape and measures 3.2 × 2.2 m., creating an area of 6.45 sq.m. It is closed from three directions by walls 4, 7 and 11, but open to the west to Courtyard A. The floor of this unit is of beaten

earth (Locus 10), and flat pebbles (Pavement 14). Mortar 24, a large, basalt square-shaped block, is located adjacent to Wall 7 (Figs. 5.19–5.20). It was encircled by small stones and sunk below floor level (Fig. 5.19). Near the mortar, a limestone pebble figurine was found, lying upside down. This open (or partly roofed) area was also used for grinding food, like the nearby Open Area 2 (Unit B). We removed floors 10 and 14, which were the upper surface here, and dug into Fill 31 of the lower phase.

**Room C**. A rectangular room, confined by walls 6, 11, 7 and 12. It measures 3 by 1.4 m., having an area of 3.75 sq.m. (Figs. 5.20–5.21) The room does not have an identifiable entrance. Floor 9 is a beaten earth surface and on it, an installation consisting of a circle of stones was found (level -214.78). Fill 34 is the sediment excavated below the floor (levels -214.80–215.07).

**Room F**. A nearly square room, confined by walls 6, 12, 7 and 237. It measures 3.67 × 2.4 m., having an area of 8.5 sq.m. Its entrance is possibly from the south side, facing courtyard A. The north part of the room is covered with Pavement 77, constructed with flat basalt pebbles (level -214.85) while the south part (about 2/3 of the area) is unpaved.

**Room K**. It is reconstructed to be a nearly square room, confined by walls 293, 239, 7 and 430. The room would measure 5.0 × 5.0 m., having an area of 19 sq.m. Most of the room was eroded away by the Yarmuk River (Fig. 5.14). In the preserved northwest corner, the floor was found, constructed with two layers of flat river pebbles (Pavement 226, level -215.36 and below, Pavement 361, level-215.13).

**Room L**. It is reconstructed to be a rectangular space, confined by walls 286, 379, 293 and 430. Most of the room was eroded away by the Yarmuk River. The recon

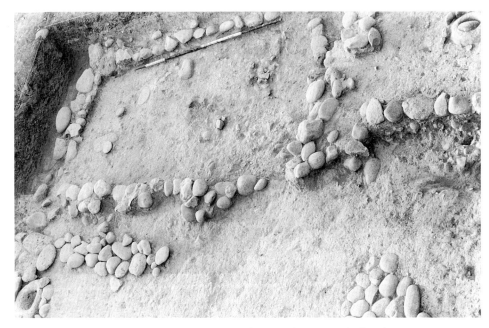

FIG. 5.20. Room C in Building Complex II with two nearby basalt mortars

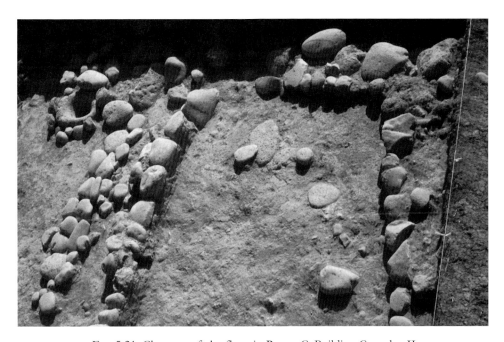

FIG. 5.21. Close-up of the floor in Room C, Building Complex II

structed area would measure 3.6 × 2.07 m., a total of 7.3 sq.m. The surface of the room slopes downward to the south.

**Room M**. This area is confined by walls 371a, 286, and 430, while the north side might have been open toward Courtyard A. Thus, it can be reconstructed as either a closed room or as an open area between rooms L and N. Most of Room M was eroded away by the Yarmuk River. The reconstructed area would measure 3.67 × 3.6 m., a total of 12.1 sq.m. In this area were found Pit 369 and U-shaped Installation 412, which is made of three large stones.

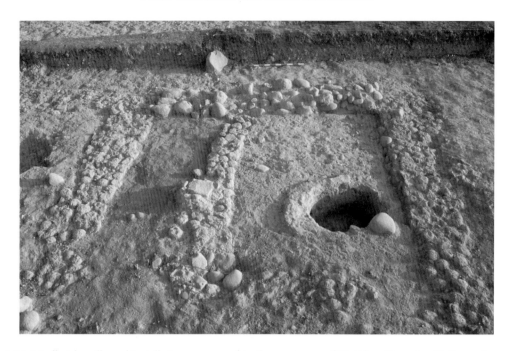

Fig. 5.22. Mudbrick walls and installation uncovered in the west part of Building Complex II (from the south)

**Room N**. It is a rectangular room, confined by walls 358, 382, 371a and 430. The room measures 2.8 × 1.8 m., having an area of 4.75 sq.m. Installation 383, consisting of a circle of stones, was found in the northwest corner.

**Room 362**. The outline of this room, is not yet fully exposed since it lies at the northern edge of the excavated area. This is a rectangular space, confined by walls 350 and 425. It measures 2.7 m. wide and at least 5.5 m. long. Pit 378 was dug at the southeast corner of the room (Fig. 5.22).

### 4. Lower Building Complex II
Several mudbrick walls defining at least three rooms were exposed at the western part of Courtyard A (Fig. 5.22). These were found below the floor and installations (e.g. Grinding Slab 386) of the upper layer. Thus, it seems quite clear that these elements are related to the lower phase of Building Complex II. When they went out of use, the courtyard area was enlarged over these earlier rooms. So far, only the uppermost parts of these walls were excavated, and the floor levels have not yet been reached.

**Room 410**. A rectangular space, confined by walls 415, 357, 411 and 374. It measures 3.33 × 2.07 m., having an area of 6.3 sq.m. It seems to have an entrance at its southeast corner.

**Room 414**. A very narrow space, confined by walls 416,

357, 415 and possibly 374. This unit measures 3.13 × 1.13 m., having an area of 3.25 sq.m.

**Room 418**. A rectangular space extending towards the unexcavated area to the west. It is confined by walls 357, 416 and 370. Wall 411 continues southwards and may surround an open area.

It should be emphasized that this is only a partial and initial reconstruction of this lower phase and the nature of these architectural units will be better understood after reaching the floor levels.

### 5. Building Complex III
Only a portion of Building Complex III has been exposed so far, since it is located at the southeastern edge of the excavated area. The main features uncovered are walls 106 (running along Alley 109), 174 and 168. They seems to create two units:

**Courtyard A**. Judging from the size, which is at least 13 m. long, it is apparently an open area. A number of installations were found here, including pits 179 and 180, Stone circles 145, 157 and 187, which may represents hearths, Bone Concentration 192, and Paved Area 198 (level -214.76). A well-carved basalt mortar was found in the topsoil, only slightly above the floor level. This item is in an excellent state of preservation and seems to have been removed from its original position only recently, probably by agricultural activities. It is possible that the items came from the courtyard itself.

**Room B**. A partly excavated rectangular room. So far, it measures 4.2 × 4.2 m., but its southern part continues into the unexcavated area.

## 6. The Passageways

Two passageways have been unearthed at Sha'ar Hagolan between the three building complexes described above. These are the earliest evidence for street construction in the Neolithic period in Israel.

**Street 8.** This is a 3-m.-wide straight passageway, separating buildings I and II. The buildings are situated parallel to each other with Building Complex I on the east side of the street and Building Complex II on the west (Fig. 5.12). This street was exposed, by the end of the 1999 season, to a length of c. 35 m. The surface of the street has been systematically excavated, and it is usually of small (1–2 cm.), rounded flint river pebbles, laid in a packed mud matrix. Many such layers were accumulated one on top of the other, creating a total thickness of some 0.3 m. It seems that the street was resurfaced from time to time. This surface is found at a relatively high elevation and related to the latest use of that street (levels -214.25–214.50). The lower part of the street has been exposed in the southern part, where it is about 50 cm. lower than the upper surface.

**Alley 109.** This is a small, curving passageway, about 1 m. wide, so far exposed to a length of 15 m. It separates buildings I and III, at the southeast edge of Area E. The surface of the alley is of beaten earth, with very few pebbles.

**Open Area/"Piazza" 204.** This is situated in the south, between the three buildings and, in the excavated area, has rectangular shape. It is characterized by whitish sediment with very few finds. Most of this open area, as well as the southern fringes of Building Complex II, were eroded away by the Yarmuk River.

## V. Summary

The large horizontal exposure of Area E revealed part of a well-planned Yarmukian village. Three massive courtyard buildings were excavated, one completely (Building Complex I) and two partly (complexes II–III). Passageways, a main wide street and a narrow alley separate the structures. In these buildings, the main activity area was the inner courtyard, while the surrounding rooms were used for living and storage. Most of the rooms in Building Complex I are paired: one room unpaved with an entrance towards the courtyard, the other paved, without an entrance. Installations are located either at the open areas (the majority) or in the unpaved rooms. This implies that the paved rooms were used for storage. In order to obtain maximum protection against humidity, insects, rodents, or theft by other people, the storage place was insulated as well as possible. The floor was very well paved and the entrance was probably from the attached room, in the form of a window, higher than floor level. For that reason, no entrances were found to the paved rooms. Building Complex II, which is much larger then Building Complex I, is also a courtyard house, and some of its rooms are also organized in pairs, as in Building Complex I.

These buildings are far too large for the basic needs of a nuclear family, and seem to indicate a more complex social organization, probably of extended families, where kinship related nuclear families lived together. Each pair of rooms seems to contain a nuclear family while the whole building or insula represents an extended family or a clan.

The passageways indicate several aspects of village planning and social organization of the Neolithic community at Sha'ar Hagolan:

1. At every village site there are open areas between the buildings. But in order to formalize passageways, the houses must be built in relation to one another, with the outer walls parallel to one another.
2. The hierarchical order of the passageways, with straight, wide, pebbled streets, and carved, narrow, beaten-earth alleys indicates advanced village planning.
3. Unlike the houses, which were built and repaired by the individual families, the resurfacing of the street is indicative of maintenance efforts made on a community level.

In conclusion, four points should be emphasized concerning the new discoveries at Sha'ar Hagolan:

1. The appearance of massive architecture in the Pottery Neolithic period is unique, as hardly any architectural remains have been discovered from this period in this region in previous excavations.
2. A new type of architecture appears in the Neolithic of the Near East – the courtyard house.
3. At Sha'ar Hagolan the houses are of monumental size and could have been used by extended families.
4. An urban concept is indicated by the formalized passageways, both wide and narrow, requiring annual maintenance.

BIBLIOGRAPHY

Bar Yosef, O. 1992. Building Activities in the Prehistoric Periods until the End of the Neolithic Period. In Kempinski, A. and Reich, R. (eds.) *The Architecture of Ancient Israel*, pp. 31–39. Jerusalem: Israel Exploration Society.

Eisenberg, E. 1993. Sha'ar Hagolan, The Middle Bronze I Site. In Stern, E. (ed.) *The New Encyclopedia of Archaeological Excavations in the Holy Land,* Vol. IV, pp. 1342–1343. Jerusalem: Israel Exploration Society.

Garfinkel, Y. 1992. *The Sha'ar Hagolan and Wadi Rabah Pottery Assemblages from Munhata (Israel)* (Cahiers du Centre de Recherche Français de Jérusalem 6). Paris: Association Paléorient.

Garfinkel, Y. 1993. The Yarmukian Culture in Israel. *Paléorient* 19: 115–134.

Garfinkel, Y. 1997. Sha'ar Hagolan 1997 (Notes and News). *Israel Exploration Journal* 47: 271–273.

Garfinkel, Y. 1999. Radiometric Dates from Eighth Millennium B.P. Israel. *Bulletin of the American Schools of Oriental Research* 315: 1–13.

Garfinkel, Y. and Miller, M. 1999. Sha'ar Hagolan 1998 (Notes and News). *Israel Exploration Journal* 49: 136–138.

Herzog, Z. 1997. *Archaeology of the City* (Monograph Series of the Institute of Archaeology, No. 13). Tel Aviv: Tel Aviv University.

Kafafi, Z. 1985. Late Neolithic Architecture of Jebel Abu Tawwab, Jordan. *Paléorient* 11: 125–128.

Kafafi, Z. 1993. The Yarmoukians in Jordan. *Paléorient* 19: 101–114.

Kenyon, K.M. 1981. *Excavations at Jericho*, Vol. III. London: British School of Archaeology in Jerusalem.

Kirkbride, D. 1971. A Commentary on the Pottery Neolithic of Palestine. *Harvard Theological Review* 64: 281–289.

Perrot, J. 1968. La Préhistoire Palestinienne. In Cazelles, H. and Feuillet, A. (eds.) *Supplément au Dictionnaire de la Bible*, pp. 286–446. Paris: Letouzy and Ané.

Stekelis, M. 1972. *The Yarmukian Culture of the Neolithic Period,* Jerusalem: Magnes Press.

# 6

# Sha'ar Hagolan Architecture in its Near Eastern Context

## Yosef Garfinkel and David Ben-Shlomo

Architecture has long been acknowledged as an important tool for recognizing and understanding various aspects of human organization in the beginning of agriculture (see, for example, Flannery 1972; Redman 1983; Garfinkel 1987a; Kuijt 2000). In the new excavations at Sha'ar Hagolan, part of a well-planned village with monumental courtyard structures and a system of streets has been uncovered (Garfinkel and Ben-Shlomo, Chapter 5 in this volume). In order to place the new discoveries in the broader context of architectural developments, we shall present a brief survey of the relevant data from the Neolithic Near East. Various aspects concerning evolution, function and social organization will be examined. Two levels of human organization are of relevance here: the family on the one hand and the community on the other. The family can be studied through the single dwelling unit while the community is reflected by the village plan. Fig. 6.1 and Table 6.1 present the location and dating of the major sites mentioned in the text. All the dates are calibrated BC.

## I. The Evolution of Neolithic House Types

The main work on Neolithic architecture in the Near East, with a systematic survey of the relevant publications, is that of Aurenche (1981a). However, this 20-year-old book naturally needs to be updated. Other works that have been written since focus upon a more specific period or region within the Neolithic era (Aurenche 1981b; Redman 1983; Kubba 1987; Banning and Byrd 1987 and 1988; Breniquet 1991; Bar-Yosef 1992).

TABLE 6.1. The dating of the main sites mentioned in the text

| Date BC (calibrated) | Period/Culture | Main sites mentioned in text |
|---|---|---|
| 5800–5300 | Halafian | Sabi Abyad V, Yarim Tepe I |
| 6400–5800 | Pottery Neolithic | Sha'ar Hagolan, Byblos, Sabi Abyad VI, Tell es-Sawwan, Hassuna, Hacilar II |
| 7000–6400 | Early Pottery Neolithic/ Pre-Pottery Neolithic C | Umm Dabaghiyah, Çatal Hüyük, Zaghe |
| 7200–7000 | Late Pre-Pottery Neolithic B | Basta, Bouqras |
| 8800–7200 | Pre-Pottery Neolithic B | Jericho, Munhata, Yiftahel, 'Ain Ghazal, Beidha, Wadi Tbeik, Nahal 'Issaron, Tell Ramad, Asikli, Çayönü |
| 9400–8800 | Pre-Pottery Neolithic A | Jericho, Netiv Hagedud, Gilgal, Hatula, Nahal Oren, Gesher, Jerf el-Ahmar, Mureybet, Hallan Çemi |
| 12000–9400 | Natufian | Mallaha, Hayonim Cave |

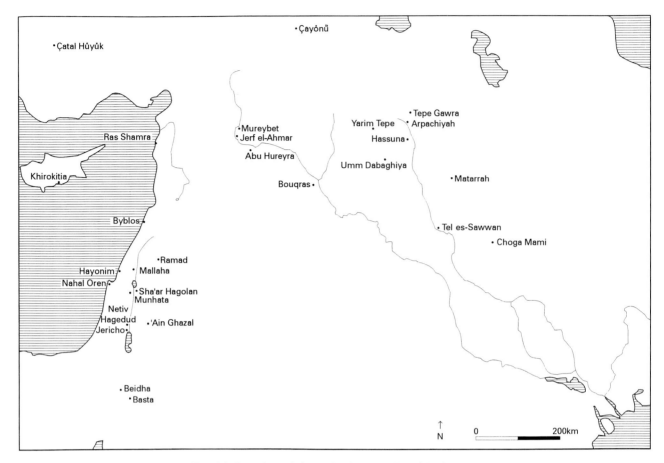

FIG. 6.1. Location of the main sites mentioned in the text

On the basis of the above-mentioned works and other recent evidence, Neolithic houses may be classified into four main types: round houses, simple rectangular houses, multi-partite complex houses and courtyard houses. Further subdivision may be observed in each of these categories. The types are arranged here from the simple or nuclear houses to the more sophisticated ones. The scheme is morphological, considering both the general shape of the houses and the internal architectural plan.

## 1. ROUND HOUSES

The round house is the first type of building constructed by early village dwellers, both in the Near East and Mesoamerica (Flannery 1972). In the Natufian and Pre-Pottery Neolithic A periods this was the only type of structure constructed (Fig. 6.2). Some 3,000 years later, rectangular architecture was introduced. The round houses can be subdivided into two basic types: a simple room without any inside partition, and a more complex type with internal space divided into a few rooms. Round

houses are easier to build than rectangular ones, as they are constructed from a single wall and require less material to confine a given area. According to ethnographic observation, round houses characterize simple farming communities (Flannery 1972; Breniquet 1996, Pls. 47–53).

**1a. Simple Round House** (Fig. 6.2: 1–6). Such structures are the earliest type known, and have already been reported from various Natufian sites, like Mallaha and Hayonim Cave (Perrot 1966a; Bar Yosef 1991), as well as from the Harifian culture at the arid zone of the Southern Levant (Goring-Morris 1991). During the Pre-Pottery Neolithic A period, simple rounded houses are known from quite a number of sites. Sometimes they are circular, as at Jericho, Nahal Oren, Gilgal and Hallan Çemi Tepesi (Kenyon 1981, Pls. 214, 279; Stekelis and Yizraeli 1963; Noy 1989; Rosenberg *et al.* 1995, Figs. 1–2). In other cases they are elliptical, as at Netiv Hagedud, Hatula and Gesher (Bar-Yosef and Gopher 1997, Fig. 3.13; Lechevallier and Ronen 1994, Pl. VI; Garfinkel 1990). There are also some examples of semi-rectangular buildings with

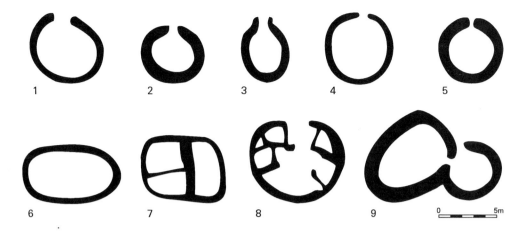

FIG. 6.2. A sample of rounded structures: 1. Mallaha (Perrot 1966a), 2. Jericho (Kenyon 1981, Pl. 277a), 3. Nahal Oren (Stekelis and Yizraeli 1963, Fig. 3), 4. Hallan Çemi (Rosenberg *et al.* 1995, Fig. 1), 5. Khirokitia (Le Brun 1994, Fig. 23), 6. Netiv Hagedud (Bar-Yosef and Gopher 1997), 7. Jerf el-Ahmar (Stordeur 1998, Fig. 3), 8. Mureybet (Cauvin 1979, Fig. 10), 9. Jericho (Kenyon 1981, Fig. 227c)

rounded corners from Gilgal and Jerf el Ahmar (Noy 1989; Stordeur 1998, Fig. 3).

During the Pre-Pottery Neolithic B period, side by side with the introduction of rectangular buildings, round houses were still constructed. In the Mediterranean villages of that period they were found only in small numbers, as at 'Ain Ghazal (Rollefson 1998: 47–48, Fig. 4). On the other hand, they characterize the Pre-Pottery Neolithic B sites of the arid zones of the Levant, as at Beidha (earliest level), Wadi Tbiek, Wadi Jibba, Nahal 'Issaron and Dhuweila (Kirkbride 1967; Bar-Yosef 1982; Goring-Morris and Gopher 1983, Fig. 3; Beats 1998). Rounded houses appeared at Pottery Neolithic sites, such as Munhata, Megiddo, Jebel Abu Tawwab and Jericho (Garfinkel 1992, Figs. 3, 7; 1993: 128–129; Kafafi 1985; Kenyon 1981, Pl. 74b).

In Cyprus, rounded architecture was used from the earliest stage of occupation until the end of the Chalcolithic Period (see, for example, Le Brun 1994: 67–107; Peltenburg 1998). At Halafian sites of North Syria and Mesopotamia, rounded architecture was frequently used, as in Yarim Tepe II and Tell Sabi Abyad (Verhoeven and Kranendonk 1996, Fig. 2.25).

**1b. Round House with Internal Division** (Fig. 6.2: 7–9). In some Pre-Pottery Neolithic A sites the rounded structure has internal divisions, creating a few rooms inside the building. Examples of these have been reported from Mureybet and Jerf el-Ahmar (Cauvin 1979; Stordeur 1998, Fig. 3). At Jericho some houses were constructed from two adjacent rounded rooms, a relatively

rare type of construction that did not have a wide distribution (Kenyon 1981, Pls. 277, 278a).

## 2. RECTANGULAR HOUSES

**2a. Rectangular House with a Single Room** (Fig. 6.3: 1–2). Simple rectangular houses represent the next step in architectural evolution. Flannery suggests that rectangular houses are more typical of sedentary societies with agricultural subsistence and mark the transition from band camps to villages (1972: 30). Rectangular houses are more easily arranged in a settlement and it is easier to add new units to the house and to subdivide it.

The simplest form is a rectangular house containing a single room. The entrance could be in the long side (broad room) or in the short side (long room). The earliest examples of simple rectangular houses can be found in Pre-Pottery Neolithic B sites, like Munhata, Jericho, Tell Ramad, Ugarit, Byblos and Çayönü (Perrot 1966b, Fig. 1; Kenyon 1981, Pls. 220–227; de Contenson 1968, Fig. 2; 1992, Pls. XVII–XVIII; Dunand 1973, Fig. 7; Aurenche 1981a, Pl. 23c–d). Thick plaster floors were also found in these houses (Garfinkel 1987a). A monumental temple structure from Nevali Çori was also constructed as one large square room with a plastered floor (Hauptmann 1993, Fig. 4).

**2b. Rectangular House with Simple Internal Division** (Fig. 6.3: 3-7). More complex rectangular structures have internal divisions creating a few, usually

74 YOSEF GARFINKEL AND DAVID BEN-SHLOMO

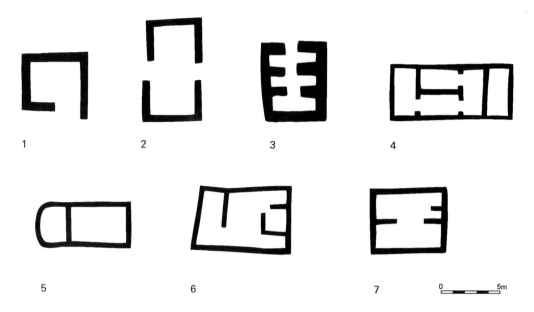

FIG. 6.3. A sample of simple rectangular structures: 1. Munhata (Perrot 1966b, Fig. 1), 2. Yiftahel (Garfinkel 1987b, Fig. 6), 3. Beidha (Kirkbride 1966, Fig. 1), 4. Abu Hureyra (Moore 1981, Fig. 2), 5. Byblos (Dunand 1973, Fig. 9), 6. Çatal Hüyük (Hodder and Matthews 1998, Fig. 6.3), 7. Hajji Firuz (Voigt 1983, Fig. 15)

between two to four, different rooms. Such structures, from the Pre-Pottery Neolithic B and onwards, have been found in all parts of the Near East, as at Jericho, Yiftahel, Byblos, El Kowm, Tell Halula, Abu Hureyra, Çatal Hüyük and Hajji Firuz (Kenyon 1981, Pls. 304–308; Garfinkel 1987b; Dunand 1973, Fig. 8: 2, 3; Stordeur *et al.* 1991, Fig. 4; Molist 1998, Fig. 2; Moore 1981, Fig. 2; Hodder and Matthews 1998, Fig. 6.3; Voigt 1983, Figs. 14–15).

A specific type in this group is the longitudinal Pre-Pottery Neolithic B building that consists of several rooms arranged along the long axis of the building. Banning and Byrd interpreted these buildings as "pier houses," and understood the thick walls and the pairs of small rooms as the basement of a pier house (1988). They mentioned examples from 'Ain Ghazal, Jericho, Beisamoun, Yiftahel and Beidha. Similar buildings are found at Hacilar level IIA/B (Mellaart 1970: 25, Fig. 25).

**2c. Multi-Cellular House** (Fig. 6.4). A further degree of complexity can be seen in buildings from the Pre-Pottery Neolithic B period and onwards. These buildings are constructed with a network of rather small rectangular or square rooms. Examples of these have been reported from Çayönü ("cell" and "grill" houses), Nevali Çori, Basta, Yarim Tepe I (Building X) and Tell Sabi Abyad (Buildings III and V) (Braidwood *et al.* 1981; Redman 1983; Hauptmann 1993, Fig. 3, House 7; Nissen *et al.* 1991, Fig. 1; Merpert and Munchaev 1973: 98, Pl. XXXVII; Verhoeven and Kranendonk 1996, Fig. 2.7). At

Çayönü the grill shaped plan has been understood as only the foundations on top of which the houses were built. The long cavities or channels, created by the grill pattern, are supposed to isolate the floor from the wet ground and to create better storage conditions for food and cereals. The cell houses are interpreted as underground storerooms (Braidwood *et al.* 1981: 253; Redman 1983). A similar phenomenon is reported at Area A at Basta where 0.5 m. wide channels were also found underneath some of the houses (Nissen *et al.* 1991: 14).

Another type of exceptional elongated building is constructed from two rows of small rooms, usually ca. 2 × 2 m., with a corridor between then. The rows can be up to 20 rooms long. Access to the rooms is usually via the corridor. Examples of these were found at sixth millennium Mesopotamian sites, as Umm Dabaghiyah and Yarim Tepe I (Kirkbride 1975: 4–5, Plan 1; Merpert and Munchaev 1973: 98, Pl. XXXVII). A question arises about the function of these buildings: were they domestic houses with many small rooms, storage units or underground foundations for upper superstructures that were not preserved?

## 3. MULTIPARTITE COMPLEX HOUSES

Complex rectangular houses differ from simple rectangular houses in having several defined sectors, each further divided into smaller units (Aurenche 1981a: 47,

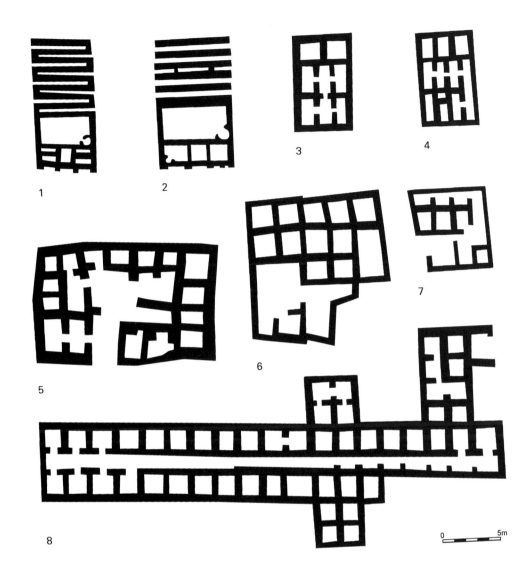

FIG. 6.4. A sample of multi-cellular rectangular structures: 1–4. Çayönü (Schirmer 1988, Figs. 5, 11), 5. Basta (Nissen *et al.* 1991, Fig. 1), 6. Tell Sabi Abyad (Verhoeven and Kranendonk 1996, Fig. 2.7), 7. Yarim Tepe I (Merpert and Munchaev 1973, Pl. XXXVII); 8. Umm Dabaghiyah (Kirkbride 1975, Pl. I)

"La plan complex"). This demonstrates a clear conception of complex inner architectural planning. No examples of this type have been found in the southern Levant.

**3a. Rectangular Bi- or Tri-Partite House** (Fig. 6.5: 1–2). These houses have two parts: one is usually roughly square and contains several (usually three) oblong rooms; the other part is oblong containing several smaller square rooms. At late Pre-Pottery Neolithic B Bouqras, houses 7, 11, 12, 28, 29 provide examples of this type (Akkermans *et al.* 1983: 340–348, Fig. 5).

A further complication is the rectangular tripartite house. These houses contain three parallel divisions. In many cases, only one of these parts is accessible from the outside. Each one is oblong and contains a series of rooms, usually accessible from one to another. There may be passages between the divisions, too. Most houses at Bouqras seem to belong to this type, with some variations. Sometimes the houses are symmetrical – three rows of three rooms (Akkermans *et al.* 1983, houses 15, 16, 17). In other cases, each division contains rooms of different number and size (houses 14, 19, 20). Later examples of similar plan were reported from Choga Mami, Sungur A

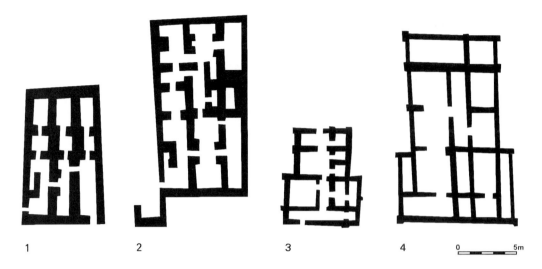

FIG. 6.5. A sample of multipartite structures: 1–2. Bouqras (Akkermans *et al*. 1983, Fig. 5), 3–4. Tell es-Sawwan (Breniquet 1991, Fig. 6)

and Yarim Tepe I (Oates 1969, Pl. XXIV; Aurenche 1981a, Fig. 10; Merpert and Munchaev 1973, buildings IV–V).

**3b. T-Shaped Tripartite House** (Fig. 6.5: 3-4). These houses usually contain 10–15 units arranged in a T shape. There is a combination of longitudinal and latitudinal units. The units in the house vary in size and are usually accessible to one another. There is no dominant unit in the house, though sometimes a longitudinal axis of passages is present along the "foot" of the T. T-Shaped houses are common at Tell es-Sawwan Level III (Yasin 1970, Pl. 1; Breniquet 1991: 79, Figs. 6, 7). Such houses could be also reconstructed at Levels III–IV at Hassuna (Lloyd and Safar 1945, Figs. 30–31) and Matarrah (Braidwood *et al*. 1952, Fig. 3, Pl. I–II; Breniquet 1991, Figs. 8–9). Breniquet sees these houses as evolving from tripartite houses.

## 4. COURTYARD HOUSES

The courtyard house-type is singled out because it has a dominant central unit: the open courtyard, surrounded by smaller rooms (Fig. 6.6: 1–2). The courtyard occupies a large portion of the structure, usually 40–50% of the net usable area of the building. The rooms are arranged around the courtyard and their entrances face it. Access to the various units of the house is usually through the courtyard, including the main entrance to the house.

The earliest clear appearance of this type of house is evident at Sha'ar Hagolan (Garfinkel and Ben-Shlomo,

Chapter 5 in this volume). The main entrance of Building Complex I in Area E is directly into the courtyard. The area of the courtyard is about 40% of the gross area of the building and 60% of the net usable area. In the courtyard, various installations and pits were found.

A somewhat different courtyard structure is the "painted house" at Zaghe, Iran (Fig. 6.6: 2; Negabhan 1979: 240–244, Fig. 2). This rectangular building has a central courtyard occupying nearly 50% of the gross area. Rooms are arranged on two of its flanks. There is also a series of perpendicular buttresses adjoining the walls. A large circular fireplace and various "terraces" are located in the courtyard. This is not a "classic" courtyard house, as two of the rooms are interconnected and the entrance to the building is not through the courtyard. Another courtyard building from Zaghe (Unit VIII) has been reported as well (Malek 1979: 187–189).

At Level II at Hassuna there are some remnants of rooms and open areas that may have been courtyard houses (Lloyd and Safar 1945, Fig. 45). As the preservation here is not as good, another reconstruction has been proposed (Breniquet 1991, Fig. 9). Later on, in the sixth millennium BC, small houses with attached courtyards do seem to appear. Possible examples are from Umm Dabaghiyah and Sabi Abyad (Kirkbride 1975, Pl. II; Veerhoeven and Kranendonk 1996, Fig. 2.17).

In summary, the above short survey of main house types of the proto-historic Near East clearly demonstrates an ongoing effort of exploring various architectural solutions. Among traditional agrarian communities in the Near East, the basic architectural concept of the courtyard house is found to remain in use to this

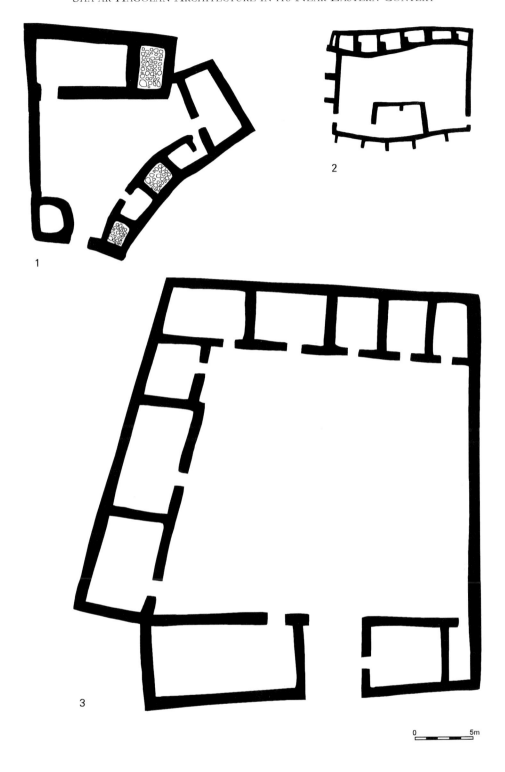

FIG. 6.6. A sample of courtyard structures: 1. Sha'ar Hagolan, 2. Zaghe (Negabhan 1979, Fig. 3.2), 3. the "Qala" in modern Hasanabad (Watson 1979, Fig. 5.29)

day. For example, the modern village Hasanabad, North Western Iran is built of several courtyard houses. The courtyards are used for various outdoor activities and for short-term storage of crops. At the edge of the village is located the "Qal'a" – landlords house (Fig. 6.6: 3). This courtyard building is bigger – especially its courtyard, in which the landlords share of the crop is kept at harvest time (Watson 1979: 34, 40, 294, Fig. 5.29).

What are the advantages of the courtyard structure that have made its plan relevant to this day? It provides optimum solutions to the basic needs of the household and the activities carried out in it. These needs can be classified into indoor and outdoor activities, including: cooking and eating; shelter from bad weather and sleeping; storage of food and goods; keeping domestic animals; working space (flint knapping, weaving, basketry, etc.); and sometimes burials. In the other types of buildings mentioned above, the outdoor activities were

probably carried out near the house, in the open area between the buildings. This situation did not provide much privacy. When the courtyard house was introduced, the open-air activities were carried out in the courtyard, which, though outdoors, remained isolated from the rest of the village.

## II. VILLAGE PLANNING

While the single houses represent the activities of the nuclear families, the village plan reflects the social organization and order at the community level. Recovery of a village plan is a much more complicated task than recovery of the plan of a single house, as it requires excavation of the entire site. Such an objective requires a long-term excavation project, and a relatively small site. Very few sites have been treated in such a way and are

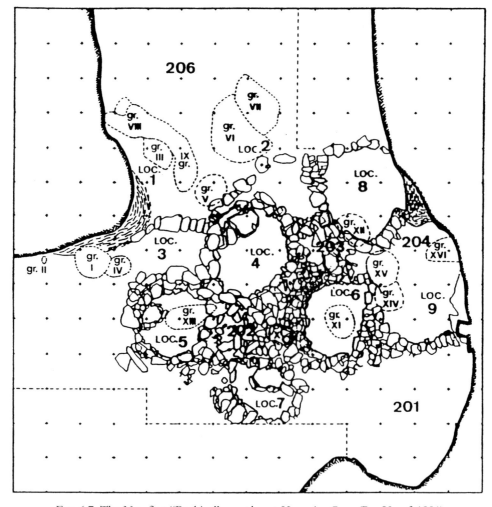

FIG. 6.7. The Natufian "Beehive" complex at Hayonim Cave (Bar-Yosef 1991)

relevant to our discussion. It seems that six basic settlement patterns existed in the proto-historic Near East: beehive pattern, rounded enclosure, free-scattered structures, arrangement around a central piazza, condensed network and construction along streets.

**1. Beehive Pattern.** The earliest evidence for an entire settlement from the ancient Near East comes from the Natufian layer of Hayonim Cave (Fig. 6.7; Bar-Yosef 1991). This is a concentration of five rounded structures abutting each other like the cells in a beehive. This simple arrangement appear later in the Pre-Pottery Neolithic B sites in the arid zones of the Levant, such as Wadi Tbiek, Wadi Jibba and Nahal 'Issaron (Bar-Yosef 1982; Goring-Morris and Gopher 1983).

**2. Rounded Enclosure.** Based on ethnographic observations it appears that some traditional societies that still use rounded architecture place the structures in a circle, creating an inner enclosure. This type of settlement organization has been suggested at the Natufian site of Mallaha, Nahal Oren (Fig. 6.8) and at some Halafian sites (Flannery 1972; Breniquet 1996, Pls. 47–53). The archaeological sites that possibly follow this pattern are not as nicely and clearly organized as the ethnographic examples. Nevertheless, unlike the previous type, in which the various individual rooms always abut each other, in this type each structure is free-standing, resulting in spaces separating the buildings.

**3. Free-Scattered Structures.** In this type of settlement, the houses, usually rectangular in shape, are scattered in no specific geometric configuration. The best example of this type is Çayönü (Fig. 6.9), and it seems that the same pattern can be found in the small area uncovered at other sites as well, like Hajji Firuz Tepe (Redman 1983, Voigt 1983).

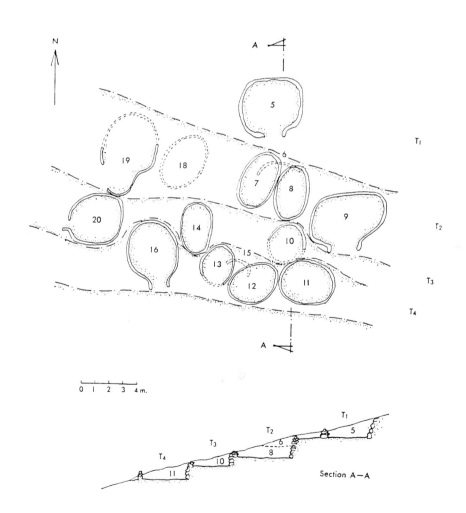

FIG. 6.8. The Pre-Pottery Neolithic A village of Nahal Oren (Stekelis and Yizraeli 1963)

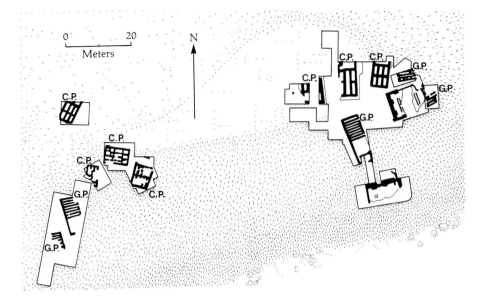

Fig. 6.9. The Pre-Pottery Neolithic B village of Çayönü (Redman 1983)

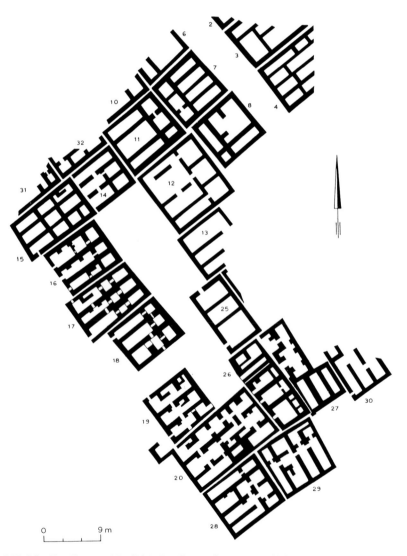

FIG. 6.10. The Pre-Pottery Neolithic B village of Bouqras (Akkermans *et al.* 1983, Fig. 5)

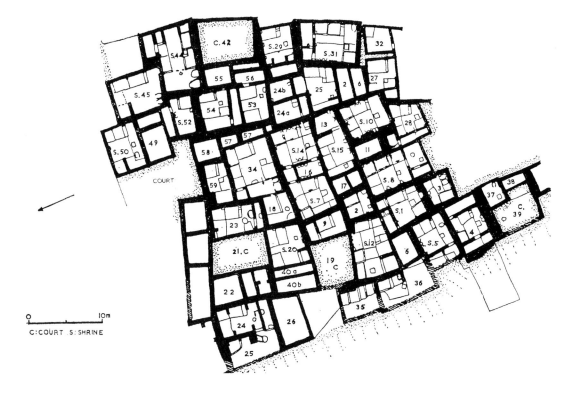

FIG. 6.11. The condensed village of Çatal Hüyük (Mellaart 1967: 59)

**4. Arrangement around a Central Piazza.** In this type, the structures in the village are arranged around a large open area. Clear examples have been uncovered at Bouqras and Umm Dabaghiyah (Fig. 6.10; Akkermans *et al.* 1983; Kirkbride 1975).

**5. Condensed Network.** In Anatolia, some of the sites were constructed as dense building areas, in which the houses are built against one another, without any passageway between the various units. The access is assumed to be through the roof. The largest exposure was carried out at Çatal Hüyük (Fig. 6.11), but the same pattern probably exists at Can Hasan III as well (Mellaart 1967; Mellart 1975, Fig. 44). Even in this planning concept, there are inner courtyards between the buildings. They are not associated with any specific building and probably function as public gathering areas.

**6. Construction along Streets.** Another pattern of a densely constructed site is where the various houses were built along narrow passageways. No free open areas were left between the buildings except for formalized streets and alleys. The earliest clear examples are from Asikli (Fig. 6.12) and Sha'ar Hagolan (Esin 1991 *et al.*: 141, Pl. 4; Garfinkel and Ben-Shlomo, Chapter 5 in this volume).

## III. DISCUSSION

The emergence of permanent dwelling units constructed from non-perishable materials, such as stone, mudbrick and plaster, is a major development in the early village communities of the Near East. Such building activities have not been found in any of the earlier prehistoric periods. They therefore represent a most dramatic change in human evolution (Wilson 1988; Hodder 1990). The construction of houses started on a modest scale, with small rounded structures of only 10–30 sq.m. These were later replaced by larger rectangular buildings with either one or a few rooms each. By the end of the Pre-Pottery Neolithic B period, extremely complex building activities took place at sites such as Basta and Bouqras, with multi-cellular and multi-partite buildings. During the sixth millennium BC, courtyard structures were introduced in which the open area near the roofed rooms was incorporated into the building.

The village plan also underwent major changes over time. First, settlement size dramatically increased from a few hundred square meters, as at Hayonim Cave and Nahal Oren, to mega-sites of 12–20 hectares. Within the sites, various types of building arrangements are found, from free scatters of buildings to a more formalized arrangement of buildings around central piazzas, con-

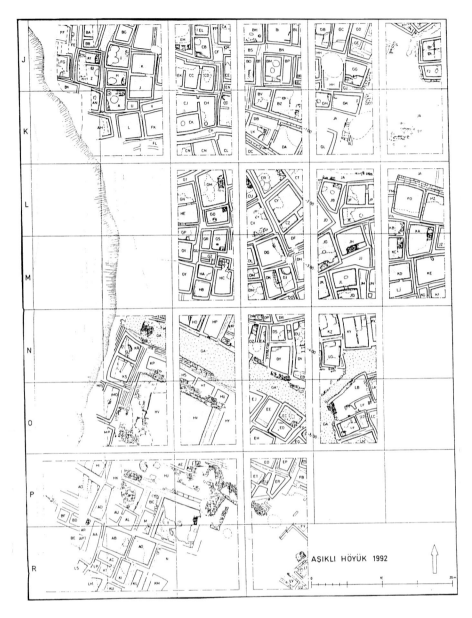

FIG. 6.12. The Pre-Pottery Neolithic B village of Asikli (Esin *et al.* 1991)

densed beehive-like networks and construction along streets. Increasing density and complexity is clearly evident from the Natufian settlements of the twelfth millennium BC onwards. This process obviously occurred on two levels: that of the individual family and that of the community. Sha'ar Hagolan presents an advance stage on both levels. The earliest appearance of clearly defined courtyard houses is indicated at the site in Areas E and H. These are constructed with a series of small rooms around a central courtyard. This classic house concept has continued to the present day. In the southern Levant, such a building was found at the fifth millennium BC site of 'Uvda Valley (Yogev 1983), and at the fourth

millennium BC sites of Fazael and En-Gedi (Porath 1985; Ussishkin 1980). As the structures in 'Uvda Valley and En-Gedi are considered to be cultic in nature, this architecture would appear to suit both domestic dwellings and temples.

On the community level, Sha'ar Hagolan presents a most sophisticated site plan, with a network of streets including a central straight street, 3 m. wide, and a curved alley 1 m. wide. The combination of large courtyard structures with a system of streets appears later in the early urban center of Arad (Amiran and Ilan 1996, Pl. 43). In a large horizontal exposure at Arad, a few dozen buildings arranged along streets were found. Each house

is much smaller than the Sha'ar Hagolan structures, probably because the houses at Arad were used by nuclear families, while those at Sha'ar Hagolan were inhabited by extended families.

Unlike the common view that the sixth millennium BC was a period of regression and decline in settlement organization in the southern Levant, Sha'ar Hagolan Area E reveals an elaborate example of courtyard structures built along streets and alleys. The main goal of the future excavation seasons at Sha'ar Hagolan is to determine whether this condensed pattern exists all over the site or only in selected areas.

## BIBLIOGRAPHY

Akkermans, P.A. *et al.* 1983. Boukras Revisited: A Preliminary Report on a Project in Eastern Syria. *Proceedings of the Prehistorical Society* 1983: 335–372.

Amiran, R. and Ilan, O. 1996. *Early Arad*, Vol. II. Jerusalem: Israel Museum and Israel Exploration Society.

Aurenche, O. 1981a. *La Maison Orientale: l'Architecture du Proche Orient Ancien des Origines au Milieu du IVe Millenaire.* Paris: Librairie Orientaliste Paul Geuthner S.A.

Aurenche, O. 1981b. L'Architecture Mesopotamienne Du 7e au 4e Millenaires. *Paléorient* 7: 43–55.

Banning, E.B. and Byrd, B.F. 1987. Houses and the Changing Residential Unit: Domestic Architecture at Pre-Pottery Neolithic B 'Ain Ghazal, Jordan. *Proceedings of the Prehistoric Society* 53: 309–325.

Banning, E.B. and Byrd, B.F. 1988. Southern Levantine Pier Houses: Intersite Architecture Patterning during the Pre-Pottery Neolithic B. *Paléorient* 14: 65–72.

Bar-Yosef, O. 1982. Pre-Pottery Neolithic Sites in Southern Sinai. *Biblical Archaeologist* 45/1: 9–12.

Bar-Yosef, O. 1991. The Archaeology of the Natufian at Hayonim Cave. In Bar-Yosef, O. and Valla, F.R. (eds.) *The Natufian Culture in the Levant*, pp. 81–92. Ann Arbor: International Monographs in Prehistory.

Bar-Yosef, O. 1992. Building Activities in the Prehistoric Periods Until the End of the Neolithic Period. In Kempinski, A. and Reich, R. (eds.) *The Architecture of Ancient Israel*, pp. 31–39. Jerusalem: Israel Exploration Society.

Bar-Yosef, O. and Gopher, A. 1997. *An Early Neolithic Village in the Jordan Valley. Part I: The Archaeology of Netiv Hagdud.* American School of Prehistoric Research Bulletin 43. Cambridge MA: Peabody Museum.

Beats, A.V.G. (ed.) 1998. *The Harra and the Hamad. Excavations and Exploration in Eastern Jordan* (Sheffield Archaeological Monographs 9). Sheffield: Sheffield Academic Press.

Braidwood, R., Braidwood, L., Smith, J.G, and Leslie, C. 1952. Matarrah: A Southern Variant of the Hassunian Assemblage Excavated in 1948. *Journal of Near Eastern Studies* 11: 1–75.

Braidwood, R., Çambel, H. and Schirmer, W. 1981. Beginnings of Village Farming Communities in South Eastern Turkey: Çayönü Tepesi 1978 and 1979. *Journal of Field Archaeology* 8: 249–258.

Breniquet, C. 1991. Tell es-Sawwan – Réalités et problèmes. *Iraq* 53: 75–90.

Breniquet, C. 1996. *La disparition de la culture de Halaf. Les origins de la culture d'Obeid le nord de la Mésopotamie.* Paris: Editions recherché sur les civilizations.

Cauvin, J. 1979. Les fouilles de Mureybet (1971–1974) et leur signification pour les origins de la sedentarisation au Proche-orient. In Freedman, D.N. (ed) *Archaeological Reports from the Tabqa Dam Project – Euphrates Valley, Syria* (Annual of the American Schools of Oriental Research 44). Cambridge MA.

Cauvin, J. 1978. *Les Premiers Villages de Syrie-Palestine du IXeme au VIIeme Millenaire Avant J.C.* Lyon: Maison de l'Orient Mediterranéen Ancien.

Contenson, H. de 1968. Quatrieme et cinquieme campagnes a Tell Ramad, 1967–1968. Rapport preliminaire. *Annales archeologues arabes syriennes* 19: 25–30

Contenson, H. de 1992. *Préhistoire de Ras Shamra* (Ras Shamra-Ougarit VIII). Paris: Editions Recherche sur les Civilisations.

Dunand, M. 1973. *Fouillies de Byblos V.* Paris: Maisonneuve.

Esin, U., Biçakçi, E, Özbasaran, M., Ahli, N.B., Berker, D, Yagmur, I. and Atli, A.K. 1991. Salvage Excavations at the Pre-Pottery Site of Asikli Höyük in Central Anatolia. *Anatolica* 17: 123–174.

Flannery, K.V. 1972. The Origins of the Village as a Settlement Type in Mesoamerica and the Near East. In Ucko, P.J., Tringham, R. and Dimbleby, G.W. (eds.) *Man, Settlement and Urbanism*, pp. 23–53. London: Duckworth.

Flannery, K.V. 1976. Two Possible Village Subdivisions – the Courtyard Group and the Residential Ward. In Flannery, K.V. (ed.) *The Early Mesoamerican Village*, pp. 72–74. New York: Academic Press.

Garfinkel, Y. 1987a. Burnt Lime Products and Social Implications in the Pre-Pottery Neolithic B Villages of the Near East. *Paléorient* 13: 68–75.

Garfinkel, Y. 1987b. Yiftahel: A Neolithic Village from the Seventh Millennium B.C. in Lower Galilee, Israel. *Journal of Field Archaeology* 14: 199–212.

Garfinkel, Y. 1990. Gesher, un nouveau site Néolithique Préceramique A dans la moyenne vallée du Jourdain, Israel. *L'Anthropologie* 94: 600–602.

Garfinkel, Y. 1992. *The Pottery Assemblages of Sha'ar Hagolan and Rabah Stages from Munhata (Israel)* (Cahiers du Centre de Recherche Français de Jérusalem 6). Paris: Association Paléorient.

Garfinkel, Y. 1993. The Yarmukian Culture in Israel. *Paléorient* 19: 115–134.

Goring-Morris, N. 1991. The Harifian of the Southern Levant. In Bar-Yosef, O. and Valla, F.R. (eds) *The Natufian Culture in the Levant*, pp. 173–216. Ann Arbor: International Monographs in Prehistory.

Goring-Morris, N. and Gopher, A. 1983. Nahal Issaron – A Neolithic Settlement in the Southern Negev. *Israel Exploration Journal* 33: 149–162.

Hauptmann, H. 1993. Ein Kultgebäude in Nevali Çori. In Frangipane, M., Hauptmann, H., Liverani, M., Matthiae, P.

and Mellink, M. (eds.) *Between the Rivers and Over the Mountains*, pp. 37–69. Rome: Università di Roma.

Hodder, I. 1990. *The Domestication of Europe*. Oxford: Blackwell.

Hodder, I. and Matthews, R. 1998. Çatalhüyük: the 1990's Seasons. In Mattews, R. (ed.) *Ancient Anatolia*, pp. 43–51. London: British Institute of Archaeology at Ankara.

Kafafi, Z. 1985. Late Neolithic Architecture of Jebel Abu Tawwab, Jordan. *Paléorient* 11: 125–128.

Kenyon, K.M. 1981. *Excavations at Jericho, Volume III*. London: The British School of Archaeology in Jerusalem.

Kirkbride, D. 1966. Five Seasons at the Pre-Pottery Neolithic Village of Beidha in Jordan. *Palestine Exploration Quarterly* 98: 8–72.

Kirkbride, D. 1967. Beidha 1965: An Interim Report. *Palestine Exploration Quarterly* 99: 5–13.

Kirkbride, D. 1975. Umm Dabaghiyah 1974: A Fourth Preliminary Report. *Iraq* 37: 3–11.

Kubba, S.A.A. 1987. *Mesopotamian Architecture and Town Planning: from the Mesolithic to the end of the Proto-Historic Period C. 10,000–3,500 B.C.* (B.A.R. International Series 367). Oxford: British Archaeological Reports.

Kuijt, I. 2000. People and Space in Early Agricultural Villages: Exploring Daily lives, Community Size, and Architecture in the Late Pre-Pottery Neolithic. *Journal of Anthropological Archaeology* 19: 75–102.

Le Brun, A. 1994. Fouilles récentes à Khirokitia (Chypre) 1988–1991. Paris: Éditions recherche sur les Civilisations.

Lechevallier, M. and Ronen, A. 1994. *Le gisement de Hatoula en Judée occidentale, Israél: rapport des fouilles 1980–1988* (Mémoires et travaux du Centre de Recherches Français de Jérusalem No. 8). Paris: Association Paléorient.

Lloyd, S. and Safar, F. 1945. Tell Hassuna. *Journal of Near Eastern Studies* 4: 255–289.

Malek, S. S. 1979. A Specialized House Builder in an Iranian Village of the 6th Millennium BC. *Paléorient* 5: 183–192.

Mellaart, J. 1967. *Çatal Hüyük, A Neolithic Town in Anatolia*. London: Thames and Hudson.

Mellaart, J. 1970. *Excavations at Hacilar*. Edinburgh: University Press.

Mellaart, J. 1975. *The Neolithic Near East*. London: Thames and Hudson.

Merpert, N. and Munchaev, K. 1973. Early Agricultural Settlements in the Sinjar Plain, Northern Iraq. *Iraq* 35: 97–113.

Molist, M. 1998. Des représentations humaines peintes au IXe millénaire BP sur le site de Tell Halula (Vallée de l'Euphrate, Syria). *Paléorient* 24: 81–87.

Moore, A.M.T. 1981. North Syria in Neolithic 2. In Cauvin, J. and Sanlaville, P. (eds.) *Préhistoire du Levant,* pp. 445–456. Paris: CNRS.

Negabhan, E.U. 1979. A Brief Report on the Painted Building of Zaghe. *Paléorient* 5: 239–250.

Nissen, H., Muheisen, M. and Gebel, H.G. 1991. Report of the Excavations at Basta 1988. *Annual of the Department of Antiquities of Jordan* 35: 13–40.

Noy, T. 1989. Gilgal I—A Pre-Pottery Neolithic Site, Israel – The 1985–1987 Seasons. *Paléorient* 15: 11–18.

Oates, J. 1969. Choga Mami, 1967–68 Preliminary Report. *Iraq* 31: 125–152.

Peltenburg, E. 1998. *Excavations at Kissonerga-Mosphilia, 1979–1992* (Studies in Mediterranean Archaeology Vol. 70: 2). Jonsered: Paul Åströms.

Perrot, J. 1966a. La gisement natoufien de Mallaha (Eynan) Israel. *L'Anthropologie* 70: 437–483.

Perrot, J. 1966b. La troisiéme campagne de fouilles a Munhata (1964). *Syria* 43: 49–63.

Porath, Y. 1985. A Chalcolithic Building at Fasa'el. *'Atiqot* 17: 1–19.

Redman, C.L. 1983. Regularity and Change in the Architecture of the Early Village. In Young , T.C., Smith, P.E.L. and Mortensen, P. (eds.) *The Hilly Flanks and Beyond. Essays on the Prehistory of the Southwestern Asia* (Studies in Ancient Oriental Civilization 36), pp. 189–197. Chicago: The Oriental Institute.

Rollefson, G.O. 1998. 'Ain Ghazal (Jordan): Ritual and Ceremony III. *Paléorient* 24: 43–58.

Rollefson, G.O. and Kafafi, Z. 1997. The 1996 Season at 'Ain Ghazal: Preliminary Report. *Annual of the Department of Antiquities of Jordan* 41: 27–48.

Rosenberg, M., Nesbitt, R.M., Redding, R.W. and Strasser, T.F. 1995. Hallan Çemi Tepesi: Some Preliminary Observations concerning Early Neolithic Subsistence Behaviors in Eastern Anatolia. *Anatolica* 21: 1–12.

Stekelis, M. and Yizraeli, T. 1963. Excavations at Nahal Oren. Preliminary Report. *Israel Exploration Journal* 13: 1–12.

Stordeur, D. 1998. Jerf el Ahmar et l'horizon PPNA en Haute Mésopotamie: Xe–IXe millénaire avant J.C. *Subartu* 4: 13–29.

Stordeur, D., Maréchal, C. and Molist, M. 1991. Stratigraphie générale du Tell Néolithique d'El Kowm 2 – Caracol (Syria). *Cahiers de l'Euphrate* 5–6: 33–53.

Ussishkin, D. 1980. The Ghassulian Shrine in En-gedi. *Tel Aviv* 7: 1–44.

Verhoeven, M. and Kranendonk, P. 1996. The Excavations: Stratigraphy and Architecture. In Akkermans, P.M.M.G. (ed.) *Tell Sabi Abyad; The Late Neolithic Settlement*, pp. 25–119. Istanbul: Netherlands Historisch-Archaeologisch Instituut.

Voigt, M.M. 1983. *Hajji Firuz Tepe, Iran: The Neolithic Settlement* (University Museum Monograph 50). Philadelphia: University of Pennsylvania.

Watson, P.J. 1979. *Archaeo-Ethnography in Western Iran*. Tucson: University of Arizona Press.

Wilson, P.J. 1988. *The Domestication of the Human Species*. New Haven and London: Yale University Press.

Yasin, W. 1970. Excavations at Tell es-Sawwan 1969. *Sumer* 26: 3–20.

Yogev, O. 1983. A Fifth Millennium BCE Sanctuary in the 'Uvda Valley. *Qadmoniot* 64: 118–122 (Hebrew).

# PART II

# MATERIAL CULTURE STUDIES

# 7

# THE POTTERY

*Anna Eirikh-Rose and Yosef Garfinkel*

## I. INTRODUCTION

This article is concerned with the Neolithic pottery of Sha'ar Hagolan and presents the results of ceramic analyses of material excavated during the first five excavations seasons 1989–1990 and 1996–1998, during which some 1,200 sq. m. were unearthed (Fig. 7.1). In this area a large pottery assemblage was recovered, the largest one so far excavated at a Neolithic site in Israel. As all the site sediment has been sieved, the assemblage also includes very small sherds. Sha'ar Hagolan belongs to a cluster of sixth millennium BC sites known as the Yarmukian Culture. Some 20 Yarmukian sites are known to date, located in the Mediterranean climatic zone of the southern Levant (Garfinkel 1993, 1999a: 16–67, 1999b; Kafafi 1993). Yarmukian pottery has been recovered at many Neolithic sites, but comprehensive analysis has

been conducted and published for only a few of these assemblages. Final, detailed monographs are available on Munhata (Garfinkel 1992a) and Abu Thawwab (Obeidat 1995). Other reports exist for the old excavations of Sha'ar Hagolan (Stekelis 1972), Nahal Qana Cave (Gopher and Tsuk 1996), 'Ain Rahub (Kafafi 1989) and 'Ain Ghazal (Kafafi 1990, 1995). So far as other Yarmukian sites are concerned, like Megiddo (Loud 1948) or Habashan Street (Kaplan 1954), only a very brief description of the recovered pottery, if any, has been presented. Similar pottery assemblages have been unearthed at another cluster of Neolithic sites, known as Jericho IX/Pottery Neolithic A. The main sites of this tradition are Jericho (Garstang *et al.* 1935, 1936; Kenyon and Holland 1982, 1983), Ghrubba (Mellaart 1956), Teluliyot Batash (Kaplan 1958), Lod (Kaplan 1977),

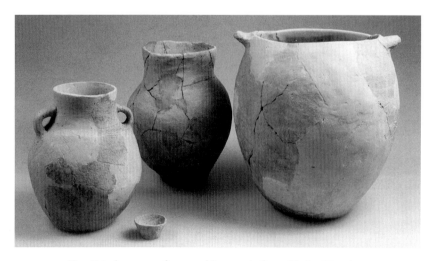

FIG. 7.1. A group of restorable vessels from Sha'ar Hagolan

Dhra' (Bennett 1980) and Khirbet ed-Dharih (Bossut *et al.* 1988).

The Yarmukian pottery from Sha'ar Hagolan was first presented by Stekelis in his preliminary reports (1951). The final excavation report did not add much data, as the treatment of the pottery is very concise, with a few plates and no clearly defined typological division (Stekelis 1972). From the renewed excavation only the pottery from the first two seasons has been presented so far (Garfinkel 1992b, 1999a). The results of this analysis are included in the present article. Thus, the main purpose here is to present, for the first time, the Sha'ar Hagolan pottery assemblage in all its standardization and diversity, and in comparison with contemporaneous pottery assemblages in the region.

## II. METHODS AND MATERIAL

Complete vessels are very rare at Sha'ar Hagolan and even restoration of whole profiles was possible in only a few cases. We basically have in hand broken pottery sherds and this creates problems in the identification and quantification of the assemblage. The first step in our analysis was to count all the sherds uncovered during the dig according to their provenance (basket and locus). Later, all the indicative sherds were separated and counted according to category: rim, base, handle and/or type of decoration.

The typological division was based mostly on rim sherds because they are the most informative about the size and shape of a vessel. In a few cases the typology statistics included "indicative sherds, not rims"; these are large pottery sherds that have clear typological attributes but are missing the rim. In most cases they are shoulders and almost-complete necks of jars. Typological analysis was conducted on rims over 2 cm. in size, since the exact vessel type cannot be deduced from very small sherds. The only exceptions were small and miniature vessels. Small rim sherds are defined as non-indicative rims. As can be seen, the main description of the assemblage is based on broken rims, which create additional problems in presenting type proportions. Pottery statistics are known to be methodologically problematic (David 1972; Egloff 1973; Orton *et al.* 1993, Shepard 1965). In any assemblage the proportion of the number of sherds of any particular type reflects two things:

1. The proportion of that type in the assemblage.
2. The average number of sherds into which pots of that type have broken (Orton *et al.* 1993: 169).

It must therefore be kept in mind that all statistics of vessel/type proportion are somewhat relative because the relation between vessel size, or shape, and the number of sherds into which it breaks is not simple. We also think that the count of minimum numbers of vessels (see, for example, Gilead and Goren 1995) does not suit our Neolithic assemblage. That is because the shape of the rim in a given vessel can vary considerably along the vessel circumference. Every rim was classified into a typological category and was counted separately. In the few cases when restoration was possible, the joined sherds were counted as one item.

In our work, we utilized the typological framework that was established for the Neolithic assemblages of Munhata and the 1989–1990 seasons at Sha'ar Hagolan (Garfinkel 1992a, 1992b, 1999a). According to his typological framework, type-definition is based upon basic vessel form (open or closed), size, the specific shape of the vessel and, in a few cases, decoration. We utilize the Munhata type numbers here, despite the fact that some types at Munhata are not found at Sha'ar Hagolan, and *vice versa* – in such cases, new numbers were added to the typological chart. It seemed preferable to describe these similar assemblages using the same conventions, thus providing a more complete picture and facilitating understanding of the similarities and differences between the assemblages.

## III. TECHNOLOGICAL OBSERVATION

All the pottery is hand-made without use of the wheel. The Yarmukian potters, in general, used local clay and preferred high-carbonate content, which gave the clay a light brownish color (Goren 1991, 1992). Flint chips, basaltic inclusions, limestone particles, sand and chopped chaff were used for temper, with flint and basalt the most popular. Some of the vessels are made on a chaff mat, as indicated by a mat impression on several of the bases.

TABLE 7.1. General count of the pottery assemblage

| Sherds | Indicative | Handles | Bases | Decorated | Scraped | Rims | Typological Diagnostic |
|--------|-----------|---------|-------|-----------|---------|------|------------------------|
| 34232 | 11671 | 574 | 981 | 7191 | 96 | 2829 | 2543 |
| 100% | 34.09% | 1.68% | 2.87% | 21.01% | 0.28% | 8.26% | 7.43% |

Coil-construction can be discerned in a few sherds. Based upon manufacturing process, the assemblage may be divided into "fine ware" and "coarse ware."

1. Fine wares are made from delicate, probably sieved clay; tempers appeared in a small number and the inclusions are small. Perhaps tempers were crushed before adding them to the clay. These wares do not have a black core on sherd section, a fact pointing to a relatively high firing temperature and/or the abandoning of organic tempers. The surfaces of the vessels of this kind are usually smooth and decorated.
2. Coarse wares are made from rough clay with a large number of large- or medium-size grits. This kind of clay was used mostly on large vessels partly because the higher percentage of temper gives the vessels greater strength during the drying process. In most cases, vessels of this kind have a thick black core visible in the sherd section. The surface of some of the vessels remained rather rough, and even smooth-surfaced vessels remained mostly undecorated.

Various kinds of surface treatment are distinguishable: grass-smoothing (sometimes the grass imprints are recognizable on the pottery surfaces), water-smoothing and smoothing with wet clay when the vessel was leather hard. Usually both surfaces of the vessel are smoothed (external and internal), but in some vessels, mainly large open ones, only the inside surface of the vessel is smoothed, in others, mainly large and very closed, only the outside surface.

## IV. Typological Description

All the statistical data concerning the assemblage is presented in the various tables. It includes 34,232 sherds, of which 22,455 (66%) are undecorated body fragments. The other, more indicative sherds are 2,829 (8%) rims, 574 (3%) handles, 981 (3%) bases and 7,191 (21%) decorated sherds. All data (sherds numbered by category), is presented in the tables according to the provenance by architectural units rather than by loci because of the size of the excavated area and the assemblage, and this method of statistical presentation is more suitable to the present article.

The whole assemblage includes 2,543 indicative rim sherds and "indicative sherds not rims" (60 items). All these sherds were divided into 21 different typological categories, which consist of 18 clear types and three varia (Table 7.2). All these types are combined into six groups (three sizes: small, medium and large, sub-divided into open or closed shape).

## 1. Small Open Vessels

*A 1 – Small Bowls or Cups* (55 items, 2.2%)
The vessels generally have thin walls and simple rims (Figs. 7.16: 1–5, 7.17: 1–4). The bowl has slightly flared or rounded walls and is a relatively shallow vessel. The cup is a relatively deep vessel with upright walls. Some of the cups have loop handles (Fig. 7.16: 5). Most of the vessels in this group are decorated, mostly painted or slipped; incised decoration and undecorated items are rare.

*A2 – Small Chalice* (1 item, 0.04%)
Miniature chalice with high full base, flat bowl and handle that extends from the bottom of the bowl to the base. Only one sherd of this type was found in the excavation (Fig. 7.17: 5), but five small chalices have been collected from the site surface over the years (Noy and Roth 1994), (Fig. 7.3, 7.4).

*A3 – Spoon*
No clear spoon-like vessels were found at Sha'ar Hagolan. One sherd can probably be identified with this group (Fig. 7.16: 2).

Fig. 7.2. A miniature bowl with painted decoration (Fig. 7.16: 1)

Fig. 7.3 A small chalice

Table 7.2. Frequencies of different typological forms

| Unit | A1 | A2 | B1 | B2 | B3 | C1 | C2 | C4 | C5 | D1 | D2 | D3 | E1 | E2 | E3 | E4a | E4b | F1 | F2 | F3 | F4 | Total |
|---|---|---|---|---|---|---|---|---|---|---|---|---|---|---|---|---|---|---|---|---|---|---|
| IA | 8 | | 1 | 1 | 1 | 42 | 27 | 6 | 1 | 3 | 6 | | 23 | 1 | 6 | 20 | 9 | 42 | 1 | 31 | 12 | 241 |
| IA-C | | | | | | | 1 | | | | | | | | | | | | | | | 1 |
| IB | | | | | | 1 | | | 1 | | | | 1 | | | | | 1 | | 1 | | 5 |
| IC | 1 | | | | | 8 | 4 | 2 | 1 | 2 | | | 3 | | | 1 | | 2 | | 5 | 1 | 30 |
| ID | | | | | 1 | 4 | 2 | | | | | | | | 3 | 5 | 1 | 2 | | 2 | | 20 |
| ID-I | | | | 1 | | 1 | 2 | 1 | | 1 | 1 | 1 | 1 | | | | | | | 1 | | 10 |
| IE | 3 | | | | | 11 | 5 | | 5 | | | | 5 | | | 1 | 1 | 19 | | 11 | 1 | 62 |
| IF | | | | | | 3 | 3 | | | | 2 | | 1 | | | 2 | 1 | 6 | | 5 | 1 | 24 |
| IG | | | | | | | 2 | | | | | | | | | | | 4 | | | | 6 |
| IH | | | | | | 2 | 1 | | | | | | 2 | | | | | 1 | | 1 | | 7 |
| IIA | 26 | 1 | 6 | 24 | 16 | 324 | 76 | 19 | 4 | 21 | 3 | 4 | 72 | 3 | 10 | 41 | 7 | 232 | 4 | 131 | 8 | 1032 |
| IIA-F | | | | | | 1 | | | | | | | | | | | | | | | | 1 |
| IIA-J | | | | | | | | | | | | | | | | | | 3 | | | | 3 |
| IIB | | | 1 | 1 | | 27 | 7 | | | 2 | 1 | | | | 1 | 2 | | 9 | | 10 | | 61 |
| IIC | | | | | | | 4 | | | | 1 | | 1 | | | 3 | | 6 | | 5 | | 20 |
| IIC-F | | | | | | 1 | | | | | | | | | | | | | | | | 1 |
| IID | 1 | | 1 | 1 | 2 | 1 | | 1 | | | | | | | | 2 | | 3 | | 1 | | 13 |
| IIE | | | | | | | | | | | | | | | | | | 1 | | 1 | | 2 |
| IIE-I | | | | | | | | | | | | | | | | | | 1 | | | | 1 |
| IIF | | | | | | 9 | 3 | | 1 | | | | | | 1 | 1 | 1 | 10 | | 9 | | 35 |
| IIG | 1 | | | | | 3 | 1 | 3 | | 1 | | | | | | 1 | 2 | 3 | | | 1 | 16 |
| IIG-E | | | | | | 1 | | | | | | | | | | | | 2 | | | | 3 |
| IIG-I | | | | | | 1 | 1 | | | | | | 2 | | | | | 7 | 1 | 4 | | 16 |
| IIH | | | | | | 3 | 2 | 1 | | 1 | 1 | | | | | | | 6 | 1 | 3 | | 18 |
| IIH-I | | | | | | 1 | | 1 | | | | | | | | | | | | | | 2 |
| II.I | | | | | | 1 | 1 | 1 | | 1 | | | | | | 2 | | 6 | | 4 | | 16 |
| IIJ | 1 | | | 2 | | 34 | 14 | 1 | 1 | 2 | 1 | | 9 | 4 | 3 | 5 | | 29 | | 20 | 2 | 128 |
| IIJ+I | | | | | | 5 | | 1 | | 1 | | | 1 | | | | 1 | | | 4 | | 13 |
| IIJ-I | | | | | | | 2 | | | | | | | | | | | 2 | | 1 | | 5 |
| IIK | | | | | | 1 | | | | 1 | | | 1 | | | | | 5 | | 1 | 1 | 10 |
| IIL | 1 | | 1 | | | 2 | 2 | | | | | | 1 | | | | | 2 | | 4 | 1 | 14 |
| IIL-K | | | | | | | 1 | | | | | | | | | | | | | | | 1 |
| IIM | 3 | | | 1 | 2 | 16 | | 2 | | 2 | 1 | | 1 | | | 2 | | 7 | | 8 | 3 | 48 |
| IIM-L | | | | | | 3 | 3 | | | | | | | | | | | 3 | | 1 | | 10 |
| IIN | | | | | | 6 | | | | | | | | | 1 | | | 3 | | 1 | | 11 |
| IIIA | | | | | | 1 | 3 | 1 | | | | | 4 | | | | | 2 | | 2 | 2 | 15 |
| IIIA-B | | | | | | 1 | 1 | 1 | | | | | 1 | | | | | 1 | | | | 5 |
| IIIB | | | | 1 | | 3 | | 1 | | | | | 1 | | 1 | 1 | 1 | 2 | | | | 11 |
| 8 | | | | | | 2 | 2 | 1 | | | 5 | | | 1 | | 1 | | 5 | | 2 | | 19 |
| 41 | | | | | | | | | | | | | | | | | | | | 1 | | 1 |
| 52 | | | | 2 | | 7 | 5 | 1 | 1 | | 3 | | 4 | | 1 | 6 | | 11 | | 5 | | 46 |
| 61 | | | | | | | | | | | | | 2 | 1 | | 1 | | | | | | 4 |
| 83 | 5 | | 1 | | 3 | 16 | 16 | 2 | 4 | 4 | 2 | | 14 | | 2 | 7 | 4 | 13 | 3 | 22 | | 118 |
| 109 | | | | 2 | | 2 | 3 | 1 | 1 | | | | | | 1 | 1 | | 2 | | | 1 | 14 |
| 204 | | | | | | | | | | | | | | | 1 | | | | | | | 1 |
| 289 | 1 | | 3 | | | 10 | 2 | 2 | 1 | | | | 2 | | | 1 | | 17 | | 4 | 1 | 44 |
| 294 | 1 | | 2 | | | 21 | 5 | 1 | | | | | | | | 2 | | 6 | 2 | 8 | 2 | 50 |
| 295 | | | | | | | | | | | | | | | | | | | | 1 | | 1 |
| 308 | | | | | | 8 | 1 | | | | | | | | | | | 2 | | 3 | | 14 |
| 323 | 1 | | 1 | | | 20 | 5 | 3 | | 1 | 1 | | 2 | | | 1 | 1 | 25 | | 7 | 1 | 69 |
| 339 | | | 1 | 2 | | 22 | 8 | | 4 | | | | 5 | | | | | 19 | | 15 | | 76 |
| 351 | | | | 2 | | 21 | 2 | 1 | | | | | 5 | | 1 | | 1 | 10 | 1 | 2 | | 47 |
| 353 | 1 | | | | | 3 | 1 | | | | | | | | | | | 1 | | 3 | | 9 |
| 357 | | | | | | | 1 | | | | | | | | | | | | | | | 1 |
| 362 | | | | 1 | | 2 | | | | | | | | | | | | 1 | | 3 | | 7 |
| 370 | | | | | | 2 | | | | | | | | | | | | 1 | | | | 3 |
| 371 | | | | | | 3 | 1 | 1 | | 1 | | | 1 | | | | | 3 | | 2 | 1 | 13 |
| 409 | | | | | | 3 | | | | | | | | | | 1 | | 4 | | 2 | | 10 |
| 410 | | | | | | 1 | | | | | | | | | 2 | | | 3 | | 2 | | 8 |
| 410,418 | | | | | | 9 | 4 | | | | 1 | | | | 1 | 1 | | 6 | 1 | 5 | | 28 |
| 410-424 | | | | | | | | 1 | | | | | | | | | | | | 1 | | 2 |
| 414 | | | | | | 1 | | | | | | | | | | | | | | 1 | | 2 |
| 418 | | | | | | 3 | 2 | | | | | | | | | | | 5 | | | | 10 |
| 420 | | | | | | | | | | | | | 1 | | | | | 1 | | | | 2 |
| 424 | | | | | | 4 | 1 | | | | | | | | | | | 2 | | 1 | | 8 |
| F | | | | | 1 | 2 | 1 | | | | | | 4 | | | | | 6 | 1 | 4 | | 19 |
| Total | 55 | 1 | 11 | 45 | 29 | 678 | 226 | 50 | 27 | 51 | 29 | 5 | 169 | 6 | 36 | 107 | 38 | 565 | 15 | 361 | 39 | 2543 |
| % | 2.2% | 0.04% | 0.4% | 1.8% | 1.1% | 26.7% | 8.9% | 2.0% | 1.1% | 2.0% | 1.1% | 0.2% | 6.6% | 0.2% | 1.4% | 4.2% | 1.5% | 22.2% | 0.6% | 14.2% | 1.5% | 100.0% |

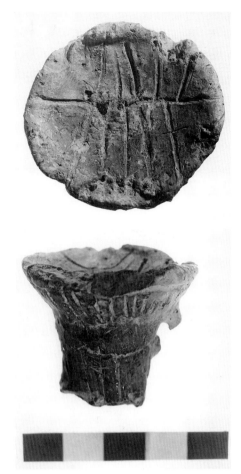

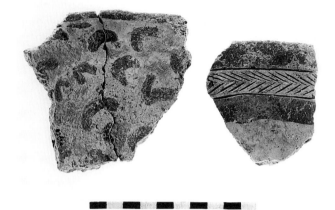

FIG. 7.5. Two decorated bowls with painted (Fig. 7.18: 17) and incised (Fig. 7.16: 10) decoration

FIG. 7.4. A small chalice with incised decoration

## 2. Medium-Size Bowls and Chalices

C1 – Decorated Bowl (678 items, 26.7%)

Bowls appear in a variety of sizes and depths but most items are relatively deep (Fig. 7.5). The walls of the bowls are upright or curved and the vessel has a small, flat, disk or rounded base. Usually bowls of this type are fine-ware with thin walls. The rims are pointed, rounded or square-shaped. The most representative rim of this type of bowl is a "cut" square section rim made by cutting the upper part of the vessel with a sharp tool, perhaps a flint knife.

Some rim fragments of this type have a handle close to the rim, mostly a vertical loop handle, but horizontal loops and pierced handles are known. So far no complete bowl with two handles has been found. Items with one handle have been reported from Munhata.

Three main types of decoration have been found:

**1. Incised decoration** (Figs. 7.16: 6–12; 7.17: 15–24). The bowls with incised decoration are one of the most representative vessels in the Yarmukian assemblage. The typical and most common incised decoration, which we

previously designated "Sha'ar Hagolan decoration" (Garfinkel 1992a: 55–56, 1999a: 64–67), is usually composed of three elements: 1. horizontal lines, 2. zigzag lines and 3. herring-bone pattern. The horizontal lines run below the rim (the distance from the rim is generally 0.5–2 cm.). The space between the lines is either filled with herring-bone pattern or left plain. On a few bowls, incised parallel skew lines appear on top of the rim (Fig. 7.18: 6). Sometimes, the incised decoration is the only decoration (Figs. 7.16: 9, 7.17: 20–21), but in most cases red slip, painting or red burnishing is added. The incised decoration always appears on the outside of the bowl and has never been noted on vessel interiors.

The interior surface of the bowl, independent of the outside, is decorated with different kinds of red slip or painting. The most common decoration is a red horizontal line along the rim sometimes combined with a wide vertical line running from the rim to the bottom of the vessel (Figs. 7.16: 16; 7.17: 17).

**2. Paint decoration** (Figs. 7.16: 13–16; 7.17: 8–17; 7.9: 1–3, 5). The external face of the bowl is decorated with either wide or thin red painted lines. Like the incisions, the painted decoration is in horizontal bands, chevrons (in most cases several parallel zigzag lines), and combinations of both, with the zigzag emanating from the horizontal lines. The wide lines are usually arranged in horizontal bands, while the thin lines appear in chevrons. The common type of painted decoration on bowls is a wide line applied to both sides of the rim, commonly nicknamed "lipstick" (Figs. 7.18: 8–11, 15; 7.19: 1–2, 5). In a few cases the painted lines are also burnished (Fig. 7.19: 3).

**3. Red slip decoration.** The external face of these bowls is red slipped (Figs. 7.18: 1–7; 7.19: 4, 6–7) and sometimes burnished (Fig. 7.19: 4).

We cannot point to any chronological, cultural or functional differences between these three types of bowl decoration at Sha'ar Hagolan—all were found together over the entire site and in many cases in the same locus.

*C2 – Undecorated* bowl (226 items, 8.9%).
These bowls are similar in shape to those of the C1 group but have no decoration and are usually crudely constructed with less surface treatment (Figs. 7.19: 9–13; 7.20: 1–10).

An interesting phenomena noted on a few bowl sherds from this group is scraping on the right side of the item after firing (Fig. 7.19: 12–13). This treatment is connected with the general phenomena of recycling pottery sherds at Sha'ar Hagolan (see below). However, only pottery sherds from undecorated C2 bowls were found with this specific side treatment.

One bowl-rim of this type was coated on both sides with a white material (Fig. 7.19: 11), apparently lime; remains of the same material were recovered on one body sherd that belong to the same type of vessel (Fig. 7.43: 7). The presence of lime on those vessels is probably related to their use.

*C4 – Chalice* (50 items, 2%)
Vessels with a high hollow base and flat bowl (Figs. 7.20: 11–20; 7.21: 1–6). The bowls on the top and base of the chalice were made separately and attached. At Munhata, Megiddo and in one case at Sha'ar Hagolan, one vertical loop handle was found extending from the bottom of the bowl to the base. Methodologically, there is a problem identifying chalices—in most cases only rim fragments of the flat bowl at the top of the chalice exist, which could also belong to simple flat bowls without chalice base, resulting in statistical uncertainty.

This type includes decorated and undecorated items. The most common decoration is red slip, On other items there are wide lines of red paint. The decoration appears on both sides of the upper part of the vessel and on the exterior of the bases. Incisions are rare. Only one chalice is decorated with short horizontal incised lines that begin 2 cm. below the rim (Fig. 7.21: 2); no herring-bone incisions have been noted on chalices.

*C5 – Various bowls* (27 items, 1.1%)
This category includes all medium size bowls that do not fit into any of the previous groups. It includes one group of bowls that should be mentioned separately (Fig. 7.21: 7–10): a shallow bowl with carination in its lower part, near the base. The base was not preserved in all examples, but judging from the general shape of the bowl, it must have been rounded or very small. Few of these bowls have handles; in one case a small pierced handle is placed exactly at the carination (Fig. 7.21: 6). In another case, the small lug handle was 5 cm. above the carination (Fig. 7.21:

10). The original rim of this bowl has been removed and the top has been scraped to form a kind of rim of uniform height. Probably, part of the rim broke off, but enough of the vessel remained for continued use. All the bowls are well made and have thin walls and surface treatment. Some of these bowls are decorated with red slip. Carination on pottery vessels is a rare phenomenon during this time period, but appears quite widely in the Wadi Raba cultural stage (Garfinkel 1999a, Figs. 67, 69, 72–73). Two bowls similar to this group are reported from Byblos (Dunand 1973, carinated bowl Fig. 16: 24464 and one bowl with a lug handle at the carination – Fig. 28, right item).

## 3. Large Open Vessels

*E1 – Krater/ Cooking Pot* (169 items, 6.6%)
A large, deep vessel with straight walls or everted walls (Figs. 7.22: 1–2; 7.23). Most vessels have lug handles close to the rim. Usually the kraters are coarsely constructed with thick walls; the clay is rough with much non-organic temper. Most of the vessels bear signs of burning close to the base. Decoration seldom occurs. These vessels closely resemble one of the holemouth jar types (F1b), the difference being only the inclination of the walls: the walls of holemouth jars are inverted.

*E2-Deep Large Bowl* (6 items, 0.2%)
This type of vessel is very rare at Sha'ar Hagolan. The few rim fragments that could be related to this category have a high body and are usually decorated (Fig. 7.27: 1).

*E3 – Basin* (36 items, 1.4%)
A very shallow large bowl, usually has straight, very thick walls and flat, large base (Figs. 7.6; 7.21: 11–13; 7.24: 2–5). The rims are usually pointed, with a sudden broadening of the sides but square sections exist. One basin has a pointed rim with a few ridges below on the

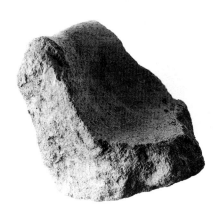

FIG. 7.6. A basin (Fig. 7.24: 4)

external face (Fig. 7.21: 11). The basins are crudely constructed, in many cases the tempers are mostly chopped straw – probably to reduce the weight of the vessel. These vessels were probably intended to be portable but because of very thick walls they became heavy vessels. The basins have surface treatment, mostly only on the internal face. They are undecorated vessels. The only decorated basin was decorated with a horizontal reverse band of herring-bone incisions below the rim.

*E4 – Pithos*

A large storage vessel that is characterized by especially large dimensions. All pithoi have very thick walls relative to their dimensions. Pithoi are constructed crudely; sometimes it is possible to recognize coil building. In most cases pithoi are badly fired and have a large black core. Pithoi have surface treatments of all kinds, especially on the internal face. In one case the rim was made from two layers of clay attached together and covered with wet clay (Fig. 7.25: 4). Large pithoi were sometimes built on the mat, as can be clearly seen on the base of one pithos which was preserved *in situ* in the 1999 excavation season. The pithoi can be divided in two main types: relatively closed or open.

*E4a – Holemouth pithos* (107 items, 4.2%)

Pithos with walls extending inwards (Figs. 7.25: 2–6; 7.26: 4; 7.27: 1–5; 7.28: 1–4). This type has large dimensions and examples are usually larger than the next type (E4b). The pithoi have different kinds of rims, mostly square; sometimes a groove appears in the middle of the square rim. The body is rounded and it becomes drastically narrow in the lower part as it reaches the base, which is relatively small. The bases are either flat or convex. Near the rim, even sometimes touching it (Fig. 7.25: 2, 6), is a row of lug handles, which appears at uniform intervals along the perimeter of the vessel. The intervals are different in different vessels. The lugs are small in comparison with the size of the vessel and do not appear to have served as handles for carrying the pithos. This row of handles can be used as a decoration or to secure a lid. The lids may have been made from organic material.

*E4b. Open pithos* (38 items, 1.5%)

Pithoi with straight or slightly open walls (Figs. 7.22: 3; 7.25: 1; 7.26: 1–3; 7.28: 5; 7.29). Since only incomplete vessels of this type have been found, the exact shape of the base is unknown. The pithoi has lug handles close to the rim or a few centimeters below. All known decorated pithoi are open vessels, and the decoration was usually in red slip (Figs. 7.22: 3; 7.28: 5). In a few cases, incised herring-bone pattern was found (Fig. 7.26: 1).

## 4. Small Closed Vessels

B1 – *Miniature Jars* (11 items, 0.4%)

Very small closed vessels with diameters of less than 7 cm., resemble the shape and the range of larger size jars (Figs. 7.17: 6, 12–13; 7.30: 1–3). The vessels are thin and well made; there are both decorated and undecorated items. The decoration includes red slip or incision (sometimes both). Some of the vessels have two looped or pierced handles.

B2 – *Small Jars* (45 items, 1.8%)

This type is similar to the previous category but larger in size with a diameter of 8–10 cm. (Fig. 7.7; 7.17: 7–11, 14; 7.30: 4). The vessels are mostly decorated. The most popular decoration is herring-bone incisions, designated as "Sha'ar Hagolan Decoration" (see below).

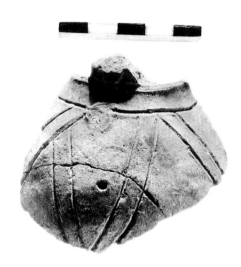

FIG. 7.7. A small jar with frame incisions.

B3 – *Goblet* (29 items, 1.1%)

This is a new vessel type that has not been recognized previously as such. It is closed, reminiscent in shape of a holemouth jar. (Fig. 7.30: 5–11). The production of these vessels is fine, the walls are thin. In most cases the items had a simple rim, pointed or rounded, and no handles. Regarding shape definition, the goblets can be divided into two groups:

i.   Very closed vessels with a simple opening (Fig. 7.30: 5–8).
ii.  Vessels with rim that rises slightly, as if beginning a neck (Fig. 7.30: 10–11).

There are decorated and undecorated items. The decoration was mainly done by red slip and the typical herring-bone incised decoration was not used for this type (at Sha'ar Hagolan). The undecorated items showed evid-

ence of painstaking finishing; they are nicely smoothed (the whole surface of the only intact vessel was burnished but undecorated).

One intact vessel from this group was recovered at Sha'ar Hagolan (Fig. 7.30: 5). It has a particularly small ring base and two holes close to the rim. The holes are placed on either side of the vessel as if in the place of handles. The holes are made intentionally, at the time of manufacture by a thin stick. Only one more vessel from this group at Sha'ar Hagolan has similar holes. The holes were probably threaded to hold a lid in place or to hang the vessel. The phenomenon of perforation is not often reported from Neolithic sites; in nearly all the cases the perforations are made after firing the vessel with a technique similar to stone perforations. Almost all known contemporary perforations are made on the jar neck (such perforations were reported from Munhata (Garfinkel 1992a, Fig. 76: 3, 12, 14), Nahal Qana Cave (Gopher and Tsuk, Figs. 3.4: 1, 3.8: 11), Byblos (Dunand 1973, Fig. 17: 23072) and Ghrubba, where a bowl was perforated near the rim (Mellaart 1956, Fig. 6: 116).

Similar goblets were found at other Neolithic sites, some of them have two opposed pierced lug handles near the rim, that probably were used for the same purpose as the holes. Vessels similar to type B3a are reported from Abu Thawwab (Obeidat 1995, Type B1, Figs. 32: 14, 24–27; 43: 1–3, 55: 6–8, 10; 62: 17), 'Ain Ghazal (Kafafi 1990, Fig. 7: 10), Pottery Neolithic A Jericho (Kenyon and Holland 1982, Fig. 2: 4; 18: 4, 5; 32: 3, 1983, Fig. 7: 1; 34: 22) and Ghrubba (Mellaart 1956, Fig. 4: 22, 29). Vessels similar to type B3b are reported from Munhata (Garfinkel 1992a, Fig. 35: 20), Abu Thawwab (Obeidat 1995, Type B3c, Fig. 44: 20–21), Pottery Neolithic A Jericho (Kenyon and Holland 1982, Fig. 11: 3) and Teluliyot Batash (Kaplan 1958, Fig. 7: 8).

## 5. Medium-Size Jars

### D1 – Sha'ar Hagolan Jar (51 items, 2%)

This type of jar is very typical of Yarmukian assemblages and has been designated as "Sha'ar Hagolan Jar" (Garfinkel 1992a 1992b, 1999a). It has a high, upright or slightly flared neck, and two loop handles that extend from the neck to the shoulder (Figs. 7.8; 7.31: 1–9, 11–13; 7.32: 1–10, 15). At Sha'ar Hagolan these jars have relatively big and rounded handles. The body is rounded and has a flat small base. The rims of these jars are well molded, like the rims of the decorated bowls, mostly square in cross section. The jars are usually well made and have relatively thin walls. On some of the vessels it can be seen that neck and body are made separately and come together (see, for example, Fig. 7.31: 3). Almost all jars from this group are decorated with the typical Sha'ar Hagolan incised decoration, including herring-bone or

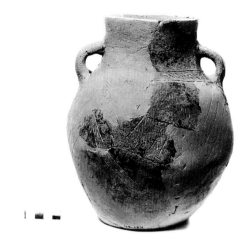

FIG. 7.8. A "Sha'ar Hagolan" jar (Fig. 7.32: 1)

frame incisions arranged in horizontal bands and chevrons. Red slip or paint usually accompanies the incisions. In one case the incised band was combined with chevrons created by single incision and paint (Fig. 7.31: 5). The incised horizontal band usually runs round the base of the neck. Sometimes additional incisions also appear on the neck. The internal face of these jars is decorated by a line of red paint near the rim ("lipstick") or by red slip that usually continues until the join between neck and body. In one case, a ridge was found at the base of the neck (Fig 7.31: 6).

### D2 – Jericho IX Jar (29 items, 1.1%)

This type of jar has a short upright or flared neck and two loop handles that extend from the rim or the very beginning of the neck to the shoulder (Figs. 7.30: 9, 12; 7.32: 11–14, 16–17). The handles are thick and sometimes have elliptical or very flat section. The jars have relatively fallen shoulders and a rounded body. Most of these jars are coarse vessels with thick walls and are undecorated. The only decoration is color, either red painted lines or red slip. These jars are more common in pottery assemblages related to the Jericho IX, thus, this type was previously designated "Jericho IX jar" (Garfinkel 1992a, 1999a).

### D3 – Various medium-size jars (5 items, 0.2%)

This group includes various, mostly decorated, jars that do not fit into previous groups. Some of them have a wide, short neck and they are well decorated with incisions and red paint (Fig. 7.30: 13). They can be considered as low neck Sha'ar Hagolan jars or decorated Jericho IX jars.

Few of these items can be recognized as "Byblos jars," characterized by high neck, horizontal handles that are

placed on the shoulder, rounded body and high ring base. Such items have been found at Yarmukian assemblages in Nahal Qana (Gopher and Tsuk 1996, Fig. 3.9: 1–2), Munhata (Garfinkel 1992a, Fig. 77: 2–4) and Byblos (Dunand 1973, Figs. 17: 24316, 26: 34258). All these jars at Sha'ar Hagolan are decorated by frame incisions in the same manner as "Sha'ar Hagolan jars" and the space between the incisions was red slipped and (in one case) burnished.

All the types of medium-size jars (Sha'ar Hagolan, Jericho IX and the varia), were found together over the entire site and in many cases came from the same locus.

## 6. Large Jars

*F1 – Holemouth jar* (565 items, 22.2%)

The holemouth jar is a closed, neckless vessel. In many cases the holemouth jar is crudely constructed with thick, rough surfaces. Many items bear signs of burning at the lower part of the vessel. Three subtypes are noted:

**a. Simple holemouth jar.** Items in this group are very closed and have a simple round or oval opening (Figs. 7.33: 2–4; 7.34: 3–4, 10; 7.35: 2, 6). The only complete vessel from this group has a flat base and its walls become narrow in the lower part. The walls of holemouth jars of this type are thin and rims are not elaborate but very simple—pointed or rounded. Holemouth jars from this group are usually without handles, but in some cases have lug handles close to the rim or immediately below; sometimes the handles are higher than the rim.

**b. Holemouth jar/krater.** Holemouth jars from this group have the same features as the krater/cooking pot, but the walls are extended inward (Figs. 7.9; 7.30: 15; 7.33: 1; 7.34: 1–2, 5, 7–9; 7.35: 1, 3–4, 8; 7.36: 1–3). Like Group E1, most of these vessels are smoke-blackened and were probably used as cooking pots. One vessel from this group is exceptional in shape as it has loop handles and a carination below the handles is decorated with red slip (Fig. 7: 30: 15).

**c. Holemouth jar with curved rim.** In this type of the holemouth jar the rim rises slightly, as if a neck were beginning (Figs. 7.34: 6, 11; 7.35: 5, 7; 7.36: 4) Most of these jars have an oval opening. The rims are usually square, but pointed and rounded rims exist. Most of holemouth jars from this group have lug handles, but a special feature for this group is that some of the vessels have a row of small lug handles below or attached to the rim. Similar vessels with a row of handles, from Abu Thawwab, have been published (Obeidat 1995, Fig. 34: 26).

Holemouth jars of all types are mostly undecorated; the infrequent decoration is mostly red slip (Figs. 7.30: 15; 7.35: 6; 7.36: 4). Sometimes red paint was applied to the handles (Fig. 7.35: 4).

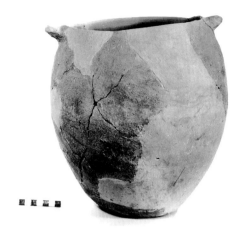

FIG. 7.9. A holemouth jar (FIG. 7.33: 1)

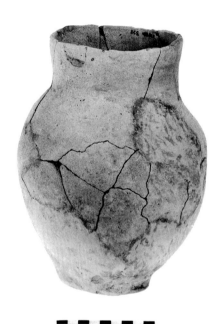

FIG. 7.10. A handless jar (FIG. 7.38: 6)

*F2 – Large Sha'ar Hagolan Jar* (15 items, 0.6%)

These vessels have a similar form to the Sha'ar Hagolan jar but are larger and less elaborate (Fig 7: 30: 16). The jars are mostly undecorated or decorated with red slip.

*F3 – Handleless Jar* (361 items, 14.2%)

Jars with different kinds of necks, straight or sloping shoulders and without handles (Figs. 7.36: 5–10; 7.37; 7.38: 1–9). The bases are flat or disk-shaped. One complete jar has an elongated body narrowing slightly toward the base (Fig. 7.10; 7.38: 6). Usually the jars are well made and smooth, especially on the external face.

According to the type of neck, the jars can be divided into a few sub-types:

**a. High necked**. Jars with a high, usually thin neck that can be divided into three groups based upon inclination: a straight neck (Figs. 7.36: 5–6; 7.37: 11; 7.38: 3–4); a neck widening toward the rim (Figs. 7.36: 8–9; 7.37: 2, 6–8; 7.38: 5–6); and a converging neck narrowing toward the rim in a conical shape (Fig. 7: 38: 7). As in the case of the Sha'ar Hagolan jar, on some of the vessels it can be seen that the neck and body are made separately and attached.

**b. Low-necked**. Jars with a very low neck – usually between 1–5 cm.; sometimes the neck is so low that it seems to be created by the rim curving outward. In most cases, the opening of these jars is wider than in the first type and the neck is straight or slightly curved. (Fig. 7.30: 14; 7.36: 7, 10; 7.37: 3–5, 9–10; 7.38: 1–2, 8–9).

The percentages of these two subtypes were measured only for the 1998 season: high necked jars were 58.2% and low necked 41.8%, not a very significant difference. Most jars are undecorated. When decoration appears it is usually in red slip (Fig. 7.36: 6–7; 7.37: 5–7; 7.38: 2–4, 8), incised decoration is rare (Figs. 7.30: 14; 7.37: 3).

*F4 – Various jars* (39 items, 1.5%)
This category includes jars that do not belong to any of the previous groups. The majority of the vessels in this category consist of very large items, perhaps a type of closed pithos (Figs. 7.38: 11; 7.39: 1–5). These jars usually have very short, straight necks. Similar items have been reported at other Neolithic sites: Munhata (Garfinkel 1992a, Figs. 74: 14–17; 77: 5–6, 9; 78: 1–10), Abu Thawwab (Obeidat 1995, Fig. 44: 19, and note the pithos decorated with incised herring-bone band in Fig. 62: 30), 'Ain Ghazal (Kafafi 1990, Fig. 4: 4), Pottery Neolithic A Jericho (Kenyon and Holland 1982, Figs. 9: 14, 10: 23–24, 19: 9; 1983, Fig. 37: 26) and Ghrubba (Mellaart 1956, Fig. 4: 48–49).

## V. ADDITIONAL TYPOLOGICAL FEATURES

In the earlier part of the article we dealt mostly with the rims, which represent the upper part of the vessels. In order to complete the typological analysis of the Yarmukian pottery from Sha'ar Hagolan, further information is given here concerning the handles, bases and the decorated sherds.

**Handles** (574 items, 2% of all sherds)
The handles were divided into four main groups:

*1. Loop handles* (378 items, 65.9%). This is the most prevalent type of handle at Sha'ar Hagolan. Loop handles are in most cases rounded and horizontal; vertical loop handles are infrequent. In rare cases on jars of Sha'ar Hagolan type (all sizes) triangle loop handles appear which create almost a right angle between the lower part of the neck and shoulder. Sometimes the loop handles are very flat and oval in section, like a band handle (Fig. 7.30: 9), in one case the groove appeared in the middle of the handle (Fig. 7.40: 17).

*2. Lug handles* (176 items, 31%). This group includes items in different sizes: from very short and rounded handles, that are sometimes designated as "knob" handles in the literature (Fig. 7.25: 5), to big, flat, rectangular handles that remain ledge handles (Fig. 7.33: 1). The typical lug is medium sized, straight or bent upward (see, for example, Figs. 7.25: 1, 3; 7.35: 1–3). In rare cases, cylindrical lug handles appear.

*3. Pierced handles* (21 items, 3.7%). Pierced handles are flat lug handles pierced in the middle (Fig. 7.40: 19). This type of handle appears mostly on small and medium-size vessels. Pierced handles are not made to be hand-held; a rope was probably threaded through the hole.

*4. Tubular handle*. One such item has been reported from the site surface. This type of handle has been reported from Munhata (Garfinkel 1992a, Fig. 84: 8) and Pottery Neolithic A Jericho (Kenyon and Holland 1983, Fig. 5: 10).

**Bases** (981 items, 3% of all sherds)
In most cases the bases are small relative to the diameter of the body and the angle between the base and walls of the vessel is always more than 90°. All bases are divided into seven main groups:

*1. Flat bases* (608 items, 62%). The most prevalent base type in the assemblage and in most Neolithic assemblages is a flat base (Figs. 7.31: 11–13; 7.40: 1; 7.42: 26).

*2. Disk bases* (285 items, 29%). This is the second most common base type (Figs. 7.27: 7–8; 7.40: 3–9; 7.43: 8).

*3. Chalice base* (9 items, 0.9%) (Figs. 7: 20: 20; 7.21: 5–6). One of the problems with recognition of chalice base—perhaps in some cases when the sherd was too small and doesn't have the connection to the body—is that it is impossible to distinguish between the lower part of a chalice base and bowl or chalice rim. This fact can probably explain the big difference between the number of chalice rims and bases.

*4. Convex base* (23 items, 2.3%) (Figs. 7.16: 1; 7.17: 13; 7.30: 4).

*5. Ring base* (33 items, 3.4%) (Figs. 7.30: 5; 7.40: 10–12).

*6. Base with mat impression* (14 items, 1.4%). Mats are in most cases rounded (Figs. 7.40: 16; 7.43: 9–10), but in few cases, there were mats of other shapes (elongate or square, Fig. 7.40: 14–15).

*7. Rounded base* (10 items, 1%) (Figs. 7.27: 6; 7.40: 2).

ANNA EIRIKH-ROSE AND YOSEF GARFINKEL

TABLE 7.2. Frequencies of different typological forms

| Unit | HANDLES | Loop H. | Lug H. | Pierced H. | BASES | Flat B. | Disk B. | Chalice B. | Convex B. | Ring B. | Mat B. | Rounded B. |
|---|---|---|---|---|---|---|---|---|---|---|---|---|
| IA | 52 | 32 | 18 | 2 | 92 | 56 | 25 | 2 | 4 | 2 | 3 | |
| IA-C | | | | | 1 | | | | | | | |
| IB | 3 | 1 | 1 | 1 | 8 | 5 | 2 | | 1 | | | |
| IC | 8 | 5 | 1 | 2 | 6 | 4 | 2 | | | | | |
| ID | 4 | 3 | 2 | | 11 | 8 | 1 | 1 | | 1 | | |
| ID-I | | | | | | | | | | | | |
| IE | 9 | 4 | 4 | 1 | 21 | 12 | 5 | | | 2 | 2 | |
| IF | 3 | 1 | 2 | | 8 | 6 | 2 | | | | | |
| IF-G | | | | | | | | | | | | |
| IG | | | | | 5 | 4 | 1 | | | | | |
| IG-H | 1 | 1 | | | | | | | | | | |
| IH | 2 | 2 | | | 4 | 2 | 2 | | | | | |
| Ii | | | | | | | | | | | | |
| IIA | 233 | 151 | 74 | 8 | 394 | 212 | 142 | 3 | 12 | 14 | 7 | 5 |
| IIA-F | | | | | | | | | | | | |
| IIA-J | | | | | 1 | | | | 1 | | | |
| IIB | 12 | 11 | 1 | | 13 | 9 | 4 | | | | | |
| IIC | 7 | 5 | 2 | | 19 | 15 | 3 | | | | 1 | |
| IIC-F | | | | | | | | | | | | |
| IID | 6 | 5 | 1 | | 6 | 4 | 2 | | | | | |
| IIE | 1 | | 1 | | | | | | | | | |
| IIE-I | 1 | 1 | | | | | | | | | | |
| IIF | 6 | 6 | | | 5 | 3 | 1 | | 1 | | | |
| IIG | 1 | 1 | | | 6 | 6 | | 1 | | | | |
| IIG-E | 1 | 1 | | | 1 | | 1 | | | | | |
| IIG-I | 4 | 2 | 2 | | 5 | 1 | 3 | | | 1 | | |
| IIH | 5 | 2 | 2 | 1 | 7 | 2 | 5 | | | | | |
| IIH-G | | | | | | | | | | | | |
| IIH-I | | | | | 2 | 1 | | | | | | 1 |
| II.I | 5 | 3 | 2 | | 9 | 7 | 1 | | 1 | | | |
| IIJ | 32 | 19 | 13 | | 47 | 33 | 11 | | | 2 | | 1 |
| IIJ+I | 1 | 1 | | | 9 | 6 | 3 | | | | | |
| IIJ-E | 1 | 1 | | | | | | | | | | |
| IIJ-I | | | | | 3 | 2 | | | 1 | | | |
| IIK | 4 | 2 | 1 | 1 | 4 | 2 | 2 | | | | | |
| IIL | 4 | 2 | 1 | 1 | | | | | | | | |
| IIL-K | | | | | 2 | 2 | | | | | | |
| IIM | 11 | 8 | 3 | | 17 | 11 | 6 | | | | | |
| IIM-L | 1 | 1 | | | 3 | 1 | 2 | | | | | |
| IIN | 3 | 2 | 1 | | 5 | 3 | 1 | | | | | 1 |
| IIIA | 5 | 3 | 2 | | 5 | 5 | | | | | | |
| IIIA-B | | | | | 3 | 3 | | | | | | |
| IIIB | 4 | 3 | 1 | | 3 | 2 | 1 | | | | | |
| 8 | 5 | 5 | | | 4 | 3 | 1 | | | | | |
| 41 | | | | | 1 | 1 | | | | | | |
| 52 | 8 | 3 | 5 | | 12 | 7 | 3 | | | 2 | | |
| 61 | 1 | | 1 | | 2 | 2 | | | | | | |
| 83 | 40 | 25 | 12 | 3 | 67 | 51 | 13 | 1 | | 1 | 1 | |
| 109 | 2 | 1 | 1 | | 3 | 2 | 1 | | | | | |
| 204 | 1 | | 1 | | 2 | 2 | | | | | | |
| 289 | 17 | 13 | 4 | | 32 | 19 | 11 | | | 2 | | |
| 294 | 14 | 12 | 2 | | 17 | 14 | 2 | | | 1 | | |
| 295 | | | | | 2 | 1 | 1 | | | | | |
| 308 | | | | | 2 | 1 | 1 | | | | | |
| 323 | 13 | 9 | 4 | | 26 | 17 | 3 | | 2 | 3 | | 1 |
| 339 | 11 | 8 | 2 | 1 | 32 | 27 | 4 | | 1 | | | |
| 351 | 6 | 5 | 1 | | 12 | 7 | 5 | | | | | |
| 353 | 3 | 2 | 1 | | 2 | 2 | | | | | | |
| 357 | | | | | 2 | 1 | | | | | | 1 |
| 362 | | | | | 2 | 1 | 1 | | | | | |
| 370 | 1 | 1 | | | 3 | 3 | | | | | | |
| 371 | 6 | 4 | 2 | | 4 | 2 | 1 | 1 | | | | |
| 380 | | | | | 1 | | 1 | | | | | |
| 409 | 3 | 2 | 1 | | 4 | 3 | 1 | | | | | |
| 410 | | | | | 1 | 1 | | | | | | |
| 410,418 | 4 | 4 | | | 8 | 3 | 5 | | | | | |
| 410-424 | | | | | 2 | 1 | 1 | | | | | |
| 414 | | | | | 1 | | 1 | | | | | |
| 418 | 2 | | 2 | | 1 | 1 | | | | | | |
| 420 | | | | | 1 | 1 | | | | | | |
| 424 | 1 | 1 | | | 1 | 1 | | | | | | |
| F | 6 | 4 | 2 | | 9 | 7 | 1 | | | 1 | | |
| Total | 574 | 378 | 176 | 21 | 981 | 608 | 285 | 9 | 23 | 33 | 14 | 10 |
| % | 100.2% | 65.9% | 31% | 3.7% | 100% | 62.0% | 29% | 0.9% | 2.3% | 3.4% | 1.4% | 1.0% |

***Decorations*** (7,191 items, 21% of all sherds)

The pottery assemblage at Sha'ar Hagolan includes both decorated and undecorated sherds. Out of 34,232 sherds, 7,191 (21%) are decorated. We distinguish eight different kinds of decoration in this assemblage (Table 7.4):

*1. Red slip* (4,161 sherds, 57.9%). Red slip covering an entire sherd can be found on one or both sides of the sherd.

*2. Burnishing* (121 sherds, 1.7%). This treatment appears mostly on red-slipped sherds, in very few cases without slip. Sometimes burnishing does not cover the entire surface, as in Fig. 7.19: 3 where one line near the rim is burnished. Burnishing also sometimes appears with another kind of decoration, such as red line painting (with only the red lines burnished) or incision (in these cases it was catalogued according to its main style). On few sherds recovered at Sha'ar Hagolan appeared Jericho IX pottery design—white or light brownish slip with thin red burnished lines on it.

*3. Wide painted lines* (578 sherds, 8%). This category consists of red lines wider than 0.5 cm. All kinds of lines (wide and thin) are arranged in horizontal and zigzag bands in the same style as Sha'ar Hagolan decoration (Figs. 7.11; 7.18: 12–16; 7.24: 8–9, 11, 13; 7.42: 22–24, 26).

FIG. 7.11. A painted sherd, wide lines

*4. Thin painted lines.* (139 sherds, 1.9%). This category consists of red lines thinner than 0.5 cm. (Figs. 7.16: 1, 13–16; 7.24: 6–7, 10, 12; 7.42: 20–21).

*5. Herring-bone incision* (1,493 sherds, 20.8%). Incisions appear in bands of horizontal and zigzag lines, sometimes combined with red slip and all kinds of painting, and create the so-called "Sha'ar Hagolan decoration" (Fig. 7.16: 6–12; 7.17: 15–24; 7.31; 7.32: 1–2, 5–9; 7.41: 5, 7–8). The Munhata report presents a detailed chart of the various combinations (Garfinkel 1992a, Fig. 22; 1999, Fig. 41). The decorative techniques were executed in the following order:

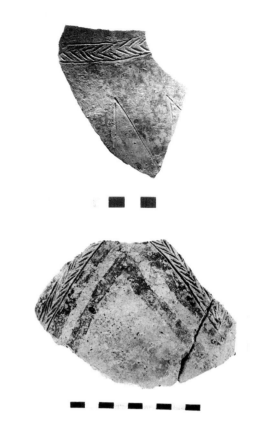

FIG. 7.12. Sherds with the typical incised herring-bone pattern

1. Incision of parallel horizontal lines (around the neck of jars and close to the rim of bowls) forming a frame.
2. Incision of parallel zigzag lines beneath the two horizontal lines along the perimeter of the vessel, forming a frame.
3. Filling of the frames with short incisions of herring-bone pattern. One can distinguish that the lines of the frame were incised with organic stick (straw?) and the herring-bone with a hard sharp material (flint?).
4. Painting red the area not incised; the incised area remains unpainted.

Herring-bone incisions in general have been reported from various periods and geographical regions of the Levant, such as Wadi Raba, Ghassulian and Golan wares (Garfinkel 1999a, Figs. 90; 172: 4; 177: 6), 'Amuq Plain (Braidwood and Braidwood 1960, Fig. 41, 42) and Sakca Gösü in Southern Turkey (Seton Williams 1948). However, the herring-bone incisions in these examples were not executed according to the two basic characteristics of the Yarmukian pottery: they are not restricted inside an incised frame, and they are not arranged on the vessel in horizontal and zigzag bands.

ANNA EIRIKH-ROSE AND YOSEF GARFINKEL

TABLE 7.4. Frequencies of decoration techniques

| Unit | Decorated | Red Slip | Burnish | Wide Painted L. | Thin Painted L. | Herring-Bone Inc. | Frame Inc. | Other Inc. | Other |
|---|---|---|---|---|---|---|---|---|---|
| IA | 615 | 405 | | 38 | 17 | 99 | 34 | 5 | |
| IA-C | | | | | | | | | |
| IB | 26 | 16 | 1 | 1 | 1 | 1 | 4 | 2 | |
| IC | 88 | 46 | | 10 | 2 | 16 | 14 | | |
| ID | 38 | 30 | | | | 6 | | | 1 |
| ID-I | 9 | 4 | | 1 | 1 | 1 | | 2 | |
| IE | 97 | 65 | | 5 | 2 | 16 | 4 | 2 | 3 |
| IF | 40 | 29 | | 1 | 1 | 6 | 2 | 1 | |
| IF-G | 1 | 1 | | | | | | | |
| IG | 9 | 5 | | 2 | 1 | 1 | | | |
| IG-H | 1 | | | | | | 1 | | |
| IH | 28 | 14 | | | | 10 | 3 | 1 | |
| Ii | | | | | | | | | |
| IIA | 3192 | 1760 | 67 | 279 | 53 | 706 | 266 | 53 | 12 |
| IIA-F | 4 | 2 | | 2 | | | | | |
| IIA-J | 9 | 8 | | | | 1 | | | |
| IIB | 167 | 96 | 1 | 16 | 5 | 46 | 6 | | 1 |
| IIC | 34 | 21 | | 2 | 5 | 3 | 2 | 1 | |
| IIC-F | | | | | | | | | |
| IID | 27 | 17 | | 1 | 1 | 7 | 1 | | |
| IIE | 1 | | 1 | | | | | | |
| IIE-I | | | | | | | | | |
| IIF | 84 | 51 | | 8 | 1 | 15 | 8 | 1 | |
| IIG | 32 | 18 | 3 | 8 | 1 | 1 | | 1 | |
| IIG-E | 6 | 3 | | | | 3 | | | |
| IIG-I | 30 | 21 | | 1 | | 4 | 3 | 1 | |
| IIH | 21 | 13 | 1 | 2 | | 3 | 2 | | |
| IIH-G | | | | | | | | | |
| IIH-I | 5 | 3 | | 1 | | 1 | | | |
| II.I | 18 | 15 | | 2 | | | | | 1 |
| IIJ | 280 | 168 | 14 | 33 | 6 | 43 | 16 | 4 | 1 |
| IIJ+I | 35 | 22 | | 2 | 1 | 7 | 2 | 1 | |
| IIJ-E | | | | | | | | | |
| IIJ-I | 7 | 4 | | 1 | | 2 | | | |
| IIK | 18 | 9 | | 2 | | 5 | 2 | | |
| IIL | 21 | 12 | | 4 | | 3 | 2 | | |
| IIL-K | 9 | 7 | | | | 2 | | | |
| IIM | 252 | 141 | 1 | 16 | 2 | 63 | 28 | 1 | |
| IIM-L | 37 | 17 | 7 | 2 | 1 | 5 | 4 | 1 | |
| IIN | 56 | 26 | 2 | 7 | | 11 | 8 | 1 | 1 |
| IIIA | 21 | 15 | | | | 3 | 1 | | 2 |
| IIIA-B | 24 | 18 | | | | 2 | 3 | 1 | |
| IIIB | 22 | 17 | | 3 | 1 | | 1 | | |
| 8 | 46 | 19 | 1 | 6 | | 13 | 7 | | 1 |
| 41 | 8 | 5 | | | | 1 | | 1 | 1 |
| 52 | 83 | 49 | | 6 | 3 | 13 | 8 | 3 | |
| 61 | 1 | | | 1 | | | | | |
| 83 | 267 | 157 | | 12 | 6 | 69 | 16 | 6 | 1 |
| 109 | 31 | 19 | | 4 | 1 | 4 | 2 | 1 | |
| 204 | 9 | 3 | | 1 | 1 | 1 | 3 | | |
| 289 | 162 | 114 | | 6 | | 33 | 7 | 1 | 1 |
| 294 | 179 | 96 | 6 | 7 | 5 | 40 | 24 | 1 | |
| 295 | 8 | 6 | | | | | 2 | | |
| 308 | 42 | 31 | | 2 | | 6 | 2 | 1 | |
| 323 | 200 | 121 | 3 | 12 | 7 | 41 | 10 | 5 | 1 |
| 339 | 266 | 120 | 8 | 26 | 3 | 83 | 24 | 2 | 1 |
| 351 | 124 | 92 | 2 | 6 | | 23 | 1 | | |
| 353 | 30 | 17 | | | | 7 | 6 | | |
| 357 | 8 | 8 | | | | | | | |
| 362 | 15 | 12 | | 1 | | | 1 | 1 | |
| 370 | 7 | 6 | | | | | 1 | | |
| 371 | 54 | 31 | | 7 | 2 | 9 | 4 | | 1 |
| 380 | 1 | | | | | | 1 | | |
| 409 | 29 | 13 | | 4 | 1 | 8 | 3 | 1 | |
| 410 | 17 | 12 | | | 1 | 3 | 1 | | |
| 410,418 | 137 | 79 | | 18 | 4 | 23 | 9 | 3 | 1 |
| 410-424 | 6 | 5 | | | | 1 | | | |
| 414 | 11 | 6 | | 1 | | 2 | 2 | | |
| 418 | 24 | 7 | 2 | 2 | 2 | 10 | 1 | | |
| 420 | 3 | 2 | | | | 1 | | | |
| 424 | 25 | 12 | | | | 10 | 5 | | |
| F | 34 | 20 | 1 | 6 | 1 | | | 6 | |
| Total | 7191 | 4161 | 121 | 578 | 139 | 1493 | 557 | 111 | 30 |
| % | 100% | 57.9% | 1.7% | 8.0% | 1.9% | 20.8% | 7.7% | 1.5% | 0.4% |

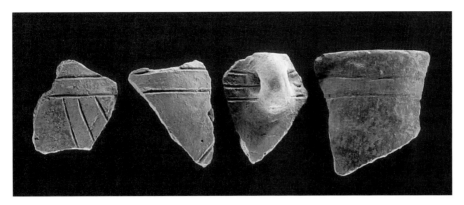

FIG. 7.13. Sherds decorated with frame incisions (Fig. 7.41: 3)

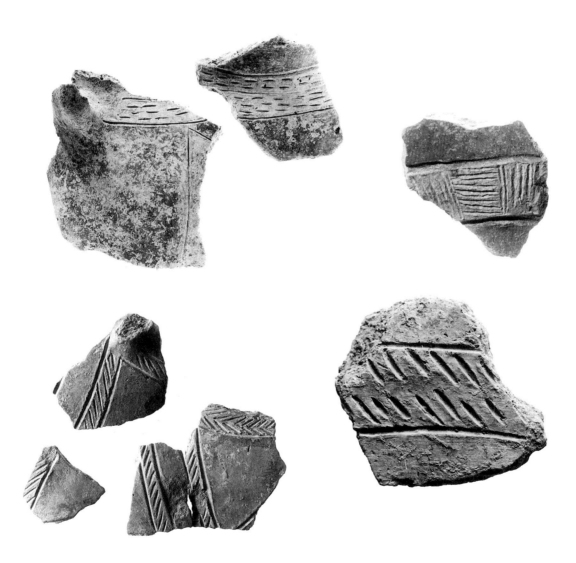

FIG. 7.14. A group of sherds decorated with incised patterns other than herring-bone (Fig. 7.41: 10–11)

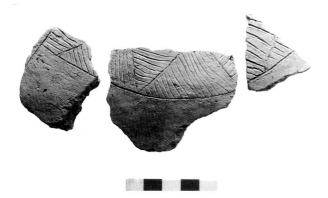

FIG. 7.15. Incised sherds (Fig. 7.41: 14–16)

TABLE 7.5. Distribution of scraped sherds in the excavated area

| Unit | Total | Scraped sherds | % of Total | % of the scraped sherds |
|---|---|---|---|---|
| IIA | 13160 | 54 | 0.4% | 56.3% |
| IIG-E | 40 | 2 | 5.0% | 2.1% |
| IIJ | 1355 | 4 | 0.3% | 4.2% |
| IIJ+I | 185 | 3 | 1.6% | 3.1% |
| 289 | 799 | 4 | 0.5% | 4.2% |
| 294 | 624 | 2 | 0.3% | 2.1% |
| 323 | 837 | 8 | 1.0% | 8.3% |
| 339 | 940 | 6 | 0.6% | 6.3% |
| 351 | 597 | 5 | 0.8% | 5.2% |
| 362 | 127 | 2 | 1.6% | 2.1% |
| 409 | 130 | 2 | 1.5% | 2.1% |
| 424 | 66 | 3 | 4.5% | 3.1% |
| Total | 33158 | 96 | 0.3% | 100% |

*6. Frame incision* (557 sherds, 7.7%). These items include incision of parallel horizontal and zigzag lines forming a frame in the same style as described above (Fig 7.7; 7.13; 7.41: 1–4; 7.42: 18–19). However, the classical herring-bone incisions were not filled in, and it seems as if the potter stopped at the middle of the work. On one sherd, the frame was only half filled with a herring-bone incision.

*7. Other incisions.* (111 sherds, 1.5%). This group included straight or diagonal lines enclosed by a frame (Figs. 7.14: 1, 3; 7.41: 6, 9–12; 7.42: 5, 11–13, 16, 17); herring-bone incision without frame (Fig. 7.42: 3, 6, 7); square incision in frame (Fig. 7.14: 2; 7.42: 14–15); parallel lines (Figs. 7.41: 17; 7.42: 9); chevrons full of parallel lines (Figs. 7.15; 7.41: 14–16; 7.42: 10) and single zigzag lines (Fig. 7.43: 2). Most of those incisions are variations of the general style of herring-bone or frame incision. Almost all these decorations have parallels at other Neolithic sites.

*8. Other decorations* (30 sherds, 0.4%). This group included plastic decoration (Fig. 7.43: 1), and lunar-shaped (thumb-nail) impression. These kinds of decoration are also relatively rare in other Yarmukian sites.

## VI. RECYCLING POTTERY

A very interesting phenomenon observed at Sha'ar Hagolan was scraped pottery sherds. Sometimes sherds of broken vessels were scraped on the side to obtain a desired shape or until the edges were smooth. It is clear that all the scraping was done after the vessel was fired. This phenomenon is relatively widespread in absolute numbers: 96 scraped sherds (Table 7.5). There are quite a few consistent shapes and we have divided all the scraped sherds into several groups.

*1. Scraped bases.* The lower part of a vessel was scraped all over, at the same distance from the base (Fig. 7.43: 8).

Mostly disc-bases were chosen. What we can see here is probably the reusing of a broken vessel by turning it into another vessel – a plate or a lid. The interpretation of these scraped bases as lids seems more likely since mainly disk bases were chosen, which are most suitable for holding in the hand. Also, in one case we recovered a large-sized scraped sherd with a handle in the middle, more appropriate for a lid than a shallow bowl.

*2. Geometric-shape sherds* (Fig. 7.43: 3–6). Small or medium sherds scraped on the sides and modified into various geometric shapes, for example:

1. Triangle. Sometimes the item is pointed with three corners (Fig. 7.43: 6).
2. Oval. The sherd is broken but the general shape seems to be oval (Fig. 7.43: 5).
3. Elongated hexagon (Fig. 7.43: 4).
4. Round. This form is very popular at Neolithic sites and is known as a "disk". We decided to include disks with the other geometric sherds as they correlate in size and shape.

Only the disk shape was recognized in previous studies of Neolithic assemblages (Garfinkel 1992a, Fig. 85: 1–13; Kenyon and Holland 1983, Figs. 40: 5, 215: 11–12). It is hard to establish the purpose of these items and a few theories have been proposed over the years. Kaplan regarded them as patches to repair pottery cracks (1969). However for such repairs it is not necessary to use scraped sherds in geometric shapes. Another proposal interpreted them as jar stoppers, but many of them are smaller than the jar neck and could not have been utilized as stoppers (Garfinkel 1992a).

The forms of this group of scraped sherds are comparable to clay tokens that appeared during this period in various parts of the Near East (Schmandt-Besserat 1992, 1994). But the method of manufacture is very different, as the tokens were made in these shapes from wet clay

and fired. The comparison of scraped sherds (disks) with tokens was also suggested by Orelle (Orelle 1993), but she mostly refers to perforated disks (also found at Sha'ar Hagolan and at other Yarmukian sites, at Munhata, for example (Garfinkel 1992). The geometric scraped sherds may have been used in some kind of game or in some sort of accounting activity.

*3. Unformed scraped sherds.* This category includes sherds with one or several scraped sides, which don't have any recognizable form. Part of those sherds could be broken pieces of scraped sherds from the above category; two scraped bowl rim sherds (Fig. 7.19: 12–13) may be included in this category. The use of this type of scraped sherds remains unclear, perhaps they were utilized as some kind of tool.

Pottery recycling phenomena have been observed at Franchthi cave (Vitteli 1993); there the pottery sherds were smoothed or even retouched. The sherds found there are in geometric shapes (disk, rectangular, triangular or diamond-shaped) or uniformed scraped; mostly sherds from the walls of cups or bowls were selected for use (Vitteli 1993, Plate 4).

The distribution of the scraped sherds is of interest, as most of them came from the courtyard of Building II (Table 7.5). Another concentration, smaller in size, was found in Room 323. It is possible that some specific activity was carried out in these two locations. Further analysis is needed to evaluate the spatial distribution of the scraped sherds at Sha'ar Hagolan.

## VII. Vessel Function

The vessels, according to their shape and size, could have served the inhabitants of the site for a large number of functions which are related to different kinds of activities. Establishing the function of each type of vessel should lead to ideas concerning the function of the site, or different parts of the site. However, it is very difficult to know the exact function of a vessel that was used 8,000 years ago. Our function assignation is possible by comparing ancient vessels with ethnographic analogies and by analogy to pots in a modern kitchen. Obviously, all functional assignment needs to be considered cautiously. It is acceptable to divide all functional diversity into a few groups: vessels that are used for storage, food processing (with heat and without), transporting and serving (Rice 1987, Table 72). It is also necessary to consider that some types of vessels can be put into more than one category and that there are groups of vessel that are difficult to place in any category. But in general the Sha'ar Hagolan pottery assemblage can be functionally divided according to Rice's categories:

*1. Storage.* Two kinds of storage vessels can be discerned:

A  Long-term storage of grain – for this purpose large and heavy vessels with a large volume and relatively open shape will be suitable – pithoi from both groups (E4a and E4b).

B  Liquid storage – jars with small openings relative to the body are suitable for this purpose. Probably, for large amounts of liquid, the big pithos jars (F4) were used, while for smaller amounts the jars in categories F2 and F3 were suitable.

*2. Hot and cold food processing.* One of the important advantages of pottery is the resistance to thermal stresses that enables open-hearth cooking. Soot was frequently found on the lower body of two types, the Krater (E1) and the holemouth jar (F1). The large shallow basins can serve in cold food preparation.

*3. Serving.* For this purpose, bowls and medium-size jars with carefully executed decorations are very suitable, in addition to similar undecorated items.

*4. Valuable materials preparation.* Small and miniature vessels, such as miniature bowls (A1), small and miniature vessels, can be used for the preparation or storage of valuable commodities (cosmetics, spices or medicine). On the other hand, these small, and especially miniature, vessels can be used together with chalices for votive (cultic) functions.

The frequencies of the various types reflect the activities carried out in the Neolithic village. Thus, it is necessary to measure the proportion of the vessels according to function. The grain storage vessels constitute 5.7% of the assemblage. The jars for liquid storage are 16.3 %; the food preparation vessels 30.4%; serving vessels 40.2%; 4.4% of the vessels were used for spices/cosmetics; and chalices (2%), were probably for serving or for some kind of votive function.

These proportions mean that most of the vessels (more than 60%) are used for food preparation and serving, mostly serving, another large part for storage and a smaller proportion served other functions. This is a normal proportion for family household needs. The abundance of serving vessels, especially carefully decorated ones, is typical of early pottery society and may have social, ethnic or other implications (Rice 1999). Because a wide range of vessel types are found in each building at Sha'ar Hagolan, all functions were apparently concentrated in the framework of each habitation unit, as would be expected.

## VIII. Comparative Discussion

For a better understanding of the Sha'ar Hagolan assemblage and its place within the Neolithic framework, it is necessary to compare the present data with pottery assemblages from other Yarmukian sites. Detailed typological comparison has only been carried out with the site of Munhata (Garfinkel 1992a) and both assemblages were analyzed in the same typological framework. In other cases, when data was fully or partly available, the comparison was between groups of vessels.

Sha'ar Hagolan and Munhata assemblages have very similar vessel frequencies and most of the types appear in the same proportions (Table 7.6). However, there are a few differences between the assemblages. Some types that appear at Munhata were not found at Sha'ar Hagolan, and vice versa. This is apparently due to site variability and is the case in every period at most sites (especially when pottery was hand-made in household production). In any case, the proportion of these vessels in each assemblage is very low. Types A3 and C3, which are absent at Sha'ar Hagolan, represent 0.4% and 1.3 % at Munhata. Similarly, types B3 and D3 which are absent at Munhata, comprise 1.1% and 0.2% at Sha'ar Hagolan. The other difference probably reflects the activities carried out at the sites. At Sha'ar Hagolan there is a larger percentage of tableware vessels (B2, B3 and C2), while at Munhata there are more vessels for storage and preparation (E4 and E3). These differences are spatial or functional rather than chronological, perhaps attesting to status differences between inhabitants of the sites.

Similar differences can be observed between different zones in the same site, for example, the differences at Sha'ar Hagolan between Building Complexes I and II (Table 7.7). In Building Complex I the decorated bowls constitute 17.7% of the assemblage and in Complex II they rise to 29.7%. On the other hand, in Complex I the pithoi constitute 10.1% of the assemblage while they decrease to 5% in Complex II. The proportion of types in Complex I are closer to those at Munhata and are very different from those in Complex II.

The comparison with other sites is quite a complicated task because a different typological framework was used for each assemblage. We can point to similarities or dissimilarities in the proportions of some vessel types, such as bowls or jars. At Abu Thawwab small bowls appeared in a much larger proportion (7.59%) than at Sha'ar Hagolan where they constituted only 2.2% (Obeidat 1995: 37, only some frequencies are given). The same is true of chalices – 3.59% in contrast to 2% at Sha'ar Hagolan. The category of large bowls is quite similar at both sites, 36.71% at Abu Tawwab (Type AanA6, the big bowls here are related to the medium size bowls of Sha'ar Hagolan) and 35.6% at Sha'ar Hagolan. Kraters appeared at Abu Thawwab in greater quantity and it would seem from the publication that there were many more decorated kraters than at Sha'ar Hagolan. Jars and holemouth jars are more common at Sha'ar Hagolan (41.8%) while at Abu Thawwab they are only 29.54% of the assemblage. Big storage vessels are not a separate category at Abu Thawwab, but appear in various drawings (see, for example, Figs. 31: 1; 32: 23; 44: 19). On a more general level, it seems that the Abu Thawwab assemblage is more

TABLE 7.6. Comparison of the pottery assemblages of Sha'ar Hagolan and Munhata

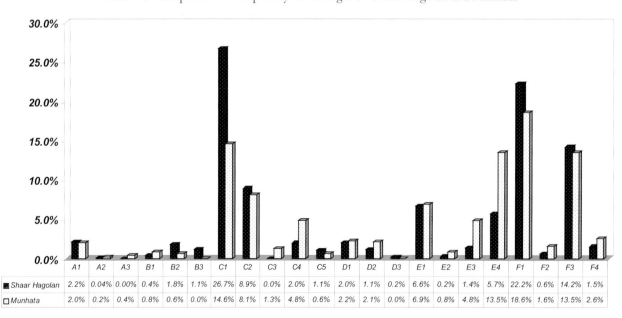

| | A1 | A2 | A3 | B1 | B2 | B3 | C1 | C2 | C3 | C4 | C5 | D1 | D2 | D3 | E1 | E2 | E3 | E4 | F1 | F2 | F3 | F4 |
|---|---|---|---|---|---|---|---|---|---|---|---|---|---|---|---|---|---|---|---|---|---|---|
| Shaar Hagolan | 2.2% | 0.04% | 0.00% | 0.4% | 1.8% | 1.1% | 26.7% | 8.9% | 0.0% | 2.0% | 1.1% | 2.0% | 1.1% | 0.2% | 6.6% | 0.2% | 1.4% | 5.7% | 22.2% | 0.6% | 14.2% | 1.5% |
| Munhata | 2.0% | 0.2% | 0.4% | 0.8% | 0.6% | 0.0% | 14.6% | 8.1% | 1.3% | 4.8% | 0.6% | 2.2% | 2.1% | 0.0% | 6.9% | 0.8% | 4.8% | 13.5% | 18.6% | 1.6% | 13.5% | 2.6% |

TABLE 7.7. Comparison of pottery assemblages in Building Complexes I and II

| Unit | A1 | A2 | B1 | B2 | B3 | C1 | C2 | C4 | C5 | D1 | D2 | D3 | E1 | E2 | E3 | E4a | E4b | F1 | F2 | F3 | F4 |
|---|---|---|---|---|---|---|---|---|---|---|---|---|---|---|---|---|---|---|---|---|---|
| IA | 8 | | 1 | 1 | 1 | 42 | 27 | 6 | 1 | 3 | 6 | | 23 | 1 | 6 | 20 | 9 | 42 | 1 | 31 | 12 |
| IA-C | | | | | | | 1 | | | | | | | | | | | | | | |
| IB | | | | | | 1 | | | | 1 | | | 1 | | | | | 1 | | 1 | |
| IC | 1 | | | | | 8 | 4 | 2 | 1 | 2 | | | 3 | | 1 | | | 2 | | 5 | 1 |
| ID | | | | | 1 | 4 | 2 | | | | | | | | 3 | 5 | 1 | 2 | | 2 | |
| ID-I | | | | 1 | | 1 | 2 | 1 | | 1 | 1 | 1 | 1 | | | | | | | 1 | |
| IE | 3 | | | | | 11 | 5 | | 5 | | | | 5 | | | 1 | 1 | 19 | | 11 | 1 |
| IF | | | | | | 3 | 3 | | | | 2 | | 1 | | 2 | | 1 | 6 | | 5 | 1 |
| IG | | | | | | | 2 | | | | | | | | | | | 4 | | | |
| IH | | | | | | 2 | 1 | | | | | | 2 | | | | | 1 | | 1 | |
| Total | 12 | 0 | 1 | 2 | 2 | 72 | 47 | 9 | 7 | 7 | 9 | 1 | 35 | 1 | 10 | 29 | 12 | 77 | 1 | 57 | 15 |
| % | 3.0% | 0.0% | 0.2% | 0.5% | 0.5% | 17.7% | 11.6% | 2.2% | 1.7% | 1.7% | 2.2% | 0.2% | 8.6% | 0.2% | 2.5% | 7.1% | 3.0% | 19.0% | 0.2% | 14.0% | 3.7% |
| | | | | | | | | | | | | | | | | | | | | | |
| IIA | 26 | 1 | 6 | 24 | 16 | 324 | 76 | 19 | 4 | 21 | 3 | 4 | 72 | 3 | 10 | 41 | 7 | 232 | 4 | 131 | 8 |
| IIA-F | | | | | | 1 | | | | | | | | | | | | | | | |
| IIA-J | | | | | | | | | | | | | | | | | | 3 | | | |
| IIB | | | 1 | 1 | | 27 | 7 | | | 2 | 1 | | | | 1 | 2 | | 9 | | 10 | |
| IIC | | | | | | | 4 | | | | 1 | | 1 | | | 3 | | 6 | | 5 | |
| IIC-F | | | | | | 1 | | | | | | | | | | | | | | | |
| IID | 1 | | 1 | 1 | 2 | 1 | | 1 | | | | | | | | 2 | | 3 | | 1 | |
| IIE | | | | | | | | | | | | | | | | | | 1 | | 1 | |
| IIE-I | | | | | | | | | | | | | | | | | | 1 | | | |
| IIF | | | | | | 9 | 3 | | 1 | | | | | | 1 | 1 | 1 | 10 | | 9 | |
| IIG | 1 | | | | | 3 | 1 | 3 | | 1 | | | | | | 1 | 2 | 3 | | | 1 |
| IIG-E | | | | | | 1 | | | | | | | | | | | | 2 | | | |
| IIG-I | | | | | | 1 | 1 | | | | | | 2 | | | | | 7 | 1 | 4 | |
| IIH | | | | | | 3 | 2 | 1 | | 1 | 1 | | | | | | | 6 | 1 | 3 | |
| IIH-I | | | | | | 1 | | | 1 | | | | | | | | | | | | |
| II.I | | | | | | 1 | 1 | | 1 | 1 | | | | | | | 2 | 6 | | 4 | |
| IIJ | 1 | | | 2 | | 34 | 14 | 1 | 1 | 2 | 1 | | 9 | | 4 | 3 | 5 | 29 | | 20 | 2 |
| IIJ+I | | | | | | 5 | 1 | | | 1 | | | 1 | | | | 1 | 4 | | | |
| IIJ-I | | | | | | | 2 | | | | | | | | | | | 2 | | 1 | |
| IIK | | | | | | 1 | | | | 1 | | | 1 | | | | | 5 | | 1 | 1 |
| IIL | 1 | | 1 | | | 2 | 2 | | | | | | 1 | | | | | 2 | | 4 | 1 |
| IIL-K | | | | | | | | | | 1 | | | | | | | | | | | |
| IIM | 3 | | | 1 | 2 | 16 | | 2 | | 2 | 1 | | 1 | | | 2 | | 7 | | 8 | 3 |
| IIM-L | | | | | | 3 | 3 | | | | | | | | | | | 3 | | 1 | |
| IIN | | | | | | 6 | | | | | | | | | | 1 | | 3 | | 1 | |
| Total | 33 | 1 | 9 | 29 | 20 | 439 | 117 | 28 | 8 | 33 | 8 | 4 | 88 | 3 | 16 | 56 | 18 | 340 | 6 | 208 | 16 |
| % | 2.2% | 0.1% | 0.6% | 2.0% | 1.4% | 29.7% | 7.9% | 1.9% | 0.5% | 2.2% | 0.5% | 0.3% | 5.9% | 0.2% | 1.1% | 3.8% | 1.2% | 23.0% | 0.4% | 14.1% | 1.1% |

elaborate and includes more fine and tableware, resembling Building Complex II at Sha'ar Hagolan.

At 'Ain Ghazal the percentage of jars (including holemouth jars) is enormous in comparison to Sha'ar Hagolan. At 'Ain Ghazal there are 20% medium jars and 52% large jars (recalculated from Kafafi 1990: 15, Tables 15–16) while at Sha'ar Hagolan they constitute 3.3% and 38.5% respectively. At 'Ain Ghazal the proportion of bowls and large open vessels is smaller. It seems that the population of 'Ain Ghazal needed more vessels for liquid storage and food preparation and fewer for serving and other purposes.

The pottery assemblage most closely resembling that at Sha'ar Hagolan is from Munhata. Two basic explanations can be proposed. First, the same typological concept was used in analyzing these assemblages; secondly, the two sites are very close geographically and located within the same ecological environment. The two other Yarmukian sites, Abu Thawwab and 'Ain Ghazal, present a slightly different profile of type frequency. The Abu Thawwab assemblage has more decorated, fine and tableware vessels, while in the 'Ain Ghazal assemblage, jars dominate.

## IX. SUMMARY

In this article we have presented, for the first time, the Neolithic pottery assemblage of Sha'ar Hagolan, which was collected during the first five excavation seasons, 1989–1990 and 1996–1998. The analysis dealt with 34,232 sherds, the largest assemblage collected at any Yarmukian site.

The typological frame for the Yarmukian pottery of Munhata was used for the Sha'ar Hagolan assemblage and 21 types of vessels were recognized (18 characteristic types and three varia). The most widespread type of vessel is the decorated bowl, the holemouth jar and the handleless jar. Miniature and small vessels are relatively rare. The rarest types are the small chalice and deep bowl. The pottery types at Sha'ar Hagolan reflect the diversity of human needs and household activities: food processing and serving are the predominant widespread uses of pottery (ca. 60%).

Some 21% of the sherds at Sha'ar Hagolan are decorated. The most characteristic decoration is incised herring-bone pattern bands, encircling the vessels in horizontal and zigzag lines ("Sha'ar Hagolan decoration"). This popular decoration, usually applied to small- and medium-size vessels, can be considered as a *fossile directeur* for the Yarmukian culture.

An interesting phenomenon in the assemblage is the secondary use of pottery. Few types of scraped sherds

were found, including bases modified into lids and body sherds shaped into geometric pieces. This unique evidence for the reuse of broken pottery vessels in the Neolithic period has never been reported on such a scale before.

The village of Sha'ar Hagolan is the central site of the Yarmukian culture, as it is the largest in size, the richest in art objects and the only one with monumental structures and streets. Thus, the pottery uncovered at Sha'ar Hagolan is the most representative assemblage of the Yarmukian culture. The pottery assemblages from other Yarmukian sites present the same basic material culture tradition, with certain small differences that probably reflect spatial or functional variabilities.

## Acknowledgments
This research was supported by the Israel Science Foundation funded by the Israel Academy of Science and Humanities. The pottery objects were drawn by M. Sarig at the Institute of Archaeology of the Hebrew University of Jerusalem. Photographs are by D. Harris, G. Laron, I. Sztulman and the Israel Antiquities Authority.

## BIBLIOGRAPHY

Bennett, C. 1980. Soundings at Dhra'. *Levant* 12: 30–40.
Bossut, P., Kafafi, Z. and Dollfus, G. 1988. Khirbet ed-Dharih (survey Site 49, WHS 524): un nouveau gisement néolithique avec ceramique du sud-jordanien. *Paléorient* 14: 127–131.
Braidwood, R.J. and Braidwood, L.S. 1960. *Excavations in the Plain of Antioch, Vol. I: The Earlier Assemblages: Phases A–J* (Oriental Institute Publications 61). Chicago: University of Chicago Press.
David, N. 1972. On the Life Span of Pottery, Type Frequencies and Archaeological Inference. *American Antiquity* 37: 141–142.
Dunand, M. 1973. *Fouilles de Byblos* Vol. V. Paris: Maisonneuve.
Egloff, B.J. 1973. A Method for Counting Ceramic Rim Sherds. *American Antiquity* 38: 351–353.
Garfinkel, Y. 1992a. *The Pottery Assemblages of Sha'ar Hagolan and Rabah Stages from Munhata (Israel)* (Cahiers du Centre de Recherche Français de Jérusalem 6). Paris: Association Paléorient.
Garfinkel, Y. 1992b The Material Culture of the Central Jordan Valley in the Pottery Neolithic and Early Chalcolithic Periods. Unpublished Ph.D. dissertation, The Hebrew University, Jerusalem (Hebrew).
Garfinkel, Y. 1993. The Yarmukian Culture in Israel. *Paléorient* 19: 115–134.
Garfinkel, Y. 1999a. *Neolithic and Chalcolithic Pottery of the Southern Levant* (Qedem 39). Jerusalem: Institute of Archaeology, Hebrew University.
Garfinkel, Y. 1999b. Radiometric Dates from Eighth Millen-

nium B.P. Israel. *Bulletin of the American School of Oriental Research* 315: 1–13.

Garstang, J., Droops, J.P. and Crowfoot, J. 1935. Jericho: City and Necropolis (Fifth Report). *Annals of Archaeology and Anthropology* 22: 143–73.

Garstang, J., Ben-Dor, I. and Fitzgerald, G. M. 1936. Jericho: City and Necropolis (Report for Sixth and Concluding Seasons, 1936). *Annals of Archaeology and Anthropology* 23: 77–90.

Gilead, I. and Goren, Y. 1995. The Pottery Assemblages from Grar. In Gilead, I. (ed.) *Grar: A Chalcolithic Site in the Northern Negev* (Beer-Sheva 7), pp. 137–221. Beer-Sheva: Ben-Gurion University Press.

Gopher, A. and Tsuk, T. 1996. *The Nahal Qanah Cave: Earliest Gold in the Southern Levant* (Monograph Series of the Institute of Archaeology 12). Tel Aviv: Tel Aviv University.

Goren, Y. 1991. The Beginning of Pottery Production in Israel. Technology and Typology of Proto-Historic Ceramic Assemblages in Eretz-Israel (6th–4th Millennia B.C.). Unpublished Ph.D. dissertation. The Hebrew University, Jerusalem (Hebrew).

Goren, Y. 1992. Petrographic Study of the Pottery Assemblage from Munhata. In Garfinkel, Y. *The Pottery Assemblages of Sha'ar Hagolan and Rabah Stages from Munhata (Israel)* (Cahiers du Centre de Recherche Français de Jérusalem 6), pp. 329–342. Paris: Association Paléorient.

Kafafi, Z. 1989. Late Neolithic I Pottery from 'Ain er-Rahub, Jordan. *Zeitschrift des Deutschen Palästina Vereins* 105: 1–17.

Kafafi, Z. 1990. Early Pottery Contexts from 'Ain Ghazal, Jordan. *Bulletin of the American School of Oriental Research* 280: 15–30.

Kafafi, Z. 1993. The Yarmoukians in Jordan. *Paléorient* 19: 101–14.

Kafafi, Z. 1995. Decorative Elements on the Excavated Neolithic Pottery at 'Ayn Ghazal. *Studies in the History and Archaeology of Jordan* 5: 545–553.

Kaplan, J. 1954. The Neolithic and Chalcolithic Settlement in Tel Aviv and Neighborhood. Unpublished Ph.D. dissertation, The Hebrew University, Jerusalem (Hebrew).

Kaplan, J. 1957. Excavations at Telulyot Batashi in the Vale of Sorek. *Eretz-Israel* 5: 9–24 (Hebrew).

Kaplan, J. 1977. Neolithic and Chalcolithic Remains at Lod. *Eretz-Israel* 13: 57–75 (Hebrew).

Kenyon, K. and Holland, T. 1982. *Excavation at Jericho*, Vol. IV: *The Pottery Type Series and Other Finds*. London: British School of Archaeology in Jerusalem.

Kenyon, K. and Holland, T. 1983. *Excavation at Jericho*, Vol. V. London: British School of Archaeology in Jerusalem.

Loud, G. 1948. *Megiddo II: Seasons of 1935–39* (Oriental Institute Publications 62). Chicago: University of Chicago Press.

Mellaart, J. 1956. The Neolithic Site of Ghrubba. *Annual of the Department of Antiquities of Jordan* 3: 24–40.

Noy, T. and Roth, Y. 1991. Small Bowls on Legs from the Neolithic Site at Sha'ar Ha-golan. In Heltzer, M., Segal, A. and Kaufman, D. (eds.) *Studies in the Archaeology and History of Ancient Israel*, pp. 43–46. Haifa: Haifa University Press.

Obeidat, D. 1995. *Die neolithische Keramik aus Abu Thawwab, Jordanien* (Studies in Early Near Eastern Production, Subsistence and Environment 2). Berlin: *ex oriente*.

Orrelle, E.1993. Nahal Zehora I and II: Fifth Millennium B.C. Villages of the Wadi Raba Culture. Unpublished M.A. Dissertation. Tel Aviv: Tel Aviv University.

Orton, C., Tyers, P. and Vince, A. 1993. *Pottery in Archaeology*. Cambridge: Cambridge University Press.

Rice, P.M. 1987. *Pottery Analysis a Source Book*. Chicago: University of Chicago Press.

Rice, P.M. 1999. On the Origins of Pottery. *Journal of Archaeological Method and Theory* 6/1: 3–54.

Schmandt-Besserat, D. 1992. *From Counting to Cuneiform*. Austin: University of Texas Press.

Schmandt-Besserat, D. 1994. Tokens, a Prehistoric Archive System. In Ferioli, P. (ed.) *Archives before Writing*, pp. 13–28. Rome: Scriptorium.

Seton Williams, M.V. 1948. Neolithic Burnished Ware in the Near East. *Iraq* 10: 34–50

Shepard, A. 1965. *Ceramics for Archaeologist*. Washington: Carnegie Institution.

Stekelis, M. 1951. A New Neolithic Industry: The Yarmukian of Palestine. *Israel Exploration Journal* 1: 1–19.

Stekelis, M. 1972. *The Yarmukian Culture of the Neolithic Period*. Jerusalem: Magnes Press.

Vittelli, K.D. 1993. *Franchti Neolithic Pottery*. Indianapolis: Indiana University Press.

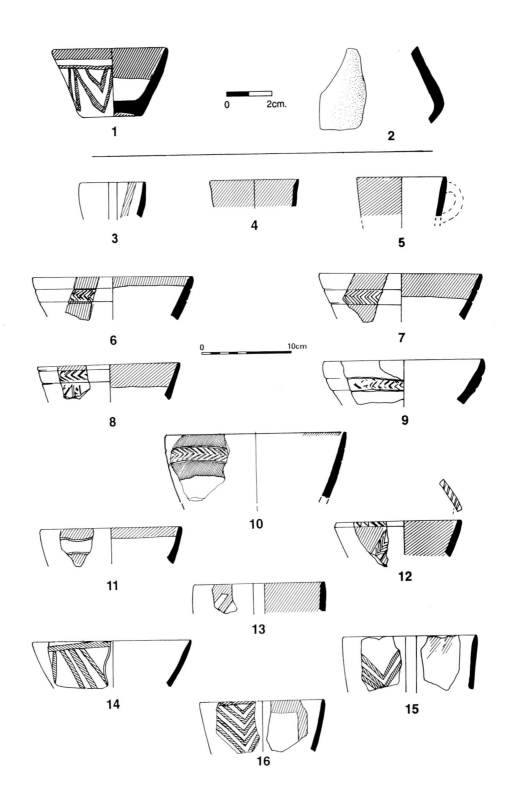

Fɪɢ. 7.16. Neolithic pottery: small open vessels (A1, A3) and decorated bowls (C1). See p. 134 for description.

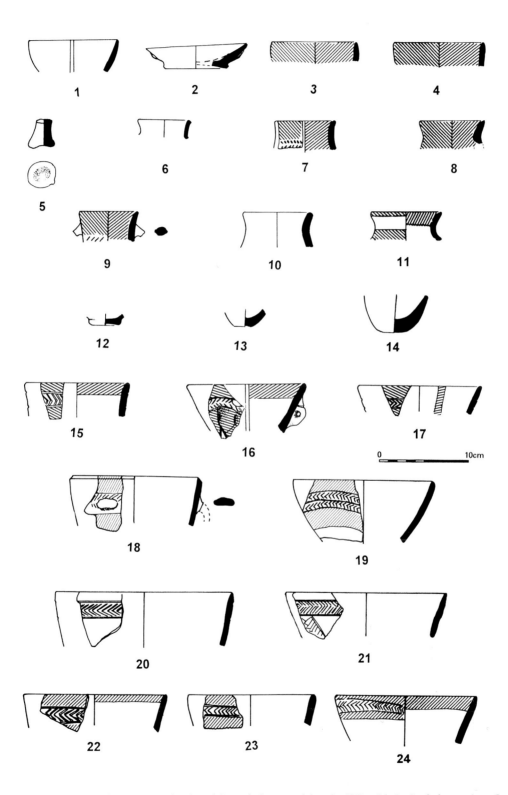

FIG. 7.17. Neolithic pottery: small open vessels (A1, A3) and decorated bowls (C1) with incised decoration. See p. 134 for description.

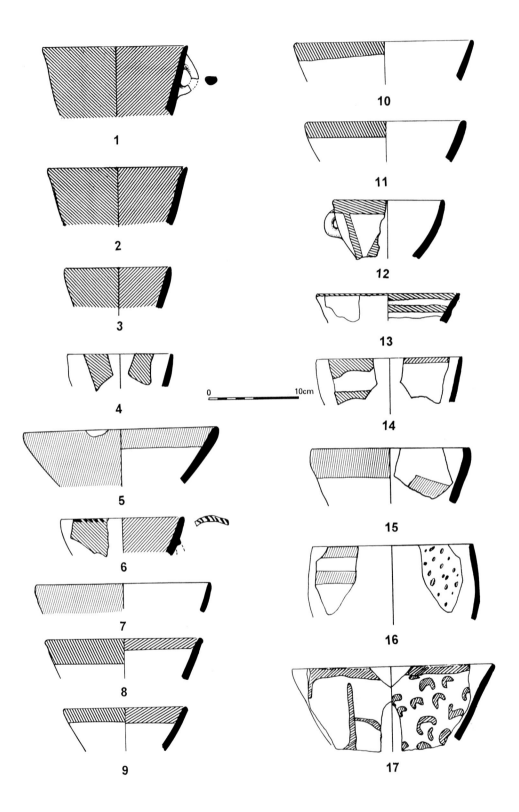

Fig. 7.18. Neolithic pottery: decorated bowls (C1) with paint and slip decoration. See p. 134 for description.

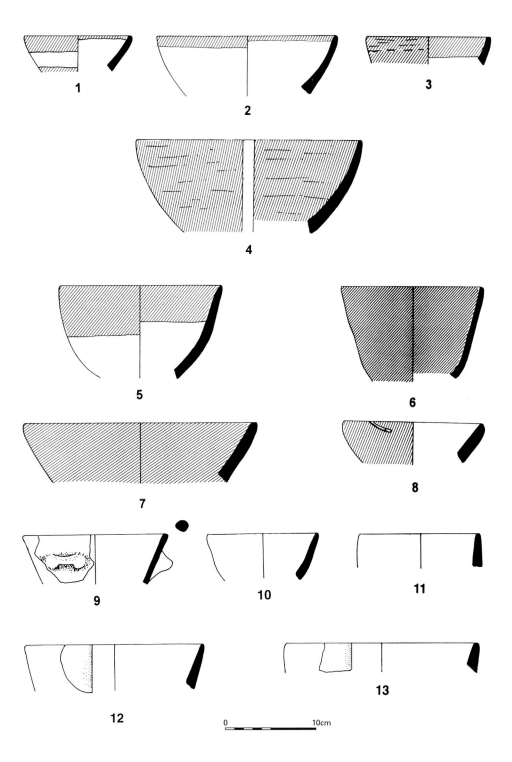

FIG. 7.19. Neolithic pottery: decorated and undecorated bowls (C1, C2). See pp. 134–135 for description.

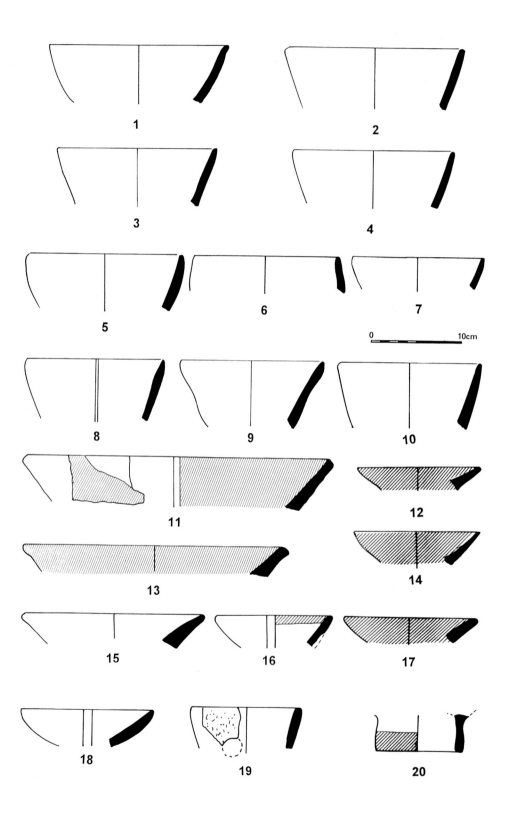

FIG. 7.20. Neolithic pottery: undecorated bowls (C2), chalices (C4) and various bowls (C5). See p. 135 for description.

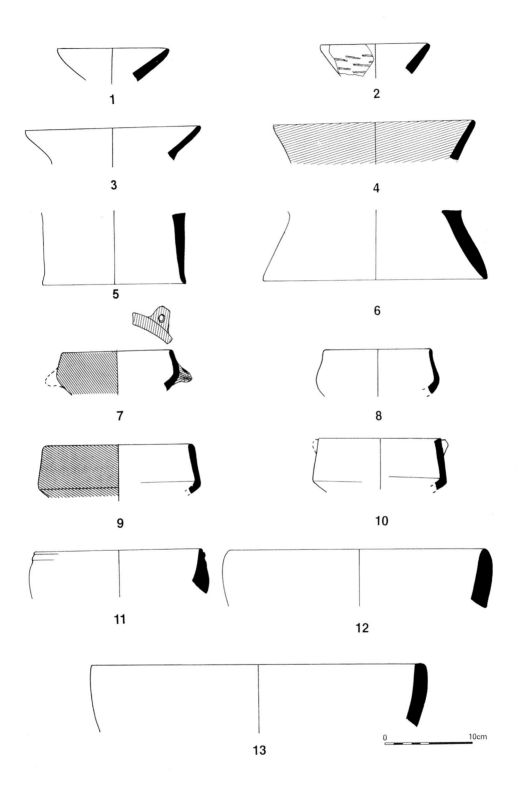

FIG. 7.21. Neolithic pottery: chalices (C4), various bowls (C5) and basins (E3). See p. 135 for description.

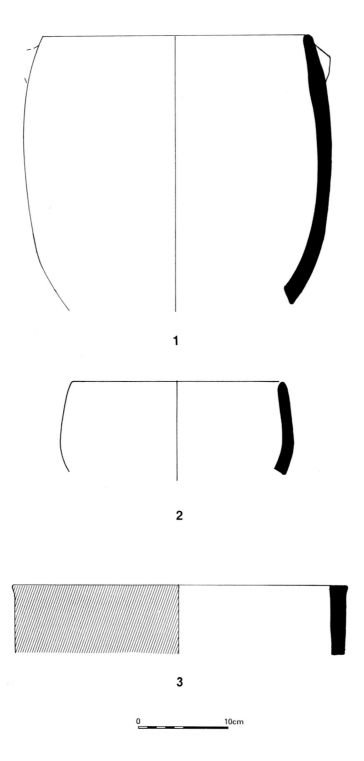

Fig. 7.22. Neolithic pottery: pots (E1) and pithos (E4). See p. 135 for description.

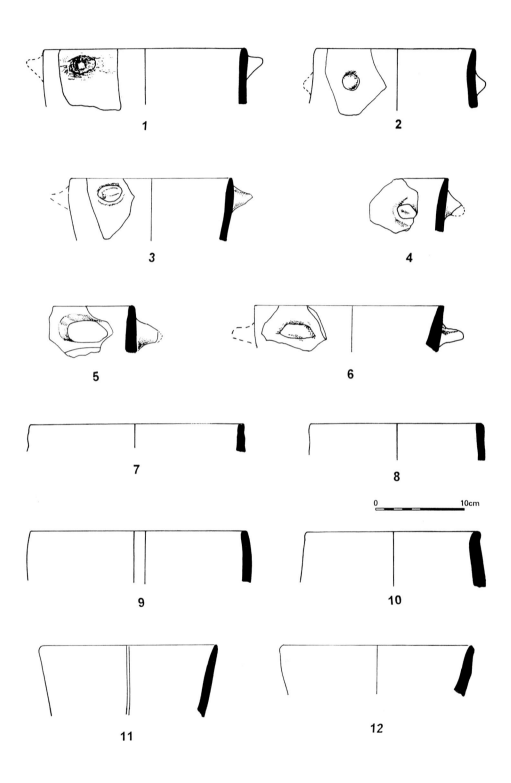

FIG. 7.23. Neolithic pottery: pots (E1). See p. 135 for description.

ANNA EIRIKH-ROSE AND YOSEF GARFINKEL

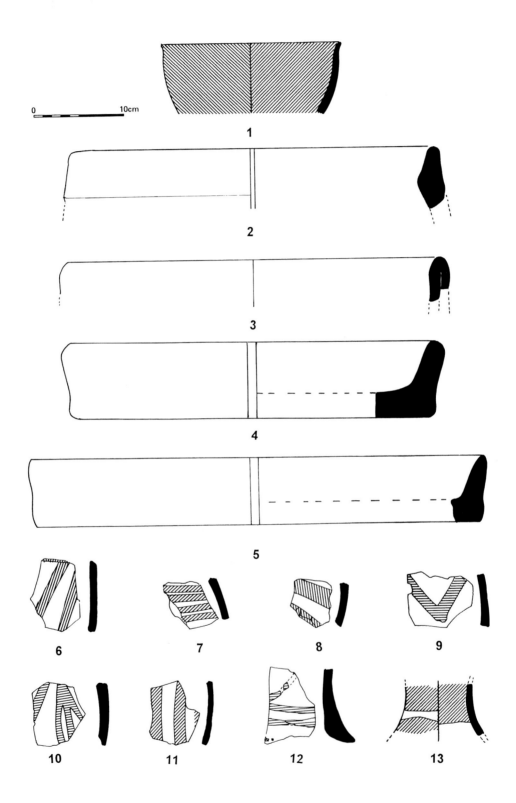

FIG. 7.24. Neolithic pottery: large bowls (E2), basins (E3) and red painted body sherds. See p. 135 for description

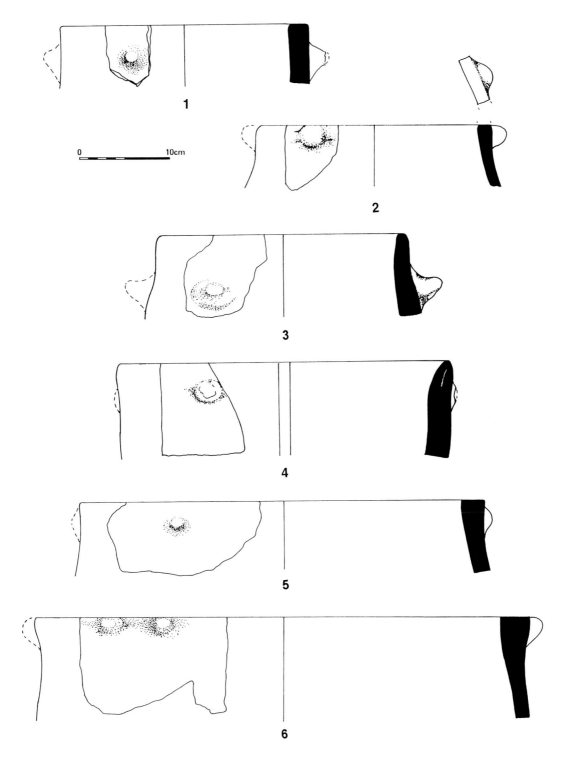

0                    10cm

1

2

3

4

5

6

Fig. 7.25. Neolithic pottery: holemouth pithoi (E4a). See p. 135 for description.

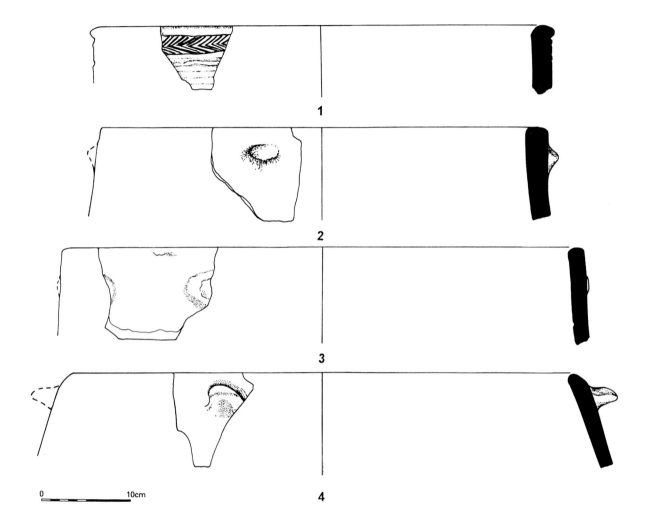

0 ___ 10cm

Fig. 7.26. Neolithic pottery: pithoi (E4). See p. 135 for description.

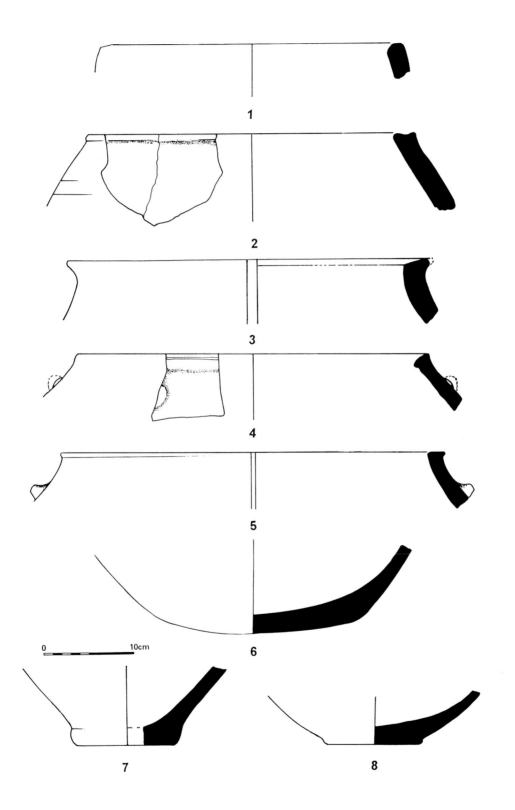

Fig. 7.27. Neolithic pottery: pithoi (E4). See p. 136 for description.

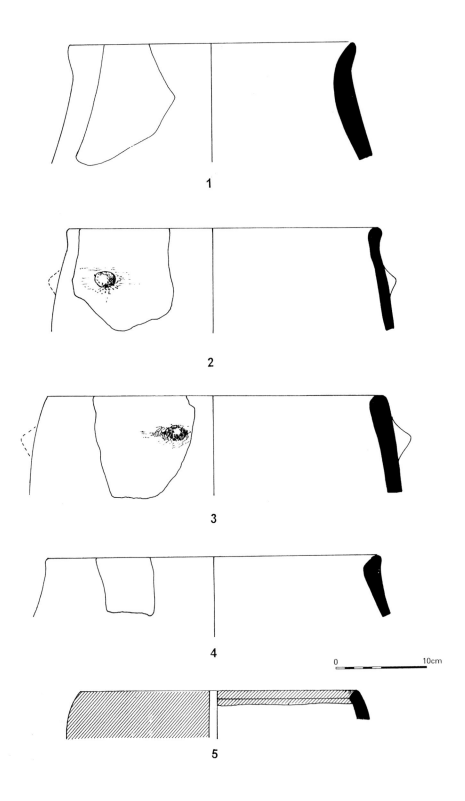

FIG. 7.28. Neolithic pottery: pithoi (E4). See p. 136 for description.

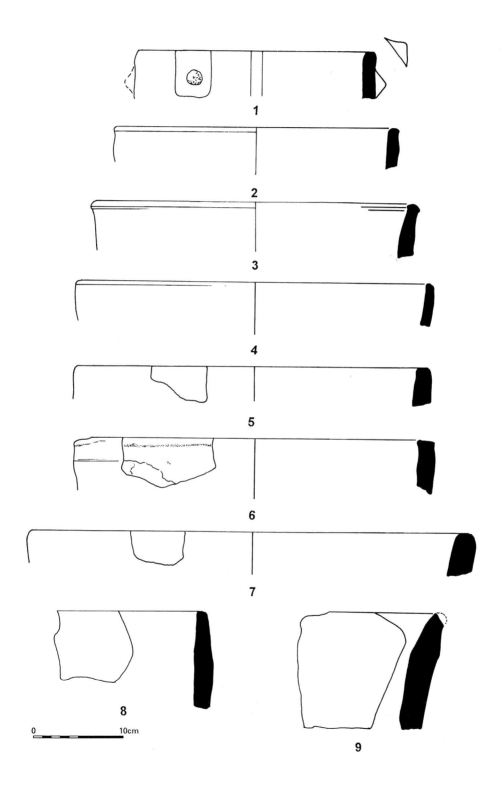

FIG. 7.29. Neolithic pottery: pithoi (E4). See p. 136 for description.

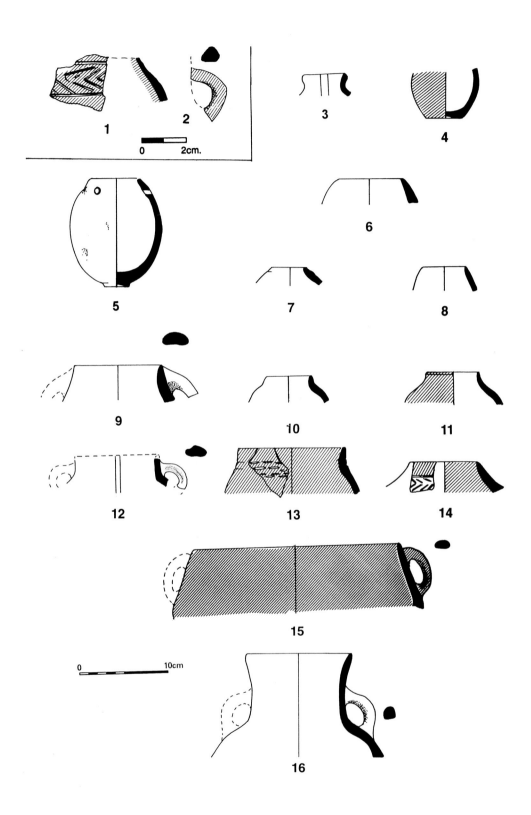

FIG. 7.30. Neolithic pottery: various closed vessels. See p. 136 for description.

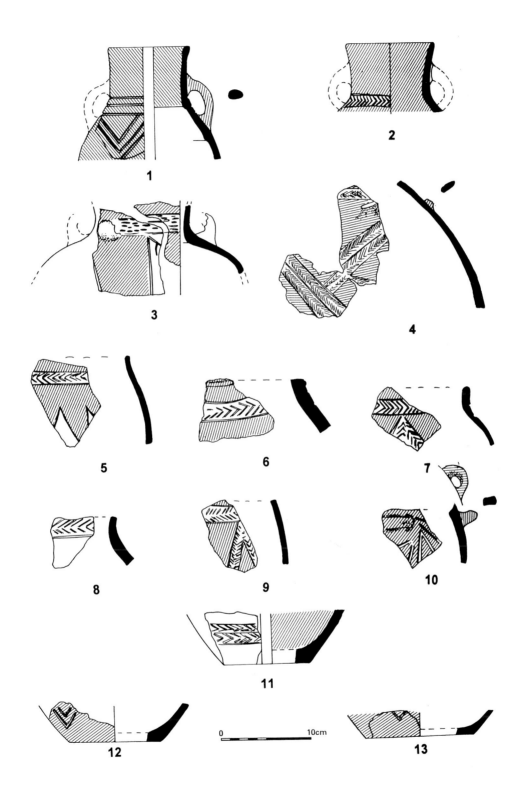

FIG. 7.31. Neolithic pottery: "Sha'ar Hagolan Jars" (D1). See p. 136 for description.

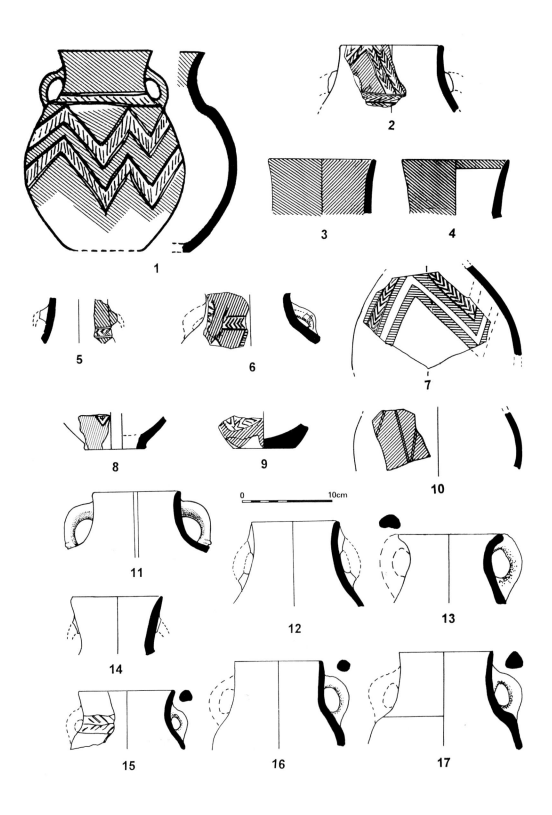

FIG. 7.32. Neolithic pottery: "Sha'ar Hagolan Jars" (D1) and "Jericho IX" (D2). See p. 136–137 for description.

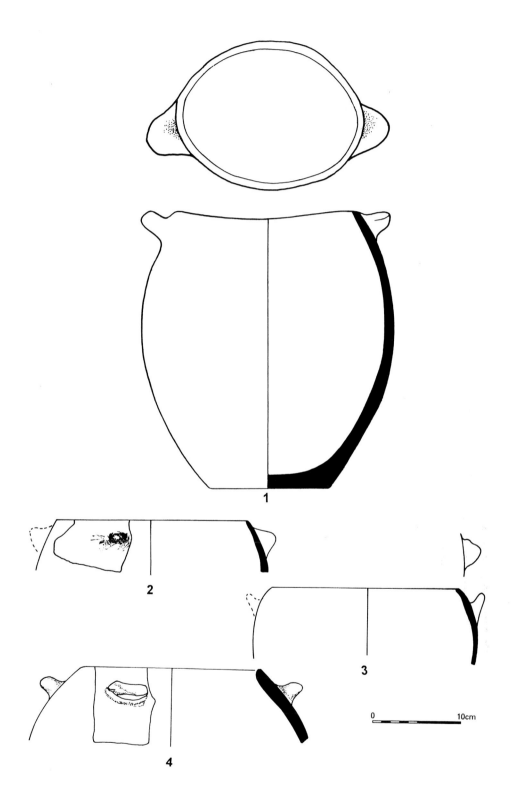

FIG. 7.33. Neolithic pottery: holemouth jars (F1). See p. 137 for description.

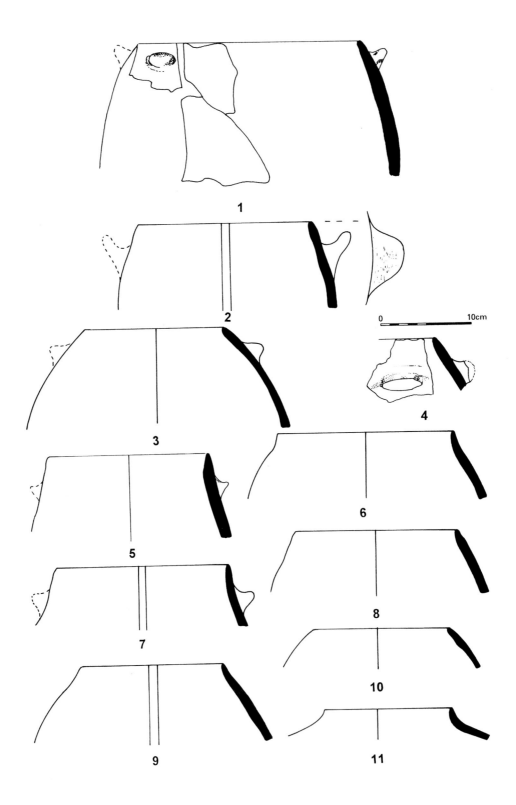

FIG. 7.34. Neolithic pottery: holemouth jars (F1). See p. 137 for description.

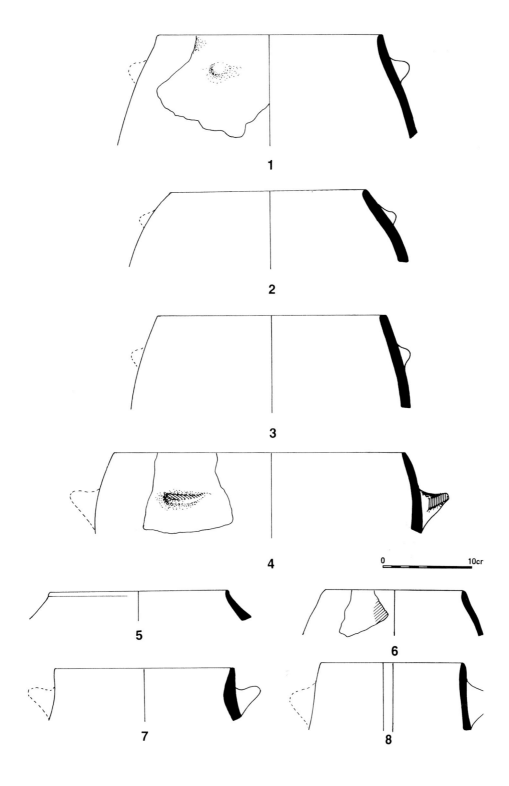

FIG. 7.35. Neolithic pottery: holemouth jars (F1). For description see p. 137.

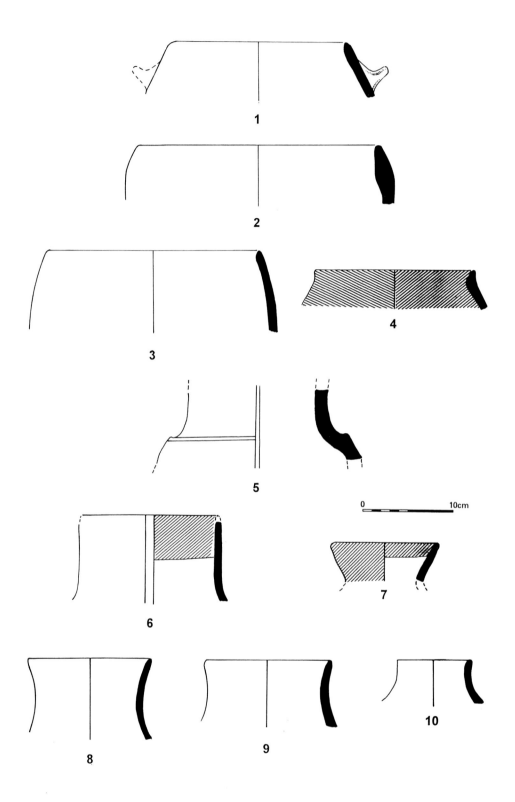

FIG. 7.36. Neolithic pottery: holemouth jars (F1) and handleless jars (F3). See p. 137 for description.

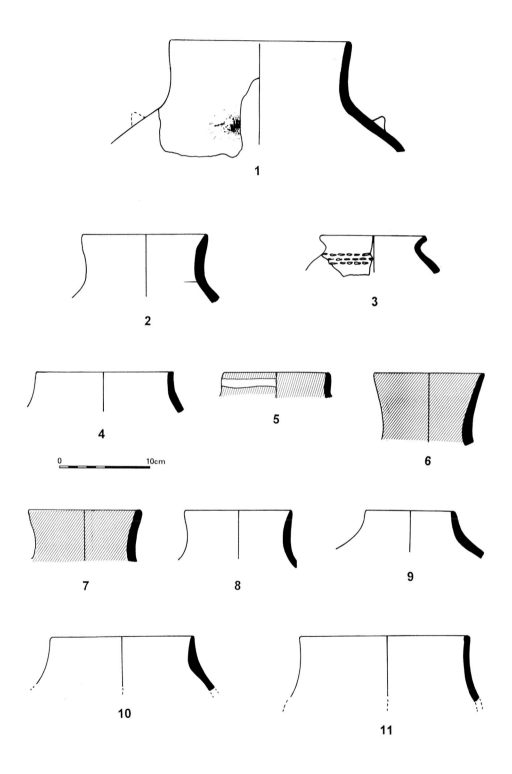

FIG. 7.37. Neolithic pottery: handleless jars (F3). See p. 137 for description.

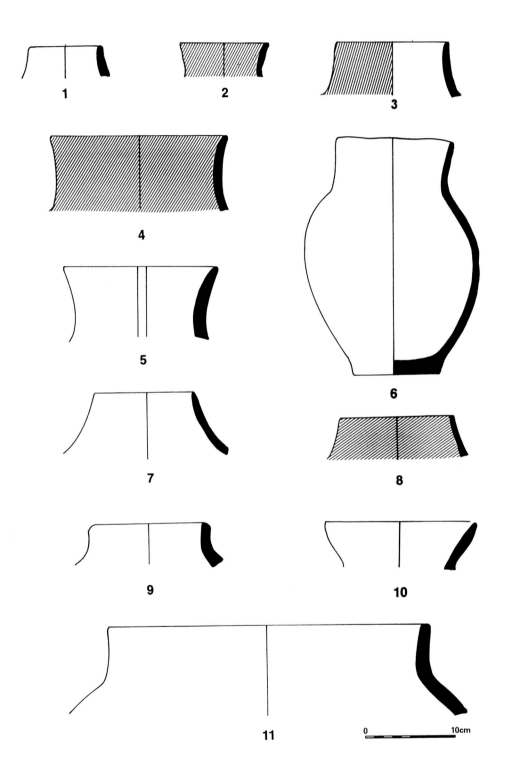

FIG. 7.38. Neolithic pottery: handleless jars (F3) and other jars (F4). See p. 137 for description.

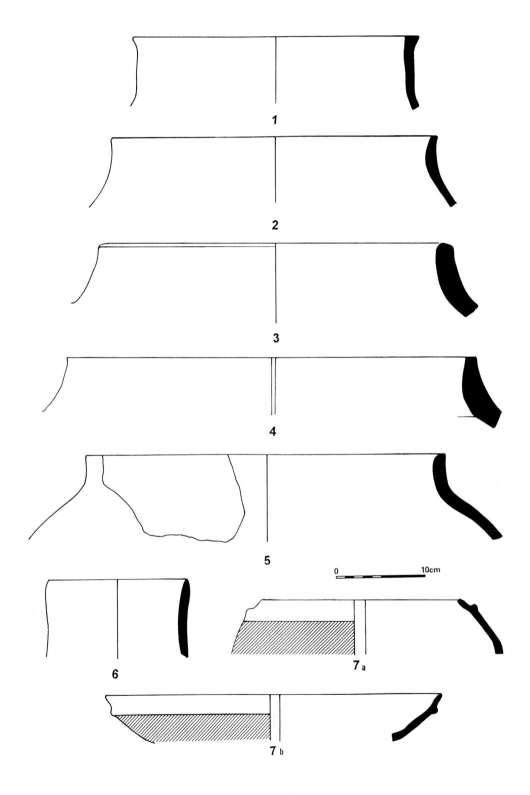

FIG. 7.39. Neolithic pottery: various jars (F4). See p. 137 for description.

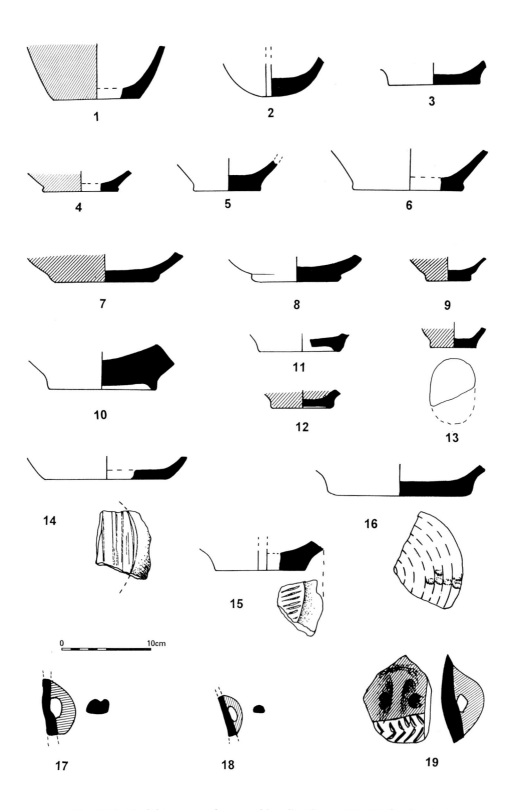

Fig. 7.40. Neolithic pottery: bases and handles. See p. 137–138 for description.

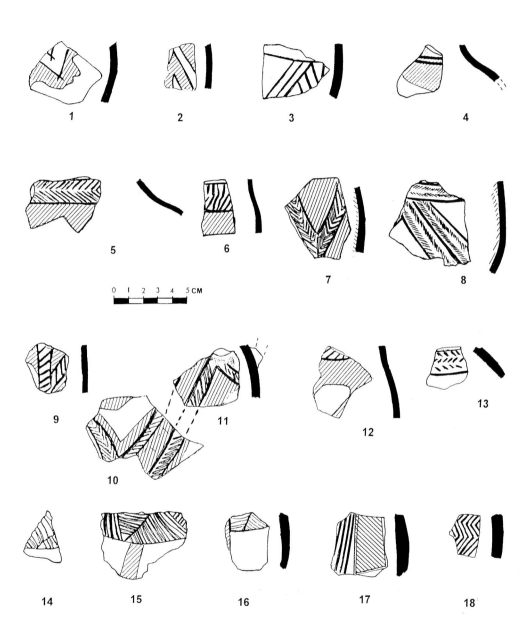

FIG. 7.41. Neolithic pottery: sherds, decorated by incision. See p. 138 for description.

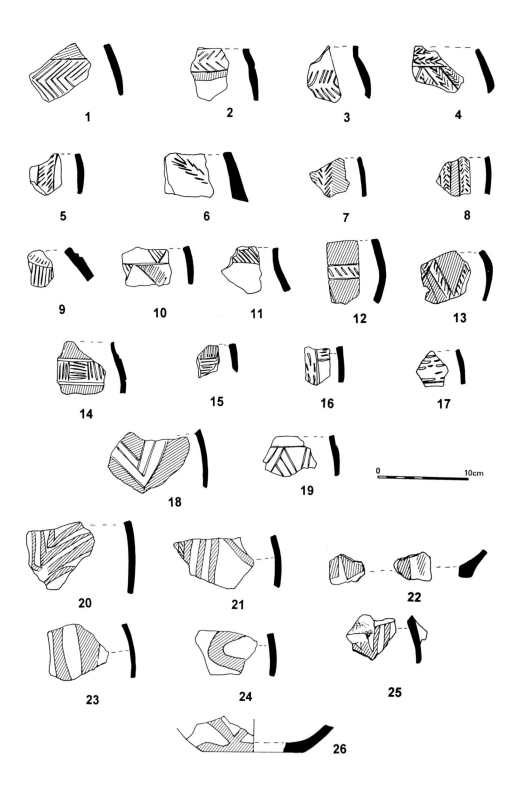

FIG. 7.42. Neolithic pottery: decorated sherds. See p. 138 for description.

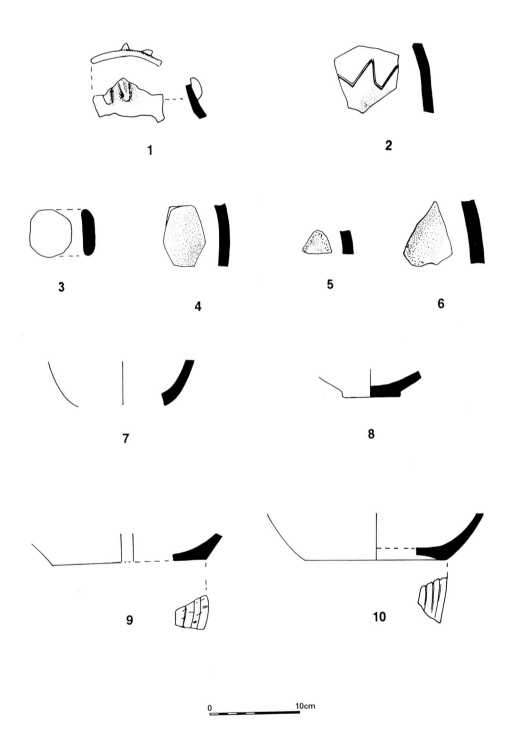

Fig. 7.43. Neolithic pottery: decorated sherds, scraped sherds and bases. See p. 138 for description.

# KEY TO FIGS 7.16–7.43

FIG. 7.16. Neolithic pottery: small open vessels (A1, A3) and decorated bowls (C1)

| No | Season | Locus | Basket | Form | Comments |
|----|--------|-------|--------|------|----------|
| 1 | 1996 | 64 | 262 | A1 | Intact vessel, painted red lines |
| 2 | 1997 | 90 | 510 | A3? | Spoon fragment?, partly scraped after firing |
| 3 | 1997 | 201 | 789 | A1 | Remnants of red slip outside, diagonal red painted line inside |
| 4 | 1997 | 148 | 585 | A1 | Red slip |
| 5 | 1996 | 53 | 310 | A1 | Red slip |
| 6 | 1996 | 2 | 320 | C1 | Incised herring-bone decoration and red paint |
| 7 | 1997 | 2 | 756 | C1 | Incised herring-bone decoration and red paint |
| 8 | 1996 | 37 | 212 | C1 | Incised herring-bone decoration and red paint |
| 9 | 1997 | 203 | 791 | C1 | Incised herring-bone decoration |
| 10 | 1998 | 356 | 1207 | C1 | Incised herring-bone decoration and red paint |
| 11 | 1997 | 167 | 303 | C1 | Incised frame and red paint |
| 12 | 1997 | 196 | 770 | C1 | Incised short lines on rim, incised herring-bone decoration and red paint |
| 13 | 1997 | 2 | 733 | C1 | Painted red lines outside, red slip inside |
| 14 | 1997 | 76 | 717 | C1 | Painted red lines outside |
| 15 | 1997 | 194 | 786 | C1 | Painted red lines outside and inside |
| 16 | 1997 | 104 | 654 | C1 | Painted red lines outside and inside |

FIG. 7.17. Neolithic pottery: small open vessels (A1, A3) and decorated bowls (C1) with incised decoration

| No | Season | Item No | Locus | Form | Comments |
|----|--------|---------|-------|------|----------|
| 1 | 1990 | 153/2 | 32 | A1 | ——— |
| 2 | 1989 | 127/2 | 22 | A1 | Very shallow bowl |
| 3 | 1989 | 139/2 | 25 | A1 | Red slip |
| 4 | 1990 | 113/3 | 28 | A1 | Red slip |
| 5 | 1989 | 122/1 | 3 | A2 | Small chalice base? |
| 6 | 1990 | 182/1 | 31 | B1 | ——— |
| 7 | 1989 | 39/4 | 3 | B2 | Incised herring-bone decoration and red paint |
| 8 | 1990 | 157/1 | 32 | B2 | Red slip |
| 9 | 1989 | 104/1 | 2 | B2 | Incised herring-bone decoration and red paint |
| 10 | 1989 | 71/1 | 3 | B2 | ——— |
| 11 | 1990 | 113/4 | 28 | B2 | Incised frame and red paint |
| 12 | 1989 | 164/1 | 32 | B1? | Miniature base |
| 13 | 1989 | 123/2 | 25 | B1? | Miniature base |
| 14 | 1989 | 139/3 | 25 | B2? | Small base |
| 15 | 1990 | 188/11 | 38 | C1 | Incised herring-bone decoration and red paint |
| 16 | 1990 | 113/5 | 28 | C1 | Incised herring-bone decoration and red paint, vertical pierced handle |
| 17 | 1990 | 133/6 | 28 | C1 | Incised herring-bone decoration and red paint |
| 18 | 1989 | 60/4 | 3 | C1 | Incised herring-bone decoration and red paint |
| 19 | —— | H | Surface f. | C1 | From the collection of Sha'ar Hagolan museum; Incised herring-bone decoration and red paint |
| 20 | —— | F | Surface f. | C1 | From the collection of Sha'ar Hagolan museum Incised herring-bone decoration. |
| 21 | —— | G | Surface f. | C1 | From the collection of Sha'ar Hagolan museum Incised herring-bone decoration. |
| 22 | 1990 | 126/5 | 32 | C1 | Incised herring-bone decoration and red paint |
| 23 | 1989 | 184/2 | 21 | C1 | Incised herring-bone decoration and red paint |
| 24 | 1989 | 95/2 | 3 | C1 | Incised herring-bone decoration and red paint |

FIG. 7.18. Neolithic pottery: decorated bowls (C1) with paint and slip decoration

| No | Season | Item No | Locus | Form | Comments |
|----|--------|---------|-------|------|----------|
| 1 | 1989 | 177/2 | 2 | C1 | Red slip |
| 2 | 1990 | 141/11 | 32 | C1 | Red slip |
| 3 | 1989 | 39/3 | 3 | C1 | Red slip |
| 4 | 1989 | 173/2 | 3 | C1 | Red slip |
| 5 | 1989 | 86/2 | 3 | C1 | Red slip |
| 6 | 1989 | 95/1 | 3 | C1 | Incised short lines on rim, red paint |
| 7 | 1990 | 98/8 | 32 | C1 | Red slip outside |
| 8 | 1990 | 181/2 | 32 | C1 | Red, "lipstick" band outside and inside |
| 9 | 1990 | 1126/1 | 32 | C1 | Red, "lipstick" band outside and inside |
| 10 | 1990 | 156/10 | 32 | C1 | Red, "lipstick" band outside |
| 11 | 1990 | 156/8 | 32 | C1 | Red, "lipstick" band outside |
| 12 | 1989 | 60/2 | 3 | C1 | Painted red lines outside |
| 13 | 1989 | 36 | 1 | C1 | Painted red lines outside and inside |
| 14 | 1989 | 60/3 | 3 | C1 | Painted red lines outside and inside |
| 15 | 1989 | 64/7 64/8 | 3 | C1 | Painted red lines outside and inside |
| 16 | 1989 | 78/1 | 17 | C1 | Painted red lines outside, remains of red painted decoration inside |
| 17 | —— | —— | —— | C1 | Item from Stekelis's excavations that was placed in storage room of Prehistory Department of Hebrew University in Jerusalem. Painted decoration outside and inside |

FIG. 7.19. Neolithic pottery: decorated and undecorated bowls (C1, C2)

| No | Season | Locus | Basket | Form | Comments |
|----|--------|-------|--------|------|----------|
| 1 | 1997 | 201 | 800 | C1 | Horizontal thick red lines |
| 2 | 1997 | 83a | 385 | C1 | Red line on rim inside and outside |
| 3 | 1997 | 2 | 716 | C1 | Red slip inside and outside, burnished line outside near rim |
| 4 | 1997 | 76 | 778 | C1 | Red slip and burnished |
| 5 | 1996 | 57 | 254 | C1 | Red paint on upper part |

| 6 | 1997 | 196 | 782 | C1 | Red slip |
|---|---|---|---|---|---|
| 7 | 1997 | 140 | 582 | C1 | Red slip |
| 8 | 1997 | 141 | 571 | C1 | Red slip, vertical deep incised on rim |
| 9 | 1997 | 112 | 422 | C2 | Horizontal loop handle |
| 10 | 1996 | 53 | 301 | C2 | |
| 11 | 1997 | 140 | 687 | C2 | Thick white slip (lime?) on both sides |
| 12 | 1997 | 167 | 703 | C2 | Scraped on the right side after firing |
| 13 | 1997 | 140 | 636 | C2 | Scraped on the right side after firing |

FIG. 7.20. Neolithic pottery: undecorated bowls (C2), chalices (C4) and various bowls (C5)

| No | Season | Item No | Locus | Form | Comments |
|---|---|---|---|---|---|
| 1 | 1989 | 58/4 | 9 | C2 | |
| 2 | 1989 | 125/1 | 25 | C2 | |
| 3 | 1990 | 141/3 | 32 | C2 | |
| 4 | 1989 | 187/3 | 21 | C2 | |
| 5 | 1989 | 146/4 | 3 | C2 | |
| 6 | 1989 | 70/1 | 3 | C2 | |
| 7 | 1989 | 81/2 | 20 | C2 | |
| 8 | 1989 | 151/1 | 3 | C2 | |
| 9 | 1989 | 55/2 | 3 | C2 | |
| 10 | 1990 | 143/2 | 32 | C2 | |
| 11 | 1989 | 31/1 | 3 | C4? | Chalice/ large bowl, red slip |
| 12 | 1990 | 143/5 | 32 | C4? | Bowl fragment, red slip |
| 13 | 1989 | 71/3 | 3 | C4? | Bowl fragment, red slip |
| 14 | 1990 | 154/4 | 32 | C4? | Bowl fragment, red slip |
| 15 | 1989 | 60/5 | 3 | C4? | Bowl fragment |
| 16 | 1990 | 140/2 | 32 | C4? | Bowl fragment, red painted band |
| 17 | 1990 | 113/9 | 28 | C4? | Bowl fragment, red slip |
| 18 | 1990 | 149/1 | 35 | C4? | Bowl fragment |
| 19 | 1989 | 179/4 | 3 | C5 | Bowl with opening, that was made before firing |
| 20 | 1990 | 153/2 | 32 | C4 | Base fragment, red painted band |

FIG. 7.21. Neolithic pottery: chalices (C4), various bowls (C5) and basins (E3)

| No | Season | Locus | Basket | Form | Comments |
|---|---|---|---|---|---|
| 1 | 1996 | 53 | 291 | C4 | Bowl fragment, straw smoothing |
| 2 | 1996 | 52 | 194 | C4 | Bowl fragment, incisions made by organic stick |
| 3 | 1997 | 91 | 411 | C4 | Bowl fragment |
| 4 | 1997 | 137 | 776 | C4 | Bowl fragment, red slip |
| 5 | 1997 | 83a | 349 | C4 | Base fragment |
| 6 | 1997 | 83a | 349 | C4 | Base fragment |
| 7 | 1996 | 57 | 266 | C5 | Red slip outside |
| 8 | 1997 | 201 | 789 | C5 | |
| 9 | 1997 | 52 | 209 | C5 | Red slip outside |
| 10 | 1997 | 141 | 559 | C5 | Upper part scraped |
| 11 | 1997 | 204 | 803 | E3 | |
| 12 | 1997 | 90 | 378 | E3 | Light clay, mostly straw tempers |
| 13 | 1997 | 194 | 761 | E3 | |

FIG. 7.22. Neolithic pottery: pots (E1) and pithos (E4)

| No | Season | Basket | Locus | Form | Comments |
|---|---|---|---|---|---|
| 1 | 1997 | 769 | 96 | E1 | Lug handle near rim, firing sites on lower part |
| 2 | 1997 | 409 | 96 | E1 | |
| 3 | 1997 | 291 | 53 | E4b | Red slip outside |

FIG. 7.23. Neolithic pottery: pots (E1)

| No | Season | Item No | Locus | Form | Comments |
|---|---|---|---|---|---|
| 1 | — | O | — | E1 | From the collection of Sha'ar Hagolan museum Lug handle near rim |
| 2 | 1989 | 39/7 | 3 | E1 | Lug handle near rim |
| 3 | 1989 | 87/1 | 9 | E1 | Lug handle near rim |
| 4 | 1990 | 131/2 | 32 | E1 | Lug handle near rim |
| 5 | 1990 | 176/1 | 38 | E1 | Lug handle near rim |
| 6 | 1989 | 181/5 | 21 | E1 | Lug handle near rim |
| 7 | 1989 | 70/2 | 3 | E1 | |
| 8 | 1989 | 70/3 | 3 | E1 | |
| 9 | 1989 | 80/3 | 18 | E1 | |
| 10 | 1989 | 98/5 | 21 | E1 | |
| 11 | 1990 | 141/4 | 32 | E1 | |
| 12 | 1989 | 64/9 | 3 | E1 | |

Fig. 7.24. Neolithic pottery: large bowls (E2), basins (E3) and red painted body sherds

| No | Season | Item No | Locus | Form | Comments |
|---|---|---|---|---|---|
| 1 | 1989 | 117/2 | 3 | E2 | Red slip |
| 2 | 1990 | 175/2 | 37 | E3 | |
| 3 | 1989 | 98/1 | 21 | E3 | |
| 4 | 1989 | 86/1 | 3 | E3 | |
| 5 | — | — | Surface Find | E3 | From the collection of Sha'ar Hagolan museum |
| 6 | 1989 | 98/3 | 21 | | Thin red painted lines |
| 7 | 1989 | 125/5 | 25 | | Thin red painted lines |
| 8 | 1989 | 125/8 | 25 | | Thick red painted lines |
| 9 | 1989 | 112/3 | 3 | | Thick red painted lines |
| 10 | 1990 | 161/3 | 32 | | Thin red painted lines |
| 11 | 1989 | 125/3 | 25 | | Thin red painted lines |
| 12 | 1989 | 69/1 | 9 | | Thin red painted lines |
| 13 | 1989 | 64/3 | 3 | | Thick red painted lines |

FIG. 7.25. Neolithic pottery: holemouth pithoi (E4a)

| No | Season | Locus | Basket | Form | Comments |
|---|---|---|---|---|---|
| 1 | 1996 | 52 | 297 | E4b | Lug handle near rim |
| 2 | 1997 | 125 | 567 | E4a | Lug handle near rim |
| 3 | 1997 | 109 | 437 | E4a | Lug handle near rim |
| 4 | 1997 | 136 | 546 | E4a | Rim made from two layers of clay attached together and covered with wet clay; lug handle near rim |
| 5 | 1997 | 83b | 674 | E4a | Lug handle near rim |
| 6 | 1996 | 37 | 212 | E4a | Lug handles near rim, coils clearly seen on section |

FIG. 7.26. Neolithic pottery: pithoi (E4)

| No | Season | Item No | Locus | Form | Comments |
|---|---|---|---|---|---|
| 1 | — | — | Surface find | E4b | Incised herring-bone decoration |
| 2 | 1989 | 62/1 | 1 | E4b | Lug handle near rim |
| 3 | 1989 | 186/1 | 21 | E4b | Road of lug handles near rim |
| 4 | — | 1365-S | — | E4a | From Stekelis's excavations, now at the Hebrew University; lug handle near rim |

FIG. 7.27. Neolithic pottery: pithoi (E4)

| No | Season | Item No | Locus | Form | Comments |
|---|---|---|---|---|---|
| 1 | 1990 | 121/1 | 31 | E4a | "Shaved" surface |
| 2 | 1989 | 186/269/1 | 213 | E4a | Vessel restored from two loci, coils clearly seen on section |
| 3 | 1990 | 144/4 | 34 | E4a | |
| 4 | 1990 | 113/7 | 28 | E4a | Lug handle near rim |
| 5 | 1989 | 118/1 | 18 | E4a | Lug handle near rim |
| 6 | | 183 | | E4 | Pithos base |
| 7 | 1990 | 143/9 | 32 | E4 | Pithos base |
| 8 | 1989 | 146/8 | 3 | E4 | Pithos base |

FIG. 7.28. Neolithic pottery: pithoi (E4)

| No | Season | Item No | Locus | Form | Comments |
|---|---|---|---|---|---|
| 1 | —— | 727-S | —— | E4a | Item from Stekelis's excavations |
| 2 | —— | K | Surface find | E4a | From the collection of Sha'ar Hagolan museum Lug handle near rim |
| 3 | —— | M | Surface find | E4a | From the collection of Sha'ar Hagolan museum Lug handle near rim |
| 4 | —— | 3 | Surface find | E4a | |
| 5 | 1989 | 177/3 | 2 | E4b | Red slip inside and red painted band outside |

FIG. 7.29. Neolithic pottery: pithoi (E4)

| No | Season | Item No | Locus | Form | Comments |
|---|---|---|---|---|---|
| 1 | 1989 | 39/6 | 3 | E4b | Lug handle near rim |
| 2 | 1989 | 114/1 | 18 | E4b | |
| 3 | 1990 | 156/4 | 32 | E4b | |
| 4 | 1989 | 146/2 | 3 | E4b | |
| 5 | 1989 | 69/2 | 9 | E4b | |
| 6 | 1989 | 123/1 | 25 | E4b | |
| 7 | 1989 | 58/3 | 9 | E4b | |
| 8 | 1990 | 131/6 | 32 | E4b | |
| 9 | 1990 | 175/1 | 37 | E4b | |

FIG. 7.30. Neolithic pottery: various closed vessels

| No | Season | Locus | Basket | Form | Comments |
|---|---|---|---|---|---|
| 1 | 1996 | 2 | 320 | B1 | Incised herring-bone and red paint |
| 2 | 1996 | 2 | 320 | B1 | Probably the handle of No. 1 |
| 3 | 1997 | 194 | 761 | B1 | |
| 4 | 1997 | 201 | 783 | B2 | Body fragment, red slip |
| 5 | 58/99 | H251 | H542 | B3 (a) | Intact vessel, burnished, two opposed perforations near rim |
| 6 | 1997 | 163 | 697 | B3 (a) | |
| 7 | 1997 | 182 | 707 | B3 (a) | |
| 8 | 1997 | 120 | 687 | B3 (a) | |
| 9 | 1996 | 38 | 246 | D2 | |
| 10 | 1997 | 120 | 637 | B3 (b) | |
| 11 | 1997 | 90 | 378 | B3(b) | Red slip |
| 12 | 1997 | 83b | 674 | D2 | Rim badly damaged, but still recognizable |
| 13 | 1997 | 137 | 772 | D3 | Incised short lines and red paint |
| 14 | 1996 | 16 | 251 | F3 (b) | Incised herring-bone and red paint |
| 15 | 1996 | 53 | 310 | F1 | Red slip and well smoothed on both sides |
| 16 | 1996 | 53 | 310 | F2 | |

FIG. 7.31. Neolithic pottery: "Sha'ar Hagolan Jars" (D1)

| No | Season | Locus | Basket | Form | Comments |
|---|---|---|---|---|---|
| 1 | 1996 | 52 | 230 | D1 | Incised frame and red paint |
| 2 | 1997 | 83a | 425 | D1 | Incised herring-bone and red paint |
| 3 | 1996 | 53 | 247 | D1 | Incised decoration and red paint; neck and body made separately and connected together; grass smoothing inside |
| 4 | 1997 | 102 | 653 | D1 | Incised herring-bone and red paint |
| 5 | 1996 | 53 | 290 | D1 | Incised herring-bone, incised simple zigzal line and red paint |
| 6 | 1997 | 141 | 559 | D1 | Incised herring-bone and red paint; ridge on the neck |
| 7 | 1997 | 90 | 510 | D1 | Incised herring-bone and red paint; neck and body made separately and connected together. |
| 8 | 1997 | 136 | 546 | D1 | Incised herring-bone; reduced firing |
| 9 | 1997 | 83a | 385 | D1 | Incised herring-bone and red paint |
| 10 | 1996 | 52 | 316 | D1 ? | Incised frame and red paint; horizontal handle |
| 11 | 1997 | 172 | 661 | D1 | Base fragment with incised herring-bone and red paint |
| 12 | 1996 | 52 | 297 | D1 | Base fragment with incised frame and red paint |
| 13 | 1996 | 53 | 247 | D1 | Well smoothed base fragment with incisions and red paint |

FIG. 7.32. Neolithic pottery: "Sha'ar Hagolan Jars" (D1) and "Jericho IX" (D2)

| No | Season | Item No | Locus | Form | Comments |
|---|---|---|---|---|---|
| 1 | —— | 49/154 | —— | D1 | (Amiran 1969, Pl. 1:1) Incised decoration and red paint |
| 2 | 1989 | 146/1 | 3 | D1 | Incised herring-bone and red paint |
| 3 | 1989 | 39/2 | 3 | D1 | Red slip |
| 4 | 1989 | 187/2 | 21 | D1 | Red slip |
| 5 | 1989 | 110/1 | 2 | D1 | Body fragment; incised herring-bone and red paint |
| 6 | 1989 | 87/2 | 9 | D1 | Body fragment; incised herring-bone and red paint |
| 7 | 1990 | 156/1 | 32 | D1 | Body fragment; incised herring-bone and red paint (thin line) |
| 8 | 1989 | 70/5 | 3 | D1 | Base; incised frame decoration and red paint |
| 9 | 1989 | 152/2 | 3 | D1 | Base; incised herring-bone and red paint |
| 10 | 1989 | 123/3 | 25 | D1 | Body fragment, incised simple zigzag line and red paint |
| 11 | 1989 | 76/1 | 16 | D2 | |
| 12 | 1989 | 177/5 | 2 | D2 | |
| 13 | —— | E | —— | D2 | From the collection of Sha'ar Hagolan museum |
| 14 | 1990 | 153/6 | 32 | D2 | |
| 15 | —— | B | —— | D1 | From the collection of Sha'ar Hagolan museum Incised herring-bone decoration |

| 16 | —— | C | —— | D2 | From the collection of Sha'ar Hagolan museum |
| 17 | —— | D | —— | D2 | From the collection of Sha'ar Hagolan museum, ridge on the shoulder |

FIG. 7.33. Neolithic pottery: holemouth jars (F1)

| No | Season | Item No | Locus | Form | Comments |
|---|---|---|---|---|---|
| 1 | —— | 49/153 | —— | F1 (b) | (Stekelis 1972, Pl. 41:2). Lug handle |
| 2 | —— | J | Surface find | F1 (a) | From the collection of Sha'ar Hagolan museum. Lug handle |
| 3 | 1989 | 36/1 | 1 | F1 (a) | Lug handle |
| 4 | 1990 | 154/5 | 32 | F1 (a) | Lug handle |

FIG. 7.34. Neolithic pottery: holemouth jars (F1)

| No | Season | Item No | Locus | Form | Comments |
|---|---|---|---|---|---|
| 1 | 1989 | 145/1 174/1 | 3 | F1 (b) | Lug handle |
| 2 | 1989 | 97/1 | 21 | F1 (b) | Lug handle |
| 3 | 1989 | 101/5 | 3 | F1 (a) | Lug handle |
| 4 | 1990 | 126/2 | 32 | F1 (a) | Lug handle |
| 5 | 1990 | 178/4 | 21 | F1 (b) | Lug handle |
| 6 | 1989 | 64/5 | 3 | F1 (c) | |
| 7 | 1989 | 97/2 | 21 | F1 (b) | Lug handle |
| 8 | 1989 | 70/4 | 3 | F1 (b) | |
| 9 | 1989 | 41/1 | 2 | F1 (b) | |
| 10 | 1989 | 46/1 | 9 | F1 (a) | |
| 11 | 1989 | 55/2 | 3 | F1 (c) | |

FIG. 7.35. Neolithic pottery: holemouth jars (F1)

| No | Season | Locus | Basket | Form | Comments |
|---|---|---|---|---|---|
| 1 | 1996 | 52 | 316 | F1 (b) | Lug handle, grass smooth outside and inside |
| 2 | 1997 | 173 | 689 | F1 (a) | Lug handle |
| 3 | 1997 | 178 | 730 | F1 (b) | Well made rim, lug handle |
| 4 | 1997 | 173 | 656 | F1 (b) | Lug handle with red paint |
| 5 | 1997 | 2 | 773 | F1 (c) | |
| 6 | 1997 | 167 | 641 | F1 (a) | Red paint outside |
| 7 | 1997 | 141 | 571 | F1 (c) | Lug handle |
| 8 | 1996 | 53 | 296 | F1 (b) | Lug handle |

FIG. 7.36. Neolithic pottery: holemouth jars (F1) and handleless jars (F3)

| No | Season | Item No | Locus | Form | Comments |
|---|---|---|---|---|---|
| 1 | 1989 | 124/2 | 19 | F1 (b) | Lug handle |
| 2 | 1989 | 146/6 | 3 | F1 (b) | |
| 3 | 1989 | 65/1 | 9 | F1 (b) | |
| 4 | 1989 | 125/6 | 25 | F1 (c) | Red slip |
| 5 | 1989 | 127/1 | 22 | F3 | Ridge on the shoulder |
| 6 | 1990 | 153/1 | 32 | F3 | Red paint |
| 7 | 1990 | 161/2 | 32 | F3 | Red paint |
| 8 | 1990 | 148/4 143/10 | 32 | F3 | |
| 9 | 1990 | 126/3 | 32 | F3 | |
| 10 | 1989 | 179/2 | 3 | F3 | |

FIG. 7.37. Neolithic pottery: handleless jars (F3)

| No | Season | Item No | Locus | Form | Comments |
|---|---|---|---|---|---|
| 1 | —— | L | Surface find | F3 | From the collection of Sha'ar Hagolan museum. Lug handle on the shoulder |
| 2 | —— | S | Surface find | F3 | From the collection of Sha'ar Hagolan museum |
| 3 | —— | K | Surface find | F3 | From the collection of Sha'ar Hagolan museum. Incised decoration |
| 4 | 1989 | 45/3 | 2 | F3 | |
| 5 | 1989 | 60/6 | 3 | F3 | Red slip |
| 6 | 1989 | 63/3-5 | 3 | F3 | Red slip |
| 7 | 1989 | 46/2 | 9 | F3 | Red slip |
| 8 | 1989 | 65/5 | 9 | F3 | |
| 9 | 1989 | 98/7 | 21 | F3 | |
| 10 | 1989 | 61/3 | 9 | F3 | |
| 11 | 1989 | 73/3 | 17 | F3 | |

FIG. 7.38. Neolithic pottery: handleless jars (F3) and other jars (F4)

| No | Season | Locus | Basket | Form | Comments |
|---|---|---|---|---|---|
| 1 | 1997 | 12 | 627 | F3 | Low-necked, white clay without tempers |
| 2 | 1996 | 57 | 226 | F3 | Red slip outside and inside |
| 3 | 1996 | 53 | 274 | F3 | Red slip outside |
| 4 | 1996 | 52 | 222 | F3 | Red slip outside and inside |
| 5 | 1997 | 137 | 565 | F3 | |
| 6 | 1996 | 76/77 | | F3 | Vessel restored from two neighbouring loci |
| 7 | 1997 | 88 | 421 | F3 | |
| 8 | 1996 | 53 | 258 | F3 | Red slip outside and inside |
| 9 | 1997 | 178 | 769 | F3 | |
| 10 | 1996 | 72 | 285 | F4 | |
| 11 | 1997 | 88 | 436 | F4 | Pithos, smoothed surface outside and inside |

FIG. 7.39. Neolithic pottery: various jars (F4)

| No | Season | Item No | Locus | Form | Comments |
|---|---|---|---|---|---|
| 1 | —— | B | Surface find | F4 | Pithos, from the collection of Sha'ar Hagolan museum |
| 2 | 1990 | 176/2 | 38 | F4 | Pithos |
| 3 | 1989 | 125/4 | 25 | F4 | Pithos |
| 4 | —— | N | Surface find | F4 | Pithos from the collection of Sha'ar Hagolan museum |
| 5 | —— | 1/1 | Surface find | F4 | Pithos from the collection of Sha'ar Hagolan museum |
| 6 | 1990 | 181/1 | 37 | F4 | Pithos |
| 7a | 19901 | 143/8 | 32 | F4 | Red paint |
| 7b | 990 | 143/8 | 32 | F4 | Different interpretation of the same item |

FIG. 7.40. Neolithic pottery: bases and handles

| No | Season | Item No | Locus | Comments |
|---|---|---|---|---|
| 1 | 1989 | 65/6 | 9 | Flat base, red slip |
| 2 | 1989 | 39/8 | 3 | Rounded base |
| 3 | 1989 | 146/7 | 3 | Disk base |
| 4 | 1989 | 32/1 | 2 | Disk base, red slip |
| 5 | 1989 | 64/6 | 3 | Disk base |
| 6 | 1989 | 97/3 | 21 | Disk base |
| 7 | 1989 | 179/5 | 3 | Disk base, red slip including the base itself |
| 8 | 1989 | 187/4 | 21 | Disk base |
| 9 | 1990 | 115/3 | 35 | Disk base, red slip including the base itself |

| No | Season | Item No | Locus | Comments |
|---|---|---|---|---|
| 10 | —— | P | Surface find | Ring base, from the collection of Sha'ar Hagolan museum |
| 11 | 1989 | 187/1 | 21 | Ring base |
| 12 | 1989 | 117/1 | 3 | Ring base, red slip |
| 13 | 1989 | 80/1 | 18 | Oval base, red paint |
| 14 | 1989 | 93/1 | 9 | Base with mat impression |
| 15 | 1990 | 141/2 | 32 | Base with mat impression |
| 16 | 1990 | 176/4 | 38 | Base with mat impression |
| 17 | 1989 | 44/1 | 2 | Loop handle with grove, red slip |
| 18 | 1989 | 64/4 | 3 | Loop handle, red slip |
| 19 | 1989 | 97/4 | 21 | Pierced handle, incised decoration, red slip |

FIG. 7.41. Neolithic pottery: sherds, decorated by incision

| No | Season | Item No | Locus | Comments |
|---|---|---|---|---|
| 1 | 1990 | 126/6 | 32 | Frame incision, red paint |
| 2 | 1989 | 186/4 | 21 | Frame incision, red paint |
| 3 | 1990 | 115/1 | 35 | Frame incision |
| 4 | 1989 | 95/3 | 3 | Frame incision, red paint |
| 5 | 1989 | 80/4 | 18 | Wide herring-bone incision, red paint |
| 6 | 1989 | 63/6 | 3 | Herring-bone incision, red paint |
| 7 | 1989 | 39/1 | 3 | Herring-bone incision, red paint |
| 8 | 1990 | 153/3 | 32 | Herring-bone incision, red paint on internal face |
| 9 | 1989 | 63/6 | 3 | Incised parallel lines in frame, red paint |
| 10 | 1989 | 118/4 | 18 | Incised parallel lines in frame, red paint |
| 11 | 1989 | 114/2 156/15 | 18 32 | Additional sherd from the same vessel (No. 10) |
| 12 | 1989 | 64/2 | 3 | Incision and red paint |
| 13 | 1989 | 73/1 | 17 | Complex herring-bone incision |
| 14 | 1990 | 131/3 | 32 | Incised parallel lines in triangles |
| 15 | 1990 | 143/7 | 32 | Additional sherd from the same vessel (No. 14) |
| 16 | 1990 | 143/6 | 32 | Additional sherd from the same vessel (No. 14) |
| 17 | 1989 | 178/5 | 21 | Incised parallel lines, red paint |
| 18 | 1989 | 39/5 | 3 | Incised parallel lines in double herring-bone pattern |

FIG. 7.42. Neolithic pottery: decorated sherds

| No | Season | Locus | Basket | Comments |
|---|---|---|---|---|
| 1 | 1997 | 178 | 661 | Wide herring-bone incision, red paint |

| No | Season | Locus | Basket | Comments |
|---|---|---|---|---|
| 2 | 1996 | 64 | 271 | Wide herring-bone incision, red paint |
| 3 | 1997 | 2 | 733 | Herring-bone incision without frame |
| 4 | 1996 | 2 | 320 | Herring-bone incision |
| 5 | 1996 | 16 | 251 | Incised parallel lines in frame |
| 6 | 1997 | 125 | 594 | Herring-bone incision without frame |
| 7 | 1997 | 88 | 375 | Herring-bone incision without frame, red paint |
| 8 | 1996 | 30 | 327 | Narrow herring-bone incision |
| 9 | 1997 | 121 | 518 | Incised parallel lines in triangles |
| 10 | 1996 | 52 | 253 | Incised parallel lines in triangles |
| 11 | 1997 | 196 | 770 | Incised parallel lines in frame |
| 12 | 1997 | 125 | 572 | Incised parallel lines in frame, red paint |
| 13 | 1997 | 141 | 571 | Incised parallel lines in frame, red paint |
| 14 | 1997 | 108 | 528 | Incised alternate parallel lines in frame, red paint |
| 15 | 1997 | 89 | 402 | Incised alternate parallel lines in frame, red paint |
| 16 | 1997 | 182 | 722 | Incised parallel lines in frame |
| 17 | 1997 | 83a | 493 | Incised parallel lines in frame |
| 18 | 1997 | 2 | 716 | Frame incision, red paint |
| 19 | 1996 | 57 | 254 | Frame incision |
| 20 | 1997 | 83a | 385 | Thin red painted lines |
| 21 | 1996 | 38 | 219 | Thin red painted lines |
| 22 | 1996 | 48 | 210 | Base fragment with thick red painted lines |
| 23 | 1997 | 2 | 716 | Thick red painted lines |
| 24 | 1997 | 194 | 790 | Thick red painted lines |
| 25 | 1997 | 2 | 733 | Thin red painted lines near handle |
| 26 | 1996 | 53 | 286 | Base fragment with thick red painted lines |

FIG. 7.43. Neolithic pottery: decorated sherds, scraped sherds and bases

| No | Season | Locus | Basket | Comments |
|---|---|---|---|---|
| 1 | 1997 | 83a | 385 | Applied plastic decoration |
| 2 | 1997 | 148 | 585 | Incised line |
| 3 | 1997 | 182 | 707 | Disk (scraped sherd) |
| 4 | 1998 | 303 | 1142 | Scraped sherd in hexagon shape |
| 5 | 1998 | 285 | 978 | Scraped oval sherd |
| 6 | 1998 | 249 | 958 | Scraped triangle sherd |
| 7 | 1997 | 98 | 399 | White slip (lime?) inside |
| 8 | 1998 | 334 | 1101 | Base fragment, well scraped |
| 9 | 1997 | 173 | 666 | Base with mat impression |
| 10 | 1997 | 148 | 585 | Base with mat impression |

# PETROGRAPHIC ANALYSIS OF POTTERY

*Anat Cohen-Weinberger*

## I. INTRODUCTION

The Yarmukian culture of the Neolithic period is named after the Yarmuk River located near the Sha'ar Hagolan site. The ancient pottery of this culture is characterized by a well-developed technique of decoration and finish. Recently the Neolithic pottery from Sha'ar Hagolan was replicated by an experimental pottery workshop. First, potential raw materials that could have been used by the Sha'ar Hagolan potters were sampled from five localities near the site. These were moistened and shaped into small briquettes (two briquettes for each sample), and then fired at temperatures of 550° C and 800° C (Zuckerman, Chapter 9 in this volume). Subsequently, thin sections prepared from 10 briquettes were examined under a petrographic (polarizing) microscope. This study aimed at identifying the raw materials used by the Neolithic potters of Sha'ar Hagolan, and comparing it to the raw material sampled around the site. For this comparison, I utilized previous petrographic analyses conducted by Goren (1991, 1992) of pottery from Sha'ar Hagolan and from a contemporary phase at Munhata.

For the present analysis it is important to assess the geologic setting of the excavated site. Sha'ar Hagolan is located in the northern part of the Jordan Valley, which is covered by Quaternary alluvium. Alluvial sediments were derived from sedimentary and volcanic rocks. These rocks, include:

a. The lower basalts and cover basalt exposures in the southern Golan, Ramot Issachar and the eastern Lower Galilee.
b. Sediments of the Pliocene (Bira and Gesher formations) and Miocene (Hordos Formation) periods, which are characterized by carbonatic rocks: marl, limestone, gypsum, conglomerate.

c. Rocks from the Eocene period (mainly chalk) exposed along the Yarmuk river (Shaliv 1991; Sneh *et al.* 1996, 1998).

## II. RESULTS

The matrix of all samples is carbonatic and rich in foraminifera. The non-plastic components (about 10% of the paste) are mainly olivine basalt fragments, chalk, chert, gypsum and some fine quartz. In the briquettes that were fired up to 800°C, the carbonate was decomposed and hollows were left in the foraminifera. The matrix lost the optical characteristics and became isotropic.

## III. DISCUSSION

The previous petrographic analysis of vessels from Sha'ar Hagolan (Goren 1991: 203) shows that out of 28 vessels, 11 were made of the same raw material as the present briquettes (Group VLI in Goren 1991). Four vessels made of other raw materials consist of carbonatic clay and basaltic non-plastic components of either chalk, crushed calcite, limestone, or without the non-plastic components (Groups 1, CC1, CK1, LS1, in Goren 1991). One vessel was made of carbonatic clay with quartz as the non-plastic component (Group QZ6 in Goren 1991). No correlation between the raw materials and the vessel types was found. The figurines were made from the same raw material as was used for vessels (Goren 1991: 203). The similarity between the petrographic results of Goren (1991) and of the present study indicates that most of the vessels of the site were locally made from the readily available raw materials.

The present study indicates that the non-plastic components appear naturally in the clay. The combination of carbonatic matrix with foraminifera and various non-plastic components in the pottery assemblage could lead to incorrect technological conclusions, such as, that the potters carefully chose the non-plastic components and intentionally added them to the paste of each vessel type, or that different non-plastic components were used in different workshops. Thus, experiments such as this are important for understanding the technology of pottery production.[1]

## BIBLIOGRAPHY

Cohen-Weinberger, A. 1998. Petrographic Analysis of the Egyptian Forms from Stratum VI at Tel Beth Shean. In Gitin, S., Mazar, A. and Stern, E. (eds.) *Mediterranean Peoples in Transition, Thirteenth to Early Tenth Centuries BCE*, pp. 406–412. Jerusalem: Israel Exploration Society.

Goren, Y. 1991. The Beginning of Pottery Production in Israel. Technology and Typology of Proto-Historic Ceramic Assemblages in Eretz-Israel (6th–4th Millennia B.C.). Unpublished Ph.D. dissertation. The Hebrew University, Jerusalem (Hebrew).

Goren, Y. 1992. Petrographic Study of the Pottery Assemblage from Munhata. In Garfinkel, Y. *The Pottery Assemblage of the Sha'ar Hagolan and Rabah Stages of Munhata (Israel).n* (Les Cahiers du centre de recherche Français de Jérusalem no.6), pp. 329–348. Paris: Association Paléorient.

Shaliv, G. 1991. *Stages in the Tectonic and Volcanic History of the Neogene Basin in the Lower Galilee and the Valleys.* Jerusalem: Report of the Geological Survey of Israel.

Sneh, A., Bartov, Y. and Rosensaft, M. 1996. *Geologic Map of the Lower Galilee, Carmel and Southern Golan, 1: 100,000,* Jerusalem: Geological Survey of Israel.

Sneh, A., Bartov, Y. and Rosensaft, M. 1998. *Geological Map of Israel 1: 200,000, Sheet 1.* Jerusalem: Geological Survey of Israel.

[1] Similar experimental identification of raw materials utilized in the manufacture of the pottery from Beth-Shean also shows that the clay originating in the geological formation naturally contains non-plastic components (Cohen-Weinberger 1998: 407–409).

# An Experimental Pottery Production Workshop

## Daphna Zuckerman

## I. Introduction

The first potters of ancient Israel lived in the Neolithic village of Sha'ar Hagolan. They were skilled craftsmen who produced clay objects from local materials, such as sun dried bricks, food containers and cult figurines (Garfinkel 1999a; 1999b). This extensive use of clay is a most typical feature of the Neolithic period in the Near East (Wengrow 1998). During the course of our excavation, we find and study the surviving sherds in an attempt to learn about the chronology of the site and the nature of household activities conducted by its residents, and at times, the technologies they employed.

What interested me, as a potter and an archaeologist, was to learn more about the group of people who lived and worked in the village and left their fingerprints on the pottery we analyzed. I therefore decided to create a pottery workshop on the site, trying, as closely as possible, to emulate the conditions under which the ancient potters worked, and to reconstruct their methods of production (Ascher 1961; Vitelli 1984).

Prior to the commencement of the 1999 season of excavations, we prepared a plan for the project. We constructed a technological classification of the pottery found at Sha'ar Hagolan and ran laboratory tests on the sherds, seeking to identify the origin of the clay, the types of tempers added to the clay, the color and hardness of the pottery and the methods of production. We also tried to discern which tools the ancient potters had employed for decorating, burnishing and painting the pottery. Lastly, we looked for evidence of the firing techniques and attempted to determined at which temperatures the different pots had been fired.

The petrographic study of the pottery found at Sha'ar Hagolan was conducted by Y. Goren (1992) and it was he who gave us general information regarding the types of local clays the Neolithic potters had used. Our aim was to identify the specific locations where the ancient potters had found the raw materials. After we had gathered all the preliminary information, we were ready to launch our on-site workshop. This preliminary report focuses on pottery making only. It is hoped that the results will help us to continue the experiments on other uses of clay, like the production of mudbricks and figurines, in the Neolithic period.

## II. The Production of Neolithic Pottery at Sha'ar Hagolan

Six main stages in the ancient production of pottery were: locating the clays, preparing the clays, shaping the vessels, surface treatments and decoration, drying and finally firing (Shepard 1968; Orton *et al.* 1997). Our replicative experiment followed these steps:

**1. Locating the Clays.** Our first step was to conduct a survey in the area in order to identify appropriate clay deposits. During the survey, we collected samples of various dry materials. We ground them to a powder and added water. Using the resulting mixture, we formed several small vessels and plates in order to test the qualities of the materials we had gathered—their plasticity, rate of shrinkage, drying time, firing temperature, texture and the final colors of the fired products. We then chose several flexible and workable clays from two deposits we had located near the archaeological site (Fig. 9.1).

**2. Preparation of the Clay.** Next, the clays were brought from the deposits to the site, and kept in piles near the water container. We crushed and sieved them and

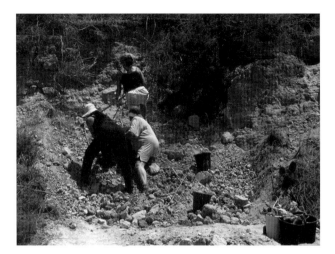

Fig. 9.1. The experimental pottery workshop 1999: locating the clays near the Neolithic site

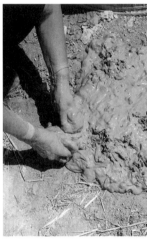
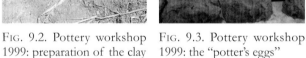

Fig. 9.2. Pottery workshop 1999: preparation of the clay    Fig. 9.3. Pottery workshop 1999: the "potter's eggs"

removed the stones, roots and dirt. We then mixed the clay powder and the water in large basins with our hands and bare feet. The water and clay were thereby transformed into lumps of mud. We kneaded this mud several times and added organic tempers as straw or dung (London 1981). The prepared mix, commonly nicknamed "potter's eggs," was ready and we could now begin manufacturing the pots (Figs. 9.2–9.3).

Following the preparation of the clay, samples of Neolithic sherds were sent to the laboratory in order to determine the types of temper they contained, and compare the ancient clay with that which we had prepared. A. Cohen-Weinberger of the Israel Antiquities Authority conducted the petrographic tests (see Chapter 8 in this volume) and M. Lavi executed the X-ray tests at the Hebrew University Laboratories.

**3. Shaping the Vessels.** All the Yarmukian pottery manufactured in ancient times was formed by hand. The potters used various manual techniques in forming the vessels:

a. Pinching Technique – Shaping small vessels with the fingers from a lump of clay. This technique may leave the potter's fingerprints on the vessel.

b. Coiling Technique – Forming a vessel from clay coils. Each coil is placed on the preceding one. Larger jars are formed from thicker coils. The lines where the coils were joined together are visible inside the ancient vessels.

At a session held during a visit to the local Sha'ar Hagolan Archaeology Museum, we introduced the volunteer excavators to the pottery assemblage, and then brought sherds and drawings of the pottery over to the on-site workshop. The "inexperienced" contemporary potters most likely encountered problems similar to those encountered by their ancient predecessors while working with the coarse clay in the hot weather: trying both to keep the clay moist, as well as keeping the pots in "leather hard" condition.

In the pottery workshop, we used the pinching and coiling techniques to form the pots, and collected pebbles, twigs, shells, sherds and flint tools which served as potter's tools for shaping and decorating the pots (Figs. 9.4–9.5).

On the bases of the Neolithic pots, we found the imprints of mats upon which the pots were rotated during production. Emulating the ancient technique, we wove mats from the reeds which grow near the Yarmuk River and used them accordingly.

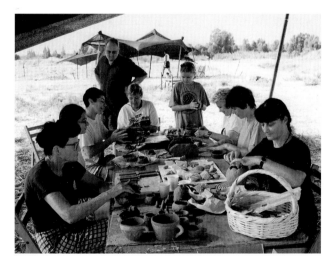

Fig. 9.4. Pottery workshop 1999: shaping a vessel by hand

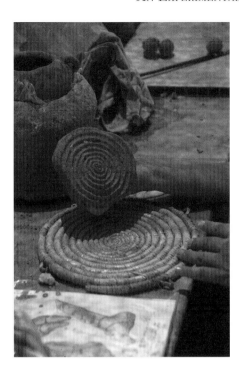

FIG. 9.5. Pottery workshop 1999: shaping a vessel on a straw mat

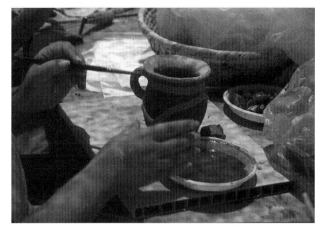

FIG. 9.7. Pottery workshop 1999: painting the vessels

**4. Surface Treatments and Decoration.** The surface treatment and the decoration of the pot is the final stage prior to firing. Examining the Neolithic pottery, we were able to learn about the way in which the ancient potters finished a pot. They finished the pots during the "leather hard" stage using smooth pebbles for burnishing, flint tools for incising, and straw for smoothing both the interior as well as the exterior of the pots. We covered some of the pots in a yellow-white slip (a suspension of local clay in water), and incised them with the unique Yarmukian "herring bone" patterns (Fig. 9.6). We painted others with red ochre from Mt. Hermon and the Golan Heights, located one to two days walk north of Sha'ar Hagolan. D. Ben Ami shared with us his broad knowledge of the sources of ochre in these regions.

For comparison, we sent the ancient and our experimental pottery to the laboratory for an analysis of the composition of the paints so as to identify the source of red ochre used in the Neolithic period (Fig. 9.7). The finished pots were then put to dry.

**5. Drying.** Due to the hot weather typical of the Yarmuk Valley, we decided to dry the pots indoors for about a day before transferring them to dry in the sun. It took two to six days for them to dry, depending on the size of the pot. During the drying process, cracks appeared in many of the pots. Some of those cracks were a result of the unskilled potters. The non-homogenous nature of the clay fabric also contributed to the cracking. The cracked pots were broken and sunk in water in order to recycle

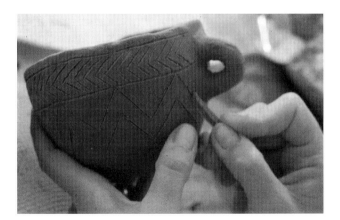

FIG. 9.6. Pottery workshop 1999: incised herring-bone decoration

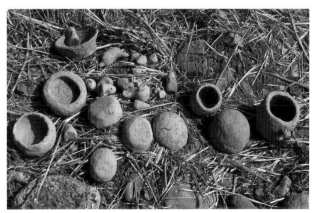

FIG. 9.8. Pottery workshop 1999: sun-drying the vessels

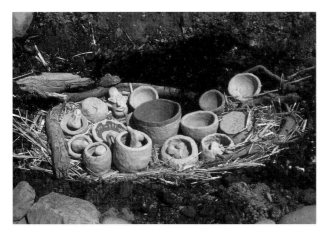

FIG. 9.9. Pottery workshop 1999: placing the vessels in the fire pit

FIG. 9.10. Pottery workshop 1999: the firing

the clay. This method of recycling used today by contemporary potters is apparently similar to that used by Neolithic potters. When we had a sufficient quantity of intact dried pots, we prepared for the firing in an open fire (Fig. 9.8).

**6. Firing.** The process of firing a pot, in fact, puts to test the quality of the potter's craft and the materials which he or she uses. A poor fire can destroy weeks of hard work. This became clear to us through our experiments at Sha'ar Hagolan. We believe that the Neolithic craftsmen were skilled potters who had learnt the firing process by trial and error, as we did (Figs. 9.9–9.10).

We fired the pots in an open fire in which the pots and the fuel were placed together on the ground, or in a shallow pit. The fuel materials we used were of local origin: cane which grows along the river, dung, grasses and branches. Although we experimented with all sorts of firing methods, the pots kept coming out of the fire entirely black. In our final, and successful, attempt, we placed the pottery in the pit on a pile of fuel and sherds. The fuel was also arranged on the pottery and around it. We were careful to prevent direct contact between the pottery and the dung. The firing lasted one hour, though the pots remained in the pit an additional hour in order to cool. At last, our light colored "Yarmukian" pottery emerged from the ashes... (Figs. 9.11–9.12).

The temperature the pottery reached during the firing was between 500–550° C. The ancient firing temperatures are still being determined by laboratory testing.

FIG. 9.11. Pottery workshop 1999: end of the firing

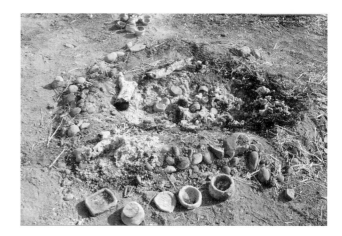

FIG. 9.12. Pottery workshop 1999: the finished "Yarmukian" pottery

## III. DISCUSSION

The experimental pottery workshop conducted at the Neolithic village of Sha'ar Hagolan, and the analysis of

its results, which are still in progress, contributes to our knowledge in several areas:

1. The environment of the site in the past and the locally found raw materials used by the ancient potters.
2. The development of pottery production, especially during its earliest appearance in this area.
3. New ways in which we might investigate ancient pottery production (or any ancient technology), i.e., comparing the archaeological remains with the results of our replicative experiments.
4. Understanding everyday life in the ancient village by becoming familiar with the local conditions.
5. The mutually valuable insight provided by interaction between the modern potter and the archaeologist (through the ancient potter): each can learn much from the other.
6. The contributions which anthropology and ethno-archaeology can make to archaeological research in their investigation of traditions which are rapidly disappearing.

In conclusion, the workshop was established at the site while the archaeological excavations were underway. As the buckets of finds filled up, pottery sherds began to appear. The ancient potters who produced this pottery worked in the same area as we did, saw the same sights, suffered from the same hot weather, and used the same raw materials and tools. Potters have passed down the methods we employed from generation to generation, from earliest times, to the present day.

We can now recognize the manufacturing process and understand the marks left on the Yarmukian pottery by ancient potters' hands and tools. Some of these marks are also visible on the pottery we produced at the site 8,000 years later. Analysis of the ancient pottery assemblage side by side with the "modern" pottery helps us determine how to continue our research concerning the Neolithic clay products and the people who inhabited the site and manufactured them.

## Acknowledgements

I wish to thank the directors of the excavation, Drs. Y. Garfinkel and M.A. Miller, who were open to the idea of establishing the workshop and kindly provided enormous support throughout all stages of the project. Warm thanks are extended to the creative workshop staff including A. Eirikh-Rose, an area supervisor at the excavation, B. Horfi, a potter, R. Shahal, an archaeologist, G. Laron, photographer, and the volunteers at the excavation who served as the potters and worked daily in the workshop. Special thanks go to E. Kameiski, a talented potter and pottery conservator at the Israel Antiquities Authority.

## BIBLIOGRAPHY

Ascher, R. 1961. Experimental Archaeology. *American Anthropologist* 63: 793–816.

Garfinkel, Y. 1999a. *The Yarmukians, Neolithic Art from Sha'ar Hagolan*. Jerusalem: Bible Lands Museum.

Garfinkel, Y. 1999b. *Neolithic and Chalcolithic Pottery of the Southern Levant*. (*Qedem* 39). Jerusalem: Institute of Archaeology, Hebrew University.

Goren, Y. 1992. Petrographic Study of the Pottery Assemblage from Munhata. In Garfinkel, Y. *The Sha'ar Hagolan and Wadi Rabah Pottery Assemblages From Munhata* (Cahiers du Centre de Recherche Français de Jérusalem 6), pp. 329–348. Paris. Association Paléorient.

London, G.A. 1981. Dung-Tempered Clay. *Journal of Field Archaeology* 8: 189–195.

Orton, C., Tyers, P. and Vince, A. 1997. *Pottery in Archaeology*. Cambridge: Cambridge University Press.

Shepard, A.O.1968. *Ceramics for the Archaeologist*. Washington: Carnegie Institution.

Wengrow, D. 1998. 'The Changing Face of Clay': Continuity and Change in the Transition from Village to Urban Life in the Near East. *Antiquity* 72: 783–795.

Vitelli, D.K. 1984. Greek Neolithic Pottery by Experiment. In Rice, P. M. (ed.) *Pots and Potters: Current Approaches in Ceramic Archaeology* (Monograph 24), pp. 113–131. Los Angeles: Institute of Archaeology, University of California.

# 10

# The Flint Knapping Industry

## Nira Alperson and Yosef Garfinkel

## I. Introduction

The flint assemblages of Sha'ar Hagolan were first described by Stekelis in a detailed report that accounted for the excavation seasons he conducted there in the years 1949–1952, as well as material collected on the site surface by local farmers (Stekelis 1972). The report covers the excavated assemblage, approximately 6,000 artifacts, and includes the description of all tool types, cores and core waste. Stekelis concluded that a Neolithic workshop for the production of stone tools and flint tools operated at the site of Sha'ar Hagolan (Stekelis 1972: 11). Stekelis thus observed that the entire process of production, modification and use of the tools occurred at the site; this observation was supported by the analysis of lithic assemblages from the renewed excavations, which are the focus of this article.

The renewed excavations yielded an opulent assemblage from which the material from the first two seasons (1989–1990) was partially published (Garfinkel 1992, 1993). The following presentation includes a compilation of the published data with the addition of the assemblage originating from the third excavation season (1996). The site of Sha'ar Hagolan is unique as it is a uni-cultural site inhabited during the Pottery Neolithic and therefore displays an unmixed assemblage which originates from one chronological phase.

The main objectives of the following presentation can be summarized as follows:

1. Presenting a comprehensive description (quantitative and qualitative) of the flint assemblage from the renewed excavations.
2. Displaying an extensive illustrative presentation of the different categories of the assemblage.

3. Emphasizing technological aspects which were not dealt with in detail in previous studies of the Yarmukian flint industry.

## II. Technological Aspects

**1. Acquisition of Raw Material.** The analysis of the lithic assemblage focused on the flint component. While the assemblage also encompasses limestone artifacts, due to the small sample size (45 pieces) these will not be presented in detail. Cores are not present in the limestone assemblage, yet the presence of core trimming elements (e.g. ridge blade and core-tablet) indicate that the process of manufacturing the limestone artifacts took place at the site. An additional raw material present in the Sha'ar Hagolan lithic assemblage is obsidian – volcanic glass – the nearest potential source of which is located c. 700 km. north of the site (Fig. 10.1). Approximately 10 obsidian artifacts were retrieved from the renewed excavation (including the 1999 season). This amount is not sufficient for analysis and it is not clear whether these artifacts were knapped on the site or were imported to it as final products.

The flint assemblage was manufactured primarily on river pebbles. Through the analysis of the primary elements from the 1996 season, a differentiation was made between two types of cortical coverage: of the 3,928 primary elements, 94% have a smooth and rounded cortical coverage typical of river pebbles (Figs. 10.2–10.3) and the remaining 6% have an irregular white limestone cortex typical of flint nodules.

We can thus conclude that the lithic assemblage involves three principal types of raw material. The

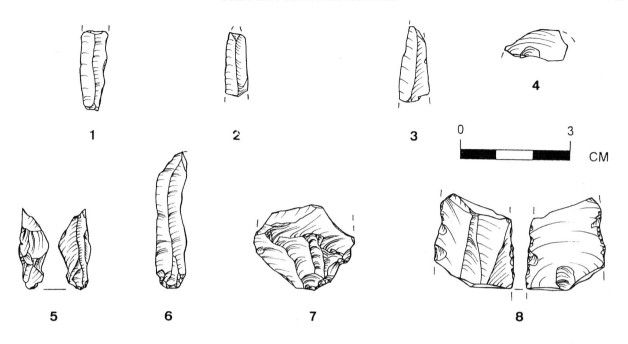

FIG. 10.1. Obsidian artifacts

majority of the assemblage was modified on river pebbles which are abundant in the adjacent Yarmuk River. In addition, flint nodules and limestone were used. It is interesting to note that numerous stone implements modified on limestone and basalt are present at the site of Sha'ar Hagolan. Basalt grinding slabs, mortars, pestles and bowls and limestone weights and bowls occur in high frequencies. It is likely that certain knapping procedures were involved in the modification of these stone implements and thus contributed basalt and limestone artifacts to the lithic assemblage. The absence of basalt artifacts and the low frequencies of limestone artifacts in the present assemblage can indicate that the stone implements were not modified at the site.

**2. Core Modification.** The initial stage of core modification, hence removal of the cortex (roughout) apparently occurred at the site, as viewed from the high frequencies of primary elements in the assemblage (Table 10.1).

Some of the primary elements are rounded or oval flakes with 100 percent cortex (Fig. 10.2: 1–4). These were the first flakes to be removed from the natural river pebbles. Then, additional primary elements were removed, on which one can see the scar of the first primary blow as well as more cortex (Figs. 10.2: 5–10, 10.3). Sometimes the knapping of the second flake was executed from the same location (Figs. 10.2: 8, 10, 10.3) and sometimes the pebble was turned 90 degrees (Fig.

TABLE 10.1. Industry frequencies

| TYPE | N | % |
|---|---|---|
| Primary elements | 7254 | 21.00 |
| Flakes | 9770 | 28.29 |
| Blades | 1145 | 3.31 |
| Bladelets | 1009 | 2.92 |
| CTE | 864 | 2.50 |
| Pebbles | 47 | 0.13 |
| Cores | 470 | 1.36 |
| Burin spalls | 205 | 0.59 |
| Ax spalls | 2 | 0.005 |
| Chips | 6695 | 19.39 |
| Chunks | 5444 | 15.76 |
| Tools | 988 | 2.86 |
| Signs of use | 635 | 1.83 |
| **Total** | **34528** | **99.94** |

10.2: 9) or 180 degrees (Fig. 10.2: 5, 6). A similar use of flint pebbles has been observed at the Pre-Pottery Neolithic A site of Gesher, also located in the central Jordan Valley (Garfinkel and Nadel 1989: 147).

In addition, the presence of 47 complete pebbles, 23 preparation cores (Fig. 10.4) and 27 hammerstones in the assemblage can strengthen the assumption that the initial stages of modification of the cores took place at the site. Examination of the industry frequencies reveals that flakes are the prominent product, constituting up to 28% of the assemblage (Table 10.1). The relatively low

TABLE 10.2. Core-type frequencies

| TYPE | N | % |
|---|---|---|
| Preparation cores | 23 | 4.89 |
| Single striking platform cores | 120 | 25.53 |
| Two opposed striking platforms | 11 | 2.34 |
| Multiple striking platforms | 52 | 11.06 |
| Crested cores | 28 | 5.95 |
| Amorphous cores | 49 | 10.42 |
| Small cores | 119 | 25.32 |
| Cores on flakes | 20 | 4.25 |
| Robust cores | 13 | 2.76 |
| Indeterminate cores | 8 | 1.70 |
| Hammerstones | 27 | 5.74 |
| **Total** | **470** | **99.96** |

frequencies of blades and bladelets also indicate that the industry is primarily flake-oriented. Emphasis on flake production is also demonstrated in the core assemblage.

The relatively high variability of the cores (Table 10.2, Figs. 10.4–10.8) is apparently the result of an "opportunistic" knapping system, which does not aim to a desired morphology of the cores and their products through strict and planned knapping procedures. Aspects of the "opportunistic" nature of the industry can also be viewed in the types and frequencies of the core trimming elements (Figs. 10.9–10.12). The bulk of these are core trimming elements whose removal enables a renewal of the core's striking platform (e.g., core-tablets and over-shoots), while those which enable the renewal of the flaking surface (e.g., ridge blades and flakes) appear in much lower frequencies. The ratio of cores and core trimming elements also supports the notion of an "opportunistic" industry. The low ratio of core trimming elements to cores (2:1) indicates that a minimum of preparation procedures was applied to the cores through-out the knapping process, thus supporting the interpreta-tion of opportunistic knapping procedures.

An especially interesting feature that stems from examination of core frequencies is the relatively high presence of "small cores" in the assemblage, constituting up to 25% of the cores (Table 10.2). These cores do not exceed 4 cm. in their maximum length and are most variable in nature (Figs. 10.5: 1–5; 10.6). Several hypo-thetical circumstances could have contributed to the notable presence of these cores in the assemblage: First is that these items might be the result of a technological system that aims to a maximal exploitation of the cores, hence resulting in exhausted cores. This assumption is problematic since it is not in accord with the high availability of raw material in the vicinity of the site. An alternative explanation can be that the initial size of pebbles in use for the modification of these cores was

small to begin with. This suggestion is not in accord with the nature of the industry, especially in the case of the primary elements, which are of relatively large dimen-sions. In addition, the pebbles on the adjacent Yarmuk River bank display high variability and the complete pebbles at the site are relatively large. A third explanation is that some of these items are functionally not cores, representing instead a type of core-tool. Stekelis des-cribed in his concluding report to the excavations at Sha'ar Hagolan, core-tools which he defined as "core-scrapers" for processing of wood, bones and leather (Stekelis 1972: 17). Approximately 540 pieces of this type were collected in Stekelis' excavations, constituting c. 24% of the flint assemblage; the high frequencies of these items both in Stekelis' assemblage and in the renewed excavations suggest that some of the items classified as small cores are core-tools as defined by Stekelis.

To conclude, it seems that the technological system of Sha'ar Hagolan was basically "opportunistic" in nature. Core reduction focused on the production of flakes through a minimum of shaping procedures. Nonetheless, we should consider several other features. The relatively high frequency of single striking platform cores (c. 25%) (Figs. 10: 4; 10: 5), some with indications of blade removal, the presence of ridge blades and the blade component in the debitage and tools. These features hint at the use of a standardized system of blade production.

In addition, two items included in the category of cores with two opposed striking platforms display an interesting resemblance to cores of the naviform tech-nology, together with blades whose profile and dorsal scar patterns resemble products of the naviform tech-nology (as described by Wilke and Quintero 1994). A naviform core can also be found in Stekelis' report (Stekelis, 1972, Plate 33: 3). The assumption that a certain form of naviform technology was in use at Sha'ar Hagolan is not in accordance with the generally accepted view according to which this Pre-Pottery Neolithic technology did not persist during the Pottery-Neolithic (Garfinkel 1993; Quintero and Wilke 1995).

The discussed technological aspects suggest that the various stages of knapping which produced the flint assemblage occurred at the site: the high frequency of knapped chips and primary elements, the presence of complete pebbles and hammerstones together with cores in initial stages of preparation and core trimming elements argue for the assumption that the activity of knapping the flint assemblage took place at the site. The high variability of core types, the irregularity of the cores and the relatively low ratio of core trimming elements per core are indicators of an "opportunistic" system. The chief products of this system are flakes, with only a small number of blades and bladelets.

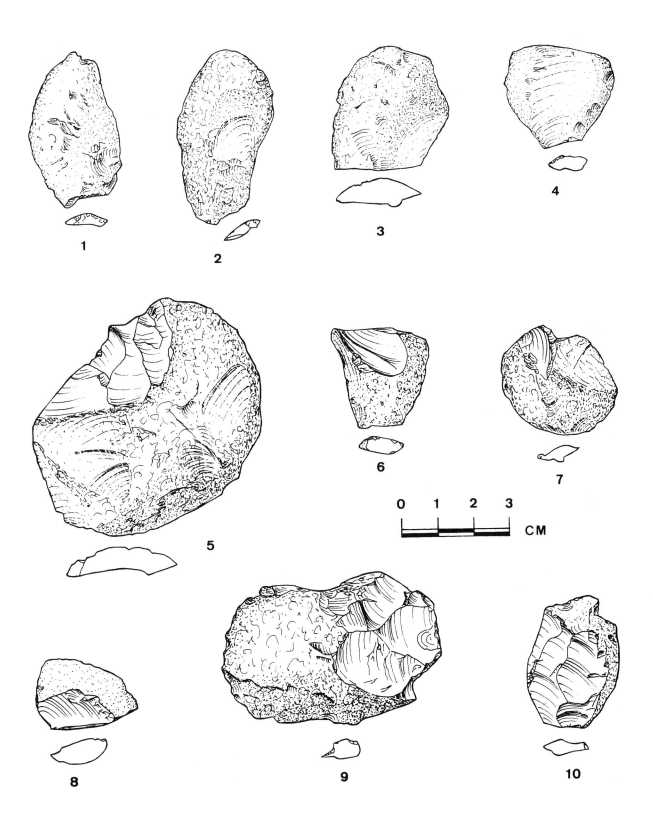

FIG. 10.2. Primary flakes removed from natural river pebbles

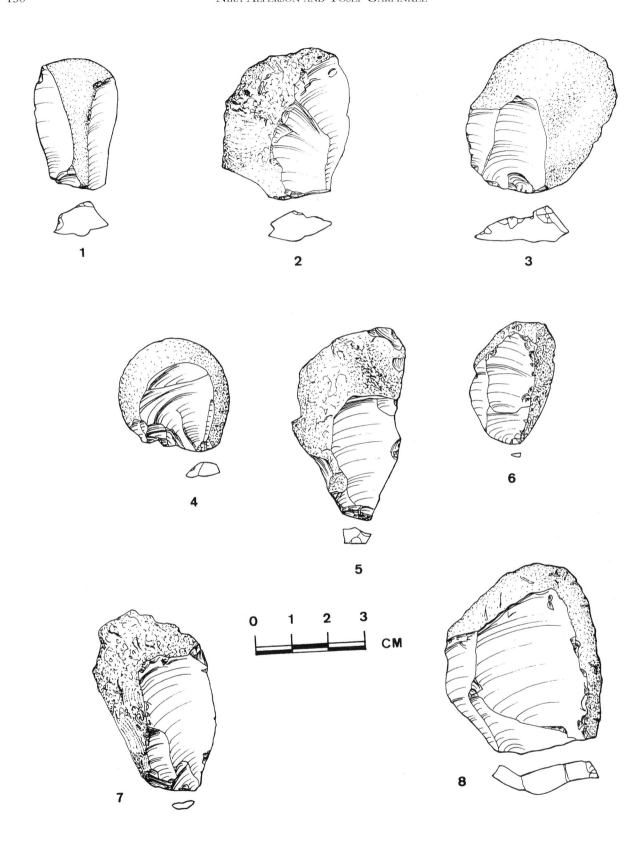

FIG. 10.3. Primary flakes removed from natural river pebbles

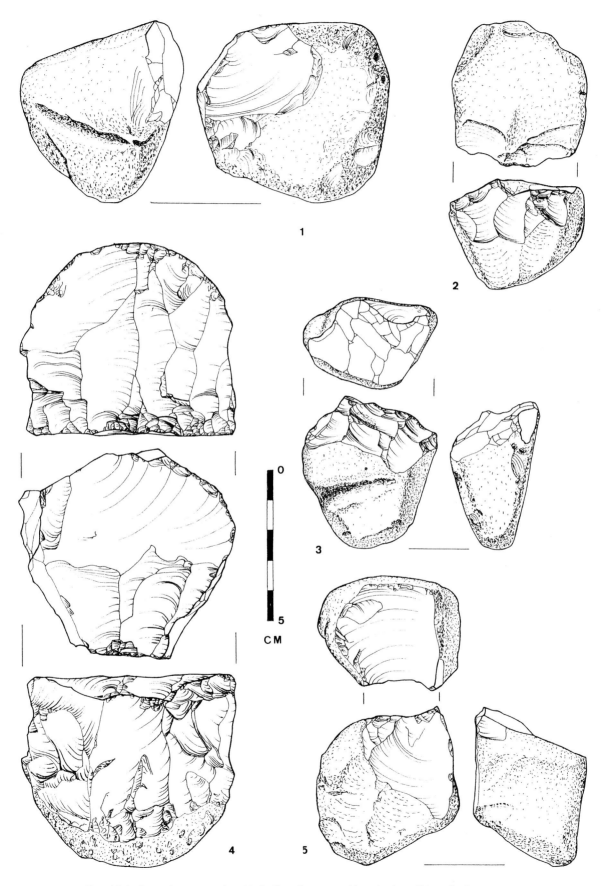

FIG. 10.4. Cores in preparation (1–3, 5) and a core with a single striking platform (4)

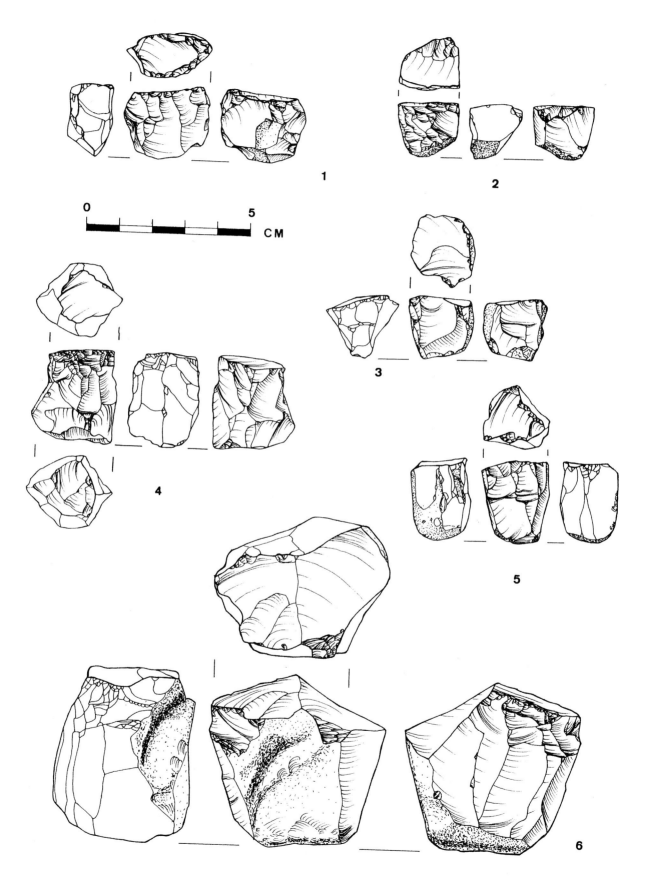

FIG. 10.5. Small cores (1–5) and a core with a single striking platform (6)

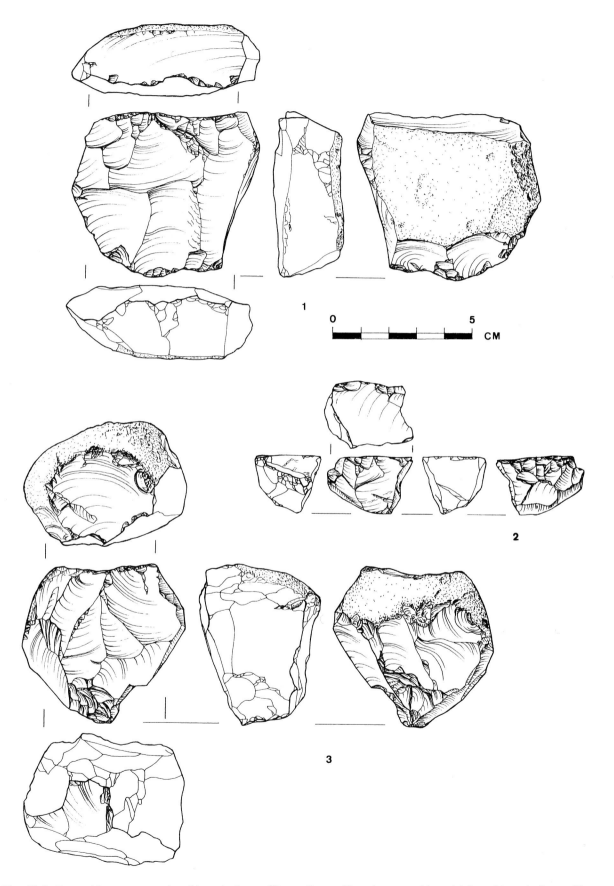

0     5 CM

1

2

3

Fig. 10.6. Core with two opposed striking platforms (1), small core (2) and a core with multiple striking platforms (3)

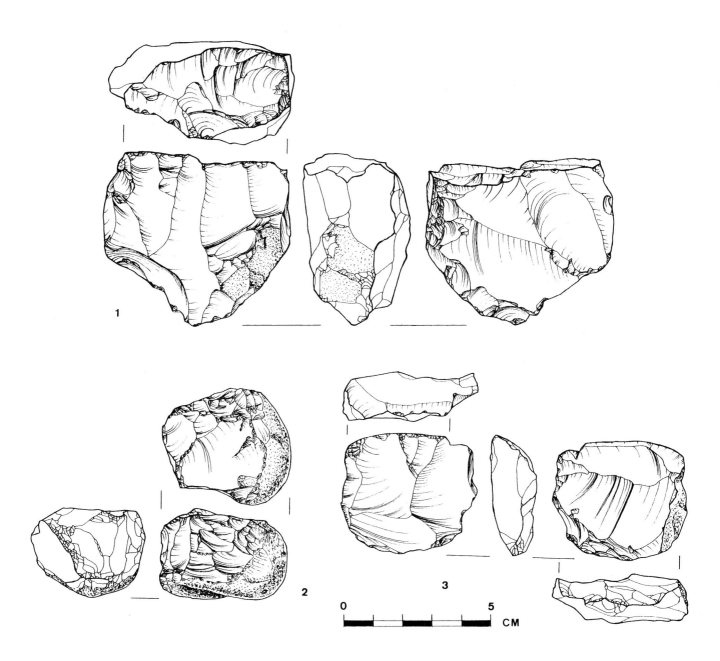

FIG. 10.7. Cores with multiple striking platforms

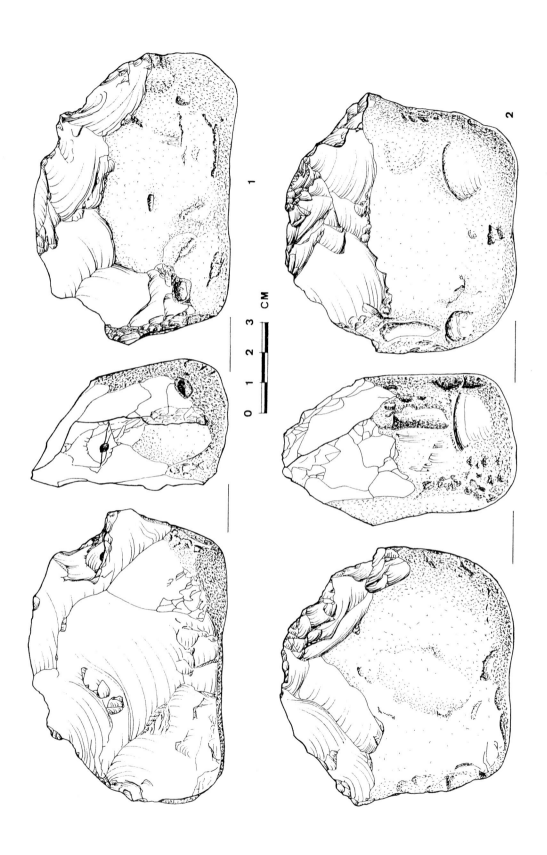

FIG. 10.8. Crested cores

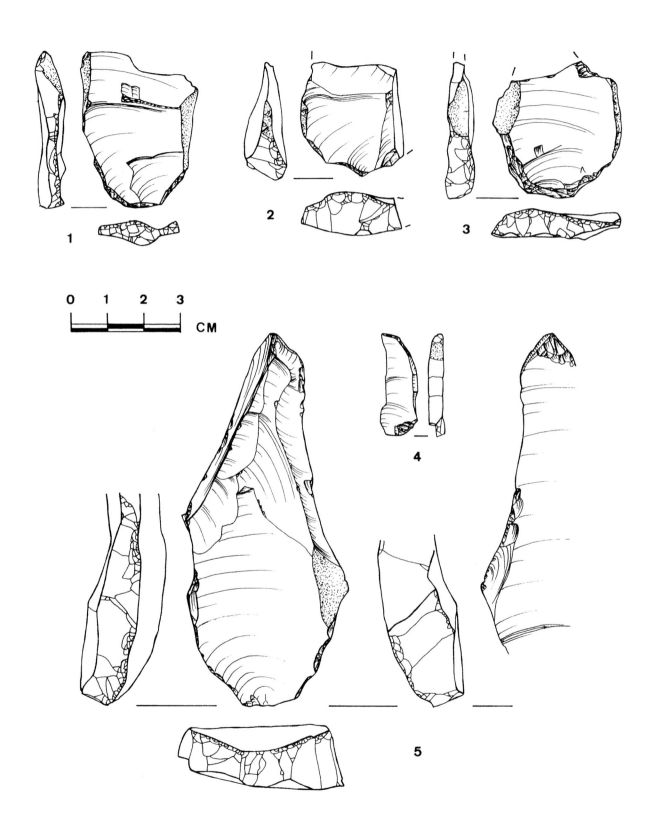

FIG. 10.9. Core trimming elements: core tablets

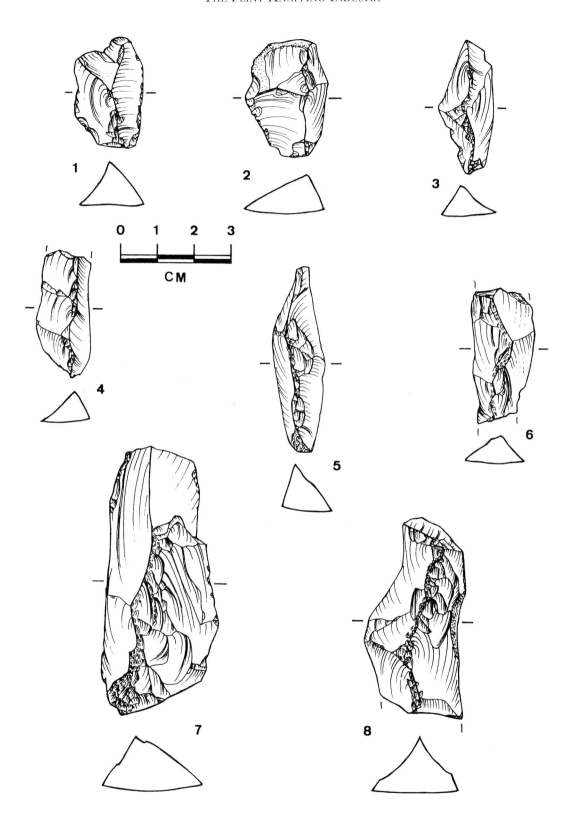

Fig. 10.10. Core trimming elements: ridge blades and flakes

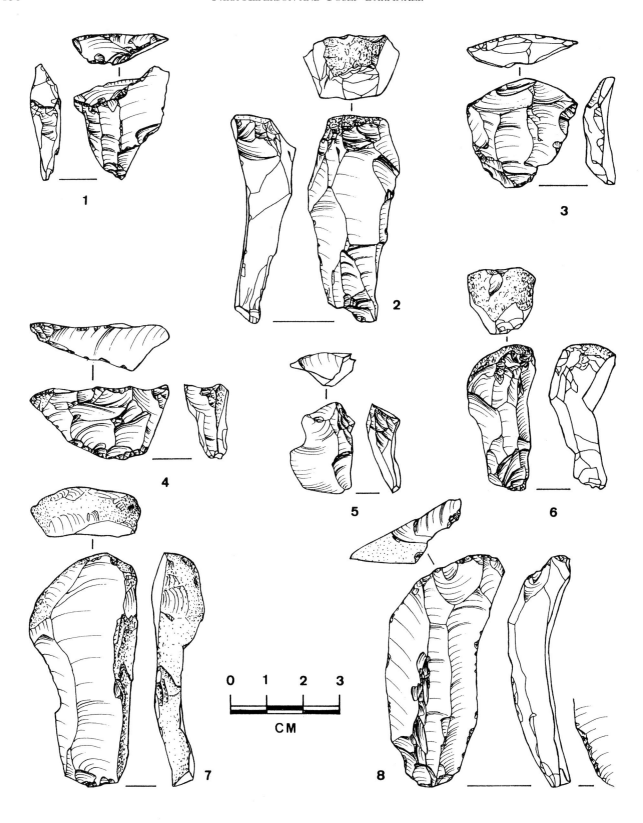

FIG. 10.11. Core trimming elements: overshoots

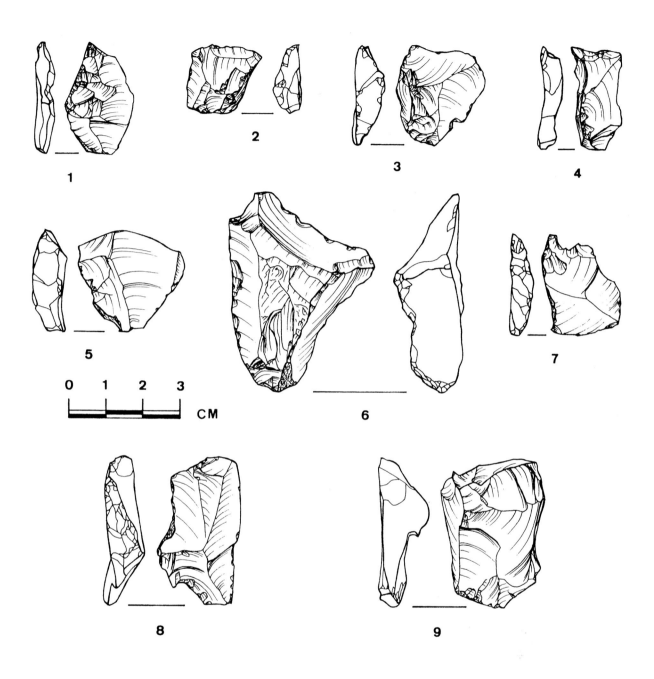

FIG. 10.12. Core trimming elements: various elements

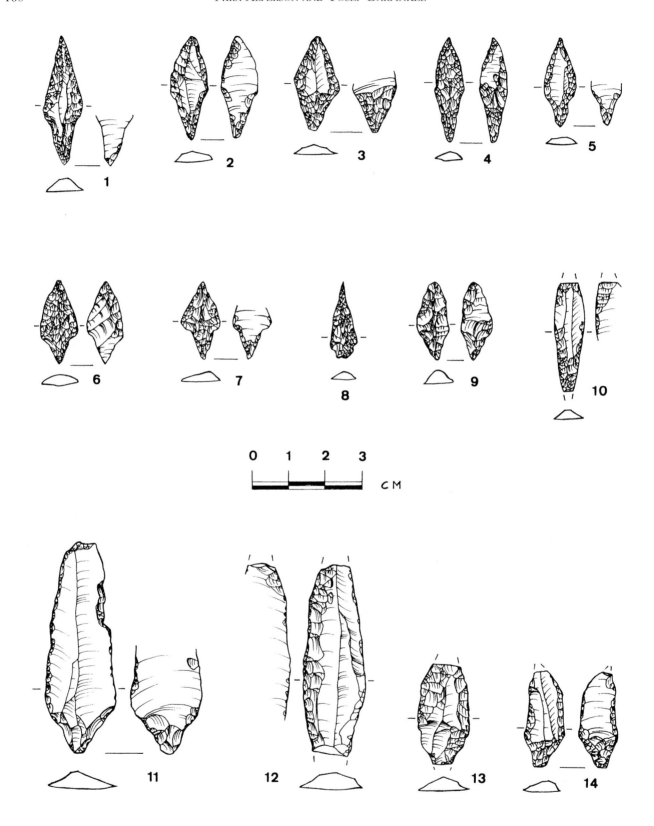

FIG. 10.13. Selected sample of arrowheads: Nizzanim (1–3, 5), Herzliya (4, 9–10), Haparsah (6–7), indeterminate fragment (8), large arrowheads (11–12), in preparation (13–14)

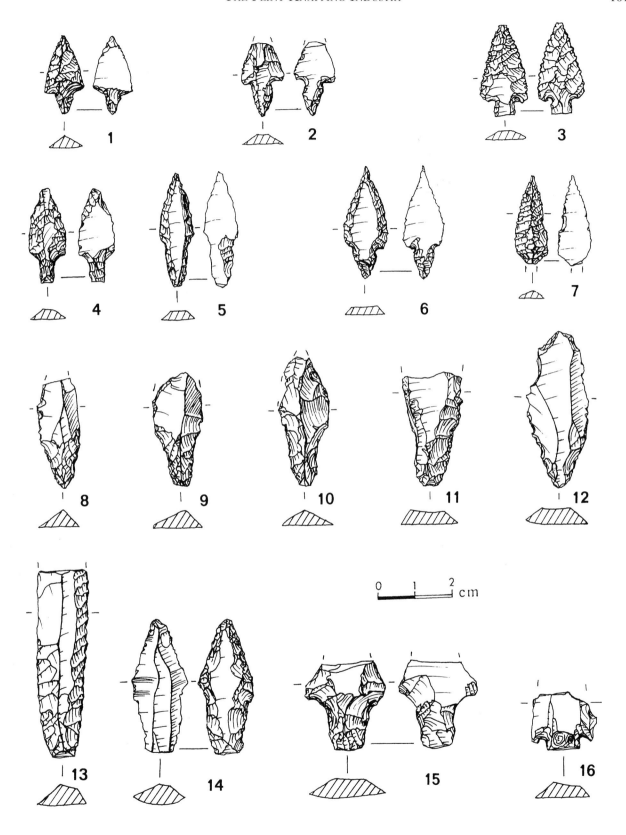

FIG. 10.14. Selected sample of arrowheads

### III. TYPOLOGICAL ASPECTS

Tool assemblages of the Yarmukian culture were discussed in several studies (Stekelis 1972; Gopher 1989; Gopher and Tsuk 1996; Garfinkel 1992). Nevertheless, a uniform typological list for the analysis of these assemblages and others of the Pre-Pottery and Pottery Neolithic periods in general is unfortunately absent. As previously mentioned, such a list is of great importance in conducting a systematic discussion on the tool assemblages of these periods (Bar-Yosef 1994). The tool assemblage of the renewed excavations at Sha'ar Hagolan comprises 988 artifacts, c. 3% of the flint assemblage. Following is a detailed description of the different categories of tool types (Table 10.3):

**Arrowheads (N=37).** As in the earlier Pre-Pottery Neolithic sites, elongated arrowheads generally classified as "Byblos" and "Amuq" types are present in Yarmukian assemblages (Garfinkel 1993). Fragments of large arrowheads (N=9) are present in the assemblage (Table 10.4), of which one is a burnt fragment of the "Jericho" type, typical of the Pre-Pottery Neolithic B (e.g., Munhata: Gopher 1989).

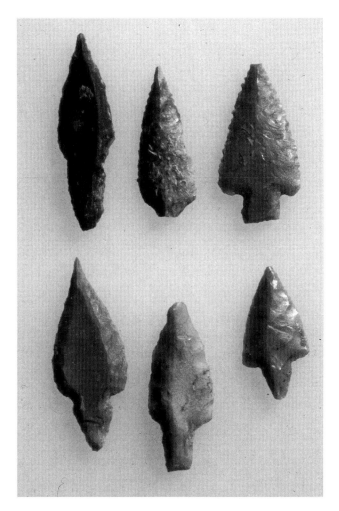

FIG. 10.15. A group of arrowheads

TABLE 10.3. Tool-type frequencies

| TYPE | N | % |
|---|---|---|
| Arrowheads | 37 | 3.74 |
| Sickle blades | 117 | 11.84 |
| Bifacial tools | 28 | 2.83 |
| Awls/borers | 77 | 7.79 |
| End-scrapers | 126 | 12.75 |
| Scrapers | 45 | 4.55 |
| Burins | 30 | 3.03 |
| Notches | 75 | 7.59 |
| Denticulates | 44 | 4.45 |
| Retouched pieces | 231 | 23.38 |
| Truncated pieces | 77 | 7.79 |
| Chopping tools | 18 | 1.82 |
| Multiple tools | 10 | 1.01 |
| Flake chisels | 17 | 1.71 |
| Varia | 56 | 5.66 |
| **Total** | **988** | **99.94** |

TABLE 10.4. Arrowhead counts

| TYPE | N | % |
|---|---|---|
| SMALL | | |
| Haparsah | 8 | 21.62 |
| Nizzanim | 5 | 13.51 |
| Herzliya | 7 | 18.92 |
| In preparation | 4 | 10.81 |
| Indeterminate fragments | 4 | 10.81 |
| LARGE | | |
| Fragments of large arrowheads | 8 | 21.62 |
| Jericho | 1 | 2.70 |
| **Total** | **37** | **99.99** |

The arrowhead category (Figs. 10.13–10.15) presents the prominent innovation of the Yarmukian tool kit, the appearance of three types of small arrowheads (c. 2–3 cm.), commonly fashioned with pressure flaking (Bar-Yosef 1981). The small arrowheads (N=28) comprise the bulk of the category (Figs. 10.13–10.15), an interesting feature considering that none were documented in Stekelis' excavations (Gopher 1994; Stekelis 1972). A possible assumption is that the absence of the small arrowheads in Stekelis' excavations was a result of a lack of sieving procedures, though it appears that sieving was sometimes applied (Bar-Yosef personal communication).

**Sickle blades (N=117).** Artifacts bearing gloss/sheen, produced as a result of their use as "sickles," were classified in the sickle blade category (Figs. 10.16–10.18). The frequency of this tool type is relatively high, constituting up to 12% of the tool assemblage. Apart from 11 items classified as varia, all the sickle blades of Sha'ar Hagolan are modified with deep denticulation on one or

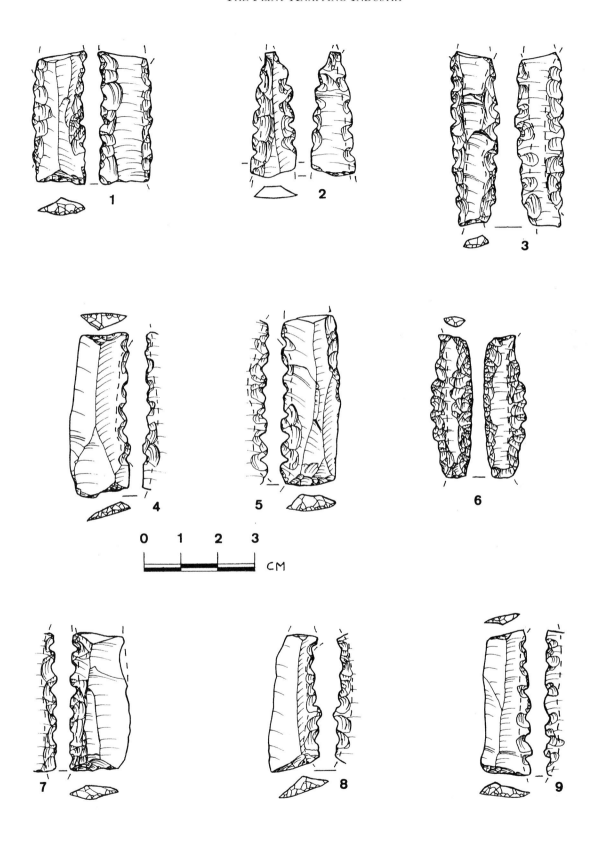

FIG. 10.16. Selected sample of sickle blades

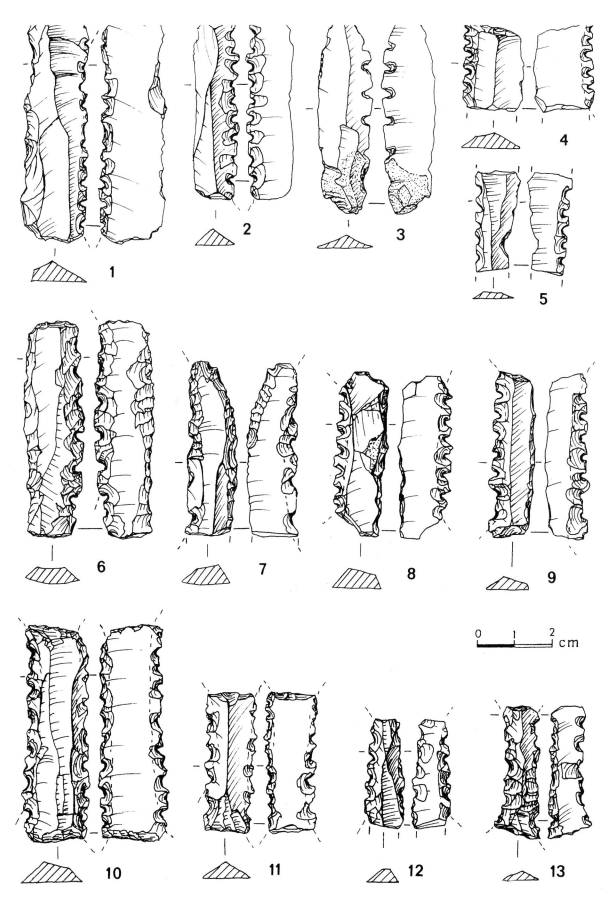

Fig. 10.17. Selected sample of sickle blades

TABLE 10.5. Sickle blade counts

| TYPE | | N | % |
|---|---|---|---|
| LATERAL EDGE A | LATERAL EDGE B | | |
| Deep denticulation | Retouch | 31 | 26.49 |
| Deep denticulation | Deep denticulation | 18 | 15.38 |
| Deep denticulation | Blank (no retouch) | 49 | 41.88 |
| Deep denticulation fragments | | 8 | 6.83 |
| Varia | | 11 | 9.40 |
| Total | | 117 | 99.98 |

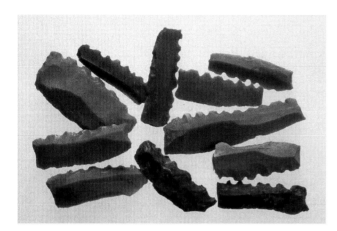

FIG. 10.18. A group of sickle blades

both edges, a feature described by Stekelis (1951, 1972) and Garfinkel (1992, 1993) as a prominent characteristic of the Yarmukian sickle blades. The Sickle blades were sorted into three major groups according to type of retouch and its location (Table 10.5). The largest group are the sickle blades with one blank edge and deep denticulation on the other edge. The sickle blades of the varia group are usually modified with subtle retouch on one or two edges.

**Bifacial tools (N=28).** The bifacial tools category consists of tools modified by bifacial removals resulting in sharp edges. These constitute c. 3% of the tool assemblage. Axes comprise the bulk of this category, together with adzes, chisels and bifacial knives (Table 10.6) and are mostly shaped to a narrow-elongated form (Fig. 10.19). Two of the 16 axes are polished at the edge. Only one item classified as an ax-spall, i.e., the product of resharpening of the ax's edge, was documented. It is therefore likely that procedures of reshaping or resharpening of the bifacial tools were not prevalent at the site.

**Awls/Borers (N=77).** This category comprises c. 8% of the tools, clearly low frequencies when compared to their high frequency in Stekelis' excavations. His report refers to c. 770 awls, up to 34% of the total lithic assemblage. Of the 77 items in this category, 12 are borers

and the remaining 65 are various types of awls (Fig. 10.20: 5–14).

**End-Scrapers (N=126).** Various types of end-scrapers comprise c. 13% of the tools (Figs. 10.21, 10.22: 4, 6–8). The majority of end-scrapers are carinated (Table 10.7) and the bulk of these are modified on thick primary flakes.

**Scrapers (N=45).** Artifacts with broad and continuous retouch on one or two lateral edges were classified as scrapers (Fig. 10.25: 6). Forty-five scrapers were documented comprising c. 5% of the tools. All scrapers are modified on flakes, seven of which are thick robust flakes (Table 10.8). Apart from five scrapers with retouch on the ventral face, all scrapers are retouched on their dorsal face.

**Burins (N=30).** Burins comprise c. 3% of the tools (Fig. 10.23: 1,2,4,5). Seven additional items with burin removals are included in the multiple tool category. In

TABLE 10.6. Bifacial tool counts

| TYPE | N | % |
|---|---|---|
| Axes | 14 | 50.00 |
| Polished axes | 2 | 7.14 |
| Adzes | 3 | 10.71 |
| Chisels | 3 | 10.71 |
| Bifacial knives | 3 | 10.71 |
| Indeterminate fragments | 3 | 10.71 |
| Total | 28 | 99.98 |

TABLE 10.7. End-scraper counts

| TYPE | N | % |
|---|---|---|
| End-scraper | 35 | 27.77 |
| Carinated end-scraper | 41 | 32.54 |
| Nosed end-scraper | 16 | 12.70 |
| Circumference end-scraper | 15 | 11.90 |
| Denticulate end-scraper | 4 | 3.17 |
| Double end-scraper | 3 | 2.38 |
| Micro end-scraper (on bladelet) | 1 | 0.80 |
| Fragments | 11 | 8.73 |
| Total | 126 | 99.99 |

Table 10.8. Scraper counts

| TYPE | N | % |
|---|---|---|
| On flake | 31 | 68.88 |
| On robust flake | 7 | 15.55 |
| On ventral face | 5 | 11.11 |
| Fragments | 2 | 4.44 |
| **Total** | **45** | **99.98** |

Table 10.9. Retouched piece counts

| BLANK TYPE | N | % |
|---|---|---|
| Flake | 122 | 52.81 |
| Blade | 79 | 34.19 |
| Bladelet | 18 | 7.79 |
| Core waste | 2 | 0.86 |
| Fragments | 10 | 4.32 |
| **Total** | **231** | **99.97** |

Table 10.10. Truncated piece counts

| BLANK TYPE | N | % |
|---|---|---|
| Primary elements | 2 | 2.59 |
| Flake | 25 | 32.46 |
| Blade | 38 | 49.35 |
| Bladelet | 12 | 15.58 |
| **Total** | **77** | **99.98** |

contrast to the low frequencies of the burins themselves, the burin spall counts are high (N=205). This is possibly the result of reshaping or resharpening procedures applied to the burins, which are evidential on some of the burin spalls (Fig. 10.23: 3,6)

**Notches (N=75) and Denticulates (N=44).** Notches comprise c. 8% of the tools. They are located at various positions on the artifacts. In two cases, two opposed notches are modified on one flake (Fig. 10.24: 2,7). Denticulates refer to artifacts bearing two notches or more on one edge. The denticulates category is notably small, comprising c. 4% of the tool assemblage.

**Retouched pieces (N=231).** Retouched pieces constitute the most frequent component in the tool assemblage (23%). The bulk of these are retouched flakes (Fig. 10.24: 1, 3). Retouched blades constitute up to c. 34% of the retouched pieces (Table 10.9) and are divided as follows: backed blades (5); blades retouched on one edge (39); blades retouched on two edges (30); and robust (over 3 cm. breadth) retouched blades (5).

**Truncated pieces (N=77).** This category refers to artifacts with their proximal and/or distal ends truncated by retouch perpendicular to the ventral face (Figs. 10.20: 1–4; 10.25: 1–5). Truncated pieces constitute up to c. 8% of the tools and vary in blank types, the majority being truncated blades (Table 10.10). It is possible that one of

these items is an intrusive Canaanite sickle blade dated to the Middle Bronze I (Fig. 10.25: 1).

**Chopping tools (N=18).** The chopping tool category is notably small, constituting up to 2% of the tool assemblage. These items are modified on river pebbles through unifacial or bifacial removals resulting in the creation of a sharp edge (Fig. 10.24: 8).

**Multiple tools (N=10).** This category refers to tools which present more than one typological identification and are thus unsuitable for classification in the formal typological groups. The various types in this category include combinations of truncation and notch, end-scraper and notch, burin and notch, burin and end-scraper.

**Flake chisels (N=17).** This category comprises items commonly referred to as "fabricators" or *outils écaillés*. These are flakes or blades that carry subsequent unipolar or bipolar removals on their ventral and/or dorsal face. Since no preparation of a striking platform was evident on these items, they were not classified as cores.

**Varia (N=56).** A particularly interesting artifact type present in the varia category is the tabular knife type also known as the Tile Knife which is present in Levantine Neolithic assemblages both in Pre-Pottery and Pottery Neolithic periods (Betts and Helms 1987; Palumbo and Parenti 1997; Rollefson *et al.* 1994). The item from Sha'ar Hagolan is polished on both faces and engraved with horizontal and oblique lines on one face (Fig. 10.24: 4).

A category which is not included in the tool category is the "signs of use" category (N=635). It refers to artifacts that bear retouch which does not exceed 1 cm in length and is usually irregular and subtle. The separation of these items from the tool assemblage is based on the assumption that the signs of use can be either the result of intended use or the result of random trampling of these items. However it is interesting to note that the breakdown of these artifacts according to blank types is similar to that observed in the retouched pieces category. Thus, it is possible that some of these artifacts were indeed in use and that the appearance of use-signs on them is not random.

While flakes are the prominent product of the Sha'ar Hagolan industry, blades appear in much higher frequencies in the tool assemblage. This feature is particularly evident in the retouched pieces category in which retouched blades constitute up to 34% and in the category of truncated pieces, where blades constitute up to 49%. It therefore seems that blades were intentionally chosen as blanks for the modification of certain tools.

Another feature emerging from the typological analysis is that several differences exist between Stekelis'

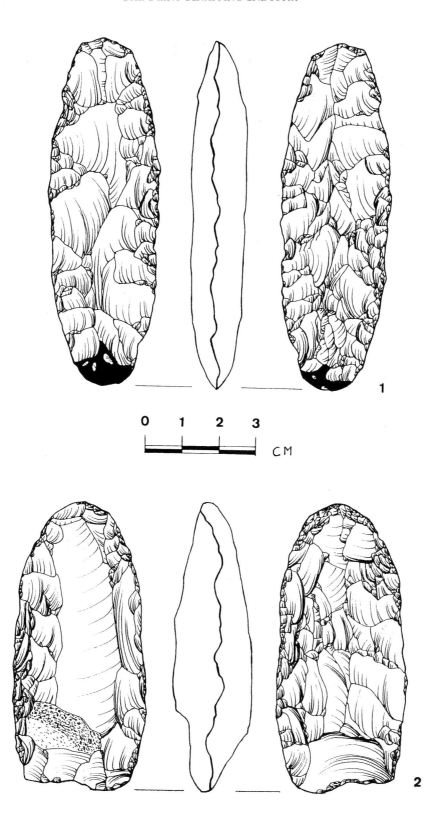

FIG. 10.19. Selected flint axes

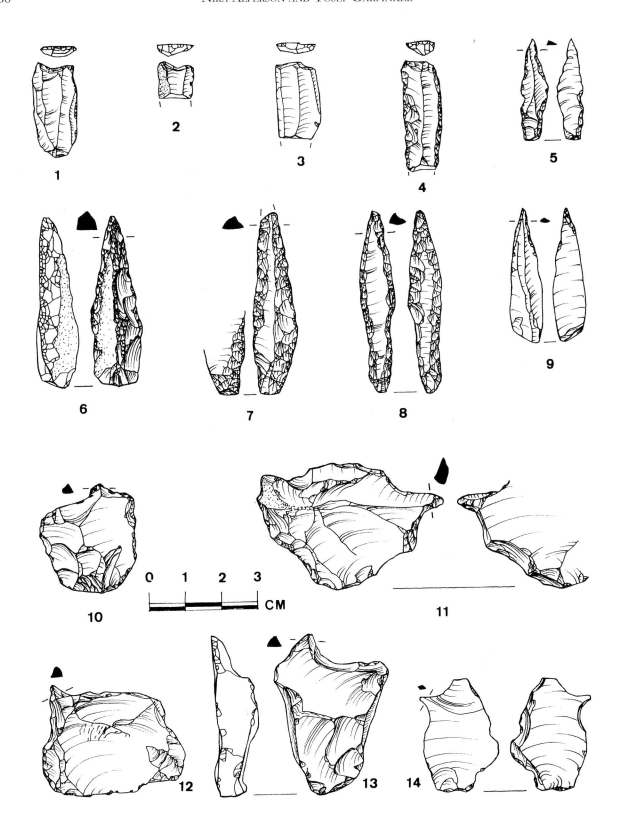

FIG. 10.20. Truncated blades (1–4) and awls/borers (5–14)

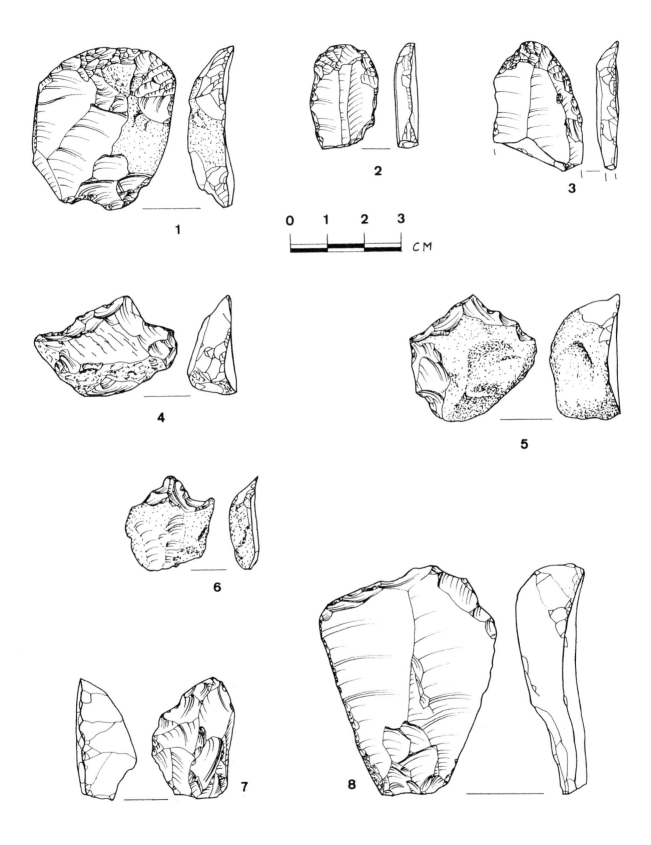

FIG. 10.21. Selected sample of end-scrapers

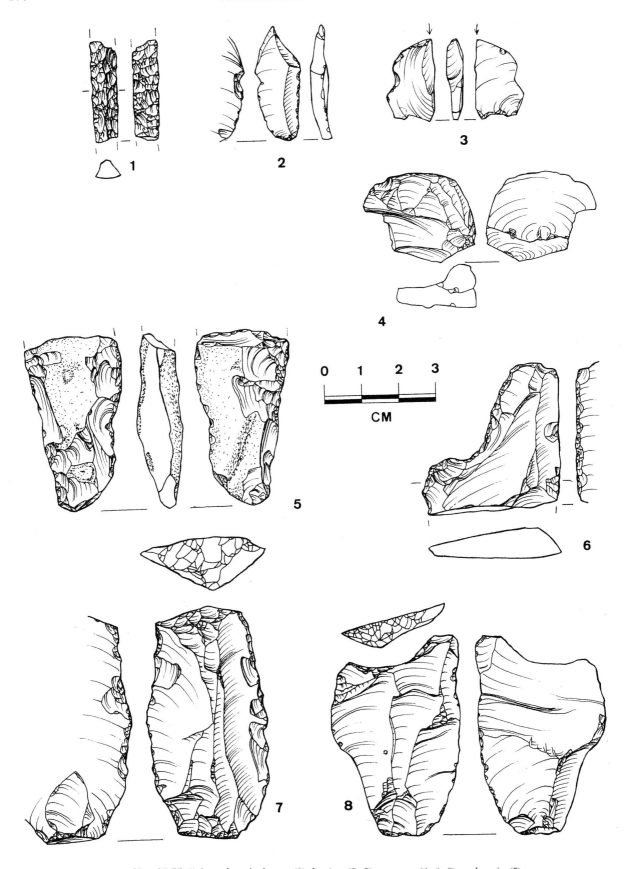

FIG. 10.22. Selected tools: borer (1), burins (2–3), scraper (4, 6–8) and varia (5)

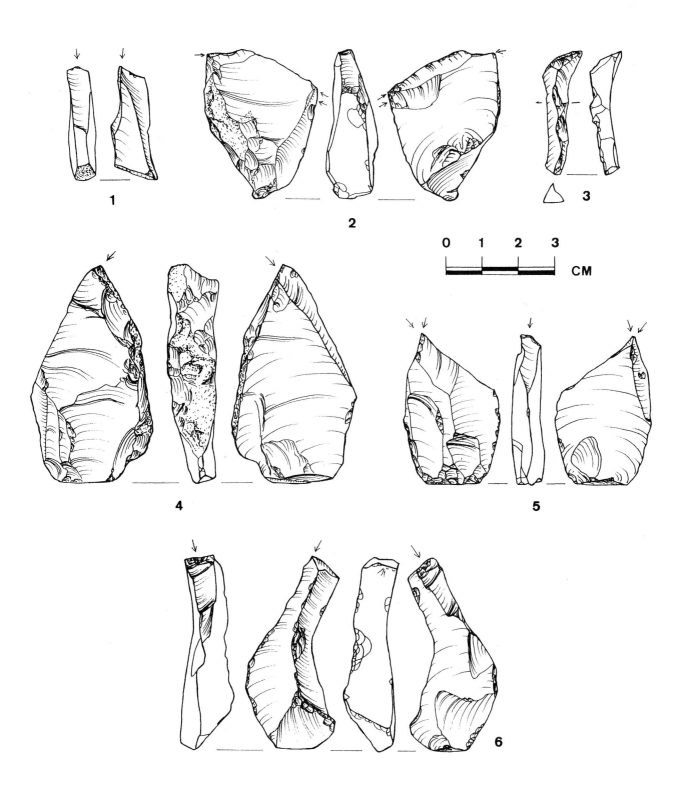

FIG. 10.23. Selected burins (1–2), burin spall (3) and reshaping burin spall (6)

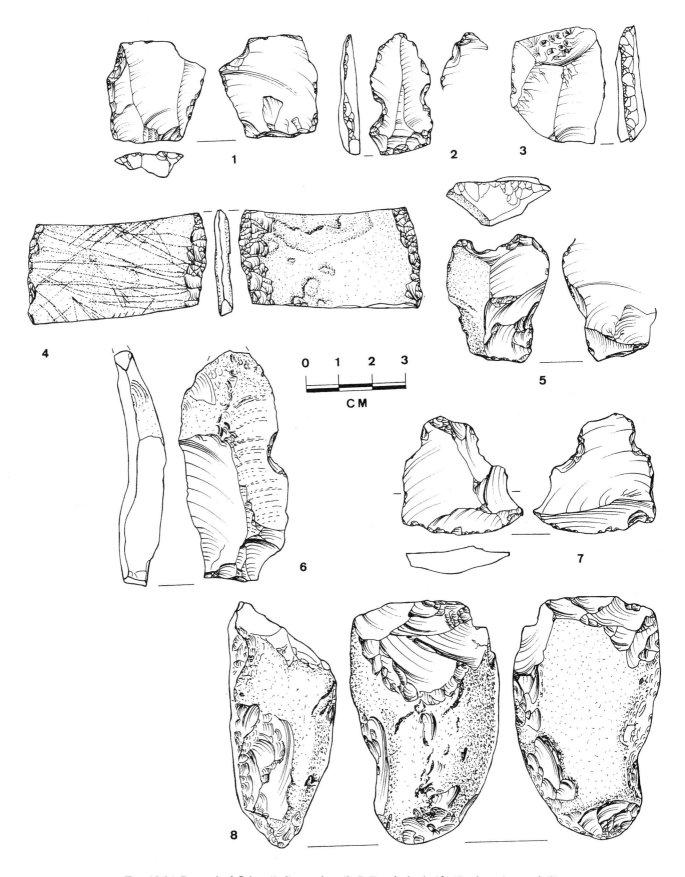

FIG. 10.24. Retouched flakes (1, 3), notches (2, 5–7), tabular knife (4), chopping tool (8)

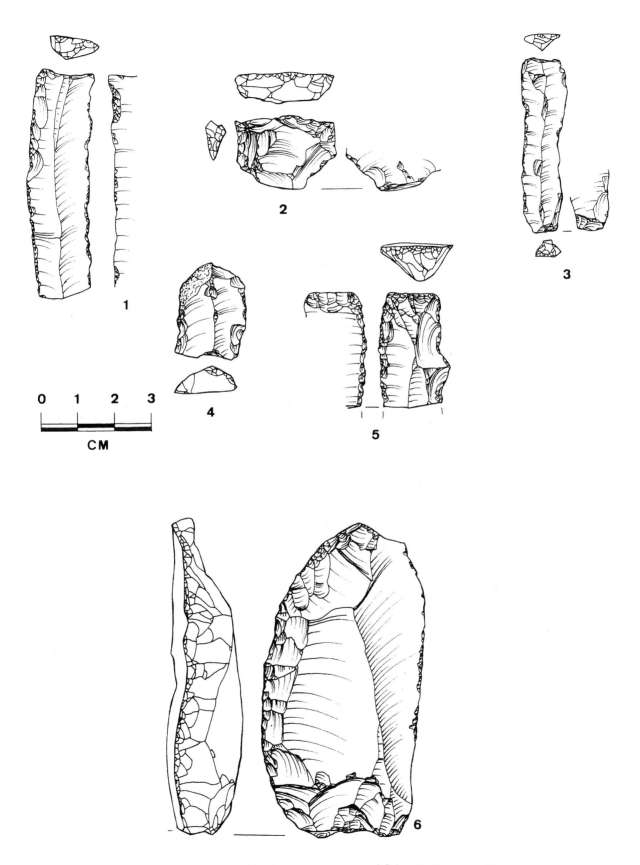

Fig. 10.25. Truncated blades (1, 3, 5), truncated flakes (2, 4), scraper (6)

sample and the new one. For instance, the frequency of awls in the study assemblage is relatively low, whereas small arrowheads are unknown in Stekelis' sample. These differences may be the result of spatial differentiation, which is discussed in detail in the following section.

## IV. Aspects of Spatial Distribution

The renewed excavations at Sha'ar Hagolan unearthed three monumental buildings, a revelation which contradicted the assumption that structures at Yarmukian sites are rounded pits rather than solid architecture. The discussed flint assemblage originates from Building Complex I – a 220 sq.m. complex composed of one roughly triangular courtyard surrounded by eight rooms (Fig. 10.26). The probability that different activities were carried out in different parts of the building induced an examination of several locations in order to determine whether the flint assemblage presents patterns of spatial variability. Through the analysis of the 1996 assemblage, several locations were chosen in order to examine the potential existence of such patterns. Some of these are presented here:

1. **Locus 64**: a rounded room at the southwestern corner of the building; excavated to a depth of 24 cm.
2. **Locus 69**: a rectangular room at the southeastern corner of the building; excavated to a depth of 21 cm.
3. **Locus 53**: the courtyard area between Locus 64 and Locus 69; excavated to a depth of 29 cm.

Two aspects were compared: industry frequencies; and burnt versus non-burnt item frequencies. The small sample size did not allow a comparison of tools and cores. A comparison of the different loci to the total assemblage (Table 10.11) displays a certain degree of variation within the different locations. Locus 69, the rectangular room at the southeastern corner of the building, is of special interest. The flint assemblage from this room displays higher frequencies of primary elements, cores (two of which are in preparation), complete pebbles and core trimming elements together with notably lower frequencies of chips and chunks. A possible interpretation for this pattern can be that the procedures of core modification were emphasized in this part of the building, perhaps insinuating in favor of a "knapping area." Note, however, that the flint assemblage of Locus 69 consists of only 127 items, so the relatively high frequency of cores is in fact 5 items only. The nearby courtyard area of Locus 53 resembles Locus 69 in most of the examined features, while there the sample size is

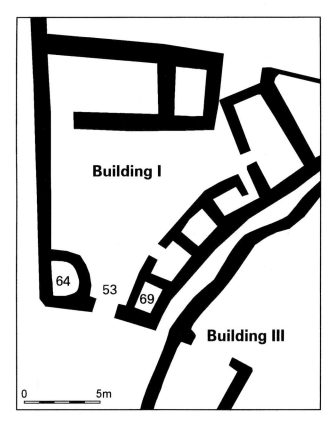

Fig. 10.26. Schematic plan of Building Complex I with the locations discussed

Table 10.11. Industry frequencies and burnt item frequencies at different locations, in comparison to the total assemblage (1996 season)

| CATEGEGORY | Locus 53 (N=3053) | Locus 69 (N=127) | Locus 64 (N=970) | Total 1996 (N=18,511) |
|---|---|---|---|---|
| Primary elements | 32.13 | 32.28 | 25.77 | 21.21 |
| Flakes | 27.8 | 22.83 | 25.97 | 25.63 |
| Blades | 3.2 | 3.93 | 4.53 | 3.33 |
| Bladelets | 1.8 | 2.26 | 2.26 | 2.69 |
| CTE | 1.86 | 3.93 | 1.13 | 1.42 |
| Pebbles | 0.26 | 0.78 | – | 0.08 |
| Cores | 3.34 | 3.93 | 0.82 | 1.29 |
| Burin spalls | 0.36 | – | 0.41 | 0.32 |
| Ax spalls | – | – | – | 0.005 |
| Chips | 9.33 | 9.44 | 15.67 | 17.62 |
| Chunks | 15.13 | 15.74 | 18.04 | 21.15 |
| Tools and use-signs | 4.74 | 5.51 | 7.74 | 5.18 |
| **Total** | **99.95** | **99.94** | **99.96** | **99.92** |
| Burnt items | 22.2 | 20.47 | 30.51 | 28.41 |
| Non-burnt items | 77.79 | 79.52 | 69.48 | 71.58 |
| **Total** | **99.99** | **99.99** | **99.99** | **99.99** |

adequate, with 102 cores, four of which are in preparation. In addition, in both areas the ratio of burnt/non-burnt items is lower than in Locus 64. There, categories characteristic of core modification procedures appear in low frequencies in comparison with the entire assemblage, while the frequencies of tools and artifacts with signs of use is higher. Furthermore, the frequency of burnt items is higher in Locus 64. These features imply that other activities might have been carried out there.

Further spatial analysis is required in order to achieve a comprehensive understanding of the different activities. Compilation of such data with information retrieved from other find categories (e.g., pottery, stone implements, figurines, faunal remains) will enable a more thorough examination of these aspects.

## V. CONCLUSIONS

As mentioned in the introduction to our discussion, Stekelis' observation that the entire process of production, modification and tool use occurred at the site is confirmed by the data retrieved from the new excavations. The inhabitants of Sha'ar Hagolan produced the flint assemblage on site, a reconstruction that is supported by successful refitting of several artifacts from the 1997 assemblage (Matskevich, Chapter 11 in this volume). Combining the various data displayed in the material culture of Sha'ar Hagolan will enable a fascinating reconstruction of the activities and customs of the Sha'ar Hagolan inhabitants during Yarmukian times.

### Acknowledgments

This research was supported by the Israel Science Foundation, founded by the Israel Academy of Sciences and Humanities. The authors wish to thank E. Hovers for reading and commenting on early drafts of this paper, J. Moskovitch for artifact drawing and D. Harris for the photographs.

## BIBLIOGRAPHY

Alperson, N. 1999. The Flint Industry at the Site of Sha'ar Hagolan – A Report for the 1996 Season. Seminar Paper, The Hebrew University, Jerusalem (Hebrew).

Bar-Yosef, O. 1981. The Pre-Pottery Neolithic Period in the Southern Levant. In Sanlaville, P. and Cauvin, J. (eds.) *Préhistoire du Levant*, pp. 555–567. Paris: CNRS.

Bar-Yosef, O. 1994. Form, Function and Numbers in Neolithic Lithic Studies. In Gebel, H.G. and Kozlowski, S.K. (eds.) *Neolithic Chipped Stone Industries of the Fertile Crescent: Proceedings of the First Workshop on PPN Chipped Lithic Industries* (Studies in Early Near Eastern Production, Subsistence, and Environment 1), pp. 5–13. Berlin: *ex oriente*.

Betts, A. and Helms, S. 1987. A Preliminary Survey of Late Neolithic Settlements at el-Ghirqa, Eastern Jordan. *Proceeding of the Prehistoric Society* 53: 327–336.

Garfinkel, Y. 1992. The Material Culture in the Central Jordan Valley in the Pottery Neolithic and Early Chalcolithic Periods. Unpublished Ph.D. Thesis, The Hebrew University, Jerusalem (Hebrew).

Garfinkel, Y. and Nadel, D. 1989. The Sultanian Flint Assemblage from Gesher and its Implications for Recognizing Early Neolithic Entities in the Levant. *Paléorient* 15: 139–151.

Garfinkel, Y. 1993. The Yarmukian Culture in Israel. *Paléorient* 19: 115–134.

Gopher, A. 1989. *The Flint Assemblages from Munhata* (Les Cahiers du Centre de Recherche Français de Jerusalem 4). Paris: Association Paléorient.

Gopher, A. 1994. *Arrow Heads of the Neolithic Levant* (American Schools of Oriental Research Dissertation Series Vol. 10). Winona Lake, IN: Eisenbrauns.

Gopher, A. and Tsuk, T. 1996. *The Nahal Qana Cave. Earliest Gold in the Southern Levant* (Monograph Series of the Institute of Archaeology Tel Aviv University No. 12). Tel Aviv: Tel Aviv University.

Palumbo, G. and Parenti, F. 1997. Les Couteax Yarmoukiens Polis Sur Plaquette du Site de Shayyeh, Vallée du Zarqa, Jordanie. *Paléorient* 22: 129–132.

Quintero, L.A. and Wilke, P.J. 1995. Evolution and Economic Significance of Naviform Core-and-Blade Technology in the Southern Levant. *Paléorient* 21: 17–33.

Rollefson, G., Forstadt, M. and Beck, M. 1994. A Preliminary Typological Analysis of Scrapers, Knives and Borers from 'Ain Ghazal. In Gebel, H.G. and Kozlowski, S.K. (eds.) *Neolithic Chipped Stone Industries of the Fertile Crescent. Proceedings of the First Workshop on PPN Chipped Lithic Industries* (Studies in Early Near Eastern Production, Subsistence, and Environment 1), pp. 445–466. Berlin: *ex oriente*.

Stekelis, M. 1951. A New Neolithic Industry: The Yarmukian of Palestine. *Israel Exploration Journal* 1: 1–19.

Stekelis, M. 1972. *The Yarmukian Culture of the Neolithic Period*. Jerusalem: Magnes Press (first published in Hebrew in 1966).

Wilke, P. J. and Quintero, L.A. 1994. Naviform Core-and-Blade Technology: Assemblage Character as Determined by Replicative Experiments. In Gebel, H.G. and Kozlowski, S.K. (eds.) *Neolithic Chipped Stone Industries of the Fertile Crescent. Proceedings of the First Workshop on PPN Chipped Lithic Industries* (Studies in Early Near Eastern Production, Subsistence, and Environment 1), pp. 33–60. Berlin: *ex oriente*.

# 11

# Notes on Conjoinable Flint Pieces

## Zinovi Matskevich

## I. Introduction

This paper presents the results of an analysis of a few conjoinable flint artifacts from the renewed excavation of Sha'ar Hagolan. The main objective is to supplement the results of the detailed techno-typological study (Alperson and Garfinkel, Chapter 10 in this volume) by providing additional data that enables consideration of various aspects of the lithic industry from a slightly different perspective.

It should be noted that the variability of Yarmukian lithic technology appears to be exceptionally high and is still poorly understood (Garfinkel 1993; Gopher and Gophna 1993). As is evident from the analysis of the Sha'ar Hagolan assemblage, the bulk of the industry is simple flake production (Alperson and Garfinkel, Chapter 10 in this volume). On the other hand, several assemblages (e.g. Hamadiya: Garfinkel and Goldman in preparation) are characterized by an elaborate blade industry. As a hypothesis, it can be stated that complex processes, probably related to development of specialization, are involved in the observed variability of the Yarmukian lithic industry.

An additional level of variability exists on an inter-site level and is reflected in different knapping modes within a particular lithic assemblage. Nevertheless, most of the current research has been concentrated on a few well-defined *fossiles directeurs* (such as characteristic forms of sickle blades and arrowheads). On other hand, general quantitative descriptions of an assemblage display the prevalent character of an industry but do not enable us to focus on specific aspects. This paper attempts to describe a specific reduction sequence as an example of the general technological variability of the Sha'ar Hagolan assemblage. Refitting, carried out on a few flint items from the assemblage, enables us to describe the sequence in greater detail.

Lithic refitting studies have become, in the recent years, a widely accepted method in prehistoric research and are used for the investigation of numerous topics: core reduction sequence as a chrono-cultural marker (e.g. Volkman 1983), post depositional processes (e.g. Villa 1982), inter-cultural technological and spatial variability (e.g. Goring-Morris *et al.* 1998), contextual analysis of a lithic assemblage (e.g. Cahen *et al.* 1979), etc. In nearly all cases, refitted assemblages come from small sites of short occupational duration, mostly of Paleolithic age.

In terms of flint refitting, Sha'ar Hagolan presents a totally different case. The site is a large Neolithic settlement with a long occupational sequence (Stekelis 1972; Garfinkel 1992; Garfinkel and Miller, Chapter 2 in this volume). The lithic assemblage unearthed in the main area of excavation (Area E) is exceptionally large with c. 70,000 items from the four first seasons (Alperson and Garfinkel, Chapter 10 in this volume, and my own analysis). Although the renewed excavation focuses mainly on a single uppermost Yarmukian stratigraphical phase of the site, doubtless this excavated material reflects a long occupational interval.

All those factors make a statistically significant amount of refitting (even with more systematic attempts than those made at present) unlikely. Nevertheless it should be pointed out that although the number of refitted items presented here is small (three complexes of three items in each), their significance seems to be notable and enables discussion of several important issues.

## II. MATERIAL AND METHODOLOGY

The conjoinable artifacts were detected during a techno-typological analysis of the flint assemblage from the excavation of the 1997 season (Garfinkel 1997), which includes c. 34,000 artifacts. Attempts at refitting, though not systematic, were carried out during analysis of all the excavated material, but only in one case were they successful. All the refitted artifacts originated from loci 112 and 115 at the southeastern part of Courtyard A of Building I (see Garfinkel and Ben-Shlomo, Chapter 5 in this volume).

FIG. 11.1. Refitted complex 1: three refitted flakes

## III. DESCRIPTION OF CONJOINS

### Raw Material

The refitted artifacts are of gray-banded (Complex 1) and pale brown (complexes 2 and 3) Eocene flint with heavily battered cortex. This is the most common raw material in the Sha'ar Hagolan assemblage. The material is locally available and originated from the bed of the nearby Yarmuk River, where it appears in the form of pebbles, mostly of small and medium sizes (C. Delage, personal communication). The quality of the raw material is relatively low. As will be shown below, the form of the raw material (small pebbles) was in many cases the factor that determined the form of the reduction sequence.

**Complex 1**. Three refitted flakes (Figs. 11.1, 11.4: 1; Table 11.1). After removing the first primary flake (item A) and additional flakes partly covered by cortex, a few bladelets were detached before the next refitted item (B) which is a wide flake with four parallel elongated scars. Then the flaking was continued, and the next item in the sequence (C) is a thick, curved bladelet. All the items were detached from a single plain striking platform.

The only preparation of the core's platform was to remove a cortical flake before the decortication of the

flaking surface and slightly blunting the platform during the reduction sequence. The flaking was carried out on the narrow side of a small flint pebble. The detached flakes removed part of the opposite side of the core, leaving some cortex on their distal extremity. It should therefore be concluded that all the flaking was aimed to produce small, short items (the length of all the pieces is 26–29 mm.). It seems that the objective of the reduction sequence was production of elongated flakes or bladelets. Nevertheless, there was no special treatment of the core (such as preparation of a ridge or removal of a core tablet). Formation of a convexity, necessary for production of the first blade, occurred during the decortication of the core. This was done from the same striking platform as the following flaking.

**Complex 2**. Three refitted flakes (Figs. 11.2, 11.4: 2; Table 11.1). The series presents an advanced stage of a reduction sequence similar to that of Complex 1. Three flakes were detached from a single plain blunted striking platform. The first one (A) is a small flake (20 mm. long) which probably represents an unsuccessful blow. The following two items (B, C) are an elongated flake and a

TABLE 11.1. Basic characteristics of refitted pieces

| Complex | Item | Provenance locus / basket | Category of debitage | Length (mm.) | Width (mm.) | Thickness (mm.) | Number of previous scars* | Type of striking platform |
|---------|------|---------------------------|----------------------|--------------|-------------|-----------------|---------------------------|---------------------------|
| 1 | A | 115/593 | primary flake | 28 | 26 | 7 | 0 | plain |
|   | B | 112/422 | flake | 29 | 24 | 6 | 3 | plain |
|   | C | 115/593 | bladelet | 26 | 12 | 4 | 2 | plain |
| 2 | A | 115/593 | flake | 20 | 11 | 3 | 2 | plain |
|   | B | 115/593 | flake | 30 | 20 | 6 | 4 | plain |
|   | C | 115/593 | blade | 27 | 13 | 5 | 3 | plain |
| 3 | A | 115/593 | overshoot blade | 32 | 16 | 6 | 7 | dihedral |
|   | B | 115/593 | flake | 21 | 28 | 4 | 3 | plain |
|   | C | 115/593 | core | 47 | 36 | 25 | 15 | ---- |

* Scars greater than 5 mm. in length were counted

FIG. 11.2. Refitted complex 2: three refitted flakes

blade. These two items removed the distal extremity of the core, which is covered by cortex. Remains of cortex also appear on the right lateral side of the item C. That enables us to reconstruct the initial form of the core as a pebble, similar to that used in the previous complex. Scars of previous blows, which are visible on the dorsal face of the items, show detaching of elongated pieces with similar characteristics from the same striking platform at previous stages of the reduction sequence.

**Complex 3**. Three items: a core with two refitted flakes (Figs. 11.3, 11.4: 3; Table 11.1). As in the previous cases, the initial form of the core can be reconstructed as an elongated flint pebble. The preparation was restricted to removing few primary flakes in order to form two plain opposed striking platforms and a narrow flaking surface for production of elongated items. At the stage preceding

the removal of the refitted items, elongated flakes/blades were removed from both the platforms on the narrow side of the core. The platforms appear to have been occasionally blunted during the sequence. It is impossible to determine whether both the platforms were used simultaneously or alternately on the basis of the refitted material, though it seems likely that every time the flaking was done from one principal striking platform. The first refitted item (A) is the last blade in this series. The blade is an overshoot, so its length (32 mm.) is the maximal possible length of all the previous items. Following its removal, the core was rotated 90° and an additional series of flakes was removed on its wider side from the same striking platform as item A. The first item in the series (B) is a thin, small, transverse flake. The subsequent two or three flakes, which were removed before the core (item C) was finally abandoned, appear to have had similar characteristics. The core at its final stage could be classified as an amorphic core for flake production with two striking platforms (Fig. 11.4: 3).

## IV. DISCUSSION AND CONCLUSIONS

The three complexes of refitted items present the same general technological characteristics with the same reduction sequence (Table 11.2):

1. Choice of raw material: small flint pebbles of local source were chosen for production.
2. Decortication or rough out: few primary flakes were removed in order to prepare a striking platform and form of a flaking surface on the narrow side of the pebble.
3. Debitage: a series of elongated flakes or short irregular blades were removed from one (complexes 1 and 2) or two (Complex 3) plain striking platforms which were occasionally blunted during the flaking. Some of the items in the series (as item B of Complex 1) were broad flakes that were probably removed in order to renew the flaking surface. It should be noted that the natural convexity and narrowness of the pebble was used in order to produce elongated items.

FIG. 11.3. Refitted complex 3: a core and two refitted flakes

TABLE 11.2. Stages of the reduction sequence and the related refitted items

| Complex | Decortication | Debitage | Final flaking | Abandoned core |
|---------|---------------|----------|---------------|----------------|
| 1 | A | B, C | | |
| 2 | | A, B, C | | |
| 3 | | A | B | C |

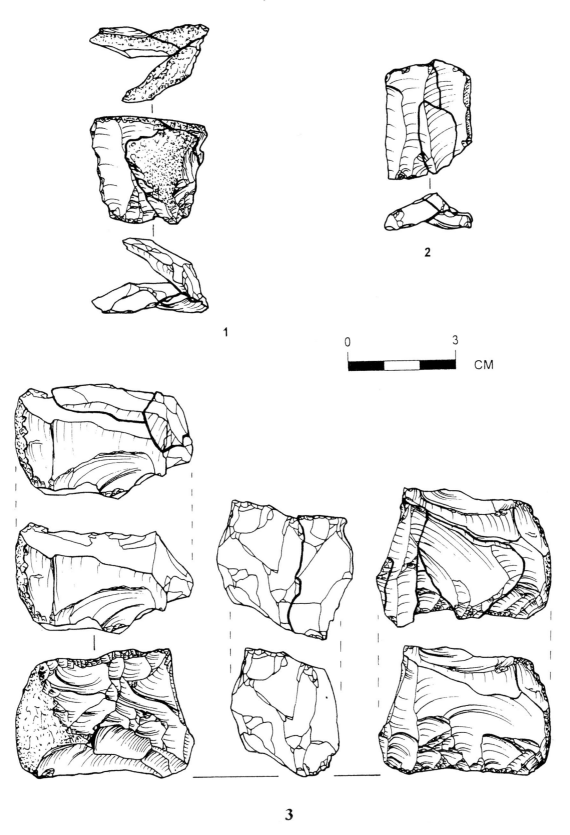

FIG. 11.4. Technical drawings of the three refitted complexes. Complex 3 shows the core with (top) and without (bottom) the refitted flakes.

The maximum length of the items was determined by the natural dimensions of the pebble.

4. Final flaking: as evident in Complex 3, at the last stage of the sequence, the core could be used for the unsystematic manufacture of small flakes.

5. Discarded core: the flaking of the previous stage removed traces of more standardized production of the earlier stages, producing the "amorphic" final form of the core. It must be emphasized that this category is the most prominent one in the Sha'ar Hagolan assemblage (see Alperson and Garfinkel, Chapter 10 in this volume).

The described reduction sequence is very simple, but by no means "opportunistic" or irregular. The gestures of the knapper were adapted to the properties of particular raw material in order to obtain the intended final product. In all of the examples presented the same set of operations was performed in the same particular order. The goal of the sequence appears to be short, small blades or elongated flakes. The proportion of such blanks in different tool categories of the Sha'ar Hagolan assemblage cannot always be quantified (due to the massive retouch of numerous items as well as uncertainty of identification of an applied reduction sequence on the basis of the morphology of a final product). Nevertheless, the analysis of the assemblage reveals that a significant proportion of *ad hoc* tools (notches, retouched flakes and blades, etc.), as well as some of the more standardized implements (e.g., sickle blades and small arrowheads) could have been produced from such items.

It should be noted that the described reduction sequence is by no mean the single or "the most important" one in the complex technological system of the Sha'ar Hagolan lithic assemblage. Other, different *chaînes opératoires* were applied for production of artifacts with different required characteristics (e.g., scrapers on massive flakes, see Alperson and Garfinkel, Chapter 10 in this volume). Several kinds of blanks were made on raw materials of non-local origin (C. Delage personal communication). There is also a possibility that some of the reduction sequences (such as a production of "true" blades from prepared blade cores) were only occasionally performed on the site and therefore, their presence in the assemblage is minor (Alperson and Garfinkel, Chapter 10 in this volume). In any case, determination of the relative quantitative importance of different production modes in the Sha'ar Hagolan flint industry is not possible on the basis of the presented material and is, therefore, beyond the scope of this paper.

Besides the importance for understanding the lithic production system, the presence of conjoinable flint pieces in the Sha'ar Hagolan assemblage has several additional points of interest:

**Spatial Organization.** The spatial distribution of refitted artifacts is useful in locating flint knapping areas in different parts of the settlement. It is noteworthy that all the items were found in the courtyard of a domestic unit (Building Complex I), but this requires further investigation and, probably, further attempts at refitting material from different parts of the excavated area.

**Stratigraphic and Taphonomic Aspects.** The discovery of refittable material in direct contiguity should indicate an insignificant movement of artifacts due to post-depositional processes. Their presence in the courtyard fill may indicate a primary depositional context for most of the associated artifacts and their relation to an occupational phase of the building.

It was shown that even the small number of refitted artifacts permits dealing with several questions in greater detail and resolution than is possible using traditional techno-typological analysis. The comparison of the advantages and deficiencies of the different methods is beyond the scope of the paper (see Cohen *et al.* 1976; Cziesla 1987 for comprehensive discussions). Nevertheless, it should be noted that one of the main problems of the refitting method – difficulties in quantifying data and determining the relative significance of the observed phenomena – affected the the present study. The conclusions presented here thus require further investigation, including broader-scale and more systematic refitting attempts.

## Acknowledgements

The research was supported by the Israel Science Foundation founded by the Israel Academy of Sciences and Humanities. I wish to thank Dr. Y. Garfinkel for the opportunity to work with the Sha'ar Hagolan lithic assemblage and for his patience. I would also like to thank A. Davidzon, A. Eirikh-Rose, D. Dag and O. Barzilai for their advice, support and fruitful discussions. The artifact drawings were prepared by J. Moskovitch, the photographs were taken by G. Laron.

## BIBLIOGRAPHY

Cahen, D., Keeley, L.H. and Van Noten, F. 1979. Stone Tools, Toolkits, and Human Behavior in Prehistory. *Current Anthropology* 20: 661–683.

Czielsla, E. 1987. On Refitting of Stone Artifacts. In Cziesla, E., Eickhoff, S, Arts, N. and Winter, D. (eds.) *The Big Puzzle* (Studies in Modern Archaeology 1), pp. 9–44. Bonn: Holos.

Garfinkel, Y. 1992. The Material Culture of the Central Jordan Valley in the Pottery Neolithic and Early Chalcolithic Periods. Unpublished Ph.D. dissertation, The Hebrew University, Jerusalem (Hebrew).

Garfinkel, Y. 1993. The Yarmukian Culture in Israel. *Paléorient* 19: 115–134.

Garfinkel, Y. 1997. Sha'ar Hagolan 1997. *Israel Exploration Journal* 47: 271–273.

Gopher, A. and Gophna, R. 1993. Cultures of the Eighth and Seventh Millennia BP in the Southern Levant: A Review for the 1990s. *Journal of World Prehistory* 7: 297–353.

Goring-Morris, N., Marder, O., Davidzon, A. and Ibrahim, F. 1998. Putting Humpty Together Again: Preliminary Observations on Refitting Studies in the Eastern Mediterranean. In Milliken, S. (ed.) *The Organisation of Lithic Technology in Late Glacial and Early Postglacial Europe* (B.A.R. International Series 700), pp. 149–182. Oxford: British Archaeological Reports.

Stekelis, M. 1972. *The Yarmukian Culture of the Neolithic Period.* Jerusalem: Magnes Press.

Volkman, P. 1983. Boker Tachtit: Core Reconstruction. In Marks, A.E. (ed.) *Prehistory and Paleoenviroment in the Central Negev, Israel.* Vol. III, pp. 129–190. Dallas: Southern Methodist University Press.

Villa, P. 1982. Conjoinable Pieces and Site Formation Processes. *American Antiquity* 47: 277–290.

# 12

# THE STONE TOOLS

## *Yosef Garfinkel*

## I. INTRODUCTION

Stone implements made of basalt and limestone were an important component of Yarmukian household equipment, as attested by the relatively large numbers found at Sha'ar Hagolan (probably over six hundred by the end of the 2001 season). This is the third largest material culture category after flint and pottery. At Sha'ar Hagolan, basalt and limestone raw materials are locally available as pebbles on the bank of the nearby Yarmuk River. The basalt originated from the Golan Heights and the limestone from Mount Gilead. Sandstone items, which are very rare, had to be transported from a distance. The nearest location of this deposit is in Wadi Zarqa, some 50 km. to the south.

The analysis of the stone objects from the first two seasons (1989–1990) has been completed, and the results have been presented in my Ph.D. thesis (Garfinkel 1992: 58–61, 134–135, Table 58). The material from the other seasons is currently under analysis by M.A. Miller. Nevertheless, in order to give the reader some idea of the stone tool assemblage, I present here a report on the relevant material from the first two seasons, as well as data on some selected surface artifacts in the collection of the local Sha'ar Hagolan Museum.

## II. STONE TOOL TYPOLOGY

The Sha'ar Hagolan assemblage has been classified according to a typological framework constructed especially for proto-historic sites in the central Jordan Valley (Garfinkel 1992: 58–60). Prior to that, very little had been published on the stone tools of the Pottery Neolithic period from the earlier excavations at Sha'ar

TABLE 12.1. The stone objects from Stekelis' excavations at Sha'ar Hagolan (1972: 24)

| Typological Category | Number |
|---|---|
| Bowls | 5 |
| Small bowls | 5 |
| Grinding stones (basalt and limestone) | 3 |
| Stones with cup-marks | 11 |
| Broken stone objects | 2 |
| Basalt pebbles with incomplete perforation | 6 |
| Varia | 1 |
| Limestone pebbles broken at the end | 3 |
| **Total** | 36 |

Hagolan (Table 12.1) and from Pottery Neolithic A Jericho (Dorrell 1983). Studies published after 1992 were not, obviously, available to me at that time (Wright 1993; Gopher and Orrelle 1995). The typological list is constructed of seven categories (six specific groups, and one for varia). Each of the main categories has been further subdivided into specific tool types as follows:

**1. Grinding Tools.** Grinding is performed with a grinding stone upon a large slab (Fig. 12.1). Sliding the grinding stone horizontally back and forth across the surface of the slab pulverizes the grain or food. The two basic categories here are: (1) the lower, stable slab, and (2) the upper movable, active, grinding stone. Five subgroups can be suggested here:

a. Flat grinding slab.
b. Grinding slab with raised rim.
c. Miniature grinding slab (grinding pallet).
d. Small active grinding stone (up to 15 cm.).
e. Large active grinding stone (larger then 15 cm.).

FIG. 12.1. A large flat grinding slab with a large grinding stone on top, both made of basalt

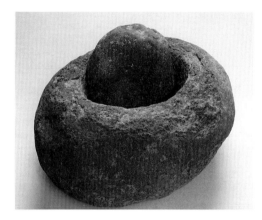

FIG. 12.2. Basalt mortar and pestle

**2. Pounding Tools**. Pounding is performed with a pestle and mortar (Fig. 12.2). The hand moves vertically, up and down. The pestle breaks up the food in the mortar. Four sub-groups can be suggested here:

a. Deep mortar (deeper than 10 cm.).
b. Shallow mortar (shallower than 10 cm.).
c. Miniature mortar; hand-size small stones with a relatively deep cup mark.
d. Pestle.

**3. Battering and Chopping Tools.** A variety of artifacts that are used for battering on other items, include:

a. Elaborate hammerstone. These are items deliberately modeled into a ball or cube-like shape. They are covered with battering marks all over their surface.
b. Simple hammerstone. These are simple stones or river pebbles that were used as are, without any deliberate modeling.
c. Ax and adze. Well-modeled elongated items with a sharp, sometimes polished working edge. Only the non-flint items (basalt or limestone) were included in this category.
d. Chisel. Elongated items with battering and signs of flake removal on both edges. Only the non-flint items (basalt or limestone) were included here.
e. Anvil. Large, thick, flat plate on which the battering and chopping activities were carried out.

**4. Weights**
a. Small perforated weight. These are usually flat, thin, soft limestone disks with a perforation near the edge, and not in the center. They weigh less than 0.3–0.4 kg.

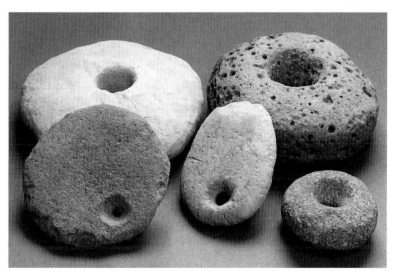

FIG. 12.3. Various drilled weights from surface collection

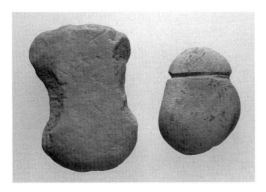

FIG. 12.4. "Narrow Vest" weights from surface collection

b.  Medium weight. These are usually rounded items, made of hard limestone or basalt, with a central bi-conical drilled hole. They weigh over 0.5 kg. but do does not exceed 1 kg. (Fig. 12.3, smaller items).
c.  Large weight. These are usually rounded items, made of hard limestone or basalt, with a central, bi-conical drilled hole (Fig. 12.3, bigger items). They weigh over 1 kg.
d.  "Narrow vest" weight. These are usually flat, thin, soft limestone disks, like Category a, but instead of a drilled hole, two opposed notches were chopped at the center of both sides (Fig. 12.4, left item). In some rare cases a deep groove was incised, encircling the item (Fig. 12.4, right item). This creates a "narrow vest" allowing a string to be securely tied around the weight.
e.  Weight in preparation. These are items on which drilling has been started, but the hole has not been created.

**5. Bowls.** This group includes containers made of stone, which co-exist alongside similar pottery and probably wooden artifacts.

a.  Limestone bowls (Fig. 12.5).
b.  Basalt bowls. Sometimes it is difficult to differentiate between basalt bowls and small mortars.
c.  Pedestal bowls. This type is later then the Yarmukian, and made its first appearance in the post-Wadi Rabah culture of the fifth millennium BC.

**6. Sharpeners and Whetstones.** Items that served for polishing and sharpening other artifacts, apparently made of wood and bone. Three basic types are known:

a.  Rounded sharpener. A rounded item usually made of a basalt river pebble, bearing a deep, central, straight groove (Fig. 12.6).
b.  Square sharpener. Rarely discovered items, similar to the previous type, but with a square outline (Fig. 12.6, left item in the lower row).
c.  Whetstone. A simple disk, with large parts of its surface well smoothed or polished.

**7. Varia.**
a.  Stone disk. These are usually well-modeled, rounded limestone artifacts. They may be considered a primary stage in the production of small weights.
b.  Others. A variety of other, rare artifacts, which do not fit any of the above types.

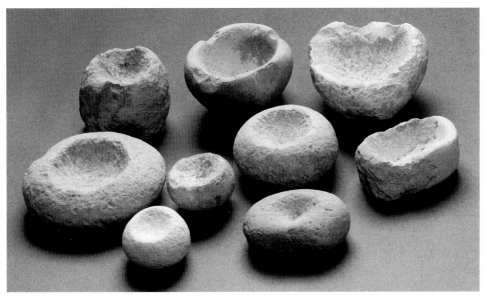

FIG. 12.5. A group of limestone bowls from surface collection

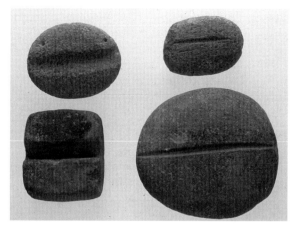

FIG. 12.6. A group of sharpeners from surface collection

## III. THE STONE TOOLS OF SHA'AR HAGOLAN

During Stekelis' excavations, a small assemblage of 36 stone objects was unearthed (1972: 24–25). This collection is presented here in Table 12.1. In the first two seasons of the renewed excavations, 68 items were recovered from a c. 100 sq.m. area (Table 12.2). This assemblage has been classified according to the typological framework presented above. The following types were found at Sha'ar Hagolan:

TABLE 12.2. The stone objects from the renewed excavations at Sha'ar Hagolan 1989–90 (Garfinkel 1992, Table 58)

| Category | Total | % |
|---|---|---|
| **1. Grinding Tools** | | |
| **a.** Flat slab | 1 | 1.6 |
| **c.** Miniature slab | 1 | 1.6 |
| **d.** Small grinding stone | 11 | 17.5 |
| **e.** Big grinding stone | 4 | 6.3 |
| **2. Pounding Tools** | | |
| **a.** Deep mortar | 3 | 4.8 |
| **d.** Pestle | 2 | 3.2 |
| **3. Battering/chopping** | | |
| **a.** Elaborate hammer | 1 | 1.6 |
| **b.** Simple hammer | 2 | 3.2 |
| **e.** Anvil | 4 | 6.3 |
| **4. Weights** | | |
| **a.** Small | 6 | 9.5 |
| **b.** Medium | 3 | 4.8 |
| **e.** In preparation | 5 | 7.9 |
| **5. Bowls** | | |
| **a.** Limestone | 8 | 12.7 |
| **6. Sharpeners** | | |
| a. Rounded | 4 | 6.3 |
| **7. Varia** | | |
| a. Stone disk | 2 | 3.2 |
| a. Stone disk | 6 | 9.5 |
| Total | 63 | 100.0 |

**1. Grinding Tools**. This is a large group, constituting 27% of the stone items. The following types were found:

a. Flat grinding slab (a large basalt item, found sunk into floor level at Building Complex I).
c. Miniature grinding slab (a small, square limestone slab).
d. Small grinding stone (11 basalt artifacts).
e. Large grinding stone (four basalt items).

**2. Pounding Tools**. This group is smaller then that of the grinding tools, and constitutes only 8% of the stone items. It includes:

a. Deep mortar (three artifacts, two of them found *in situ*, sunken below the floor levels of Building II).
d. Pestle (two basalt artifacts).

**3. Battering and Chopping Tools.** This group constitutes 11.1% of the stone items. It includes:

a. Elaborate hammerstones (one basalt item).
b. Simple hammerstones (two elongated limestone artifacts).
e. Anvils (four basalt artifacts).

**4. Weights.** This is one of the most characteristics stone tool at Sha'ar Hagolan, constituting 22.3% of the assemblage. The following types were found:

a. Small perforated weight (six items, three rounded with a central drilled hole, the other three roughly worked, with drilled hole at the side).
b. Medium weight (three limestone items).
e. Weight in preparation (five items).

**5. Bowls.** This group constitutes 12.7% of the stone tools, including eight limestone bowls (subtype a). Seven of these are deep bowls made in soft stone, and one item is a shallow bowl made in hard limestone. Stekelis reported one such bowl with herringbone incised decoration (1972, Pl. 40: 1).

**6. Sharpeners and Whetstones.** This group constitutes 6.3% of the stone tools and only the rounded sharpener of subtype a, has been found. There are four items, with a central groove incised on an elliptical basalt river pebble. In three cases the incision was done on the elongated axis of the item, and in one case on the wide axis. Some people believe that these items symbolize the female sex organ, and some have even suggested that red coloration on them represents bleeding. However, this is mere fantasy, as no such item was found with red coloring, either at Sha'ar Hagolan or in the large horizontal exposure at the site of Munhata (Garfinkel 1999b).

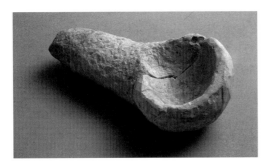

FIG. 12.7. A hard limestone spoon from surface collection

**7. Varia.** This group constitutes 12.7% of the stone tools, including the following:

a.  Stone disk (two items, one partially denticulated).
b.  Others (six items). In addition, it should be mentioned that a stone spoon was found on the site surface (Fig. 12.7), resembling the pottery spoons of this period (Garfinkel 1999a: 25–26, Fig. 10: 10).

## IV. DISCUSSION

From a functional point of view, the above stone tools can be divided into three basic categories: food processing and serving implements, weights and tools:

**Food processing and serving implements (Categories 1, 2, 5).** This is the dominant group of stone tools and includes: basalt mortars, grinding slabs, grinding stones, pestles and bowls. Although pottery was introduced in the Yarmukian era, stone bowls continued to be an integral part of the inventory at that time and a large number of soft limestone bowls have been found at Sha'ar Hagolan. They are usually rounded, but are sometimes oval or rectangular. Sometimes a bowl was decorated with herringbone incisions, imitating the decoration on clay bowls. There are a few examples of basalt bowls as well.

Of special interest is a rare object in the shape of a spoon made of limestone. Clay spoons are known in the ceramic repertoire, but this is the only known example in limestone.

**Weights (Category 4).** This is the second largest group in the assemblage. The circular stone weights together with the bi-conical clay whorls (see Fig. 2.28), attest to the extensive use of weights in Yarmukian activities. Small and "narrow vest" weights were made of soft limestone. Medium-sized weights were made of either hard limestone or basalt. Most of the large weights were made of

basalt. A drilled hole can be found in most of these, located either in the center or near the edge.

As the weights vary considerably in size and weight, they were probably used for a variety of purposes: as spindle whorls, fishing weights and as weights on digging sticks. The increased importance of weights appears to be a uniquely Yarmukian development.

**Tools (Categories 3, 6–7).** This group includes hammerstones, anvils and sharpeners.

In relation to the large number of stone tool artifacts discovered in the renewed excavations during the years 1996–1999, the 68 items from 1989–1990 seasons form a relatively small assemblage. Nevertheless, it is the largest Yarmukian assemblage published so far. As mentioned above, Stekelis discovered only 36 artifacts in his dig (Table 12.1). From the site of Munhata, only 39 items have been specifically related to the Yarmukian settlement of Layer 2b (Gopher and Orrelle 1995: 62, Table 51), and when some unstratified material is added, this number reaches 47 (Gopher and Orrelle 1995: 79, Table 54). This is a surprisingly small number of artifacts as the excavated area at Munhata is c. 2,000 sq.m. If a 100 sq.m. area at Sha'ar Hagolan yielded 68 artifacts, an area of 2,000 sq.m. would be expected to produce c. 1,300 stone tools. This is a peculiar discrepancy that demands further attention. The study of the rich stone tool assemblage from Sha'ar Hagolan is only beginning. We must still complete typological analysis of the data collected from over 1,800 sq.m., and carry out a special analysis of this major aspect of Yarmukian daily life.

## BIBLIOGRAPHY

Garfinkel, Y. 1992. The Material Culture of the Central Jordan Valley in the Pottery Neolithic and Early Chalcolithic Periods. Unpublished Ph.D. dissertation, The Hebrew University, Jerusalem (Hebrew).
Garfinkel, Y. 1999a. *Neolithic and Chalcolithic Pottery of the Southern Levant* (Qedem 39). Jerusalem: The Hebrew University.
Garfinkel, Y. 1999b. Facts, Fiction, and Yarmukian Figurines. *Cambridge Archaeological Journal* 9: 130–133.
Gopher, A. and Orrelle, E. 1995. *The Ground Stone Assemblages of Munhata* (Cahiers du Centre de recherche français de Jérusalem 7). Paris: Association Paléorient.
Dorrell, P. 1983. Stone Vessels, Tools and Objects. In Kenyon, K. and Holland, T. (eds.) *Excavation at Jericho,* Vol. V, pp. 485–575. London: British School of Archaeology in Jerusalem.
Stekelis, M. 1972. *The Yarmukian Culture of the Neolithic Period.* Jerusalem: Magnes Press.
Wright, K. 1993. Early Holocene Ground Stone Assemblages in the Levant. *Levant* 25: 93–111.

# PART III

# ART OBJECTS

# 13

# ART FROM SHA'AR HAGOLAN:
# VISIONS OF A NEOLITHIC VILLAGE IN THE LEVANT

*Yosef Garfinkel, Naomi Korn and Michele A. Miller*

## I. INTRODUCTION

The site of Sha'ar Hagolan has produced the richest assemblage of prehistoric art objects ever recovered at a single site in Israel, and the largest in the Levant from the sixth millennium BC. In using the term "art" we are deliberately choosing a word that we believe to be the most understandable and inclusive to the largest audience. In doing so, apparently we are making a provocative statement to other colleagues in the field. We are, in fact, aware of the proposal made by some scholars to reject the term "art" when dealing with prehistoric figures, depictions, etc., and to introduce other terms, including "symbolic expressions," "imagery," "material representation" and the like. In the words of Soffer and Conkey (1997: 2):

> …as defined in the past century, art is a cultural phenomenon that is assumed to function in what we recognize… as the aesthetic sphere. There are long-standing debates… about the definition(s) of "art"… This aesthetic function is something that we cannot assume to have been the case in Prehistory… many of the traditional approaches of art history are not appropriate to the interpretation of prehistoric remains because we cannot assume that their primary function was aesthetic.

Recently, one of us (Y.G.) was even accused of "anachronism" for using the term "art" to describe material from Sha'ar Hagolan; these authors added that

> a consensus has been reached that using the word "art" to refer to Upper Palaeolithic images is both misleading and limiting. This aptly applies in equal measure to assemblages of imagery from the Neolithic. (Gopher and Orrelle 1999: 133)

However, there are at least two disturbing points regarding the rhetoric of the above statements. First, that a consensus among scholars is equal to a conclusion of fact, when, on the contrary, many long-held consensuses of one group or generation of scholars have been readily questioned and discarded by another. Such is the nature of academic debate. Secondly, that just because a theory may be relevant to the hunter-gatherers of the Upper Palaeolithic, it necessarily "aptly applies" to the early village communities of the Neolithic era.

Such a division in terminology can also be said to follow an egocentric, narrow-minded approach that implies that only western civilization has "art" while other human societies have "imagery" and has been rightly rejected by many archaeologists and anthropologists. The so-called "consensus" is either the authors' wishful thinking, or the result of unfamiliarity with the totality of the relevant literature. As summarized by Morphy (1989: 1):

> Researchers have tried to solve the problem by changing the name; by switching from "art object," to "image" or "representation" or "information system" on the grounds that these are more neutral, less value-laden terms. Yet the replacement terms do not really help the situation. They are often more narrow in their definition than "art" itself which, because of all the argument over what it is, can have the advantage of being broadly conceived, whereas "representation," for example, may apply to only one aspect of an object.

The same approach has been expressed by ethnographers:

> Art from non-Western cultures is not essentially different from our own, in that it is produced by individual, talented, imaginative artists, who ought to be accorded the same degree of recognition as western artists." (Price 1989, summarized by Gell 1998)

And on the matter of aesthetic it was specifically noted that:

> There is no sense in developing one "theory of art" for our own art, and another, distinctively different theory, for the art of those cultures who happened, once upon a time, to fall under the sway of colonialism. If Western (aesthetic) theories of art apply to "our" art, then they apply to everybody's art, and should be so applied. (Gell 1998: 1)

Some of the debate, in fact, may stem from different ideas held by modern scholars over what constitutes what we currently perceive as "art." Perhaps if we conceive of art having purely an aesthetic function, it may be difficult to associate the term with prehistoric manifestations. Yet art has never, and is not now, purely an aesthetic creation. Many of the great masterpieces of art that now hang in the world's museums originally functioned (and function) in multiple ways in the culture(s) in which they were produced and consumed; often as religious icons, as status symbols, or as individual and provocative statements on current society.[1] By using the term art we are not denying or reducing the significance of any of these or other important functions of the prehistoric material we study.

Language is a means of communication, but it can also become a means of miscommunication. Developing a highly specialized jargon in a discipline may lead to a better understanding among the members of the discipline, but it will be a barrier to the people outside this exclusive group. The term "art" is understandable to a general audience. It enables straightforward communication between the archaeologist and the larger public. By using terms like "imagery" we immediately disconnect ourselves from this public, and from those who may wish to know more about our research. For some, who wish their work to remain exclusive, that perhaps is the point. We note, however, that even the above mentioned book by Conkey, Soffer *et al.,* is ingeniously called: "*Beyond Art – Pleistocene Image and Symbol.*"[2] Ironically, the rejected term "art" was, nevertheless, incorporated within their title.

## II. THE ART ASSEMBLAGE

The first figurines from the site were discovered by members of the adjacent Kibbutz Sha'ar Hagolan during the construction of fishponds in the late 1930s. These, together with other finds (flint, pottery sherds, pestles and grindstones) were originally stored in crates under beds in the kibbutz living quarters. This rich artistic collection became known to archaeological research following the work of Stekelis (1951, 1952). In his final report (1972), he did not differentiate between the finds from his excavations and those collected from the surface by Kibbutz members. As a result, the majority of the finds published by Stekelis lack clear stratigraphic contexts. After Stekelis' work and publications, additional art objects were collected over the years by members of Kibbutz Sha'ar Hagolan following plowing, tree-planting, installation of underground water pipes and maintenance of now disused fishponds. For approximately 60 years, amateur archaeological surveys were systematically carried out by the Kibbutz members in search of antiquities. In this way a large, local collection of art objects was created. All these objects, however, lack the stratigraphic contexts which provide secure dating. Dating these objects, therefore, must be based upon typological criteria alone.

The results of our excavations and the systematic site survey clearly indicated that there is no evidence at Sha'ar Hagolan for either immediately earlier (Pre-Pottery Neolithic) or later (Wadi Rabah or other Chalcolithic) settlement. There is only a Middle Bronze I settlement of the late third millennium BC. That period did not produce anthropomorphic figurines. Sha'ar Hagolan should therefore be regarded as a single-period Neolithic site, which greatly simplifies the attribution of surface finds to the Yarmukian culture. In addition, the artifacts from the site surface are stylistically similar to those now found in stratigraphic contexts. Thus the rich surface collection can therefore be securely identified as related to the Yarmukian culture.

Besides associating the art objects with the Yarmukian settlement, our excavation contributed a context to these artifacts. Since the renewal of the excavations in 1989, so far some 1,800 sq. m. of the site have been uncovered. A portion of the prehistoric village has been exposed which includes two streets and three monumental structures. One of these buildings, which has been exposed in its entirety, consists of a large courtyard surrounded by eight rooms. In this building the statue (see below) and a few figurine fragments were found. West of this structure, a second monumental building is currently under the process of excavation. So far 600 sq. m. have been uncovered, and the extremities of the building have yet to be established. In this building 48 figurines have been found so far, including new types and complete items (Ben-Shlomo and Garfinkel, Chapter 14 in this volume).

It thus appears that one of the most interesting

---

[1] One has only to visit any contemporary art show to realize that aesthetics is often far from the point.
[2] In fact, they are not the first scholars of the European Upper Palaeolithic to use this term; a 1992 paper by R. White is entitled, "Beyond Art: Toward an Understanding of the Origins of Material Representation in Europe."

features of the Yarmukian culture from Sha'ar Hagolan is this rich collection of art objects. This material has been grouped as follows:

1. clay statue
2. seated cowrie-eyed figurines
3. clay pillar figurines
4. cylindrical clay figurines
5. various clay figurines
6. anthropomorphic pebble figurines
7. various stone figures
8. seals
9. basalt pebbles engraved in geometric designs
10. zoomorphic figurines

Of this wealth of symbolic expressions a selection of 20 items, from four of the above mentioned groups (1–3, 5–6) is presented here. All of these anthropomorphic figurines were discovered in the new excavations and, we believe, significantly contribute to the study of Yarmukian iconography.

## III. The Clay Statue

Neolithic statues differ from figurines in many aspects, and attest to a relatively rare phenomenon. On a general estimation, while well over a thousand figurines have been discovered from the Neolithic Near East, less than a hundred statues have derived from this region. Although one such item can be related to the Pre-Pottery Neolithic A Period (Noy 1979, misdated), statues are primarily known in the Levant from Pre-Pottery Neolithic B contexts. In the Southern Levant, statues have been reported from Jericho, 'Ain Ghazal and Nahal Hemar Cave (Garstang *et al.* 1935: 166; Tubb and Grissom 1995; Bar-Yosef and Alon 1988). In addition, a few items were reported from Tell Ramad (de Contenson 1967, Figs. 18–20b) in the Central Levant, and some from Nevaliçori and Gübekli Tepe (Hauptmann 1993; Schmidt 1998) in the Upper Euphrates of the Northern Levant. Other chronological periods in this area, like the Pre-Pottery Neolithic C and the Pottery Neolithic, have so far yielded only small figurines. Now, a recently discovered statue from Sha'ar Hagolan alters this picture. This classification is based upon several distinct characteristics that set it apart from the figurines. These aspects include its large size, depositional context, raw material, craftsmanship and manufacture.

The statue from Sha'ar Hagolan measures at least 30–35 cm. (reconstructed height), making it three times larger than the typical Sha'ar Hagolan figurines. The statue was discovered in the 1997 season of excavations at Sha'ar Hagolan in the courtyard of a large monumental building

(Loc. 96). It was found as a small cache, including a head, leg and additional small fragments of an anthropomorphic figure, although these do not comprise all the components of a complete figure. The head fragment was lying on the leg and surrounded by the rest of the fragments. It is possible that these remnants were intentionally buried in a very shallow pit, a ritual performed on cultic art items from this period in the ancient Near East (Garfinkel 1994). Similarly, statues from 'Ain Ghazal, Jericho, Tell Ramad and Nahal Hemar, have also been found in ritually buried caches (Garfinkel 1994). At Nevali Çori and Gübekli Tepe the statues were associated with a central public building of cult (Hauptmann 1993; Schmidt 1998). The figurines, on the other hand, are usually found individually and are associated with domestic contexts, like living areas and garbage pits.

There are clear distinctions between the raw materials and modeling techniques employed in making the figurines and the statues. At Sha'ar Hagolan, we have found that in most instances, the same clay paste that was used to make the pottery vessels was also used in producing clay figurines (presented in Section IV below). This clay is yellow/orange in color and includes small gravel particles. The statue, however, is made of pure whitish clay, without the common particles, with a similar type of clay used at Munhata for cylindrical male figurines and clay rods (Garfinkel 1995: 37, 44). The surface of the statue was exceptionally well finished, including smoothing and burnishing. This quality of burnishing is not evident on other items from Sha'ar Hagolan, and reflects, like the manufacturing techniques of other statues from the Levant, a considerable investment of time. Further information on the manufacturing technology of the statue was determined through Computer Tomography Imaging (Applbaum *et al.* 1998). Statues and figurines from Jericho, Tell Ramad and 'Ain Ghazal, exhibit similar differences in raw materials. While the statues from these sites are made from a composition of several types of clay, plaster and organic materials (Tubb 1985; Tubb and Grissom 1995), the figurines were made from a single raw material, either modeled from a simple clay paste (see, for example, Garfinkel 1995), engraved schematically on a stone (see, for example, Stekelis 1972) or engraved on bone (Bar-Yosef and Alon 1988: 21–23).

From an iconographic viewpoint, the statue from Sha'ar Hagolan bears distinct similarities to the characteristic Yarmukian clay figurines of this period, as discussed below. These similarities assist us in understanding its various features. However, the statue is more schematic and lacks certain prominent features which typify the figurines. The Neolithic figurines were usually executed in a simplistic fashion, which did not require a high level of craftsmanship. Nevertheless, when the statues were

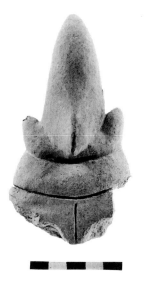

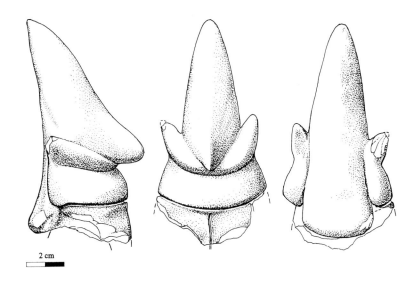

FIG. 13.1. The head fragment of the anthropomorphic statue

FIG. 13.2. Technical drawing of the head fragment of the anthropomorphic statue

constructed, a great emphasis was put on their realistic representation. They represent a high level of artistic sophistication. It thus seems that generally, every member of the community was able to make figurines, while only specialists made the statues. (For an alternate view, see Millen this volume, p. 223.)

**1. The Head Fragment.** The face is depicted in a highly schematic manner (Figs. 13.1–13.3). The top of the head is extremely elongated and has a triangular outline. The nose was made by pinching the clay, and the bridge of the nose is clearly defined and dominant.

The eyes were made by elongated ribbons of clay, which were attached diagonally to the side of the head. They are lacking a central incision, which is a typical feature in Yarmukian anthropomorphic clay figurines. This central incision creates the famous "cowrie eye" or "coffee bean" eye effect, characteristic of the proto-historic Near East and southeastern Europe. In this respect, the item is unique.

Below the eyes, two parallel circular incisions partially encircle the sides and the front of the item. These may represent a scarf, which appears on both Yarmukian clay and pebble figurines. Below this there is a short vertical incision. Although the chest was not preserved, the contour of the item bears two rounded outlines, which probably indicate the breasts. The location of the short vertical incision between the breasts is known from the clay Yarmukian figurines discussed in the next section. It represents the upper part of a garment composed of two

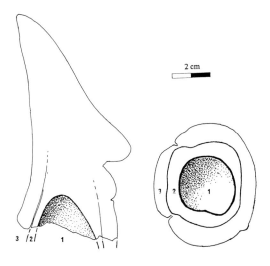

FIG. 13.3. Section and bottom view of the head fragment

symmetrical parts, starting in between the breasts and continuing to the shoulders.

The back of the head was modeled with a large, elongated bulb of clay. This element is well known from Yarmukian clay figurines and is probably part of the hairstyle.

A concave smooth depression in the base of the head indicates that it was made separately from the rest of the statue and then attached to the torso. The head measurements are: 128 × 61 × 56 mm.

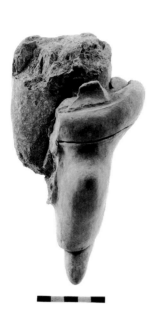

FIG. 13.4. The leg fragment of the anthropomorphic statue

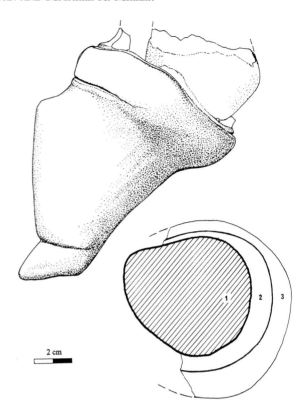

2 cm

FIG. 13.5. Technical drawing of the leg fragment

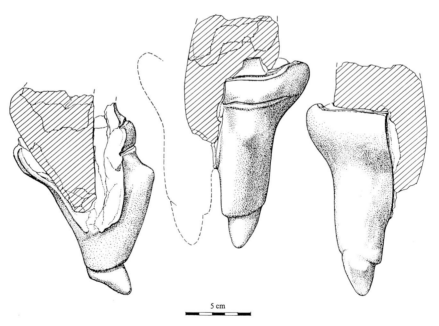

5 cm

FIG. 13.6. Additional views of the leg fragment

**2. The Leg Fragment.** The left leg includes the thigh, knee and foot (Figs. 13.4–13.6). The leg is bent at the knee. Two deep incisions, at the top of the thigh and above the foot, represent fat-folds. The item is composed of two pieces of clay; more refined for the outside and coarser for interior of the leg. The measurements of the leg are: 180 × 94 × 76 mm.

**3. The Other Fragments.** An additional four fragments were found. They were all made from the same type of clay as the two main fragments. Their shape suggests that they were parts of the outer surface of the statue and later fell off the main core.

a. Upper thigh fragment made from a rounded plate of clay (Fig. 13.7: a). A deep diagonal incision divides the piece into two and represents a fat fold. The outer surface is well smoothed. Its measurements are: 61 × 46 × 15 mm.

b. Lower torso fragment (Fig. 13.7: b). The outer surface is well smoothed. Its measurements are: 36 × 42 × 19 mm.

c. Ribbon of clay (Fig. 13.7: c). Both elongated edges bear a deep incision. It is unclear where this fragment was originally located on the statue. Its measurements are: 61 × 15 × 7 mm.

d. Elongated and curved ribbon of clay (Fig. 13.7: d). An additional square lump of clay was attached. The front of this lump was pinched and the sides were impressed in order to create a central ridge. The exact location of this item on the statue is unclear. Its measurements are: 62 × 18 × 21 mm.

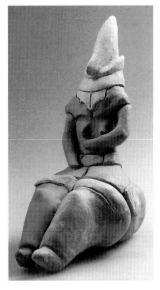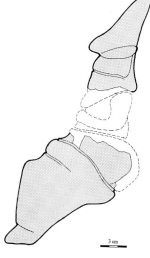

FIG. 13.8. The reconstructed anthropomorphic statue

FIG. 13.9. Technical drawing of the reconstructed anthropomorphic statue

**4. The Reconstruction.** The various fragments of the statue were reconstructed into a complete figure in the conservation laboratory of the Bible Lands Museum, Jerusalem. The work was done by Regula Muller Shacham and Jessica Waller prior to being placed on display in a special exhibition (Garfinkel 1999a: 62–63). The missing parts were constructed of clay, and the various original fragments (head, leg, and three small fragments) were inlaid into the reconstruction. The general outlines of the typical Yarmukian cowrie-eyed figurine (Figs. 13.8–13.9) were followed in this reconstruction. If in the future more fragments are found, the reconstructed figure can be dismantled and the additional fragments added.

Measurements: Reconstructed height of the entire statue, ca. 300–350 mm.

Provenience: 1997 Excavation Season, Locus 96, Bucket 501

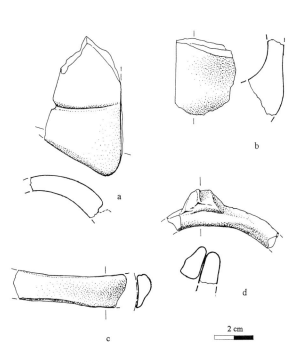

FIG. 13.7. Technical drawing of the other fragments of the anthropomorphic statue

## IV. SEATED COWRIE-EYED FIGURINES

The most famous type of clay figurine from Sha'ar Hagolan has been designated by various names in the literature: "fertility figurine" (Stekelis 1972), "seated figurine wearing a soutane and mask" (Yeivin and Mozel 1977: 194), "terrible" – terrible mother figurine (Cauvin 1972: 86), "grotesque figurine" (Mellaart 1975: 239) and "broad type figurine" (Noy 1990). Since each of these designations usually addresses only one aspect of the figurines' features, and since this group includes both

male and female figurines, we refer to this group as "seated cowrie-eyed figurines."

The first Yarmukian cowrie-eyed clay figurine came to light in the Megiddo excavations of the 1930s. It was assigned to Layer XIX of the Early Bronze Age, and the excavators did not realize its significance as a Neolithic figurine (Loud 1948, Pl. 241). The second figurine of this sort was discovered in Kaplan's excavations at Rehov Habashan in Tel Aviv, and on this basis he correctly identified the Megiddo figurine as a Yarmukian item (Kaplan 1954: 100, footnote 19; 1959). The largest collection of such figurines was exposed in Perrot's excavations at Munhata in the 1960s, including one complete specimen (Perrot 1965; Garfinkel 1995, Fig. 24). A male figurine of this type has been found in the "néolithique ancien" of Byblos in Lebanon (Cauvin 1972: 85, Fig. 28: 1; Dunand 1973, Pl. CXIII: 21160). No seated cowrie-eyed figurines were described in the preliminary publications of Stekelis' excavations at Sha'ar Hagolan (Stekelis 1951; 1952). Only the final excavation report contains eight such items, some of them small fragments (Stekelis 1972, Pls. 49: 1–3; 59: 6–10). Other discussions of this type can be consulted in various later publications (Cauvin 1972; Yeivin and Mozel 1977; Noy 1990, 1999; Garfinkel 1995, 1999a, 1999b; Gopher and Orrelle 1996, 1999). Similar items have also been recently reported from Jordan: Abu Thawwab (Kafafi 1988, Fig. 11: 1; 1993: 110) and 'Ain Ghazal (Kafafi 1993: 112, Fig. 5a), thus broadening their geographical distribution.

At Sha'ar Hagolan, up to the 1999 season 74 fragments have been discovered. Of these, 53 items (71%) were found in stratigraphic context in our new excavations. The other items have been collected on the site surface over the years and brought to the local museum at Kibbutz Sha'ar Hagolan. The surface material is usually badly eroded, fragmentary and bears no traces of paint. The material from the dig, on the other hand, includes a few complete items (for the first time), and on many of them, red slip or red paint is still visible.

## A. Modeling Techniques.
The modeling techniques employed in making the seated cowrie-eyed figurines can be reconstructed by an examination of the objects, particularly of sections visible on fragments. In addition, some of the Sha'ar Hagolan figurines were examined at the Department of Radiology, Hadassah University Hospital, Jerusalem, using sophisticated medical instruments for computerized tomographic imaging (Applbaum et al. 1998; Applbaum and Applbaum, Chapter 15 in this volume). The following stages of the production process can be reconstructed:

1. Before the modeling began, a specific mix of clay and temper was prepared. The paste used for this type of figurine is usually characterized by the systematic addition of small grit or temper. This created a clay similar to that used for pottery.

2. Each part of the body was modeled separately: head, torso, right leg and left leg. Each of these components consists of a core that was covered with one or two outer layers of clay.

3. All these components were connected in order to create the basic figurine.

4. Small details were applied to the body of the figurine. Eyes were added to the head, as well as ears, a nose and a veil over the nape. Arms, breasts and details of dress were added to the body.

5. The final portrayal of the body parts, including the eyes, fingers and fat folds, was accomplished using various incision techniques. A small hole was punctured in the abdomen to depict a navel.

6. Sometimes the complete figurine was decorated with paint. Red paint was used to draw linear patterns on various parts of the object.

7. After the figurine was shaped and painted, it was fired in order to harden the clay.

## B. Stylistic Analysis.
The cowrie-eyed figurines have been defined by 24 characteristics. Almost all of these features are present in all the examples, thus creating a close-knit and uniform group:

**1. Elongated Head** – The upper part of the figurine's head is distinctly elongated. Various explanations have been suggested: a tall hat, a triangular mask narrowing at the top and an elongated hairstyle. Since the figurines do not show any hair at the tip of the elongated head, and since hair can be seen at the back of the head, we believe it may be preferable to view this element as a tall hat or other head covering.

**2. Eyes** – One of the most prominent features of the figurines is their eyes. They are elongated, set diagonally and created by sticking clay lumps on the face and incising them lengthwise with a deep slit. Similar eyes appear on figurines from archaeological assemblages with a wide geographical distribution and chronological range. This shape resembles a coffee bean, leading to the common designation of these eyes in the archaeological literature as "coffee-bean eyes." In descriptions of the figurines from Mesopotamia, the term "snake eyes," or "lizard eyes" is common, but this expression has not been used to describe the Yarmukian figurines.

Several explanations have been suggested for this type of eye in the Yarmukian context: Kaplan, who published the first such figurine, described the eyes as typically Mongolian. This type of eye resembles the cowrie shells inlaid as eyes in a plastered skull at Pre-Pottery Neolithic

B Jericho – hence the designation "cowrie-like eyes" and "cowrie-shaped eyes." Noy interpreted this type of eye as showing "similarity to cereal seeds or date stones, and the diagonal position is reminiscent of the way in which seeds or fruits are connected to the sheaf."

**3. Ears** – It should be noted that ears are depicted on the figurines, a feature usually absent in Neolithic depictions of the human body. Earrings were included, and probably justify the inclusion of this body part on the figurine.

**4. Earrings** – The earrings are a striking phenomenon of the Yarmukian figurines. It is the earliest evidence for the use of earrings in the ancient Near East. The earrings are made of rounded lumps of clay appended to the ear, with the base emphasized by a slit incised on the circumference.

**5. Nose** – The nose is elongated and molded from a clay lump, stuck to the face.

**6. Mouth** – The mouth appears on only two figurines.

**7. Absence of Neck** – The figurines do not have a neck. The head is connected directly to the shoulders. Since the figurines are rich in details, such as ears or fingers, the absence of a neck is surprising, especially since necks are usually depicted on Neolithic human representations.

**8. Facial Form** – The strange appearance of the figurine face has led some scholars to suggest that the figurine is wearing a mask.

**9. Veil at Nape** – In all the figurines, the lower back part of the head is divided into three parts. The central part is wider and elongated, hanging over the nape of the neck. This element could be interpreted as a hairdo hanging down from the bottom of the rear of the head.

**10. Clothing** – A detailed analysis of the figurines' clothing was carried out by Yeivin and Mozel (1977). They differentiated between four slightly different types of garments. In our opinion, the apparel may be classified into only two major types: a garment and a scarf:

*Garment* – The figure wears a garment clearly comprised of a right and left part, worn symmetrically. Each part can be divided into four smaller sections:

a) The upper section closely follows the contour of the breasts, usually passing between them.
b) It then ascends to cover the shoulder.
c) It then descends to the back of the figurine.
d) The lower part of the garment comes round to the front again and covers part of the abdomen, leaving the navel uncovered.

It should be noted that each part is separate and the two parts seem to form an open garment, although it is not clear how this garment remained in place on the body without slipping off. Perhaps in reality, the two parts were sewn together, but on the figurine, the separate parts are emphasized. It seems that the sort of clothing which best suits this description, therefore, is a garment made of the skins of two different animals. The garment thus covers specific parts of the body (part of the chest, back and abdomen) while revealing others (the breasts and the navel).

*Scarf* – The scarf is depicted as a horizontal clay ribbon circling the base of the head, i.e. the area of the throat. This piece of clothing is evident on only a few figurines. On a male figurine one ribbon is evident. It begins as a line extending from the figure's lower back, ascends to the neck, encircles it once and descends to the lower back parallel to the first part of the ribbon. The other example of a scarf appears on a female figurine. Here one ribbon is evident; it begins as a line extending from the figure's lower back, ascends to the neck, encircles it once and descends to the lower back parallel to the first part of the ribbon. On this figurine, the texture of the textile is evident.

**11. Breasts** – The breasts are small and not emphasized, peeping out of the garment. This is the most striking difference between these figurines and other female figurines from the Neolithic period in the ancient Near East, where the breasts are emphasized and exaggerated.

**12. Left Arm** – Surviving examples of the left arm are located under the breast, supporting it.

**13. Right Arm** – In cases where the right arm is preserved, it is situated on the hip or on the upper part of the right thigh.

**14. Fingers** – The fingers are visible on the hands. They are formed by carefully incised parallel lines. It is interesting to note that while much attention was paid to the hands, the feet were almost totally ignored and were represented schematically.

**15. Navel** – The navel is represented by a delicately punctured hole.

**16. Pelvis** – The pelvis is the most heavily emphasized part of the figurine and marks its maximal circumference. The enlarged pelvis may represent an excessive development of fat on the buttocks, known as steatopygia.

**17. Sex Organs** – The female sex organ is not indicated in these figurines. The male sex organ is indicated in one example. In this case the right hand is resting upon it. The male sex organ is also depicted on another male figurine from Byblos.

**18. Thighs** – The thighs, like the pelvis, are emphasized.

They are set together and are usually emphasized by a number of fat-folds.

**19. Knees** – Another feature shown on the figurines' legs is the knees. They are indicated by the bent leg position of the figure.

**20. The Lower Leg** – The lower parts of the legs are separated from each other, as opposed to the thighs which are pressed together.

**21. Seated Posture** – The figures are presented in a seated position. Figurines of seated women are a common phenomenon in the Neolithic of the Near East.

**22. Painted Lines on Legs** – Sometimes, parallel red lines are painted along the legs.

**23. Feet** – The feet are represented in a very schematic fashion. The end of the leg is pointed and no other details are added, as opposed to the careful modeling of the hands. Could the figurines be wearing shoes?

**24. Paint** – Sometimes lines or patches of paint are evident on the figurines, indicating that paint was applied to some parts of the figurine. These areas were painted red, which is associated in many societies with blood, life and fertility.

**C. The Sample.** Fourteen cowrie-eyed clay figurines are described below, including four nearly complete figurines (1–4), five head or face fragments (5–9) and leg fragments with various incisions, including herring-bone pattern (10–14). The items are presented in accordance with their state of preservation.

**1.** Complete figurine (Figs. 13.10–13.11). The item is slightly damaged at the top of the head, the left ear and earring, the right arm and the lower left leg. The facial features consist of a nose and two oblique eyes. A pinched bulb of clay, forming a triangular profile, represents the right ear and earring. This and the next figurine were previously published in large color photographs (Garfinkel 1999a: 50–51 and 52–53).

Two deep parallel circular incisions can be observed at the base of the head. The upper incision continues from one ear to the other, while the second one encircles the item from the nape of the neck around to the front and back to the nape. The meaning of these two incisions is not obvious. They may depict a mouth, since this is the feature one would expect to find in this anatomical position. Alternatively, these incisions may be interpreted as a scarf, which is represented more clearly on Figurine 3 below.

Two features appear on the back of the head, one above the other:

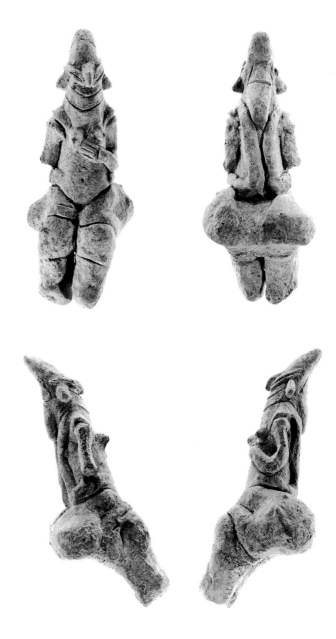

FIG. 13.10. Various views of a seated cowrie-eyed figurine

a.   The upper one consists of three deep incisions, two diagonal and one horizontal. Together they form an incomplete trapezoid. Similar incisions can be seen on one of the anthropomorphic pebble figurines from Sha'ar Hagolan.

b.   Below this, an elongated and rounded bulb of clay represents the veil at the nape of the neck.

The chest is composed of two asymmetrical breasts. The left one is smaller than the right. The upper left arm is attached to the side of the body and rests diagonally on

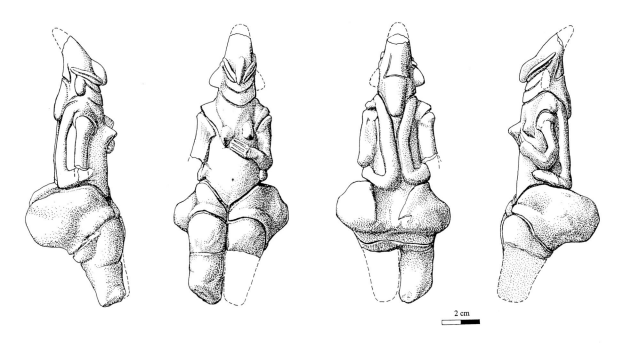

FIG. 13.11. Technical drawings of a seated cowrie-eyed figurine

the lower chest. A deep vertical incision differentiates the hand from the arm. The fingers, which were depicted by three parallel incisions, touch the right breast. The navel appears on the lower part of the stomach and it was made by a small punctured hole.

The figurine is wearing a garment. It is made of ribbons of clay, which were attached to the body. The garment is composed of two separate symmetrical pieces, one on the left side, the other on the right. Each one starts between the breast and the arm, goes up the shoulder, covers the back and curves around to the side of the stomach. The position of the garment at the side of the breasts, and not in between, is not known from other figurines.

The thighs and buttocks are massive and are the most prominent component of the body. On the buttocks and thighs, three deep circular incisions represent fat folds. The lower part of the leg is quite schematic without an emphasis on the knee or the foot. The figure is presented in a seated posture. Traces of red coloration can be observed on the item, especially the lower part of the face, the upper part of the back of the garment, and the upper right hand.

Measurements: 142 × 61 × 54 mm.

Provenience: 1998 Excavation Season, Locus 339, Bucket 1217

**2.** This item consists of three restorable fragments, together representing an almost complete figure (Figs.

13.12: 1, 13.13). The upper part includes the head, (the top is missing) and part of the torso. The face is composed of two elongated oblique eyes, a prominent nose and rounded dominant ears/earrings. Below the face, only on the frontal part of the figurine, there is a semi-circular clay ribbon. This probably represents a scarf. On the back of the head an elongated and rounded piece of clay represents the veil at the nape of the neck. The torso includes the upper part of the garment and the left breast, which is supported by a bent left arm. The right section of the front torso is missing. The back is well preserved and includes the garment, which clearly is composed of two separate parts. Very strong red coloration can be observed on the eyes, the lower part of the head, the veil at the nape, the scarf and the garment.

The lower part of the figurine was discovered in two pieces, each in a different locus. The right leg is complete. It is in a bent position and the upper part is incised with two deep circular grooves, representing fat folds. The left leg is broken off. On its upper part, traces of the fingers of the left hand can be observed. Prominent red coloration can be observed on the upper part.

Measurements: 98 × 37 × 48 mm.

Provenience: 1998 Excavation Season. Locus 332, Buckets 1065, 1071.

Left Leg: Locus 280, Bucket 1006

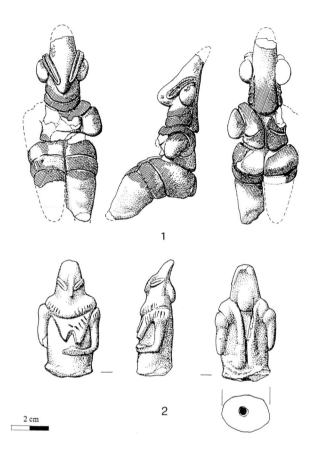

1

2

2 cm

FIG. 13.12. Technical drawing of two seated cowrie-eyed figurines

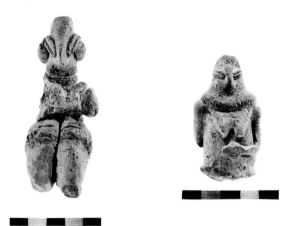

FIG. 13.13. A cowrie-eyed figurine

Fig. 13.14. A cowrie-eyed figurine

**3.** Complete item, slightly damaged, including the head and the torso (Fig. 13.12: 2, 13.14). The head is relatively short in comparison to the elongated heads of figurines of this type. The facial features are minimal and include

only the eyes and a nose. On the back, the upper part of the head is pointed and curved upwards. Below this, a lump of clay represents a veil at the nape.

The base of the head is covered by a scarf, which continues symmetrically down both sides of the back. In the front, the edges of the scarf are fringed, possibly depicting the texture of the material (textile or fur). Two drooping breasts appear below the scarf. The left arm is separated from the shoulder by a rounded incision, and its upper part also bears a fringed texture. The arm is bent and rests on the stomach, under the breasts. The hand is schematically represented by a wider piece of clay than the arm. The right arm is vertically attached to the body and its lower part is missing. The item has a flattened base. Before firing, an elongated hole was made in the center of the base. Its measurements are ca. 20 × 6 mm. (one third of the length of the item). The hole runs perpendicular to the base. It could have served for securing the item either to the lower part of a figurine or to a pedestal of its own.

Measurements: 63 × 35 × 21 mm.

Provenience: 1997 Excavation Season, Locus 152, Bucket 603

**4.** Headless figurine, the upper torso is also badly damaged (Fig. 13.15). It was restored from 11 connecting fragments. The top of the item includes the right shoulder and the upper arm. The breasts and the left side of the figurine are not preserved. Five short parallel incisions appear on the front, below the scar of the right breast, representing the fingers of the left hand. On the back, only the left side has been preserved, with a deep vertical incision in the center, which bisects the back, as well as a deep horizontal incision to the side.

The pelvic area is the most prominent feature of the figurine. The front was created by diagonal ribbons of clay. On the back, thick and prominent additions depict the buttocks. Of special interest is the right leg. Its upper part is encircled by thirteen deep punctured holes. Eight of these appear on the left side of a scar, and five appear on the right side of that scar. The scar itself seems to represent the place where the hand touched the pelvis. In the middle of the leg, a bulb of clay was added in order to emphasize the knee, and then, a large, deep punctured hole was made on it. The lower part of the leg was pinched in order to depict the foot. Red coloration appears on the lower part of the item. The left leg is eroded, and its original surface has completely disintegrated. Ribbons of red paint on either side of the buttocks can be observed, as well as traces of red coloration all over the item.

Measurements: 91 × 50 × 47 mm.

Provenience: 1998 Excavation Season, Locus 363, Bucket 1168

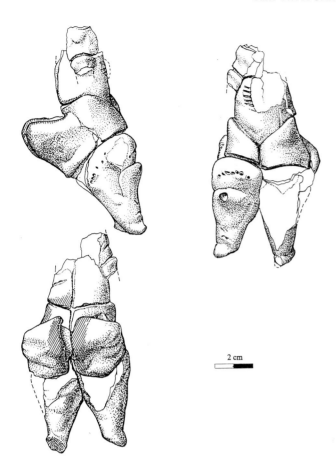

FIG. 13.15. Technical drawing of a headless seated figurine

Measurements: 44 × 22 × 16 mm.

Provenience: 1998 Excavation Season, Locus 350, Bucket 1123

**7.** Face fragment, including the left half only (Fig. 13.16: 3). The facial features include part of the eye and part of the ear. The ear is elongated and is denticulated by two deep incisions into three parts. Another three incisions can be observed at the side of the head, below the ear. This ear is shaped differently than other items from Sha'ar Hagolan, closely resembling an item from Byblos (Cauvin 1972, Fig. 28: 1; Dunand 1973, Pl. CXIII: 21160). Traces of yellow coloration can be observed on the item.

Measurements: 47 × 26 × 18 mm.

Provenience: 1998 Excavation Season, Locus 338, Bucket 1119

**8.** Face fragment (Figs. 13.16: 4, 13.18). The item includes the upper parts of two eyes and a nose. The eyes are almost vertical. The eyes and the back of the head are covered by strong and well-preserved red paint.

Measurements: 24 × 18 × 13 mm.

Provenience: 1998 Excavation Season, Locus 399, Bucket 1245

**9.** Upper head fragment (Fig. 13.16: 5). It is pointed and curved upwards. The tip of the left eye is preserved. Three ribbons of red paint appear on the front.

Measurements: 29 × 15 × 9 mm.

Provenience: 1998 Excavation Season, Locus 276, Bucket 959

**5.** Head fragment (Fig. 13.16:1, 13.17). The facial features include deeply incised, oblique eyes and a prominent nose. Incised bulbs of clay represent ears and earrings. Below the nose, there an "ear to ear," semi-circular incision. On the back of the head, above the ears, two deep, diagonal incisions appear on each side. The veil at the nape is missing and only a scar attests to its previous existence. Red coloration appears on the lower part of the face and the back of the item. This item resembles item 1 above and might have been made by the same hand.

Measurements: 44 × 28 × 24 mm.

Provenience: 1998 Excavation Season, Locus 201, Bucket 878

**6.** Head fragment (Fig. 13.11: 2). The top is complete, pointed and curved upward. The front is eroded and the facial features can be faintly observed on the left side only. These include the upper part of an oblique left eye and the left ear, which is divided in two by a deep incision. On the back, a prominent bulb of clay represents the veil at the nape. Red coloration can be observed on the back.

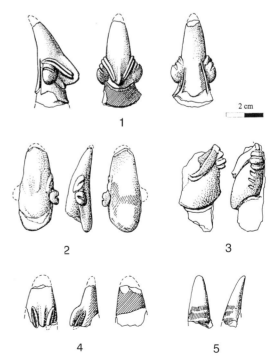

FIG. 13.16. Technical drawing of figurine head fragments

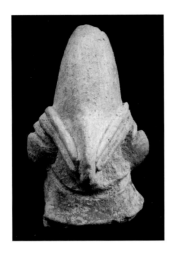

FIG. 13.17. A head fragment

FIG. 13.18. A head fragment

**10.** Right leg fragment (Fig. 13.19: 1). On the upper part of the item, a deep circular incision represents a fat fold. The lower part is pinched and depicts the knee. The leg is differentiated from the foot by another deep circular incision.

Measurements: 71 × 30 × 34 mm.

Provenience: 1998 Excavation Season, Locus 321, Bucket 1279

**11.** Left? lower leg fragment (Fig. 13.19: 2). A deep circular incision differentiates the leg from the foot. The item is decorated with a vertical incised line of "herring-bone" pattern. Traces of red coloration can be observed on the item.

Measurements: 40 × 18 × 19 mm.

Provenience: 1998 Excavation Season, Locus 348, Bucket 1168

**12.** Left lower leg fragment (Fig. 13.19: 3). A deep

diagonal incision appears on the front of the item. The lower part is pinched, representing the foot.

Measurements: 41 × 24 × 30 mm.

Provenience: 1998 Excavation Season, Locus 345, Bucket 1252

**13.** Leg fragment (Fig. 13.19: 4). The item includes the thigh, leg, knee and the foot. The leg is bent at the knee. A deep diagonal incision, located above the knee, partly encircles the item. The section created at the upper part of the item is a good indication of the manufacturing technique – a core with the addition of outer layers.

Measurements: 58 × 41 × 28 mm.

Provenience: 1997 Excavation Season, Locus 194, Bucket 761

**14.** Upper leg fragment (Fig. 13.19: 5). The item is deeply incised and covered in red coloration.

Measurements: 39 × 25 × 19 mm.

Provenience: 1996 Excavation Season, Topsoil, Bucket 257

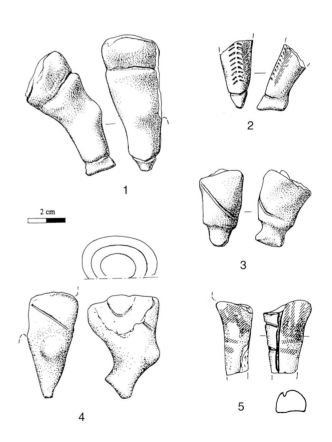

2 cm

FIG. 13.19. Technical drawing of figurine leg fragments

## V. THE PILLAR FIGURINES

Beside the common type of cowrie-eyed figurines made of clay that have been found in abundance at Sha'ar Hagolan, the site has also yielded other types of clay anthropomorphic figurines. Two new types have been uncovered, previously unknown in Yarmukian iconography. These are classified here into two cohesive groups: pillar figurines and a bent figurine (see below). The pillar figurines are small, free standing items and, as their name suggests, they are pillar-like. They have also been defined as "torso type figurines" (Broman Morales 1983: 381). The figurine-maker has concentrated primarily on the facial features, such as the eyes, nose, mouth and ears, while omitting the body features. The concept of pillar figurine is found as early as Pre-Pottery Neolithic B contexts. See, for example, Munhata (Garfinkel 1995: 19, Fig. 14;1, Pl. 4: 1), Tell Aswad (de Contenson 1995, Fig. 126: 9–24) and Bouqras (Lohof 1989). Later, from the first half of the eighth millennium bp, they have been reported from Pre-Pottery Neolithic C contexts such as Yiftahel (Commenge 1997), and Tell 'Ali (Garfinkel 1992, Fig. 14: 1; 1995: 40, Fig. 11: 2). Later, in Pottery Neolithic sites, they have been found at Tell Ramad (Cauvin 1972, Figs. 26: 1–2, 4; de Contenson 1983, Fig. 14). In Yarmukian contexts, this type of figurine has been reported from Munhata (one item, Garfinkel 1995, Fig 11: 1, Pl. 16: 4) and from the 1998 Season of Excavations at Sha'ar Hagolan.

The assemblage from Sha'ar Hagolan has yielded four items in this category (5% of the total number of clay figurines from the site). While the items from Tell Ramad and from Munhata are broken and only the upper part has been preserved, there are two complete items from Sha'ar Hagolan. This allows for a comprehensive understanding of this relatively rare type of human representation in Yarmukian art. The good preservation of these items also facilitates a recognition of their iconographic features and an indication of their modeling techniques.

The manufacturing of these items was carried out in a few basic stages:

1. The modeling and rolling of the clay to form the elongated and sometimes conical shape of the item.
2. Indentation and pinching of the base of the item to enable it be free-standing.
3. Concentration on the facial features:
    a. Pinching of the nose and sometimes of the tip of the head.
    b. Additions of small bulbs of clay to form the eyes, and sometimes the nose and ears.
    c. Incisions and puncturing in order to emphasize additional features like the eyes and the mouth.

4. Smoothing of the entire object.
5. Firing of the clay to harden it.

A. The Sample

**1.** A complete, free-standing, conical item (Figs. 13.20: 1, 13.22). The top is pointed and the base is wide and generally flat. The facial features include horizontal eyes, which were made by short and deep incisions. A remnant of a bulb of clay added to the side of the head, may represent the left ear. A small incision in the middle of the face, may represent a mouth.

Measurements: 37 × 19 × 17 mm.

Provenience: 1998 Excavation Season. Bucket 916, Locus 238

**2.** A complete, freestanding, item (Fig. 13.20: 2, 13.21). The top of the head is pointed and the base is exaggerated and concave. The facial features include the left eye (the right eye has fallen off) and the nose. They were made by the addition of small protruding bulbs of clay. The eye was later incised with a short, deep incision in order to create a cowrie-eye effect.

Measurements: 28 × 13 × 15 mm.

Provenience: 1998 Excavation Season. Bucket 1331, Locus 356

**3.** The upper part of a conical item with a pointed top (Figs. 13.20: 3, 13.23). The facial features include the nose and the eyes, which are slightly damaged. The nose was pinched from the original piece of clay and emphasized with a rounded incision on its lower part. The eyes were made by the addition of small bulbs of clay pressed into the side of the nose. Later the bulbs were incised with a central incision to create a cowrie-eye effect.

Measurements: 38 × 16 × 16 mm.

Provenience: 1998 Excavation Season. Bucket 1071, Locus 332

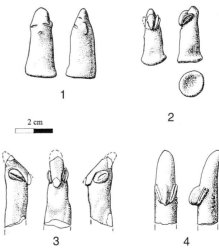

FIG. 13.20. Four pillar figurines

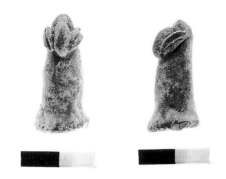

FIG. 13.21. Different views of a pillar figurine

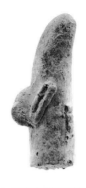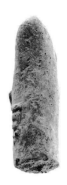

FIG. 13.24. Different views of a pillar figurine

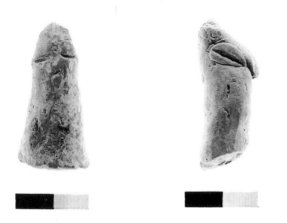

Fig. 13.22. A pillar figurine            Fig. 13.23. A pillar figurine

**B. Concluding remarks**

Pillar figurines are a rare aspect of Yarmukian symbolic expression, since only a few of them have been discovered until now. The form of the pillar figurines is more simply rendered than in other art objects found at Yarmukian sites. They closely resemble the simple "gaming pieces" discovered at various sites, including Munhata (Garfinkel 1995, Fig. 35: 1–2, 4–6). However, the simple gaming pieces bear no facial attributes while the four pillar figurines presented here do have facial features. Of the four items from Sha'ar Hagolan, three bear "cowrie eyes." Three upper-part fragments that have been published from Tell Ramad (Cauvin 1972, Fig. 26: 1–2, 4) are probably pillar figurines as well. They bear cowrie eyes, like three of the Sha'ar Hagolan items. The single pillar figurine from Munhata was shaped differently and is not similar to those from Sha'ar Hagolan.

**4.** Head fragment, damaged on the right side (Fig. 13.20: 4, 13.24). The top of the head is emphasized, elongated and curved upwards. The facial features include the eyes, the nose, and the left ear. The eyes were made by the addition of small, elongated bulbs of clay which were later incised with a central incision, thus creating a cowrie-eye effect. After this, the inside of the eyes were colored with red paint. The prominent nose was made of a pinched piece of clay. The ear was made by the attachment of an elongated piece of clay, which was incised by three deep horizontal incisions. This gave the ear a denticulated effect.

This specific item displays close northern links: the head is reminiscent of those found at Tell Ramad (de Contenson 1983, Fig. 14) and the incised ear is similar to the molding of the ears on a male figurine from Byblos (Cauvin 1972: 85, Fig. 28: 1; Dunand 1973, Pl. CXIII: 21160).

Measurements: 40 × 13 × 17 mm.

Provenience: 1998 Excavation Season. Bucket 1250, Locus 345

## VI. THE BENT FIGURINE

This item is made of the typical clay of the Central Jordan Valley, which was also utilized to produce pottery vessels. It was made of a central core of clay, to which the body parts and clothing were added. Additionally manufacturing techniques include deep and shallow incisions, smoothing and painting. Finally, the item was fired.

At first glance this item is not easy to understand. Although it is in a relatively good state of preservation and only a small part of it is missing, the contortions of the body blur immediate recognition (Figs. 13.25–13.26). Our methodology, in this case, is to compare the item with the other representations of the human image found at the site. In the context of local iconography, we interpret this to be a seated figurine in a bent position,

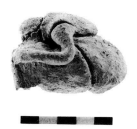

FIG. 13.25. A bent figurine

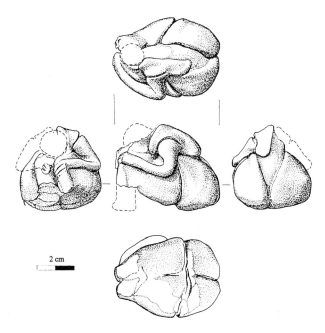

2 cm

FIG. 13.26. Technical drawing of the bent figurine

with its head between its knees. This figurine displays various classic Yarmukian characteristics:

1. the modeling of the pelvis
2. deep incisions on both sides of the thigh that represent fat folds
3. A garment starts from the upper chest and covers the back
4. the separation of the arm from the garment
5. the depiction of the hand

Basing our interpretation upon these aspects, it is possible to give the following description:

The head of the item is broken, but the left base of the head remains. The head is resting upon the lower part of the thighs. As a result of this, the front of the torso (breasts and stomach), is not visible. On the left side of the item, the upper chest, shoulders and the back are covered by the typical garment of the Yarmukian seated cowrie-eyed figurines (see above). The right side of the garment has not been preserved. The left arm is separated from the garment by a deep, circular incision, which is also a typical Yarmukian icongraphic feature. This arm is attached vertically to the side of the body, and then bent at a 90 degree angle. The hand was depicted by a few short, shallow incisions: one vertical incision separates the hand from the arm, and two horizontal incisions depict the fingers. These features are also typical of Yarmukian iconography. The fingers are bent and holding the knee, just below the head. The right arm was not preserved, but a few remnants of the fingers can be observed holding the right knee.

The pelvic area occupies most of the item. On the lower part of the back, between the garment and the fat folds of the thigh, a triangular shape is formed. The prominent thighs are symmetrical, with a deep diagonal incision on each side representing the fat folds. The legs are bent at the knees, which indicates a seated position. The lower parts of the legs are missing. On the bottom of the item, the base of the figurine is incised with two perpendicular lines, in the shape of a cross, which can also be found on the bases of other items from Sha'ar Hagolan. Traces of red paint can be observed on the item.

Stylistically, the bent figurine shares many similarities with the seated figures of the cowrie-eyed figurine group: the garment and the depiction of the shoulder, execution of the palm and fingers and the prominent pelvis and fat folds. Thus, it seems that at the site of Sha'ar Hagolan the same figure appears in two different body postures. The first and most common is the seated position, while the bent-over position is more unusual. The relationship between the two types may help us understand the symbolic meaning of these clay figures.

This item is unique in the repertoire of the artistic expression of the Neolithic Near East. Generally, figurines are represented either in a seated or a standing position. A bent posture is a very rare iconographic feature. The placement of the fingers clasped around the knees is also unusual. Needless to say, a combination of both icongraphic features is an extremely exceptional phenomena. Only one other parallel is known to us from the Near East, from Tepe Ali Kosh, in the Deh Luran Plain in western Iran (Hole *et al.* 1969: 224–225, Fig. 97: a, Pl. 38: i).

While the bent-figure appears to be extremely rare in the Neolithic Near East, it may relate to a similar bent-leg position better known on figurines from the Aegean and Balkan regions. For instance, an interesting parallel can be found in a figure from the site of Achilleion, an Early Neolithic settlement in Central Greece (Gimbutas 1989:

196, Fig. 7.46: 1, Pl. 7.10: 3). The legs of this headless figure appear to be deeply bent, though their lower half is missing, forming a position similar to the Sha'ar Hagolan figurine; however, in this case the torso is not held as close to the thighs as in our figure. While the arms are missing below the shoulder, they have been reconstructed as resting on top of the thighs. Of most interest in this Aegean figure, however, is the exaggerated and exposed pudenda which is clearly shown below the bent legs. Together with the bent posture, this feature unmistakably associates the Achilleion figure with the common position for parturition. Such "birth-giving" figures are fairly common from the Neolithic of the Aegean and Balkan region, where many have the open-leg posture which has been called the "frog goddess" posture of parturition and regeneration (Gimbutas 1986: 249–50; 1989: 197). Although our figure from Sha'ar Hagolan does not fit exactly within this group, especially in that the legs are not spread open, some similarity in the overall posture of bent legs and arms-on-thighs may indicate that this figurine also represents birth-giving.

Measurements: 43 × 60 × 39 mm.

Provenience: 1998 Excavation Season, Bucket 1149, Locus 359

## VII. Pebble Figurines

Pebble figurines are engraved limestone river pebbles that depict a schematic human representation. They are a well-known aspect of Yarmukian symbolic expression. About 145 such items have been reported thus far from the following sites: Sha'ar Hagolan, Munhata, and Hamadya in the Jordan Valley, 'Ain Ghazal in Jordan and Byblos in Lebanon. At Sha'ar Hagolan 106 such items have been recorded (75% of the total known assemblage), the largest collection of this type of anthropomorphic figurine from the Neolithic Near East. This assemblage therefore provides the basis for research into the iconography and style of Yarmukian pebble figurines. Over the years, various items have been documented and published (Stekelis 1972; Yizraeli-Noy 1999), but a full corpus has not yet been presented. One aim of our study is, therefore to present a corpus of the pebble figurines from Sha'ar Hagolan and to offer a systematic iconographic analysis based upon stylistic attributes and quantitative data. As this work is still under preparation, we are presenting here the preliminary results only. In addition, two new, complete figurines in this category are presented. The reader should be aware that most of the pebble figurines from Sha'ar Hagolan have been collected on the site surface by local farmers, while in the renewed excavations less than 10 such items have been discovered.

All the anthropomorphic pebble figurines were made on limestone river pebbles. Basalt river pebbles, which are also common in this region, were not utilized for this category of symbolic expression. The following types of limestone river pebbles were used: Soft and chalky limestone river pebbles; hard, off-white to grey limestone river pebbles; and hard, pinkish limestone river pebbles. There is a large variation in the size of the pebbles selected for carving. The lightest one weighs 30 gm. while the heaviest is 5.9 kg. The average is 0.5 kg. There is a clear relationship between the size of the figurines and the raw material utilized. The small figurines were made on soft limestone river pebbles, while most of the larger figurines were made on hard limestone river pebbles. Usually, symmetrical, elongated river pebbles were chosen. The surface of the pebble figurines often displays signs of battering, smoothing and polishing. In some rare cases, red paint can be observed.

The carving of pebbles poses different technical difficulties than the modeling of clay. This is evident in the omission of much detail from the body or dress of the figure. Stylistically, the pebble figurines can be divided, according to the amount of detail, into three categories. The pebble figurines in the first group are the least schematic, while those in the third group display the highest degree of schematization.

**1. Detailed Figurine** – Figurines in this group have a face as well as additional details of dress or body, usually the hips.

**2. Face Figurine** – In this group an attempt was made to express the face, including the eyes, nose and mouth. Occasionally, only eyes and a mouth were carved.

**3. Eye Figurine** – This is the most schematic type. Only the eyes were carved on the pebble.

Unlike the clay figurines – which display a higher degree of standardization in the execution of their attributes – the pebble figurines exhibit a freer choice in the depiction of facial features, body parts and dress. These attributes can be classified typologically into eight groups:

**1. The Eyes** – Eyes were found on all the complete pebble figurines. The eyes were depicted in various ways: single line incisions; two parallel line incisions depicting each eye; rectangular-shaped incisions depicting each eye; and rounded eyes created by drilling. The single line incision is the most common technique and appears on more that 85% of the objects. The eyes appear at a variety of angles: inclined eyes, horizontal eyes, semi-oblique eyes, oblique eyes and vertical eyes.

**2. The Nose** – The nose was found on few examples

only. It was depicted by: a thin single vertical line incision; two parallel vertical line incisions; a drilled hole between the eyes; and a rectangular-shaped incision.

**3. The Mouth** – The mouth was found on almost 40% of the figurines. It was depicted by: a drilled hole near or beneath the eyes; a circular cup-like depression; a concentration of shallow chisel strokes appearing in the center; and a thin single horizontal line incision.

**4. Veil at the Nape** – This element appears clearly on one example only.

**5. A Line Separating the Head from the Body** – This element appears clearly on one example only.

**6. Garment** – The garment was found on ten figurines. In the pebble figurines, the garment is depicted in a more schematic manner than the same garment on the clay figurines. It is composed of three parts: On the front of one example, immediately below the head, diagonal lines create two triangles; in the central back side of the pebble, two large rectangular features were incised. Usually, these features appear symmetrically and separately from each other. On the front of the pebble, incisions are present in the form of rectangles or triangles. They continue around the sides and the back of the body. In comparison to the clay figurines, these can be understood as the lower part of the garment that comes from the back of the figurine and covers part of the abdomen, leaving the navel uncovered.

**7. Scarf** – This element appears on few examples only.

**8. Thighs** – In the lower part of some 20 pebble figurines, the thighs are represented. They are depicted on the frontal part of the pebble and sometimes at the sides and at the back as well. The thighs are presented by three basic shapes, each appearing as one or two parallel incisions: curved, carinated or diagonal.

**9. Coloration** – Signs of red coloring appear on only nine examples.

Two complete items discovered by the new expedition are presented here:

**1.** A large, slightly broken, oval, hard limestone river pebble. Deep oblique symmetrical incisions represent the eyes. Below the eyes, a shallow, chiseled hole depicts the mouth. The surface is partially covered by scratches and incisions. It is the largest pebble figurine yet discovered at Sha'ar Hagolan (Figs. 13.27: 1, 13.28).
Measurements: 315 × 148 × 109 mm.; Weight: 5,900 g.
Provenience: 1989 Excavation season, surface find near Building II, Bucket 96

**2.** A free-standing hard limestone item, intentionally

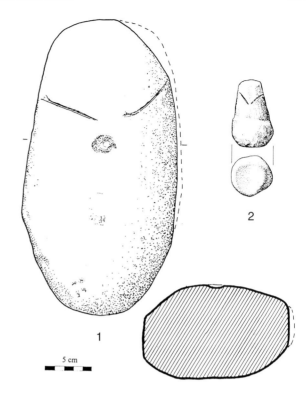

FIG. 13.27. Technical drawing of two pebble figurines

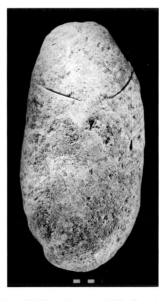

FIG. 13.28. A large pebble figurine

carved in order to produce its final shape (Figs. 13.27: 2, 13.29). The bottom is cylindrical and wider than the upper part of the item, which is more conical in shape. This is in contrast to most of the Yarmukian anthropomorphic pebble figurines, in which the natural shape of the pebble was maintained. It is thus possible that this item was

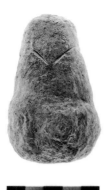

FIG. 13.29. A small pebble figurine

originally used as a pestle, and later, the anthropomorphic image was added. Two deep oblique incisions represent the eyes. They are symmetrical to each other. These are the only features represented on the figurine (Fig. 15: 2). A similar shape is known from Byblos, Lebanon, although it is not free standing (Dunand 1973, Pl. CX: 23083). The contours of both these figurines resemble the Russian "babushka" dolls.

Measurements: 71 × 47 × 41 mm.; Weight 141 g.

Provenience: 1998 Excavation Season, Bucket 1012, Locus 299

## VIII. DISCUSSION

The richest collection of prehistoric art ever unearthed at one site in Israel was found at the pottery Neolithic site of Sha'ar Hagolan. This rich repertoire of over 200 items includes mainly anthropomorphic figurines, made of clay or river pebbles, as well as zoomorphic figurines of clay and basalt river pebbles engraved with geometric designs. This unique assemblage is the most interesting and intriguing aspect of Yarmukian culture. The wealth of symbolic expression raises many questions (Ucko 1968; Voigt 1983; Talalay 1993): What are these objects? Why were they made? Who made them? Who used them? Do the anthropomorphic figures represent humans or divinities? What is the meaning of the geometric incisions? What is the meaning of the prominent oblique eyes that appear on so many Yarmukian figures? What are the sources of the Yarmukian iconographic tradition? Why are there so many of these objects? Why have most of them been discovered at one site, Sha'ar Hagolan? Before our current excavations at Sha'ar Hagolan, most of these objects were collected from the site surface, and thus no information concerning their function and use by the Yarmukians was available. Despite much scholarly specu-

lation, these questions remain unanswered. Thus, one of the main objectives of the present archaeological excavations at Sha'ar Hagolan is to obtain further data concerning the distribution of the art objects at the site (see Ben-Shlomo and Garfinkel, Chapter 14 in this volume) and to gain a better understanding of this unique phenomenon. In this paper we present only general observations about the meaning of the figurines found at Sha'ar Hagolan.

The Yarmukian clay figurines are one of the most impressive artistic achievements of Neolithic peoples. The frequency of these finds at Sha'ar Hagolan indicates that the site played a special role in the social sphere of the ancient Near East during the period of its occupation. The clay cowrie-eyed figurines are a highly standardized type of anthropomorphic figure, in which almost all extant examples share a common set of attributes. Most depict females, but two items (from Sha'ar Hagolan and Byblos) represent males. We find it significant that the makers of these figurines chose to portray many specific, minute details on the figures, such as an elongated head, diagonal eyes, nose, ears, earrings, mouth, cheeks, headdress, garment or scarf, hands, fingers, fat folds, knees, and feet. Many of these features, however, are consistently depicted in a specific fashion that does not seem to conform to a realistic portrayal of human anatomy or clothing. While various features are emphasized, exaggerated or depicted in detail, others are not depicted at all, such genitalia or feet. We believe these choices are not incidental, but reveal a conscious choice by the figurine-makers that must reflect a system of symbols and beliefs readily understood in Yarmukian society.

Pebble figurines are another major component of the Yarmukian repertoire. The creators of these pebble figurines made different, although, we believe, related choices about which features to depict on their creations. The carving of limestone pebbles posed certain technical limitations not experienced by those molding figures in clay. Faced with these limitations, the pebble figurine makers chose to exclude many details of the body or dress that are clearly depicted in clay figurines. Typologically the figurines may be divided according to the amount of detail or its absence in the specimen: detailed figurine, face figurine and eye figurine. As we have seen here, from one group to the other, the depiction on the pebbles becomes more and more schematic, and only the most important symbolic details are retained.

We take all three groups described above as conveying the same religious-ideological-symbolic messages, which is more clearly recognized in the clay figurines. This creates a circular relationship between clay and pebble figurines. On the one hand, the detailed clay figurines help us to interpret the carvings on the pebbles. On the

other hand, the pebble figurines reveal the most import-
ant details of the clay figurines, thus indicating which are
essential and which were considered less so. According to
this analysis, the most significant detail in the figure is not
the reproductive organs, but the eyes. This is in marked
contrast to the majority of Neolithic figurines from the
Near East, which do not emphasize the eyes, or from the
Aegean and Balkan regions, in which the pubic region is
often more clearly emphasized. Future discussions will
center on the use and meaning of the Yarmukian figur-
ines, and explore in greater detail the symbolism behind
the choices apparent in the features of these unique
works of prehistoric art.

**Acknowledgments**
The figurines presented here were excavated with the
support of the Curtiss T. and Mary G. Brennan Founda-
tion. The artifacts were drawn by D. Ladiray and photo-
graphed by G. Laron and D. Harris.

BIBLIOGRAPHY

Applbaum, N., Applbaum, Y., Lavi, M. and Garfinkel, Y. 1998.
Computer Tomography Imaging as an Aid in the Preserva-
tion and Conservation of Neolithic Figurines from the Site
of Sha'ar Hagolan. *Archaeology and Science Bulletin* 6: 46–54
(Hebrew).
Bar-Yosef, O. and Alon, D. 1988. *Nahal Hemar Cave* ('Atiqot
18). Jerusalem: Israel Department of Antiquities and
Museums.
Broman Morales, V. 1983. Jarmo Figurines and Other Clay
Objects. In Braidwood, L.S., Braidwood, R.J., Howe, B.,
Reed, C.A. and Watson, P.J. *Prehistoric Archaeology Along the
Zagros Flanks* (Oriental Institute Publications 105), pp. 369–
423. Chicago: University of Chicago Press.
Cauvin, J. 1972. *Religions néolithiques de Syro-Palestine*. Paris:
Maisonneuve.
Commenge, C. 1997. A Pottery Figurine from Yiftahel. In
Braun, E. (ed.) *Yiftahel – Salvage and Rescue Excavations at a
Prehistoric Village in Lower Galilee, Israel* (IAA Reports 2), pp.
181–182. Jerusalem: Israel Antiquities Authority.
Conkey, M.W., Soffer, O., Stratmann, D. and Jablonski, N.G.
(eds.) 1997. *Beyond Art: Pleistocene Image and Symbol*. San
Francisco: California Academy of Sciences.
Contenson, H. de 1967. Troisieme campagne a Tell Ramad,
1966. Rapport Préliminaire. *Annales archéologiques arabes
syriennes* 17: 17–24.
Contenson, H. de 1983. Early Agriculture in Western Asia. In
Young, T.C., Smith, P.E.L. and Mortensen, P. (eds.) *The Hilly
Flanks and Beyond, Essays on the Prehistory of Southwestern Asia,
Presented to R. J. Braidwood* (Studies in Ancient Oriental
Civilization 36), pp. 57–74. Chicago: University of Chicago
Press.
Contenson, H. de 1995. *Aswad et Ghoraife*. Beyrouth: Institut
français d'archéologie du Proche-Orient.

Dunand, M. 1973. *Fouilles de Byblos* Vol. V. Paris: Maisonneuve.
Garfinkel, Y. 1992. The Material Culture in the Central Jordan
Valley in the Pottery Neolithic and Early Chalcolithic
Periods. Unpublished Ph.D. thesis. Jerusalem: Hebrew
University of Jerusalem (Hebrew).
Garfinkel, Y. 1994. Ritual Burial of Cultic Objects: The Earliest
Evidence. *Cambridge Archaeological Journal* 4: 159–188.
Garfinkel, Y. 1995. *Human and Animal Figurines from Munhata
(Israel)* (Les cahiers des missions archéologiques français en
Israël 8). Paris: Association Paléorient.
Garfinkel, Y. 1999a. *The Yarmukians, Neolithic Art from Sha'ar
Hagolan*. Jerusalem: Bible Lands Museum.
Garfinkel, Y. 1999b. Facts, Fiction, and Yarmukian Figurines.
*Cambridge Archaeological Journal* 9: 130–133.
Garstang, J., Droop, J.P. and Crowfoot, J. 1935. Jericho: City
and Necropolis (Fifth Report). *Liverpool Annals of Archaeology
and Anthropology* 22: 143–173.
Gell, 1998. *Art and Agency. An Anthropological Theory*. Oxford:
Clarendon Press.
Gimbutas, M. 1986. Mythical Imagery of Sitagroi Society. In
Renfrew, C., Gimbutas, M. and Elster, E. (eds.) *Excavations
at Sitagroi*, Vol. 1, pp. 225–290. Los Angeles: Institute of
Archaeology, University of California.
Gimbutas, M. 1989. Figurines and Cult Equipment: Their Role
in the Reconstruction of Neolithic Religion. In Gimbutas,
M., Winn, S. and Shimabuku, D. (eds.) *Achilleion: A Neolithic
Settlement in Thessaly, Greece, 6400–5600 BC*, pp. 171–228. Los
Angeles: Institute of Archaeology, University of California.
Gopher, A. and Orrelle, E. 1996. An Alternative Interpretation
for the Material Imagery of the Yarmukian, a Neolithic
Culture of the Sixth Millennium bc in the Southern Levant.
*Cambridge Archaeological Journal* 6: 255–279.
Gopher A. and E. Orrelle. 1999. Coffee Beans, Cowries and
Vulvas: a Reply to Comments by Y. Garfinkel. *Cambridge
Archaeological Journal* 9: 133–137.
Hauptmann, H. 1993. Ein kultgebaude in Nevaliçori. In
Frangipane, M., Hauptmann, H., Liverani, M., Matthiae, P.
and Mellink, M. (eds.) *Between the Rivers and Over the Mountains*,
pp. 37 69. Rome: Università di Roma.
Hole, F., Flannery, K.V. and Neely, J.A. 1969. *Prehistory and
Human Ecology of the Deh Luran Plain. An Early Sequence from
Khuzistan, Iran* (Memoirs of the Museum of Anthropology,
No. 1). Ann Arbor: University of Michigan.
Kafafi, Z. 1988. Jebel Abu Thawwab: A Pottery Neolithic
Village in North Jordan. In Garrard, A.N. and Gebel, H.G.
(eds.) *The Prehistory of Jordan. The State of Research in 1986*
(B.A.R. International Series 396), pp. 451–471. Oxford:
British Archaeological Reports.
Kafafi, Z. 1993. The Yarmoukians in Jordan. *Paléorient* 19: 101–
114.
Kaplan, J. 1954. The Neolithic and Chalcolithic Settlements at
Tel Aviv and Its Environs. Unpublished Ph.D. thesis.
Jerusalem: Hebrew University of Jerusalem (Hebrew).
Kaplan, J. 1959. *The Archaeology and History of Tel-Aviv – Jaffa*.
Ramat Gan: Masada (Hebrew).
Loud, G. 1948. *Megiddo II: Seasons of 1935–39* (Oriental Institute
Publications 62). Chicago: University of Chicago Press.
Lohof, E. 1989. A Lesser Known Figurine from the Near

Eastern Neolithic. In Haex, O. M.C., Curvers, H.H. and Akkermans, P.M.M.G. (eds.) *To The Euphrates and Beyond, Archaeological Studies in Honour of Maurits N. van Loon*, pp. 65–74. Rotterdam: A.A. Balkema.

Mellaart, J. 1975. *The Neolithic of the Near East*. London: Thames and Hudson.

Morphy, H. 1989. Introduction. In Morphy, H. (ed.) *Animals into Art*, pp. 1–17. London: Unwin Hyman.

Noy, Y. 1979. A Stone Figurine from the Natufian site of Gilgal II. *Qadmoniot* 12: 122–123 (Hebrew).

Noy, T. 1990. New Aspects of Pottery Figurines in the Yarmukian Culture. *Eretz-Israel* 21: 226–232 (Hebrew).

Perrot, J. 1965. IV Campagne de fouilles a Munhata. *Academie des Inscriptions et Belles-lettres*: 407–411.

Price, S. 1989. *Primitive Art in Civilized Places*. Chicago: Chicago University Press.

Schmidt, K. 1998. Frühneolithische tempel Ein Forschungsbericht zum präkeramischen neolithikum Obermesopotamiens. *Milleilungen der Deutschen Orient-Gesellschaft zu Berlin* 130: 17–49.

Soffer, O. and Conkey, M.W. 1997. Studying Ancient Visual Cultures. In Conkey, M. W., Soffer, O., Stratmann, D. and Jablonski, N. G. (eds.) *Beyond Art: Pleistocene Image and Symbol*, pp. 1–16. San Francisco: California Academy of Sciences.

Stekelis, M. 1951. A New Neolithic Industry: The Yarmukian of Palestine. *Israel Exploration Journal* 1: 1–19.

Stekelis, M. 1952. Two More Yarmukian Figurines. *Israel Exploration Journal* 2: 216–217.

Stekelis, M. 1972. *The Yarmukian Culture of the Neolithic Period*. Jerusalem: Magnes Press.

Talalay, L.E. 1993. *Deities, Dolls and Devices. Neolithic Figurines from Franchthi Cave, Greece* (Excavations at Franchthi Cave, Greece 9). Bloomington and Indianapolis: Indiana University Press.

Tubb, K.W. 1985. Preliminary Report on the 'Ain Ghazal Statues. *Mitteilungen der Deutschen Orient-Gesellschaft zu Berlin* 117: 117–134.

Tubb, K.W. and Grissom, C.A. 1995. 'Ayn Ghazal: A Comparative Study of the 1983 and 1985 Statuary Caches. *Studies in the History and Archaeology of Jordan* 5: 437–447.

Ucko, P.J. 1968. *Anthropomorphic Figurines of Predynastic Egypt and Neolithic Crete, with Comparative Material from the Prehistoric Near East and Mainland Greece* (Royal Anthropological Institute Occasional Paper 24.). London: Andrew Szmidla.

Voigt, M.M. 1983. *Hajji Firuz Tepe, Iran: The Neolithic Settlement* (University Museum Monograph 50). Philadelphia: University of Pennsylvania.

White, R. 1992. Beyond Art: Toward an Understanding of the Origins of Material Representation in Europe. *Annual Review Anthropology*, 21: 537–564.

Yeivin, E. and Mozel, I. 1977. A *Fossil Directeur* Figurine of the Pottery Neolithic A. *Tel Aviv* 4: 194–200.

Yizraeli-Noy, T. 1999. *The Human Figure in Prehistoric Art in the Land of Israel*. Jerusalem: Israel Museum and Israel Exploration Society (Hebrew).

# 14

# THE SPATIAL DISTRIBUTION OF THE ANTHROPOMORPHIC FIGURINES IN AREA E

## David Ben-Shlomo and Yosef Garfinkel

## I. INTRODUCTION

The site of Sha'ar Hagolan has produced the richest prehistoric art assemblage ever unearthed at one site in Israel. As early as the late 1930s, local farmers collected art objects from the site surface. Stekelis, the first archaeologist to excavate at Sha'ar Hagolan, published quite a number of figurines in his earliest publications about the site (1951, 1952). In the final report (1972), Stekelis did not differentiate between the finds from his excavations and surface finds. Hence, many of the finds published by Stekelis lack stratigraphic context. Since his excavations, local farmers have found more figurines (Garfinkel 1992), many of which were recently published by the late Tamar Yizraeli-Noy (1999). The unique art assemblage of Sha'ar Hagolan is a most interesting and intriguing aspect of this Neolithic culture.

The wealth of symbolic expression in prehistoric contexts raises many questions (Ucko 1968; Voigt 1983; Talalay 1993; Hamilton *et al.* 1996). However, without context, no information concerning the function and use of the art objects was available. This situation resulted in much unfounded and often misleading speculation (see Garfinkel 1999b). The main objective of our presentation is to obtain further data concerning the distribution of the art objects at the site and to gain a better understanding of this unique phenomenon.

## II. THE DATA

The focal point of the renewal of excavations at Sha'ar Hagolan is the large horizontal exposure of Area E, where c. 1,300 sq. m. were uncovered up to the end of the 1999 season (Garfinkel and Ben-Shlomo, Chapter 5 in this volume). Part of a well-planned village with large courtyard structures and streets has been found. This area is also extremely rich in material culture remains, including pottery, flint, stone tools and art objects. So far, 64 anthropomorphic figurines were found in Area E. Typologically these figurines can be divided into the following three categories:

A  Seated cowrie-eyed figures made of clay. This is the most common type, and 53 (82.8%) items have been discovered.

B  Pebble figurines made on various types of limestone pebbles taken from the nearby Yarmuk River. Only 4 (6.3%) such items have been found.

C  Other clay figurines (7 items, 10.9%). Four different types are included here: four pillar figurines, a bent figure, a statue and a cylindrical figurine. The first three types were found in a good state of preservation, and have been published (Garfinkel 1999; Garfinkel *et al.,* Chapter 13 in this volume). However, the cylindrical item is only a small lower torso fragment and has not been published yet. Similar items, in a better state of preservation, have been published from Munhata (Garfinkel 1995, Fig. 30).

The large assemblage of figurines was found at various architectural units of Area E: Building Complex I (9 items), open area north of Building Complex I (2 items), Building Complex II (48 items) and Building Complex III (1 item). Four items from the site topsoil were also found in Area E, and they are related to the Neolithic period based on their typological similarities to figurines discovered in the Neolithic layer. The data concerning the distribution of the different figurine types in the various excavated units is presented here in Table 14.1 and Fig. 14.1.

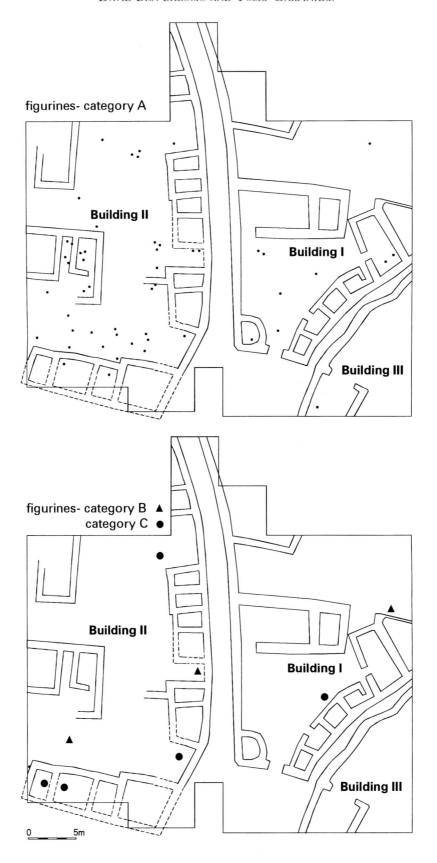

FIG. 14.1. Spatial distribution of the various figurines in Area E

TABLE 14.1. Spatial distribution of the anthropomorphic figurines in Area E

| Location | Seated cowrie-eyed | Pebble | Other types | Total | % |
|---|---|---|---|---|---|
| Building Complex I | 8 | 0 | 1 | 9 | 14.1% |
| North of Building Complex I | 1 | 1 | 0 | 2 | 3.1% |
| Building Complex II | 41 | 2 | 5 | 48 | 75.0% |
| Building Complex III | 1 | 0 | 0 | 1 | 1.5% |
| Topsoil | 2 | 1 | 1 | 4 | 6.3% |
| **Total** | 53 | 4 | 7 | 64 | 100% |
| **%** | 82.8% | 6.3% | 10.9% | 100% | |

The spatial distribution of the seated cowrie-eyed clay figurines is presented in the upper map of Fig. 14.1. A total of 53 items belonging to this category have been found, including a few complete figurines and many fragments. Most of these (41), including two complete items, came from Building Complex II. In this building most of the figurines were discovered in the open courtyard, and only two inside the roofed rooms. An additional eight fragments were found in Building Complex I, three figurines inside rooms and the other five in the open courtyard. One seated cowrie-eyed clay figurine was found in the open area north of Building Complex I, and one in Building Complex III.

In the lower map of Fig. 14.1 the spatial distribution of the pebble figurines is presented. The two complete items came from the floors of Building Complex II. One broken item was found in the open area north of Building Complex I. No pebble figurine was found inside Building Complex I or Building Complex III.

In the lower map of Fig. 14.1 the distribution of rare types is presented. The clay statue was found in the courtyard of Building Complex I. The four pillar figurines were all found in Building Complex II, as well as the cylindrical item. The bent figurine was found near the southwest corner of Building Complex II. It is clear that Building Complex II is not only the richest in the total number of figurines unearthed inside it, but also produced most of the unique types as well.

Only 13 (23%) of the figurines were found in rooms, seven of them in rooms 410 and 414, in the northwest part of Building Complex II. The figurines from roofed rooms could not be associated with a specific installation or other objects. Most of the figurines (46 items, 77%) were found in open areas and courtyards. Most figurines, though found in the courtyard, are concentrated near the room entrances. This observation is valid for both buildings. A few items were found in pits, such as a complete figurine from the open area north of Building Complex I and the fragments of the clay statue. This may reflect ritual burial of a cultic object (Garfinkel 1994).

Most figurines come from debris accumulated on the building's floors. This debris is rich in finds and includes flint, pottery sherds, animal bones, stone tools, sea shells and a few obsidian artifacts. Most of the items (figurines, pottery sherds and animal bones) are broken, worn-out artifacts that have been intentionally discarded. It seems that the courtyards were the main areas in which unwanted artifacts were deposited, while the rooms were kept clean. This means that the figurines, at least the fragments, are in a secondary, discarded context. But were the figurines kept in the rooms during their use, or were they used in several locations within the courtyards? Since most of the figurines were found near the room entrances, perhaps they were fixed to the doors and intended to guard the rooms, preventing evil powers from entering?

## III. Discussion

The most remarkable fact is the uneven distribution of figurines among the buildings. Nearly 75% of the finds are from Building Complex II, 14% from Building Complex I and only 1.5% from Building Complex III. As only a small portion of Building Complex III has been excavated so far, our comparison will concentrate on the other two buildings. Building Complex II is five times richer in figurines then Building Complex I. Furthermore, it should be taken into account that the uppermost phase of Building Complex I has been completely exposed and no more figurines are expected to be found there, while Building Complex II is still being excavated and more figurines may be found in it in further seasons. This increases the proportion of figurines in favor of Building

Complex II. It is thus clear that the largest collection of art objects was found in the largest known Neolithic structure, and that this building was located in the largest known Neolithic site.

The pottery analysis also indicates a difference between the structures. Medium-sized decorated bowls, which are elaborate serving vessels, constitute 17.7% of the pottery assemblage of Building Complex I, while in Building Complex II these constitute 29.7% (Eirikh-Rose and Garfinkel, Chapter 7 in this volume). The correlation between the high concentration of figurines and higher percentage of elaborate pottery is of special importance and seems to indicate intensive social activities in this structure.

Various explanations can be suggested concerning the difference between the two buildings:

1. Building Complex II represents a longer occupation period, and thus more items accumulated in it over the years. However, both buildings are situated parallel to each other and both have two main construction phases. They are, *sensu stricto*, contemporaneous to one another.
2. Building Complex II was more abruptly abandoned, thus leaving more valuable objects behind. In general it seems that more artifacts (*in situ* grinding stones, stone weights) were found laying on the floors of Building Complex II, however, many of the figurines are small fragments, which accumulated in the buildings over the years, and not only items from the last moment of the buildings' use.
3. Each building had a different function.
4. Building Complex II housed a different class of people who had more figurines in the first place.

Following his excavations at the Pre-Pottery Neolithic B site of 'Ain Ghazal, Rollefson suggested subdividing the art objects from the site into two groups based on their size (1983, 1986). This idea can be applied to Neolithic objects in general. On the one hand there are small anthropomorphic and zoomorphic figurines, usually smaller than 10 cm. These were used by individuals and reflect use on the individual household level. On the other hand, there are large anthropomorphic statues, plastered skulls and masks, usually larger than 20 cm. These were used on public occasions and apparently reflect rituals performed at a community level. At Sha'ar Hagolan most of the items are small, household-type items. They were usually found in a broken state, discarded together with pottery sherds, flint debitage and animal bones, in domestic units. Only the one clay statue is larger. Its fragments were found in a pit and it may reflect a communal-type object.

## IV. CONCLUSION

Building Complex II produced the richest collection of figurines ever uncovered in one structure in the Neolithic Near East. Yet, we do not regard this building as a cultic structure (temple or shrine). All the other components of daily life were found in it in very large quantities: flint, pottery and stone objects. This structure, not yet completely uncovered, is also exceptionally large, exceeding 30 m. in length and exceeding 20 m. in width. Its total size must have been greater than 600 sq. m. Its unique size and its unique art assemblage are probably related. Perhaps a "chief," a leading religious figure, or one of the most "aristocratic" Yarmukian families dwelt in this building? Once this fascinating building has been completely excavated and analyzed, more definite conclusions may be forthcoming. It is, however, clear that the art objects tend to be concentrated in large structures and at high densities; the largest assemblage of figurines found to date was uncovered in the largest Neolithic structure that has been found in the largest known Neolithic site of the Near East.

## BIBLIOGRAPHY

Garfinkel, Y. 1992. The Material Culture of the Central Jordan Valley in the Pottery Neolithic and Early Chalcolithic Periods. Unpublished Ph.D. dissertation, The Hebrew University, Jerusalem (Hebrew).

Garfinkel, Y. 1993. The Yarmukian Culture in Israel. *Paléorient* 19: 115–134.

Garfinkel, Y. 1994. Ritual Burial of Cultic Objects: The Earliest Evidence. *Cambridge Archaeological Journal* 4: 159–188.

Garfinkel, Y. 1995. *Human and Animal Figurines of Munhata (Israel)*. (Les cahiers des missions archéologiques françaises en Israël 8). Paris: Association Paléorient.

Garfinkel, Y. 1999a. *The Yarmukians, Neolithic Art from Sha'ar Hagolan*. Jerusalem: Bible Lands Museum.

Garfinkel, Y. 1999b. Facts, Fiction, and Yarmukian Figurines. *Cambridge Archaeological Journal* 9: 130–133.

Hamilton, N., Marcus, J., Bailey, D., Haaland, G., Haaland, R. and Ucko, P.J. 1996. Viewpoint. Can We Interpret Figurines? *Cambridge Archaeological Journal* 6:281–307.

Rollefson, G.O. 1983. Ritual and Ceremony at Neolithic 'Ain Ghazal (Jordan). *Paléorient* 9: 29–38.

Rollefson, G.O. 1986. Neolithic 'Ain Ghazal (Jordan): Ritual and Ceremony, II. *Paléorient* 12: 45–52.

Stekelis, M. 1951. A New Neolithic Industry: The Yarmukian of Palestine. *Israel Exploration Journal* 1:1–19.

Stekelis, M. 1952. Two More Yarmukian Figurines. *Israel Exploration Journal* 2:216–217.

Stekelis, M. 1972. *The Yarmukian Culture of the Neolithic Period*. Jerusalem: Magnes Press.

Talalay, L.E. 1993. *Deities, Dolls and Devices. Neolithic Figurines from Franchthi Cave, Greece* (Excavations at Franchthi Cave,

Greece 9). Bloomington and Indianapolis: Indiana University Press.

Ucko, P.J. 1968. *Anthropomorphic Figurines of Predynastic Egypt and Neolithic Crete, with Comparative Material from the Prehistoric Near East and Mainland Greece* (Royal Anthropological Institute Occasional Paper 24.). London: Andrew Szmidla.

Voigt, M.M. 1983. *Hajji Firuz Tepe, Iran: The Neolithic Settlement* (University Museum Monograph 50). Philadelphia: University of Pennsylvania.

Yizraeli-Noy, T. 1999. *The Human Figure in Prehistoric Art in the Land of Israel*. Jerusalem: the Israel Museum (Hebrew).

# 15

# THE USE OF MEDICAL COMPUTED TOMOGRAPHY (CT) IN THE STUDY OF THE CERAMIC TECHNOLOGY OF FIGURINES

## *Nachum Applbaum and Yaakov H. Applbaum*

## I. BACKGROUND

The largest collection of Neolithic clay figurines has been excavated at the Sha'ar Hagolan site in Israel. Examples of this type have been described in detail in past publications (Cauvin 1972; Garfinkel 1995, 1999; Noy 1986, 1990; Yizraeli-Noy 1968; Yeivin and Mozel 1977). This article will describe our scanning of a group of these figurines, using medical Computed Tomography (CT). Results we achieved in the past have proven that CT is an almost indispensable tool in the study and understanding of the modeling techniques used in forming these artifacts in the sixth millennium BC (Applbaum and Applbaum 1999). We will discuss here four samples tested by us. We have previously published fragments 1, 2 and 4 in Hebrew in an article regarding the use of CT in the restoration of these artifacts (Applbaum *et al*. 1998). In the present article, we will be dealing with the use of the CT technology in the study of different aspects of the ceramic technology and modeling techniques of Sha'ar Hagolan figurines.

CT is gaining recognition among archaeologists and museum curators as an efficient tool for non-destructive study of archaeological material (Anderson *et al*. 1995; Hershkovitz *et al*. 1995; Notman 1986). Over the past few years we have tested a wide variety of clay and ceramic artifacts using this technique. We have demonstrated the numerous advantages of CT over other non-destructive radiological techniques in use today (Applbaum *et al*. 1994, 1995, 1999).

Whereas conventional radiography, conventional tomography (Carr 1990; Lang and Middleton 1997; Vandiver *et al*. 1991) and xeroradiography (Alexander and Johnson 1982; Glanzman and Fleming 1983; Meduri *et al*. 1993) limit us to two dimensional projections of three

dimensional objects with superimposition of impenetrable layers of the studied artifacts, CT scans provide us with clear, high-resolution, cross sectional digital images (Colsher and Pelc 1991). CT demonstrates minute changes in density. We found this information to be most helpful in comparing materials used in forming artifacts. CT images are computer-generated from electronically acquired data. This data can be reprocessed and analyzed. When contiguous scans are acquired, the data can be manipulated to produce three dimensional representations and images in infinitely different planes, including nonlinear planes.

We were first approached by Y. Garfinkel and M. Lavi after the 1997 excavation season at the Sha'ar Hagolan site. They asked us to help them with the conservation of a group of finds that had been then uncovered (Applbaum *et al*. 1998). These were fragments of figurines, still covered and encrusted with earth. During their conservation in the laboratories of the Institute of Archaeology at the Hebrew University of Jerusalem, Israel, Lavi encountered difficulties in differentiating the surface of the figurines from the earth encrusted upon them. We suggested that density studies made possible by CT scans would delineate the figurine in exact detail. This would help Lavi complete nearly perfect restorations with little risk of damage to the artifact.

During the scanning process we noticed that the CT made available to us not only valuable data regarding the conservation of the figurines, but also very clear evidence concerning the process employed in forming them.

## II. THE TECHNIQUE

The scanning process was conducted at the Institute of Radiology, Hadassah University Hospital, on a high

resolution, 3rd generation CT scanner (Elscint 2400 Elite Scanner) and on a helical multislice CT scanner (Elscint Twin Flash Scanner). The data was stored digitally so as to allow further study and processing after the initial scanning process was completed. The data was processed on an Omnipro Workstation (Elscint, Haifa, Israel).

We scanned thin consecutive and overlapping slices (1.2 mm. and 1.0 mm.) using a high-resolution technique. We used this technique to obtain fine detail and good contrast as well as to allow us to reformat the data into "slices" in different planes. CT scanning enables us to observe qualitative and quantitative differences in densities within the artifact. We also used an "edge enhancing" algorithm or filter, to achieve finer detail of the artifacts being studied. In our previous studies of ceramic and clay artifacts we had found that this filter system achieves superior results. Furthermore, we viewed the artifacts with a wide graphic "window," which we had previously found to be especially effective in viewing similar material (Applbaum and Applbaum 1999).

## III. FRAGMENT 1 (FIGS. 13.4–13.6)

This fragment (180 × 94 × 76 mm.) was excavated during the 1997 season (Locus 96 Bucket 501) (Garfinkel 1999: 62– 63). It was identified as the left leg of a figurine, namely, the thigh, knee and foot of a typical anthropomorphic figurine of the Yarmukian culture. In size, it differs somewhat from previous published examples of such figurines. In our examination of the exterior there seemed to be two deep incisions at the top of the thigh and above the foot. These two incisions had been identified as fat-folds. How they had been formed, however, could not be determined.

In order to obtain data to study the forming technique of this figurine, we conducted a set of CT sections scanned along the longitudinal axis of each fragment. In the section scans of fragment 1 (Fig. 15.1) we can very clearly observe and define the modeling or forming process of this piece.

During the forming process of the figurine, a core of clay was prepared. This core was formed as a base upon which the left leg of the figurine could be modeled as a separate entity. That core was then enlarged and extended in its length by the addition of a second layer of clay. In our study we could determine that this second layer had not been properly attached to the core, as we could observe, in the CT image, a definite air void between the core and the second layer. It appears as a sharp change in the color of the gray scale image from the light gray representing the dense clay material to dark black representing the air void between the two parts.

FIG. 15.1. Fragment 1–CT section scanned along the longitudinal axis

The leg was further extended and enlarged by additional layers of clay material. After the limb was formed and completed it was then connected, i.e. attached, to the torso of the figurine. The artifact we scanned was only a limb. This limb had obviously broken off from the body of the figurine, which, thus far, has not been uncovered at the site. Not having access to the body of the artifact, however, we could not determine whether:

1. the core on which the leg had been modeled (in its primary state) was first connected to the body; extended and then (the join) was covered over; or
2. the leg was modeled in its entirety and then attached to the body.

The CT sections were also indispensable in our understanding of the "fat-folds" that are so typical in this type of figurine. We were able to determine that these folds were formed during one of the stages of the extension of the leg by rounding the edges.

This can definitely be observed in the CT section. It appears that they developed this quite sophisticated technique in order to achieve this special effect (of fat folds) in the modeling and forming of these figurines.

## IV. FRAGMENT 2 (FIGS. 13.1–13.3)

Fragment 2 (128 × 61 × 56 mm.) was excavated during the 1997 season (Locus 96 Bucket 501) (Garfinkel 1999: 62– 63). It has been identified as the head fragment of an anthropomorphic figurine of the Yarmukian culture. Here too, in order to study the modeling or forming

Fig. 15.2. Fragment 2–CT section scanned along the longi-tudinal axis

technique used, we conducted longitudinal section scans (Fig. 15.2).

The fragment is elongated with a triangular outline. The nose and the peak of the head are two outstanding features of this figurine. In the sections obtained by CT scanning, the technique used in forming the head is quite obvious, leaving little room for speculation. The head was formed around a core as a separate piece and then attached to the body of the figurine. The core was modeled into a cone, thus giving the head its initial shape. To the front of this core, a second piece of clay was joined or attached. This can be clearly observed in our CT sections. This addition to the cone served as the base for the nose and the peak of the head that was formed thereon. We could clearly observe the joining of this piece to the core, where the base of the nose had been attached. The nose was then pinched to give it its final appearance. Only then was the join between the core and this piece of clay carefully smoothed over, to the extent that it cannot be observed by the naked eye.

Elongated ribbons of clay were attached diagonally to the side of the head. It seems that these ribbons are not eyes: "They lack the central incision typical of the cowrie

eyes of Yarmukian anthropomorphic clay figurines" as stated by Garfinkel (1999: 62). The head lacks the central incisions that constitute a typical feature in Yarmukian anthropomorphic clay figurines. These central incisions create the famous "cowrie" or "coffee bean" eyes effect, which is so typical in the proto-historic Near East and southeast Europe. In this respect, this artifact is unique. The eyes may be missing because the figurine was never finished. A few incisions were made at the beginning of the finishing process, but the final additions, such as the eyes and the nose, were not attached.

## V. Discussion: Fragments No. 1–2

The two fragments discussed above are part of a statue excavated in a small cache with other small fragments in the courtyard of a large building at Sha'ar Hagolan (Garfinkel 1999: 62). Fragment 1 has been identified as the left leg of an anthropomorphic figurine. This fragment was found lying on top of fragment 2 which has been identified as the head of such a figurine.

The fabric of these two fragments, when examined using conventional methods, appears to be similar. Garfinkel has already pointed out that the fabric of these two fragments differs from that of other fragments of figurines excavated at this site. Whereas figurines and vessels uncovered at the Sha'ar Hagolan site were usually formed from clay paste rich in small gravel particles, the fabric of these fragments is of a finer texture and does not contain such particles. He claims that the clay paste of these two fragments is similar to that which was used to form cylindrical male figurines and clay rods uncovered at Munhata (Garfinkel 1995: 37,44).

With the aid of the CT we were able to demonstrate that these two fragments are indeed part of the same figurine. To understand how we made this determination we must first explain briefly some technical aspects relating to the CT scanning technique.

An image displayed by a CT scanner is in a gray scale. Each pixel in that image is a two-dimensional representa-tion of the average absorption of x-rays within a small volume within that subject. Each pixel has a CT value or Hounsfield number attributed to it. The Hounsfield scale sets the density value of water at 0 and air at -1000. The value of each pixel, therefore, is closely related to the density of the matter in that small volume. So that when sections of two fragments have the same shade of gray, we can determine that they have the same density value and are, in fact, of identical substance. Care must be taken, however, in basing conclusions on visual inter-pretation alone, as there are only 16 shades of gray in the scale used, as opposed to the thousands of subtle

differences in densities measured by the CT scanner (Applbaum and Applbaum 1999).

We, therefore, make use of the average numerical value in Hounsfield Units (HU) for different areas in the two fragments. The CT software we use allows us to mark different areas (or regions of interest) of the image on the screen. The computer then compares the average density values attributed to pixels within the marked areas and computes the standard deviation of values within the region. We are thus able to accurately compare densities of the fabric in different areas of the scanned artifact.

This measurement of densities proves beyond a doubt, and even more important, without harming the artifacts, that these two fragments were formed from the same fabric. This new information helps substantiate the conclusion that was based upon visual observation alone, namely, that the fragments belong to the same figurine. Today these two fragments have been restored to one figurine in the laboratories of the Bible Lands Museum in Jerusalem, together with four other fragments that were excavated in the same locus (Fig. 13.8–13.9). Because of its size after restoration, this piece is now referred to as "the statue." (Garfinkel 1999a: 62, above, Chapter 13).

## VI. Figurine 3 (Figs. 13.10–13.11)

This figurine (142 ×61 × 54 mm.) was excavated during the 1998 season (Locus 339, Bucket 1217) (Garfinkel 1999: 50–51). It is an almost complete anthropomorphic seated cowrie-eyed figurine. We chose this figurine with the expectation that we might achieve a better understanding of the technique utilized in forming this type of figurine. Previous studies of these Yarmukian anthropomorphic figurines had concluded that a standard technique was employed (Garfinkel 1995: 30– 31, Yeivin and Mozel 1977: 196). A study of this *whole* object was, therefore, extremely important to us. We hoped that we might be able to fill in the gaps in the information from our prior radiological studies of fragments 1 and 2.

We conducted a full set of CT sections, scanning along the longitudinal axis of this figurine (Fig. 15.3). Before we discuss the modeling technique used in forming it, however, we wish to comment on its clay fabric. CT scanning, as we have already pointed out, supplies us with a non-destructive view of the matrix of the fabric used in forming the object being examined. Different fabrics and inclusions vary in density. These differences appear in the CT scanning results as shades in the gray scale from white to black.

The fabric of this figurine differs from that of fragments 1 and 2, as can be observed in the images (Figs.

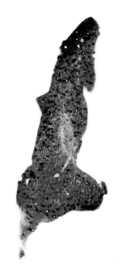

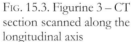

Fig. 15.3. Figurine 3 – CT section scanned along the longitudinal axis

Fig. 15.4. "Scout view" or surview of Figurine 3

15.1–15.2). A mixture of high and low-density particles can be observed in the fabric. The black particles are technical artifacts and represent a very high-density material. From the study of the exterior of the artifact, we observed that these are fine particles of gravel. The person who formed this figurine either chose clay with a large amount of fine particles of gravel or added this material as temper to the clay. According to Garfinkel, this clay paste is similar to that used at the site to make other vessels.

In our study of this figurine we conducted a "scout view" or surview (Fig. 15.4). This is a two dimensional digital radiograph obtained using the CT scanner. The CT technicians use the "scout view" or surview in planning sectional scanning. In most cases the surview is not very useful to us because it has limitations similar to those of conventional radiography, namely, two-dimensional projections of three-dimensional objects causing a superimposition of impenetrable layers. For this reason the interpretation of the surview study can be misleading and must be carried out with great caution. From the surview it was already clear to us that this figurine is somewhat complex. But the nature of this complexity could not be understood until we combined our observations from the CT sections and the surview. Using both, we were able to achieve a better understanding of the technique used in forming this particular artifact.

The scanned sections obtained along the longitudinal sagittal plane of this figurine were a great surprise. We anticipated results similar to those obtained in the scanning of fragments 1 and 2. We expected to find evidence that the core technique was used in the model-

ing. But as can be observed in Fig. 15.3, this is not the case at all. From the scans, we could not see the characteristic attributes of the core technique in the section. The only air voids that could be observed were in places where two pieces of clay were joined or attached. Furthermore, the only place this "joining technique" could be observed was in the buttocks. The addition of material to the buttocks served to form this element of the figurine. We could not find any evidence for forming the leg, the head or the torso on separate cores.

In the slices obtained from the center of the figurine, we observed an abnormality (Fig. 15.3). The image produced seemed to be unclear and somewhat out of focus but only in a well defined area. Having conducted a full scanning series of overlapping thin slices for this figurine along its longitudinal axis, we were able to view our data on a Omnipro Workstation along other planes without having to rescan the object. At the workstation we viewed the sections of this figurine along its coronal plane (Fig. 15.5). In this image a longitudinal void that passes through the center of the figurine was clearly observed. This void explains the abnormality observed in the sagittal view. It seems that during our scanning along this axis we were initially viewing images along this void. Only by sectioning this void could it be clearly observed. In order to gain a full understanding of the nature of this void, we viewed the figurine along its axial plane (Fig. 15.6). With the addition of this view, we are able finally to understand this void and the modeling technique used to form this figurine.

It seems that instead of modeling each part of the figurine separately on a core, as in the other figurines studied, this figurine was formed from one central piece of clay. This piece was formed by the preparation of a flat piece of clay (slab) that was then folded in half along

its longitudinal axis. The internal air void observed along the longitudinal axis is the remnant of this process. After the main body of the figurine was formed, additions, such as the buttocks, were made to the body. The buttocks were formed by the addition of one or two layers. Small details such as the eyes were added later.

## VII. FIGURINE 4 (FIGS. 13.12:2, 13.14)

Figurine 4 (63 × 35 × 21 mm.) was excavated during the 1997 season (Locus 152, Bucket 603) (Garfinkel 1999: 48). It was also scanned along the longitudinal axis in order to provide information to aid in its conservation.

Here too, we found that the CT enabled us to obtain interesting information about the forming process of this object. It is clear from the CT sections (Fig. 15.7) that this figurine was formed from one piece of clay. The eyes and arms were then attached. We have no indication for the use of the core technique here. During the conservation conducted on this object prior to our study, the opening of a small hole was observed in its base. The CT scans we conducted revealed that this hole was formed during the production of the object. This is a unique feature previously not observed by us in our studies of

FIG. 15.5. CT section of Figurine 3 along its coronal plane

FIG. 15.6. CT section of Figurine 3 along its axial plane

FIG. 15.7. Figurine 4 – CT section scanned along the longitudinal axis; notice hole running perpendicular to the base through the center of the object

the forming of Neolithic figurines. We have not yet been able to determine the purpose or function of this hole. It is possible that a stick served as the core for forming the figurine, with the clay being molded around a stick or post. This would be a very interesting technological indication of the skills of the person who created this artifact in the pottery Neolithic period. Or perhaps, the hole was prepared so that the figurine could be placed on display by mounting it on a stick or peg. This would further confirm our observation that this is not a fragment of a larger figurine but a whole figurine.

Typologically and technically, on one hand, this figurine differs from the others discussed above. It is thin and does not have the fat folds so typical of the pottery Neolithic figurines of the Yarmukian material culture. It was formed in a technique that differs from that used in making the other figurines discussed above. On the other hand, it does have the typical cowrie eyes. Up to now, this figure has been related to the "seated figurines" (Garfinkel 1999: 48). We may suggest, based on our observations, that this figurine should be placed in a class of its own.

## VIII. CONCLUSIONS

All previous studies of the modeling or forming technique of Neolithic pottery figurines were based solely on the examination of the exterior of the fragments (Garfinkel 1995: 30; Mozel 1975: 71; Noy 1990: 226; Yeivin and Mozel 1977: 196). There is no doubt that these studies are important but it is also obvious that these studies have many limitations. Yeivin and Mozel and Noy suggested, based on exterior examinations, that, there was one common technique used in forming all specimens of these types of figurines found in Israel (Yizraeli-Noy 1999, Yeivin and Mozel 1977: 196). They observed that the body, head and limbs were formed separately. In their reconstruction of the manufacturing technique, they suggested that the body was built from a central core. The arms, legs and head were then affixed to the body. Each of these parts was also formed from a core that was covered with two to three layers of clay. The final layer covering the parts was well smoothed, hiding the joint from the naked eye. Details such as the soutane, mouth, eyes, ears and sexual organs were then added.

In our studies, we have found that, in general, their observations are compatible with our findings concerning fragments 1 and 2. Using our CT scans, we were able to demonstrate that these two fragments are unquestionably two parts of one figurine. Prior to our radiological work, however, the study of these figurines was basically limited to areas of breaks and fractures (Garfinkel 1995: 30, Yizraeli-Noy 1999: 49). We have

demonstrated, with the help of our advanced imaging techniques, that we are able to obtain a full picture. No longer must we be restricted (to prevent damage to the objects) to specific areas, such as fractures and breaks. Our observations leave no unanswered questions as to the exact technique used in forming these figurines.

In the study of fragments 1 and 2, the cores and the different layers added to them can be seen very clearly in the "sections" we obtained in the CT scanning process. The joints between the different parts of fragments can also be clearly observed. Furthermore, we could definitely determine how additions, such as eyes, ears and arms, were added. The technique used in forming the folds and the nose could be clearly traced in the images. With the use of this non-destructive procedure we can study entire objects.

Figurine 3 typologically and morphologically belongs to the group dealt with by Yeivin and Mozel and Garfinkel. It was formed using a technique that differs from that described by Yeivin and Mozel as being "common to all the specimens found in Israel" (Yeivin and Mozel 1977: 196). One folded piece of clay served in forming the body and head of this figurine. Additions, such as the fat folds of the buttocks and fine details, were then affixed to the body.

In the studies of figurine 4, however, we demonstrated that there *were* other forming-techniques in use during this period. Figurine 4 has the characteristic "cowrie" or "coffee bean" eyes. It was clearly manufactured using different techniques than the other artifacts described here. The typical core technique was not observed in this fragment.

These new observations open the question of the modeling and ceramic technology of the Yarmukian figurines. We can no longer speak of one forming technique for all such figurines based upon superficial examination of a collection of fragments. Each example, fragmentary or whole, may now be examined in a non-destructive way to provide complete data concerning the manner in which it was manufactured. This allows us to detect forming techniques by viewing internal structures and comparing a wide range of details.

The Neolithic period is clearly one of the most important and interesting periods in the study of ancient pottery technology, as it was during this period that man first acquired this technology. In this article we present only the first fruits of our study of figurines. We are now broadening the scope of our study, using our radiological technology to include other Pottery Neolithic material. This will allow us to gain a broader understanding of the pottery technology of this period. We hope to eventually be able to answer some of the questions that have troubled scholars dealing with this material:

1. Can we detect technological differences between figurines from different regions and sites?
2. Can we perhaps speak of "centers of professional craftsman" who, having mastered a forming technique, made these figurines?
3. If so; can we determine the location of these production centers?

## Acknowledgments

We would like to thank Dr. Y. Garfinkel for his help with this study. We also wish to thank Prof. J. Bar-Ziv the head of the Institute of Radiology, Hadassah University Hospital and the technical staff of the Institute. Without their help, this study could not have been conducted.

## Bibliography

Alexander, R.E. and Johnston, R.H. 1982. Xeroradiography of Ancient Objects: A New Imaging Modality. In Olin, J.S. and Frankin, A.R. (eds.) *Archaeological Ceramics*, pp. 145–154. Washington: Smithsonian Institution Press.

Anderson, T. 1995. Analysis of Roman Cremation Vessels by Computerized Tomography. *Journal of Archaeological Science* 22: 609–617.

Applbaum, N., Applbaum, Y.H. and Horowitz, W. 1994. Computed Tomography Imaging of Sealed Clay Cuneiform Tablets. *Imaging the Past – Electronic Imaging and Computer Graphics in Museums and Archaeology*, p. 18. (Abstracts). London: British Museum.

Applbaum, N., Applbaum, Y.H. and Horowitz, W. 1995. Imaging with the Aid of Computed Tomography of Sealed Documents from the Ur III Period, *Archaeology and Science Bulletin* 3: 8–12 (Hebrew).

Applbaum, N., Applbaum, Y., Lavi, M and Garfinkel, Y. 1998. Computed Tomography Imaging as an Aid in the Preservation and Conservation of Neolithic Figurines from the Site of Sha'ar Hagolan. *Archaeology and Science Bulletin* 6: 46–54 (Hebrew).

Applbaum, N. and Applbaum, Y.H. 1999. The Use of Medical Computed Tomography (CT) in the Study of Ceramic Archaeological Finds. In Messika, N., Lalkin, N. and Breman, J. (eds.) *Computer Applications in Archaeology*, Conference Proceedings, pp. 42–53. Tel Aviv (Hebrew).

Carr, C. 1990. Advances in Ceramic Radiology and Analysis: Applications and Potential. *Journal of Archaeological Science* 17: 13–34.

Cauvin, J. 1972. *Religions néolithiques de Syro-Palestine*. Paris: Maisonneuve.

Colsher, J.G. and Pelc, N.J. 1991. Computed Tomography Systems and Performance. In Taveras, J.M and Ferrucci, J.T. (eds.) *Radiology Diagnosis-Imaging-Intervention*. Vol 1. Chapter 31, pp. 1–13. Philadelphia: Lippincott.

Garfinkel, Y. 1995. *Human and Animal Figurines of Munhata (Israel)*. (Les cahiers des missions archéologiques françaises en Israël 8). Paris: Association Paléorient.

Garfinkel, Y. 1999. *The Yarmukians, Neolithic Art from Sha'ar Hagolan*. Jerusalem: Bible Lands Museum.

Glanzman, W.D. and Fleming, S.J. 1983. Xeroradiographic Examination of Pottery Manufacturing Techniques: A Test Case from the Baq'ah Valley, Jordan. *MASCA Journal* 2: 163–169.

Hershkovitz, I., Zohar, I., Segal, I., Speirs, M.S., Meirav, O., Sherter, U., Feldman, H., Goring-Morris, N. 1995. Remedy for an 8500 Year-Old Plastered Human Skull from Kfar Hahoresh, Israel. *Journal of Archaeological Science* 22: 799–788.

Lang, J. and Middleton, A. 1997. Radiography—Theory and Practice. In Lang J.and Middleton A. (eds.): *Radiography of Cultural Material*, pp.117–135. London: Butterworth and heineman.

Meduri, A., Pirronti, T., Calicchio, D., Rispoli, F., Vidale, M., Marano, P. 1993. Xeroradiografia e Radiografia Digitale a Luminescenza Nello Studio della Tecniche di Manifattura della Ceramica Antica. *La Radiologia Medica* 86: 116–126.

Mozel, E. 1975. A Special Human Figurine from the Pottery Neolithic in Israel. *Mitekufat Haeven* 13: 70–73 (Hebrew), 74 (English summary).

Notman, D.N.H. 1986. Ancient Scanning: Computer Tomography of Ancient Mummies. In Davis R.A. (ed.) *Science in Egyptology*, pp. 13–24. Manchester: Manchester University Press.

Noy, T. 1986. Seated Clay figurines from the Neolithic Period, Israel. In Bonanna, A. (ed.) *Archaeology and Fertility Cult in the Ancient Mediterranean*, pp. 63–67, 324–351. Amsterdam: Gruner.

Noy, T. 1990. New Aspects of Pottery Figurines in the Yarmukian Culture. *Eretz-Israel* 21: 226–232 (Hebrew).

Vandiver, P., Ellingson, W.A., Robinson, T.K., Lobick, J.J., Seguin, F.H. 1991. New Applications of X-Radiographic Imaging Technologies for Archaeological Ceramics. *Archeomaterials* 5: 185–207.

Yizraeli-Noy, T. 1968. Fertility Figurines of the Neolithic Period. *The Israel Museum News* 3.2: 51–54.

Yizraeli-Noy, T. 1999. *The Human Figurine in Prehistoric Art in the Land of Israel*. Jerusalem: Israel Museum and Israel Exploration Society (Hebrew).

Yeivin, E. and Mozel, I. 1977. A Fossil Directeur Figurine of the Pottery Neolithic A. *Tel Aviv* 4: 194–200.

# THE FUNCTION OF THE ANTHROPOMORPHIC FIGURINES:
## A PRELIMINARY ANALYSIS

*Michele A. Miller*

## I. INTRODUCTION

The last decade has seen increased scholarly attention to the interpretation of prehistoric figurines. While previously archaeologists have been prone to regard these intriguing objects under broad, unexplored categories, such as "fertility figurine" or "mother goddess," new work has struggled to find in them more specific meanings and cultural information. Furthermore, recent research has emphasized the importance of context and definition, while stressing the need to place these objects within the overall considerations of a particular society (Hamilton *et al.* 1996).

Yarmukian figurines, found in great number and fascinating form, have not been ignored in this debate. Several authors, including Stekelis (1972), Cauvin (1972), Noy (1986; Yizraeli-Noy 1999), and Garfinkel (1999a, 1999b) have offered alternative interpretations of these figurines. To date, however, there has been little discussion of the kinds of evidence we can use to test these hypotheses, and while much attention has been given to the iconographic elements of the figurines, leading to considerable debate, less attention has been paid to other sources of information about the function of these objects including find context (i.e. "microcontext"), and manufacture.

I believe a further discussion of the function of these enigmatic objects would be facilitated if we follow the example set by Talalay in her study of Neolithic figurines from Franchthi Cave and consider "function" to encompass two related concepts: use and meaning. The use of an object refers to the, "basic or general purpose for which an object was designed or employed" (Talalay 1993: 38). In the case of Yarmukian figurines we might explore where, how and by whom the figurines were employed. The meaning of an object "refers to what is intended or signified or understood to be expressed by an object" (Talalay 1993: 38) and is tightly embedded in the symbolic value placed on the object. As Talalay rightly points out, the meaning of an object is often more complex than its use, and is almost always more difficult for an archaeologist to decipher (especially in prehistoric societies or those for which textual accounts are lost or undeciphered). This is because the meaning of an object is not only culturally determined, but can change with time and the individual. Despite these difficulties, it behooves us to try and understand the meaning an object may have held in the society which used it, as the ideology with which a symbolic object is endowed "can become an important source of social control (particularly among the elite.)" (Talalay 1993: 38). By deciphering this symbolism, we can begin to understand some of the forces which early elites manipulated to gain social power.

Of course the two concepts of use and symbolism are closely tied in function; aspects of how the figurines are used will perhaps help us understand the meaning of symbols encoded in their morphology while a more complete understanding of these symbols may indicate aspects of their use. Together they describe the function of the figurines in Yarmukian society. However, it is interesting that while previous scholars have primarily examined the symbols and meaning of Yarmukian figurines, concentrating on aspects of iconography such as the "cowrie eye," few have explored the evidence for the use of these figurines.

## II. The Use of Yarmukian Figurines

Questions that pertain to the understanding of the use of Yarmukian figurines include the following: Who made

them? Where were they made – are they of local manufacture or exotic imports? Who used them? Where and how were they used? Finally, we may also ask what happened to the figurines after they came out of use?

## Who Made the Yarmukian Figurines and Where Did They Make them?

While we will never know the specific identities of the persons who created these enigmatic and often mesmerizing figures, we can begin to decipher some aspects of their role in Neolithic society. For instance, we might first ask whether these figurines were made by local inhabitants at Sha'ar Hagolan or whether they were made elsewhere and imported to the site. A more difficult question that we may attempt to understand is whether the figurine-makers were in some way specialized craftpersons or not. Did everyone in the Sha'ar Hagolan community participate in figurine manufacture or was this an activity restricted to only a few special individuals? We might also try to hypothesize about the gender and status of the persons who created the Yarmukian figurines.

We have abundant evidence to show that the manufacturers of most, if not all, of the figurines found at Sha'ar Hagolan were local inhabitants of the village. The best evidence is that all the materials used for these figurines derive from the local vicinity of the site. The rounded limestone "pebbles" used for the Pebble Figurines are the same as those found lying in the fields near the site, surrounding the banks of the Yarmuk River. This limestone originates from Mount Gilead and is transported and shaped into rounded pebbles of various sizes by the action of the river. Sha'ar Hagolan residents merely had to choose suitable stones from those lying in abundance along the river and in their fields. They used these stones extensively at the site for building stone, groundstone tools (especially bowls and weights) as well as for figurines.

The clay used to manufacture the ceramic figurines, usually reddish-brown in color with fine or coarse added temper,[1] also seems to have been local in origin, as it appears to be almost identical to that used to manufacture the Sha'ar Hagolan pottery. Petrographic analyses of samples from pottery vessels found at Sha'ar Hagolan indicate that this clay was obtained from the immediate vicinity of the site (see A. Cohen-Weinberger, Chapter 8 in this volume). Recent experiments in the manufacture of Neolithic-style pottery conducted at Sha'ar Hagolan during the 1999 excavation season, under the direction of Daphne Zuckerman (Chapter 9, this volume), have identified at least one clay source less than one kilometer

from our current excavations which produces pottery with a fabric closely matching that of the Yarmukian vessels.

In addition, observations from these pottery-making experiments suggest that the figurine manufacturers were also highly accomplished and experienced potters. First, because it was likely that good clay, suitable for working and firing, was limited around the area of the site and, as ethnographic examples suggest, the sources of such clay may have been a highly-guarded secret amongst a select group of potters. Our experiments located five sources of clay in the vicinity of Sha'ar Hagolan, yet only one of these was useful for pot-making. It also takes considerable experience to recognize, in the field, the types of sediment that will produce the better clays. Even upon returning to the source of the superior pot-making clays, we had to select distinct layers of sediment. In this case, the suitable clays appeared as layers of a whiter, finer sediment sandwiched between less desirable sediments. As Vitelli has pointed out in her studies of Aegean Neolithic pottery and pottery manufacture, "all clays are not equal, and they were mined, even in the Early Neolithic, selectively," (Vitelli 1993: 247).

Second, because the necessary skills for creating both pots and clay figurines would have been similar. These include complex tasks requiring skills and knowledge acquired either through considerable trial and error or passed down from other experienced potters. To start, the clays had to be prepared in a specific manner, which includes levigating, the addition of temper, and lengthy kneading. The skills needed to form both pots and figurines by hand also appear to require extensive expertise, as our many failed efforts in pot-making indicate. The clays had a tendency to crack when worked either too little or too much, and it was difficult to keep an unfinished pot from cracking as it dried while we worked in the very hot, arid conditions at Sha'ar Hagolan. The skilled pottery makers of Neolithic Sha'ar Hagolan, however, seem to have solved such problems, as the many complex forms they created indicate. Likewise, these skilled potters had no trouble depicting the complex forms of the human figure, not only portraying a distinct seated pose, but such intricate details as fingers and fat folds.

If the hypothesis is correct that figurine manufacturers were also highly skilled potters, what else can we infer about these craftpersons? As I have indicated above, it is probable that these potters were a highly select group, with private, restricted knowledge. By this I not only mean the basic potting skills mentioned above, but also perhaps

---

[1] Eirikh-Rose and Garfinkel (this volume, p. 88) have identified two basic types of wares in the pottery from Sha'ar Hagolan: fine ware and coarse ware. The figurines appear to be manufactured from both types of clay.

knowledge associated directly with the manufacture of clay figurines. As has been noted above (Garfinkel, Korn and Miller, Chapter 13, this volume), the clay figurines possessed a highly fixed set of attributes; including seated posture, hand position, elongated head, "cowrie-like" eyes, ears, earrings, and garments which were depicted in a consistent and regular manner. This alone suggests that these figurines were produced by a small subset of the Sha'ar Hagolan population, those who were familiar with the acceptable figurine characteristics. In fact, Garfinkel has pointed to such close similarities between certain figurines, that he has hypothesized that they were created by the same hand (personal communication). This should not surprise us; in fact it is not only possible, but probable that certain potters created more than one figurine, and in fact, these potters might have "specialized" in the making of figurines as well as pots.

But what more can we say about these specialized manufacturers? Vitelli has suggested that not only were Neolithic potters specialized craftspersons, but that they also possessed special shamanistic powers (1995: 62). She concludes that "the Early Neolithic potters were not only specialists, but some kind of healers or diviners whose major role was in the arena of spiritual or social well-being" (Perlès and Vitelli 1999: 102). And if potters possibly possessed some special "magical" or spiritual powers, would not the sub-specialists who created these fantastic anthropomorphic figurines enjoy even greater powers? And isn't it probable that they imparted these powers to the figures that they created?

A corollary to the notion of the figurine specialist/shaman may be that the manufacturer of each clay figurine was known and remembered. Some of the power or function of the figurines may have thus derived from the power of their maker, as well as the power of the figure which was depicted. If this is true, we must consider the proposal that individual clay figurines were identified with specific powers that would have been known in the Sha'ar Hagolan community. In general, however, it seems that the majority of the figurines were used in a similar way by the general Sha'ar Hagolan population, probably for daily use within the domestic context (see discussion below). Certain figurines, on the other hand, may have been carefully and specifically manufactured for exceptional use.

One of these exceptional figurines may be the larger clay "statue." This figure differs in several significant ways from other clay figurines found at Sha'ar Hagolan. For one, there is some evidence that the statue was not manufactured locally at Sha'ar Hagolan. The fabric of the statuette does not resemble that of the local pottery from Sha'ar Hagolan, or in fact, of the other clay figurines from the site, being whiter and without visible temper. In fact, Garfinkel (Garfinkel, Korn and Miller, Chapter 13, this volume) reports that this fabric has more affinities to that of certain figurines and other items known from the neighboring Yarmukian period site of Munhata. Garfinkel (1999b) has also pointed out that the statue lacks several prominent characteristics which typify other clay figurines found at Sha'ar Hagolan, such as cowrie eyes and bulbous ears. It is also obvious that extra time and energy was invested in the manufacture of the statue. Techniques such as burnishing, which give the surface of this figure such a smooth sheen, take an enormous amount of time and effort. While surfaces of the pottery from Sha'ar Hagolan were smoothed by various techniques (see Eirikh-Rose and Garfinkel, Chapter 7, this volume), such a high degree of burnishing as seen on the statue is not common to ceramic material from the site. These differences may indicate that the statue was made in a slightly different tradition, or at least by a different hand, than the other clay figurines found at the site. The manufacturer of the statuette was certainly an individual highly skilled in working with clay, who invested significant time and effort in the production of this object.

This discussion of figurine manufacturers as (at least "part-time") specialists who used their considerable skills, knowledge, time and efforts to create clay figurines, however, does not seem to apply to the makers of pebble figurines. Indeed, other than the fact that both types of figurines seem to have been made locally at Sha'ar Hagolan, little else appears similar in their manufacture. While good clay for forming and firing was probably a limited resource at Sha'ar Hagolan, suitable pebbles for figurines would have been plentiful and ubiquitous at the settlement. And while only one type of clay seems to have been used for most of the figurines found at the site, indicating a clear selection process, pebble figurines were made on stones of a variety of shapes, color and hardness. Only limestone pebbles were used for figurines, as the other locally available stone basalt is much harder and would have taken more time, effort and skill to carve. These ranged from small pebbles merely 62 mm. in length to cobbles over five times that length. And while pebble figurine makers seem to have preferred raw stones ovoid in plan, the true shape of the pebbles varies widely from near round to irregular elongated. The pebble figurine makers were also not above re-using raw material to create figurines from ordinary household objects, such as a pestle.

Experiments have also shown that the manufacture of a typical pebble figurine does not require the same level of expertise, skill or time as the manufacture of the clay cowrie eye figurines. The limestone material is relatively soft, and the manufacturing techniques used, shallow incising and rudimentary drilling, are simple and quick.

No special tools are needed other than a sharp flint flake, as would have been pervasive at Neolithic Sha'ar Hagolan. In fact, during the 1999 excavation season, a volunteer only recently made aware of Yarmukian figurines managed to produce a reasonable facsimile of a "detailed pebble figurine" in under fifteen minutes. It is thus hard to see these figurines as the product of specialists.

There did exist, however, figurines made from stone that would have taken considerably more effort and skill to produce. One of these was found during the 1999 excavation season, and has received only preliminary study so far. The figure is a large one, over 10 cm. in width, carved from a dense, hard limestone. The head is missing. The remarkable aspect of this figurine, however, is that unlike the pebble figurines in which incised lines represent features on largely unmodified rounded river cobbles, in this case the whole of the stone has been sculpted to produce a figure in the round closer in appearance to the clay figurines. She appears to be in a seated position, her hands folded on her lap. She seems to wear a belt, while engraved lines on her chest may delineate breasts and upper arms, but also may indicate some sort of clothing. Her deeply accented navel is exposed. As in the clay figurines, the lower body, including two defined bulbous legs (the right leg is badly chipped), is proportionally larger than the upper body. This type of figure sculpted in the round suggests a higher degree of skill and effort to produce than the simple, incised pebble figurines, and it is likely that the person who made it had some greater experience working with stone. Perhaps in the future we will find yet other sculpted stone figures and will be able to remark on a more substantial industry of stone carving at Sha'ar Hagolan.

## Who Used the Yarmukian Figurines and How Were They Used?

Until recently scholars had little microcontext upon which to base any discussion of figurine use; most figurines were found on the ground surface, or in contexts too general to generate any lengthy discussion. Only with the recent excavations at Sha'ar Hagolan are we fortunate to have more specific contextual information on which to base any discussion of figurine use. While the find contexts of the majority of these figurines is not detailed enough to answer all of our questions concerning their use, certain types of use are suggested while others seem to be less likely. To begin with, all of the Sha'ar Hagolan figurines were found within the general domestic context of the site; figurines were found

within what appear to be multi-use domestic structures, whether from within rooms or courtyards or occasionally, in the cleared areas between buildings. Thus we can conclude that these figurines were not reserved for use as burial objects. To date, very few human remains have been found at Sha'ar Hagolan, so there remains the possibility that figurines were also placed with burials. Nevertheless, even if we may find in the future that figurines were also used in burial contexts this is certainly not their only, or probably even primary, use.

Secondly, the fact that figurines were found in a variety of contexts within the building complexes recently uncovered at Sha'ar Hagolan, and the fact that they were found in various areas throughout the site, seems to indicate that the figurines were not reserved for the exclusive use of any particular group of Sha'ar Hagolan inhabitants. Rather, the evidence seems to suggest that figurines were used by persons throughout the site. There do seem, however, to be significant differences between the frequency and types of figurines found in different areas of the site: eight characteristic clay cowrie-eyed, zero pebble, and one statue (14.1% of the total assemblage from Area E) were found in Building Complex I compared to 41 clay cowrie-eyed, two pebble, and five other figurines found in Building Complex II (75.0%; see Ben-Shlomo and Garfinkel, Chapter 14, this volume). Even if we take into account the larger total excavated area of Complex II, the greater number of figurines found in the latter structure appears significant.[2] Fewer figurines were also found in Area H, although both types are present here as well.[3]

It is unlikely that this difference can be accounted for by differences in general preservation of cultural material in the two complexes, although it should be noted that the density of finds in general was greater in Complex II. Whether this indicates a different function between these two complexes (and perhaps therefore a difference in how the figurines where used in each) or whether we can ascribe this difference to some distinction between the groups using each structure (perhaps in social hierarchy?) remains to be ascertained as excavations in Area E continue. It is interesting, however, that while fewer figurines were found in or just north of Complex I, several were somewhat unusual and two of these may have been ritually buried (see description below), while the majority of figurines found in Complex II are of characteristic types (mostly cowrie-eyed clay figurines). These unique figurines may reflect some special activities that may have been conducted in these areas.

[2] Excavated area of Complex I = approx. 225 sq. m.; excavated area of Complex II = over 600 sq. m., but not yet completed.
[3] As of the end of the 1999 season, 4 cowrie-eyed and 4 pebble, and one unusual stone figurine had been recovered in 375 sq. m. of excavated area in Area H.

In terms of their more specific microcontext within these complexes, we see that a larger percentage of figurines were found within the open courtyards of the complexes (77%), rather than in the smaller, presumably roofed, rooms which surrounded these open areas. This, too, reflects an overall pattern at Sha'ar Hagolan in which a greater density of material of all types was found in open areas rather than within room fill. The presumption is that either the majority of activities producing this material, such as flint-knapping, took place out-of-doors (with roofed rooms reserved for sleeping and storage) or that the rooms were periodically cleaned by sweeping accumulated material into the open areas. If the latter is the case we thus must consider that the majority of figurines were also unceremoniously cleared out with other debris into the courtyards, once they were no longer needed, or perhaps because they had been broken and were thus considered unusable. Ben-Shlomo and Garfinkel (Chapter 14, this volume) have noted that a majority of the figurines were found in the courtyards near room entrances, which they believe may indicate their use as entry "guardians," although this may also reflect their discard pattern as they were swept from the rooms.

Another contextual clue to the use of Yarmukian figurines is that they were usually found alone, that is not in groups of two or more. So far we have yet to uncover an altar or cache containing multiple figurines. Although sometimes more than one figurine was found within a room or general area of a courtyard, no two figurines were found adjacent or in close proximity. Thus, it is reasonable to surmise that whatever function these figurines served, they were able to act alone and probably used one at a time.

While in general, most figurines were found within the mixed sediment that filled much of the area of the site, in some cases a more clear context could be ascertained. For instance, one clay figurine (Figs. 13.12: 2, 13.14) was found within a small pit, where it seemed to have been deliberately placed. It is interesting to note that this particular figurine, while possessing many of the characteristic attributes of cowrie-eyed clay figurines, including the distinctive cowrie-shaped eyes, elongated head and position of the arms, also includes many unique elements including flattened, hanging breasts and missing lower torso. In fact, other features of this figurine, such as the hole made in the bottom of the base, seems to indicate that it was used in a unique way compared to other figurines found at the site.

Significantly, another anthropomorphic figure found within an unusual context at Sha'ar Hagolan is also unique – the "Clay Statue." Fragments of the statue were found in a shallow pit within the courtyard of Complex I

(Garfinkel, Korn and Miller, Chapter 13, this volume, Figs. 13.1–13.9), probably buried there intentionally. It is not uncommon for ritual objects to be buried if they are in some way damaged or broken (Garfinkel 1994). This contextual information, along with unique aspects of the manufacture of this unusually large figurine as discussed above, seem to indicate that the statue served some special, and probably cultic, function.

## Conclusions about Figurine Use

In summary, our contextual and morphological evidence indicate that most of the figurines found at the site were made locally, by the inhabitants of the village at Sha'ar Hagolan. There seems to be some differentiation between clay figurines, which would have been manufactured by experienced, skilled craftpersons, if not "specialists" or even "shamans," and pebble figurines, which could have been made more rapidly and by almost anyone who desired such an object. Therefore, we might conclude that the former were more special objects, with more specific use or reserved for the use of certain segments of the village population. One would expect that these figurines would be more likely to be conserved, although there is yet no indication that any were "heirlooms" or kept in any special way.

The majority of figurines were used within the general domestic contexts of Sha'ar Hagolan; that is, they were not reserved as burial objects, nor were they used in separate ritual settings. In addition, figurines seemed to be used in most areas of the site (by the year 2000 excavations, figurines have been found in all three areas of the site which have been open to more extensive excavation: Area E, Area G, and Area H), which seems to indicate that they were essential components of daily life in the Yarmukian village. On the other hand, cowrie-eyed clay figurines clearly seem to be more common in certain building complexes than others. Pebble figurines were found in limited number in the excavated areas of Sha'ar Hagolan, but many more have been found on the surface at the site, including fields as yet unexcavated. This may indicate that they were used more uniformly all over the occupied area of Sha'ar Hagolan than the cowrie-eyed figurines, which may have been used more exclusively in certain areas.

These differences may reveal a hierarchy in the manufacture and use of figurines, with more difficult to create clay cowrie-eyed clay figurines supplemented by use of hastily made pebble figurines. In addition, the difference in the proportion of clay figurines found in different complexes may indicate greater access to these objects by one group within the Sha'ar Hagolan community. We could, of course, extend this hierarchy further, putting at the very top such "special" figurines as the clay statuette

and the carved stone female figure, which reflect a greater investment in time and labor to produce. The former may also have been manufactured outside the immediate vicinity of the village, and appears to have been deliberately and carefully discarded after it broke. It is likely that this figurine, at least, held some special, probably communal, role in Sha'ar Hagolan society.

Finally, the find context of most figurines within open courtyards rather than closed rooms may reflect either the use-context of these objects, or their secondary discard after use. If the latter, most were discarded along with other debris without attendant ritual, although at least two unusual figurines appear to have been deliberately buried, perhaps reflecting some special cultic function.

## III. The Meaning of Yarmukian Figurines

Questions that pertain to the understanding of the meaning of Yarmukian figurines include the following: How can we interpret the meaning of the specific features of the figurines, such as the prominent oblique eyes that appear on so many of them? Is there any meaning in their consistent posture: seated with one arm under the breasts and the other on the thigh? What is the significance of the garments worn by the figurines, and of their surface color? Do similar features mean the same thing on clay and stone figurines?

### Eyes

We can speculate on the meaning of Yarmukian figurines by examining the symbolism represented by their features. It is the discussion of this symbolism that has created the most scholarly debate. For instance, as the eyes are the most prominent and commonly depicted feature on both clay and stone Yarmukian figurines, the symbols they represent have been hotly disputed. While Noy noted that the eyes showed "similarity to cereal seeds or date stones," (1990: 228), Garfinkel (1995) associates these with the use of cowrie shells in Levantine prehistory, and Gopher and Orrelle (1996) have looked at these, along with the "pouting lips" of the clay figurines, as resembling vulvae. In fact there can be no real debate regarding these interpretations; the symbolism attached to cowries themselves derives from the resemblance of their aperture to both the human eye and vulva, while all three (shell, vulva and seed) are related symbols of fertility.

Whereas Garfinkel points to the early use of the cowrie shell symbol in the ninth millennium Levant, the symbolism implied by the form of the shells from molluscs of the family Cypraeidae was not lost on people living in much earlier times. The arrangement of cowries found in European Upper Palaeolithic burials have

"shown that they were already being sewn onto clothing in positions which suggest that their role was symbolic as well as decorative" (Clark 1986: 23). For example, within a burial from Laugerie-Basse in the Dordogne region of France, pairs of cowries (Cyprea pyrum and C. lurida) were placed upon each upper arm of the deceased, with also two each on the forehead and either foot, and four arranged around the knees and thighs, while perforated cowries were also found on both thighs of the skeleton of an older male from the same period in the Barma Grande, Menton (Clark 1986: 23). The recent find of a cowrie shell in our excavations at Sha'ar Hagolan, which had been ground on the dorsal side, either for stringing or to lie flat as inlay (Fig. 2.29, second item in upper row), is an indication that the inhabitants of the site were aware of symbolic associations of the shell.

Cowrie shells (C. lurida) inlayed into eye orbits of plastered skulls at Pre-Pottery Neolithic B Jericho (Kenyon 1981: Pl. 57c; Clark 1986: 23, Fig. 8; Bar-Yosef 1989: 172) may mark the first identified use of cowrie shells to represent the eye. They are far from the only such shells to be used this way; surprisingly similar in appearance are terracotta heads, with cowrie shells in the place of eyes, from the Sepik River region in modern New Guinea (Clark 1986: 23, Fig. 9). It seems that cowries not only represent the human eye, but generally were believed to improve sight. For this reason they were used to decorate the prows of canoes in the Pacific islands (Clark 1986: 24), and frequently attached to the bridles of horses in all parts of the East, Near East and also Hungary (Clark 1986: 24; Murray 1939: no.165). Because of its resemblance to the eye, the cowrie was also worn as a charm against the evil eye (Murray 1939), particularly in ancient Egypt where cowries and metal imitations of cowries were frequently worn as beads (Clark 1986: 23). The use of cowries as tokens against the evil eye may explain their use in barter, as these shells have also been used as currency in cultures as disparate as ancient China, West Africa (Clark 1986: 24–25; Erikson 1993: 57–58) and Bengal, India (Gabriel 1985).

In its association with the vulva the cowrie was often worn to promote fertility and assist in parturition. Thus, in many areas of the world "cowries are worn by women as amulets, presented to them in many places as bridal offerings, and used by sterile and pregnant women to attain the respective benefits" (Sheppard 1939: no. 200). For instance, Tibetan women wear girdles made of cowrie shells as charms against barrenness (Clark 1986: 23). Another example of this belief may be the burial of a Saxon woman at Camerton in Somerset from the 7th century A.D. Within her pelvis were found the skeletal remains of a fetus of seven months, while grave goods included a large cowrie shell (Sheppard 1939: no. 200).

Even the scientific name of the cowrie, Cypraea, which derives from the name of the island of Cyprus (Tornaritis 1987: 67–68), may reflect the symbolic associations of the shell. Cyprus is the birthplace and home of the Greek goddess of Love, Aphrodite, thus reflecting the long history of association between Aphrodite, the fertility goddess, and Mediterranean cowrie shells.

Equipped with prominent "cowrie eyes," the Yarmukian figurines may thus have served a dual role as all-seeing protector, with particular charms against the evil eye, as well as enhancers or promulgators of fertility. Both functions would have been useful within the general domestic context in which they were placed, as described above.

## Other Facial Features

Drawing on a growing body of scholarship on "dual-sexed" figurines (Karageorghis 1985; Hamilton 1996: 285; Ucko 1996: 302), Gopher and Orrelle (1996) provide us with an interesting interpretation of certain facial and body features of the Yarmukian figurines that can be seen as reflecting aspects of Yarmukian gender and sexuality and/or as more generalized fertility symbols. According to this interpretation, various facial and body features of the clay Yarmukian figurines are seen as "combined representations of male and female genitalia. The use of mixed gender symbols in one image may suggest that an element of mutable gender existed [in Yarmukian society]" (Gopher and Orrelle 1996: 255). Specifically, these scholars see the elongated head of the figurines as resembling a phallus, the cheeks as testicles, lips as labia, the nose perhaps also as a phallus, and the eyes, as mentioned above, as vulvae (1996: 273).

While an intriguing interpretation, we must be careful to ensure that we interpret the meaning of these symbols within the context of Yarmukian culture, rather than our own, in which sexually-charged images are over-wrought and common-place. One way to determine if the forms depicted on the clay figurines were intentionally meant to symbolize male and female genitalia is to look for similar forms on other Yarmukian artifacts, or, depicted in the material of other, neighboring (temporally and spatially) cultures. For instance, we have associated the shape of the eyes of typical clay Yarmukian figurines with cowrie shells in part because these shells were actually found within the eye-sockets of a plastered skull from Pre-Pottery Neolithic B Jericho, and because such shells have been found at Sha'ar Hagolan, worked for use as ornamentation. In addition, plastic decorations on pottery found at Sha'ar Hagolan closely resemble the eyes of these Yarmukian clay figurines (Yizraeli-Noy 1999: 67, item 55) and may indicate that this symbol was well-integrated into the vocabulary of Yarmukian life.

Looking for other representations of phalli in Yarmukian material culture, we may point to a group of objects identified as "stylized/schematic phalli" ("Group III") by Gopher and Orrelle (1996; see, for example, an item from our excavations, Fig. 2.35 right). Aside from a basic cylindrical form, however, there is little to recommend these objects as depictions of phalli, and certainly they do not resemble the "phalli" these researchers see on Yarmukian heads and bodies. For instance, while Gopher and Orrelle propose that the three globular sections seen on the back of the heads of Yarmukian clay figurines "mimic the underside of the penile shaft" (1996: 273), this anatomical detail is omitted from Group III objects. Many of these objects have been found broken at one end. Recently, several complete Group III objects were found at Sha'ar Hagolan; these appear to be pointed at both ends – a strange way to depict a phallus. In this case, it is possible that these small objects had an as yet unknown practical function, perhaps as a peg or plug. Similar objects found throughout the Aegean and Near East, in fact, of stone or sometimes shell, have been interpreted as ear, nose or lip plugs (Miller 1996).

It may be helpful at this point to consider how the Yarmukians depicted phalli, in cases in which such an identification is assured (Sha'ar Hagolan, Byblos and Munhata). For instance, in the few determinedly male Yarmukian figurines, the phallus appears rounded, not pointed on the tip, round in section, and the testes are clearly depicted (see Stekelis 1972, Fig. 51: 3; Garfinkel 1995, Figs. 9, 30: 1, 3; 1999: 59; Gopher and Orrelle 1996, Figs. 7: 2, 9: 1, 2). According the Gopher and Orrelle, of course, the various features depicted on the heads of Yarmukian figurines might show a similar set of characteristics; for they interpret the elongated head as a phallus, with the "cheeks" resembling testicles (1996: 273), while eyes and lips resemble female genitalia. A first glance at photographs or drawings depicting the frontal view of a few of the best known cowrie-eyed figurines appears to confirm such interpretations. However careful examination of the full assemblage of Yarmukian figurines at a variety of angles casts doubt on such ideas. For instance, in only a few cases is the elongated head of the clay figurine reminiscent of a phallus in shape; at other times it comes to a sharp point or forms a cone (Figs. 13.12, 13.16).

Moreover, viewed from the side, the head of these figures is often decidedly curved, thin and pointed, almost lunate – not reminiscent of human anatomy and quite unlike the phalli depicted on Yarmukian male clay figurines. This curved shape, in fact, must be quite purposeful, since it is far easier to roll clay into a straight cone or cylinder than to render this delicately curved form. Nor, even if Gopher and Orrelle are correct, are

testes consistently depicted on these heads, for not enough of these figurines have the distinct rounded cheeks said to resemble testicles for this aspect to have been a purposeful or necessary aspect of the figurines as a group.

While having certain doubts concerning the interpretation of the typical clay Yarmukian figurine as dual-sexed, I must also, in fairness, point out an example of a Yarmukian figurine – albeit of stone, not clay – included in Gopher and Orrelle's group V (1996, Fig. 7: 3; 13: 1) which seems to transmit more clearly such a bi-gendered meaning. This interpretation was already noted by Karageorghis (1985: 46) in a comparison with a similar figurine (of unknown date) from the Sotira area in Cyprus (Swiny and Swiny 1983). As interpreted by the Swinys, the Cypriot figure resembles a seated (not gender specific) figure from the front; a seated, probably female (in comparison to other seated figurines) figure from the sides; and a phallus from the rear, in which erect penis, scrotum and genital ridge are all depicted. Interestingly, they compare this depiction of a phallus to other representations of human phalli from Neolithic and Chalcolithic Cyprus, particularly an "excellent parallel" from Sotira Teppes (dated to c. 4000 BC) similarly showing, "rounded ends with intermediate rectilinear shaft and… carving of the central groove and the double curving base, the "shouldering" at the intersection with the erect penis, and flare of the slightly larger mushroom-headed top" (Swiny and Swiny 1983: 58). Yet others have seen this same "phallic" figurine, quite differently, as a forerunner of the classic cruciform female figurine, prevalent in Chalcolithic Cyprus. In this interpretation, the Sotira Teppes figure does not depict a phallus, but rather a flattened cylindrical body in which "the 'legs' are indicated by a groove" (Peltenburg 1982: 14).

I have emphasized the different interpretations of the Cypriot figurine – as either a stylized human form or as a phallus – as it parallels differences in interpretation of Yarmukian figurines. In both cases, our interpretation of the "meaning" of prehistoric figurines is based on how we look at the figures – at the whole, or the part – and also, most probably, our own theoretical (and perhaps psychological) biases.

**Body Features, Posture and Position**
Turning to the subcranial aspects of the clay figurines, of course the most obvious features include the apparent "exaggeration" of the lower torso, with hips, thighs and buttocks rendered in generous proportion to the upper body. Much has been said about supposed associations between obesity and fertility (at least when it comes to representations of women), and certainly it has been quite common for archaeologists to routinely associate "steato-

pygous" female representations with symbols of fertility (Ucko 1996: 301). Yet, while it is true that a certain percentage of body fat is necessary for women to conceive, this level is far below that depicted on our Yarmukian women. On the other hand, a mature matron, having already produced, suckled and raised a fair number of offspring may find herself with a figure not dissimilar to that seen on these clay Neolithic figurines. The difference between the two is that in the former interpretation, the voluminous figurine represents one who is *able* to reproduce, the fertile field, so to speak, while in the latter, she represents one who has *already* reproduced, the mother, the matriarch of the family.

Of course, there are those who do not see the lower torso of these figurines as corpulent at all; Gopher and Orrelle, for instance, interpret the legs of the clay figurines as phalli whose, "incisions are indicative of foreskin folds and not obesity" (1996: 273). This interpretation would also appear to associate these figurines symbolically with sexuality and reproduction.

The ample proportions of the lower body of these figurines may also reflect a more practical consideration – they make it easier for the figurine to sit, without falling over, if placed on a small stool or other small platform. The seated posture of the Yarmukian clay figurines appears after only a short history in the Levant; the earliest seated figurine so far noted in the region is from the Pre-Pottery Neolithic A levels of Netiv ha-Gedud and Jericho (Noy 1985: 64; Yizraeli-Noy 1999: 33; Fig. 11). The sudden appearance of the seated position at the very beginning of the Neolithic is quite interesting. Some have seen this as reflecting, yet again, an increased interest in human and agricultural fertility (Noy 1985: 66). Presumably, this interpretation sees the seated female in a birthing position. Fitting this interpretation, some seated figures are shown with swollen breasts and abdomens which may indicate pregnancy, such as the figurine from Tepe Sarab near Kermanshah (Mellaart 1975: 88; Fig. 39), while a very few may even appear to be giving birth, such as the famous large clay seated figure, supported by two felines, from Çatal Höyük in Anatolia (Mellaart 1975: 106, Fig. 54). Note, however, that the upper legs of the Yarmukian figures are held firmly together, not in a birthing position, nor do these women exhibit the extended abdomen or breasts one would expect in the later stages of pregnancy.

As an alternative to this interpretation, I would therefore propose that the coincidence of the seated figurine with Neolithic culture relates not to fertility and childbirth, but to another important aspect of agricultural life – sedentism. With the growing importance of agriculture for human economy came the increased association of human groups with land "ownership." The

Yarmukian figurine is thus stationary and fixed; firmly seated in the home of her family and in her village. The seated position is also a position of power and authority. In later iconography, figures in command (whether god, king or official) are consistently shown seated, thus differentiating them from the ordinary, standing, mortals gathering around to pay tribute.[4]

The other posture seen consistently on the clay figurines is that of the left hand under the breasts and right hand resting on right thigh. This differs somewhat from the more common hand position – two hands supporting the breasts – found on many clay Neolithic figurines from throughout the Near East. The latter posture, for instance, is seen on a large number of clay figurines from Chagar Bazar in Mesopotamia (Mellaart 1975: 166, Fig. 101), and Neolithic levels of Tepe Gawra (Tobler 1950: 163, plate LXXXI). This posture is almost always perceived as associated with fertility (Speiser 1935: 64; Tobler 1950: 163) perhaps because it is seen as accentuating or protecting the female breast, but of course, many other interpretations are possible. The consistency of the posture of the Yarmukian figurines indicates that some specific meaning is thereby being communicated, but beyond speculation, we can read nothing clearly from it so many years later.

## Costume: Clothing, Coiffure and Jewelry

The wearing of specific costumes, along with ornamentation (including both body markings such as tattoos and jewelry) and hairstyle are some of the principle and most basic ways that humans, whether as groups or individuals, project information about themselves to others. This information can include gender, age, status, membership in a group (family, tribe or culture), achievement or other marks of identity. That the Yarmukian clay figurines wear a standardized set of clothing and jewelry items, also observable on several of the pebble figurines, indicates that they project a specific suite of attributes to mark their identity. While we cannot ourselves "read" the meaning of this costume without other corresponding information about Yarmukian culture, certain aspects of the costume may help us understand the function of these figurines.

For example, we can see that the upper garment shows more than it covers, as both breasts and navel are conspicuously exposed. It follows that the item is worn more for identification and display than for any utilitarian purpose (i.e. warmth or sun-protection). It is probably not the clothing of daily use, but one reserved for special

occasions or for special persons, irrespective of everyday tasks. In fact, there is some sense that such a garment could not be really worn at all; as there is no clear means of attachment of the cloth on either side, it appears to be a costume of pure fantasy. Items on the neck of the figurines may be a scarf, stole or necklace, while some sort of earring or ear-plug also commonly appears on the clay figurines. These, too, are probably part of a special ceremonial or ritual costume or regalia.

If the elongated crania of the Yarmukian figurines are not meant to depict phalli, what is the meaning of these "grotesque...tall peaked heads" (Mellaart 1975: 239)? Garfinkel (1999b: 45) has suggested that that the Yarmukian clay figurines wear either a traingular mask, an elongated hairstyle, or more likely, a form of tall, tapered hat. Certainly, many Neolithic figurines from the Near East appear to be wearing some sort of head apparatus, often pointed or elongated in form. A separate hat is, for instance, clearly seen on the large clay seated figurine from Çatal Höyük II in Anatolia (see Mellaart 1975: 106, Fig. 54; Yizraeli-Noy 1999: 52, Fig. 8). Several elaborate clay figurines from Hacilar VI also appear to have some sort of head covering and/or elaborate hair bun (see Mellaart 1975: 115, Fig. 65; Yizraeli-Noy 1999: 52, Fig. 9). Alabaster figurines found in the cemetery at Tell es-Sawwan in Southern Mesopotamia (Samarra Culture) wear pointed caps of asphalt (Mellaart 1975: 152, Fig. 89). Providing an interestingly close parallel to the Yarmukian clay figurines, in fact, are those from the Samarran site of Chogha Mami, which feature elaborate, often pointed, coiffures (or hats?), ear-plugs, cowrie-shaped eyes, painted facial markings and colored garments (see Mellaart 1975: 155, Fig. 92; Mellink and Filip 1974, Fig. 54, 55). Geographically closer are any number of figurines from the Levant which have pinched, peaked or pointed heads, including a limestone head from Tel Kishion (Yizraeli-Noy 1999: 99, Fig. 102), a clay figurine from Munhata (Yizraeli-Noy 1999: 44, Fig. 28), and several clay figurines of unknown provenance (Yizraeli-Noy 1999: 44, Fig. 25, 29, 32). Whether a hat or coiffure, the particular form worn by the Yarmukian figurines undoubtedly encoded specific meaning, perhaps about status or group identity.

## Red Coloring

Another aspect of the figurines that has been noted in previous literature is the recurrent presence of a red colorant. This color is preserved on a number of clay figurines and very few of the pebble figurines. Gopher and Orrelle have associated red coloring found on pebble

---

[4] This appears to be frequently the case in ancient Egyptian and Mesopotamian art; for example the bas-relief from the mastaba of Nefer, Vth Dynasty, Egypt (Contenau 1962: 123, Fig. 196), or the Stele of Victory of Naram Sin, middle of third millennium, Mesopotamia (Drioton 1962: 140, Fig. 217).

figurines and incised cobbles with the color of blood, and more specifically with, "any of the events in the reproductive life of women which are usually accompanied by blood, like the onset of menses or defloration (1996: 267)." While the association between red and blood is an obvious one, it does not necessarily follow with any one specific meaning. For instance, while in her well-known, far-ranging studies of Neolithic figurines, Gimbutas notes the association of red with the blood "of life" (Gimbutas 1991: 281), others have read this connection as indicating youth and vitality (Marinescu 1986: 65). Furthermore, while in some cultures the color red has been associated with heightened sexuality (Sahlins 1977: 178) in many others it was chosen as the proper color of purity for wedding costumes (Marinescu 1986: 65).

We must also be careful in our assumptions that the red pigment found preserved on the stone figurines was necessarily a purposefully applied pigment. It is likely that this red substance is ochre, a hematite ore that has been used since the Upper Palaeolithic as both an efficient abrasive (White 1993: 282) as well as a colorant (White 1993: 290). Further analysis of this substance, thus, may better indicate whether the red color found on stone figurines and other objects supplies us with more valuable information for the meaning or the manufacturing technique of Yarmukian figurines.

## IV. The Function of Yarmukian Figurines

Questions that pertain to the understanding of the function of Yarmukian figurines include the following: Why are there so many of them at Sha'ar Hagolan? Why are they all so similar? Do these anthropomorphic figures represent humans, ancestors or divinities? What role might these figurines have served in Yarmukian society?

The above discussion of how, where and by whom the figurines from Sha'ar Hagolan were manufactured and used, as well as key iconographic symbols which may elucidate their encoded meaning within Yarmukian society, has placed us in a better position to evaluate various hypotheses concerning figurine function. It remains, however, to discuss two other salient aspects of Yarmukian figurines.

The first of these is the relatively large number of Yarmukian figurines, compared to figurines from other prehistoric cultures in the Levant. While it is impossible to obtain an exact count of all known prehistoric figurines from the Levant, a good basis for comparison is T. Yizraeli-Noy's posthumously published catalogue *The Human Figure in the Land of Israel* (1999), which includes 113 figurines,

six statues, as well as seven masks, eight plastered skulls and two relief representations of a human figure or face on pottery (135 figures in total). Of these, 52 figurines (16 cowrie-eyed clay, 35 pebble and one unusual; 46% of the total figurines in the catalogue) and one pottery fragment are Yarmukian; 35 of the figurines (31%) and the sherd are from Sha'ar Hagolan. While this can only reflect the number of figurines from known and excavated sites, we can take it as enough of a rough approximation of the relative abundance of Yarmukian figurines to propose that figurines were more common during this period in the Levant than in any other prehistoric period. This implies that figurines must have therefore had an important and necessary function in Yarmukian society. Undoubtedly, they were considered as important in everyday life during the Pottery Neolithic period as pottery, stone tools and other "utilitarian" objects.

The second salient aspect of Yarmukian figurines is their surprising standardization. As noted by Garfinkel, Korn and Miller (Chapter 13, this volume), the cowrie-eyed clay figurines share a remarkably standard set of attributes, which include specific criterion for facial and body features, apparel, body position, etc. The pebble figurines can also be characterized by a fixed range of features, which must include incised eyes, and may include other facial features (nose, mouth), garments and body features in order of frequency and assumed importance. Although manufactured in vastly different media and techniques, and probably by different persons, the cowrie-eyed clay and pebble figurines thus share a number of attributes, including general form of the eye and garments, that enable us to propose that both types were meant to represent the same figure. If this is true, then the people of Sha'ar Hagolan felt the need to depict this figure repeatedly, both in detail, as made by specialists in clay, and, in more stylized from, as could be made by most inhabitants of the site. Somehow, this figure, or its depiction, must have been essential to everyday life at Sha'ar Hagolan. What was its indispensable function? I shall now examine various theories for the function of figurines in light of the evidence for Yarmukian figurines, and then conclude with another possible function based upon this evidence.

### Fertility Votive

Perhaps the function most frequently attributed to Neolithic figurines is that of fertility votive, charm, or as part of some fertility "cult." This is particularly true of figurines which appear to represent females, reflecting a belief that the primary role of women in prehistoric society was reproductive; "The humans represented are almost always female, male figurines being extremely rare. Since the opposite is true of painted representations on

pottery and in the engraved designs on seals, we thus have an indication that these models possessed a specialized purpose, undoubtedly connected with the fertility cult," (Tobler 1950: 163). This is particularly true for Neolithic figurines because of the widespread idea that as agriculture grew in importance for human economy, so did the importance of both human and animal/plant reproduction; "increased dependence on cultivation stimulates increased concern for the fertility of the crops. The metaphorical linking of women's fertility to crop fertility is so obvious that there are good reasons to believe that people have made it independently in several places… there are good reasons to assume that such concerns may be one factor in the elaboration of female imagery either verbally or in the form of figurines" (Haaland and Haaland 1996: 299).

More recently, researchers have criticized these assumptions, and taken a more critical view concerning the widespread existence of fertility cults in prehistory. Anati (1986) reviewed evidence for fertility cults in the Mediterranean region (broadly defined to include Anatolia and the Levant), and concluded: "There is no doubt that both ancient and modern cultures are concerned with human procreation and with fertility of the land and the abundance of hunting and fishing resources. However, specific information on beliefs and practices concerning 'Fertility Cults' in the ancient Mediterranean and elsewhere prior to the Bronze Age, is scanty and in need of further analysis. Concerns relevant to fertility may be part of more complex conceptions regarding nature and the supernatural. The Fertility Cult, as an isolated element, was apparently not a common trend." (1986: 12).

What about the apparent "fertility symbols" that appear to be encoded in the Yarmukian figurines? I have, in fact, proposed that the "cowrie eye," whether depicting a cowrie shell, seed, or vulvae, may indeed have a fertility association – although I have also pointed out other possible meanings. Likewise, the seated posture, hand on breast, possible "phallus" and other genital representations, can also be seen as possible fertility symbols, or they may have other meanings as discussed above. It is most likely that these symbols had multiple meanings, with some fertility association apt to be one of these. It is also not unknown for fertility symbols to take on a secondary function as protective or good-luck charms. In Roman cities, large phalli were often depicted near doorways, as a means of inviting prosperity into the house (De Caro 2000). Therefore, while it is probable that the figurines had some general relation to fertility, this is not necessarily their only function.

Moreover, Yarmukian figurines probably did not function specifically as fertility charms – i.e. objects used

in some way by individuals to promote the fertility of their person or property. Figurines or votives which serve to promote fertility in this way are likely to be highly individualized, created by each supplicant or shaman using a variety of fertility symbols according to personal ideas, beliefs and creativity. Interestingly, Bisson and White (1997) point out that among traditional circumpolar societies, where the use of amulets and fetishes was extremely common, fertility figurines tended to be of a variety of sizes, with detailed facial features, arms and legs, but little emphasis on sexual characteristics. In addition, studies of these fertility dolls show approximately equal numbers of male and female figures, as well as certain examples in which gender was not indicated (Bisson and White 1997: 42). Significantly, this data contradicts many previous assumptions about fertility votives, including the preponderance of female forms and emphasis on sexual characteristics, that have often been applied to Neolithic figurines.

**Birthing Charms**

Although sometimes confused with fertility votives, birthing charms are not used by women to increase their likelihood of getting pregnant, but to ensure a successful and healthy pregnancy, for both themselves and child. Before modern medicine, the period of pregnancy and the birthing process was a very dangerous time both for mother and child, with loss of life of one or both an all too common occurrence. Talismans invoking a successful childbirth were one way of dealing with this difficult process. According to recent studies, some of the earliest known figurines in Europe, dating from the Upper Palaeolithic, appear to have functioned as such birthing charms (Bisson and White 1997). We would expect figurines which functioned as birthing charms to somehow represent pregnancy or parturition, often by emphasizing the swollen abdomen and breasts of a pregnant woman, or by depicting a woman giving birth, as in the case of the previously mentioned figurine from Çatal Höyük. A class of figurines which portray women in squatting or "frog" position, a common posture for parturition, may also have served as birthing charms (Miller 1996). While the majority of Yarmukian figurines do not appear to be associated with pregnancy or birthing, a single figurine of a woman bent over or squatting may fit within the latter group (see Garfinkel, Korn and Miller, Chapter 13 in this volume, Fig. 13.26). It is interesting that aside from the unusual posture, this figure largely resembles more typical cowrie-eyed clay Yarmukian figurines. It thus appears that whoever was represented in the majority of figurines could be appealed to for specific problems when needed.

232 MICHELE A. MILLER

## Tokens of Individual Identity

Bailey (1994) has concluded that the large assemblage of figurines from the Chalcolithic site of Golyamo Delchevo in Bulgaria were representations of prehistoric individuals which served to establish individual identity. This hypothesis was based on the wide range of distinct figurines found at the site (considering such variables as gender identification, methods of body and face decoration, material, size and body position) in comparison to an equally diverse population as represented in the Golyamo Delchevo cemetery. Bailey then associated this data with the increasing importance of the individual and individual ownership of resources and products during the Bulgarian Chalcolithic (Bailey 1994: 327). The assemblage of figurines from Sha'ar Hagolan, however, exhibit a surprising lack of diversity; therefore, it is doubtful that they represent different individuals.

## Emblem of Group Identity

If Bailey is correct in the equation of figurine diversity with a concern for individuality, then the figurines from Sha'ar Hagolan and Yarmukian figurines in general suggest the very opposite of individuality. The high degree of standardization among these figurines, in terms of material (either limestone pebble or local clay), method of manufacture (within each material) and depiction as discussed above, suggests that the majority of these figurines portray the same figure. But who is this figure? The specifics of her identity are lost to us, but she seems to be a mature woman, one who has given birth several times; she wears ritual, ceremonial or high status regalia, and appears in a pose indicative of power and authority. She may have the ability to promote fertility or protect, and she can be appealed to in times of great danger, such as during childbirth. She is ubiquitous to Yarmukian society, and appealed to by all members of the population. She serves primarily in the domestic sphere, although occasionally she may function in more public ceremonies (e.g. the statue). As plastered skulls found at Jericho, Kefar ha-Horesh and Nahal Hemar Cave seem to indicate, some form of ancestor worship already existed in the Levant by the Pre-Pottery Neolithic. I therefore propose that she is probably a deified ancestor, the Matron of the Yarmukian people.

This "deified matron," however, should not be confused with the far-reaching "Mother Goddess" often attributed to female representations, especially those from the Neolithic; as most widely known through various publications of M. Gimbutas (1974, 1982, 1989, 1991). In fact, as long ago as 1968, P. Ucko questioned evidence for such a universal Mother Goddess theory and its application to female imagery. Since that time the Mother Goddess theory has achieved almost "cult" status, and has largely fallen out of favor among archaeologists (see Meskell

1995; Haaland and Haaland 1995). As a scholar "raised" in the later theoretical environment, I therefore come to the present conclusions with some trepidation. What is essential, however, and quite apart from the Mother Goddess theory, is that I identify the Yarmukian figurines with a specific, and undoubtedly named, ancestral deity. This matron goddess relates only to the beliefs and social order of the Yarmukian culture and cannot be applied to any other figurative representations, Neolithic or other. Moreover, I do not believe that the frequent representation of this Yarmukian matriarch indicates that Yarmukian society was a matriarchy or matrilineal, or even that it reflects the relative status of women in Yarmukian society – any more than the frequent representation of Athena reflects gender status in Classical Athens.

While serving a variety of functions within the Yarmukian household – to protect the home and its occupants, to ensure their continued success and economic "fertility" – I believe these representations of the Yarmukian goddess fulfilled a greater role as an emblem of Yarmukian society. This Yarmukian matron, with her specific set of attributes and characteristics, was a defining symbol of the Yarmukian people and their particular culture. As such, she served to encourage group cohesion at a time when an evolving economy, with increasing dependence on food production, may have been best served by village cooperation. Certainly, the massive building complexes at Sha'ar Hagolan suggest some communal effort. Whether this also reflects the co-opting of resources by an elite group, perhaps through the control of powerful symbols such as these "Yarmukian Goddess" figurines, remains to be examined.

## BIBLIOGRAPHY

Anati, E. 1986. The Question of Fertility Cults. In Bonanno, A. (ed.) *Archaeology and Fertility Cult in the Ancient Mediterranean* (Papers presented at the First International Conference on Archaeology of the Ancient Mediterranean; University of Malta), pp. 3–15. Amsterdam: B.R. Gruner.

Bailey, D.W. 1994. Reading Prehistoric Figurines as Individuals. *World Archaeology* 24: 321–331.

Bar-Yosef, D.E. 1989. Late Paleolithic and Neolithic Marine Shells in the Southern Levant as Cultural Markers. In Hayes, C.F. III, Ceci, L. and Bodner, C.C. (eds.) *Proceedings of the 1986 Shell Bead Conference, Selected Papers*, pp. 169–174. Rochester, NY: Research Division of the Rochester Museum and Science Center.

Bisson, M. and White, R. 1997. L'imagerie féminine du Paléolithique: Etude des figurines de Grimaldi, *Culture* 16: 5–64.

Clark, J.G.D. 1986. *Symbols of Excellence: Precious Materials as Expressions of Status*. Cambridge: Cambridge University Press.

Contenau, G. 1962. Egypt and Mesopotamia. In Huyghe, R. (ed.) *Larousse Encyclopedia of Prehistoric and Ancient Art*, pp. 123–134. New York: Hamlyn.

DeCaro, S. 2000. Il Gabinetto Segreto del Museo Archeologico Nazionale di Napoli, Naples: Soprintendenza Archeologica di Napoli e Caseita.

Drioton, E. 1962. The Rivalry and the Achievements of the Empires. In Huyghe, R. (ed.) *Larousse Encyclopedia of Prehistoric and Ancient Art*, pp. 135–153. New York: Hamlyn.

Erikson, J.M. 1993. *The Universal Bead*. New York: W.W. Norton and Co.

Gabriel, H. 1985. Shell Jewelry of Himalayan and Sub-Himalayan Areas. *Ornament* 8(4): 51–55.

Garfinkel, Y. 1994. Ritual Burial of Cultic Objects: The Earliest Evidence. *Cambridge Archaeological Journal* 4: 159–188.

Garfinkel, Y. 1995. *Human and Animal Figurines of Munhata (Israel)* (Les cahiers des missions archéologiques françaises en Israël 8). Paris: Association Paléorient.

Garfinkel, Y. 1999a. Facts, Fiction and Yarmukian Figurines. *Cambridge Archaeological Journal* 9: 130–133.

Garfinkel, Y. 1999b. *The Yarmukians, Neolithic Art from Sha'ar Hagolan*. Jerusalem: Bible Lands Museum.

Gimbutas, M. 1974. *The Gods and Goddesses of Old Europe*. Los Angeles: University of California Press.

Gimbutas, M. 1982. *The Goddesses and Gods of Old Europe 6500–3500 B.C.* London: Thames and Hudson.

Gimbutas, M. 1989. *The Language of the Goddess: the World of Old Europe*, San Francisco: Harper Collins.
Gimbutas, M. 1991. *The Civilization of the Goddess*. San Francisco: Harper Collins.

Gopher, A. and Orrelle, E. 1996. An Alternative Interpretation for the Material Imagery of the Yarmukian, a Neolithic Culture of the Sixth Millennium bc in the Southern Levant. *Cambridge Archaeological Journal* 6: 255–279.

Haaland, G. and Haaland, R. 1995. Who speaks the Goddess's Language: Imagination and Method in Archaeological Research. *Norwegian Archaeological Review* 28: 105–121.

Hamilton, N. 1996. The Personal is Political. *Cambridge Archaeological Journal* 6: 282–285.

Hamilton, N., Marcus, J., Bailey, D., Haaland, G., Haaland, R. and Ucko, P.J. 1996. Viewpoint, Can we Interpret Figurines? *Cambridge Archaeological Journal* 6: 281-307.

Karageorghis, V. 1985. Kypriaka IX. *Report of the Department of Antiquities of Cyprus*: 45–47.

Kenyon, K.M. 1981. *Excavations at Jericho, Vol. 3*. London: British School of Archaeology in Jerusalem.

Marinescu, M. 1986. Color in Greek Traditional Costume. *Ornament* 9(3): 63–67.

Mellaart, J. 1975. *The Neolithic of the Near East*. London: Thames and Hudson.

Mellink, M.J. and Filip, J. 1974. *Fruhe Stufen der Kunst*. Berlin: Propylaen Verlag.

Meskell, L. 1995. Goddesses, Gimbutas and 'New Age' Archaeology. *Antiquity* 69: 74–86.

Miller, M. 1996. Jewels of Shell and Stone, Clay and Bone: the Production, Function and Distribution of Aegean Stone Age Ornaments. Unpublished Ph.D. dissertation, Boston University.

Murray, M.A. 1939. The Meaning of the Cowrie-Shell. *Man* no. 167.

Noy, T. 1985. Seated Clay Figurines from the Neolithic Period, Israel. In Bonanno, A. (ed.) *Archaeology and Fertility Cult in the Ancient Mediterranean* (Papers presented at the First International Conference on Archaeology of the Ancient Mediterranean; University of Malta), pp. 63–67. Amsterdam: B.R. Gruner Publishers.

Noy, T. 1990. New Aspects of Pottery Figurines in the Yarmukian Culture. *Eretz-Israel* 21: 226–232 (Hebrew).

Peltenburg, E.J. 1982. The Evolution of the Cypriot Cruciform Figurine. *Report of the Department of Antiquities of Cyprus*: 12–14.

Perlès, C. and Vitelli, D.D. 1999. Craft Specialization in the Greek Neolithic. In Halstead, P. (ed.) *Neolithic Society in Greece* (Sheffield Studies in Aegean Archaeology 2), pp. 96-107. Sheffield: Sheffield Academic Press.

Sahlins, M. 1977. Colors and Cultures. In Dolgin, J.L., Kemnitzer, D.S., and Schneider, D.M. (eds.) *Symbolic Anthropology. A Reader in the Study of Symbols and Meaning*, pp. 165–182. New York: Columbia University.

Sheppard, T. 1939. The Meaning of the Cowrie-Shell. *Man* 2: no. 200.

Speiser, E.A. 1935. *Excavations at Tepe Gawra*, Vol. I. Philadelphia: University of Pennsylvania Press.

Stekelis, M. 1972. *The Yarmukian Culture of the Neolithic Period*. Jerusalem: Magnes Press.

Swiny, H. and Swiny, S. 1983. An Anthropomorphic Figurine from the Sotira Area. *Report of the Department of Antiquities of Cyprus*: 56–59.

Talalay, L.E. 1993. *Deities, Dolls, and Devices Neolithic Figurines from Franchthi Cave, Greece* (Excavations at Franchthi Cave, Greece 9). Bloomington: Indiana University Press.

Tobler, A.J. 1950. *Excavations at Tepe Gawra*, Vol. II. Philadelphia: University of Pennsylvania Press.

Tornaritis, G. 1985. *Mediterranean Sea Shells Cyprus*. Nicosia.

Ucko, P.J. 1968. *Anthropomorphic Figurines of Predynastic Egypt and Neolithic Crete with Comparative Material from the Prehistoric Near East and Mainland Greece* (Royal Anthropological Institute Occasional Paper 24.). London: Szmidla.

Ucko, P.J. 1996. Mother, Are You There? *Cambridge Archaeological Journal* 6: 300–304.

Vitelli, K.D. 1993. Power to the Potters. Comment on Perlès' 'Systems of Exchange and Organization of Production in Neolithic Greece' [*JMA* 5: 115–64]. *Journal of Mediterranean Archaeology* 6: 247–257.

Vitelli, K.D. 1995. Pots, Potters, and the Shaping of Greek Neolithic Society. In Barnett, W.K. and Hoopes, J.W. (eds.) *The Emergence of Pottery Technology and Innovation in Ancient Societies*, pp. 55–63. Washington: Smithsonian Institution Press.

White, R. 1993. Technological and Social Dimensions of 'Aurignacian-Age' Body Ornaments across Europe. In Knecht, K., Pike-Tay, A. and White, R. (eds.) *Before Lascaux: The Complex Record of the Early Upper Palaeolithic*, pp. 277–299. Boca Raton: CRC Press.

Yizraeli-Noy, T. 1999. *The Human Figure in Prehistoric Art in the Land of Israel*. Jerusalem: Israel Museum and Israel Exploration Society (Hebrew).

# PART IV

# SUBSISTENCE STUDIES

# 17

# PALAEOETHNOBOTANY: PRELIMINARY RESULTS

## Susan E. Allen

## I. INTRODUCTION

Archaeological investigation of early agriculture in the Levant has focused on the recovery of subsistence data from the initial, transitional phases of the Neolithic. Due to this temporal bias, large gaps remain in our understanding of later Neolithic agriculture and plant husbandry in the region, despite the importance of subsistence data to interpretations of changes in settlement patterns, architecture, and technology that appear in the late seventh and early sixth millennium BC (Banning *et al.*1994; Kafafi 1992, 1993; Kohler-Rollefson 1988, 1992; Kohler-Rollefson and Rollefson 1990). The adoption of systematic water-sieving of archaeological deposits from the Yarmukian site of Sha'ar Hagolan marks an important shift in the excavation of later Neolithic sites in the Levant. To date, only two Yarmukian sites other than Sha'ar Hagolan have produced botanical assemblages, neither of which has been fully published (Neef 1997). The Sha'ar Hagolan botanical assemblage, therefore, has the potential to increase our understanding of Yarmukian agriculture, as well as the environment to which it was adapted. This report presents the first results of the author's preliminary analysis of the macrobotanical remains from Sha'ar Hagolan. In addition, I describe in detail the recovery methods, so that readers might be aware of potential biases from sampling and recovery procedures. I then propose possible interpretations of the preliminary results from Sha'ar Hagolan and their relation to botanical evidence from other Yarmukian sites in Israel and Jordan.

A total of 279 samples were collected between 1997 and 1999. Botanical remains from 44 of these samples are presented below (Tables 17.1–17.4). The data are discussed on a year by year basis, due to differences in sampling and

recovery methods for each year. An additional 19 samples collected in 1998 have been fully sorted, but were not scored in time for inclusion in this report. The data presented in this report comprise approximately 15% of the total assemblage. Although the shallowness of the archaeological deposits resulted in the recovery of much modern plant material, these remains are not reported. In general, the botanical assemblage from Sha'ar Hagolan shows fair preservation, a low density of botanical remains, and a high degree of fragmentation. Cereal remains and unidentified grasses are predominant in the samples, but seeds of legumes, fruits, and several wild species also occur. Wood charcoal, present in small quantities, has not yet been identified to species, but samples that have been examined are certainly all angiosperms.

## II. METHODOLOGY

During the 1997 excavation season, Dr. M. A. Miller used manual flotation (Pearsall 1989) with 10-liter buckets to recover botanical remains from 15 sediment samples excavated from Building Complex I (Area E). These initial recovery attempts indicated that plant macrofossils were preserved at Sha'ar Hagolan, but did not yield significant quantities of botanical material.

In 1998 Garfinkel and Miller instituted a program of systematic water-sieving, which continued on a more limited scale during the 1999 season. With the help of many kibbutz members, we built a modified Ankara-type water-separator (French 1971). Due to the limited supply of water in the Jordan Valley, the ability of this system to recycle water was ideal for water-sieving in this location. The system recycled water by means of two settling tanks arranged on a slope with an electric pump to recirculate

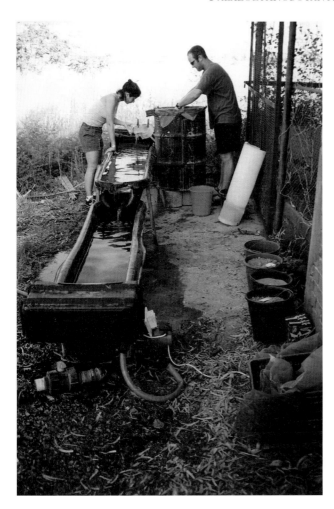

FIG. 17.1. The flotation system in operation

Rather than adding a permanent heavy fraction screen, we used pre-cut squares of fiberglass window screening (approximately 2 mm. mesh) that were secured to the top rim of the drum with a bungee cord and bulldog clamps. This allowed for easy removal of each sample of heavy fraction and facilitated cleaning of the solidified clays from the bottom of the drum, but necessitated care in removing heavy or sharp objects from the sample prior to flotation.

We filled the water-separator and settling tanks from a tap at the Sha'ar Hagolan Museum. A 1.5 horsepower electric sump pump, with a section of fine (less than 1 mm.) polyester mesh over its intake spout, circulated the cleaner water from the second settling tank up to the drum for processing new samples. Depending on the nature of the sediment and the concentration of stones and artifacts, we were able to water-sieve between 200 and 300 liters of dirt before needing to drain the sludge from the processing tank. The settling tanks were cleaned and refilled between one and two times per week.

Due to the heavy clay content of much of the sediment, powdered sodium hexametaphosphate, commercially available as Calgon, was added to the water to facilitate separation of fragile botanical remains from the dense matrix. Although Pearsall (1989) recommends pre-soaking of clay-rich samples with a deflocculant prior to flotation, field testing indicated little to no improvement in recovery from the Sha'ar Hagolan sediment after soaking samples in a 10% solution for between 30 minutes and one hour. We instead tried adding a 10% solution of Calgon and water (Pearsall 1989) to the system as a whole. Since this resulted in an increased delay in settling time and a need for more frequent water changes, we added only a small quantity of deflocculant to the tanks at more or less regular intervals. Unfortunately, this amount was not standardized throughout the season due to fluctuations in our Calgon supply, but remained below 5% at all times.

With this particular water-sieve and the Sha'ar Hagolan sediment, it was possible for two people to process between 200 and 300 liters per day. One person could process up to 200 liters per day, given the delays caused by stopping to prepare labels, record sample volumes, and rotate heavy fraction for drying. Samples from mud-brick and other solidified deposits, and clay-rich samples needing re-flotation of the heavy fraction also slowed processing time.

The resulting heavy fraction was screened into two fractions (1 mm.–5 mm.; >5 mm.) that were packaged separately for later scanning. Preliminary scanning in the field indicates that lithic materials, including complete tools, cores, and debitage, was the primary constituent of the heavy fraction. In addition, sherds and ground stone

water to the main tank (Fig. 17.1). As is usually the case with flotation systems, we made use of materials that were locally available (Davis and Wesolowsky 1975; Wagner 1988). We built the main tank for sediment processing from a 55-gallon drum with the following modifications: a 15 cm. wide overflow spout cut into and welded to the rim, to allow the outflow of floating botanical remains; the attachment of a circular bracket below the overflow spout, to receive geological sieves for collecting the light fraction; the insertion through the side of the drum of a 1-inch diameter elbow pipe with a two-way valve for regulating water flow at its outer end and a shower head attachment on the end of the pipe inside the drum; and the addition to the base of the drum, on the same side as the water inflow pipe, of an approximately 3-inch diameter pipe with a two-way valve, to which a fire hose was attached to empty accumulated mud from the bottom of the tank. Two modified cattle troughs served as easily drainable settling tanks.

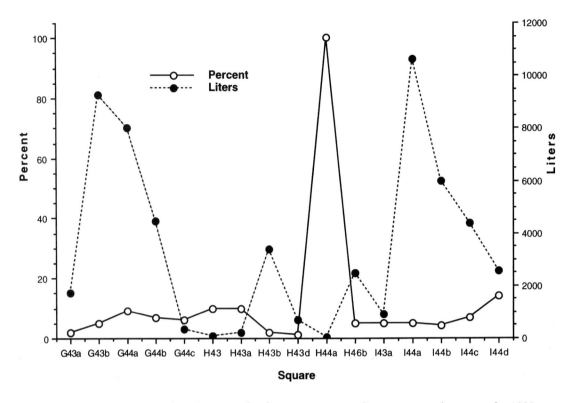

FIG. 17.2. Comparison of total excavated sediment versus sampling percentage by square for 1998

fragments were frequent. Figurine fragments and bone of all types were rare, and only modern botanical remains (e.g. uncarbonized olive pits) were recovered. This material has great potential for microrefuse analysis to clarify the location of activities and refuse disposal behaviors, but has not yet been fully analyzed. The heavy fraction is stored in Israel at the Sha'ar Hagolan Museum.

A systematic sampling strategy of at least 5% from each deposit (basket) was adopted to facilitate the potential for spatial analysis of the botanical assemblage, with the goal of sampling all Neolithic deposits. While most of these were sampled for botanical remains, it was necessary to revise the goal of at least a 5% sample from each deposit due to differences in the pace of flotation versus that of excavation. In general, features such as pits and installations were sampled at 100%. In total, 3,514.5 liters of sediment were processed by flotation in 1998 (Fig. 17.2). The water-sieved portion represents approximately 6% of the sediment excavated from the sampled deposits as a whole, but the sampling percentage varies widely across the site (Tables 17.2 and 17.3). Field recording of the total deposit volumes and the sample volumes enables comparison between samples and will facilitate further analysis of the spatial dimension of burning activity, plant processing, consumption, storage, and refuse disposal across the site.

## III. DATA PRESENTATION

I present the data first as absolute counts by taxon and plant part on a year by year basis (Tables 17.1 through 17.3), and then by ubiquity measures for groups of taxa reported in the 1998 and 1999 assemblages (Table 17.4). Absolute counts are somewhat problematic, in that they reflect differences in sample volume, preservation, or differences in the rate of fracturation or number of seeds produced by different species (Popper 1988). Absolute counts are thus poor indicators of differences between deposits and the relative importance of different taxa (Popper 1988). Despite these problems, I have reported absolute counts in order to prevent the misinterpretation that might result from a purely descriptive report.

Comparison between deposits with different sample volumes is enabled by conversion of the absolute counts to density ratios, using the sample volume as the norming variable (Miller 1988). These measures are presented as the number of items per liter in each sample. In order to facilitate the comparison of different groups of taxa between deposits, I have also calculated the ubiquity of specific groups of plants from analyzed samples from the 1998 and 1999 seasons (Table 17.4). Ubiquity, the percentage of samples in which a taxon or group of taxa appears (Popper 1988), is another measure that removes the bias

resulting from differences in sample volume. The available data and the density of botanical material recovered are not suitable for further statistical analysis at this time.

## 1. Plant Remains from the 1997 Season.

During the summer of 1998, I examined the 15 samples from 1997 under 10X microscopy at the Institute of Archaeology of the Hebrew University of Jerusalem. Small shell fragments and rodent coprolites, possibly of modern origin, were noted in several samples. Both wood and seeds were preserved in fragmentary condition. Modern plant material also occurred in these samples. In no case was wood preserved in large enough pieces for positive species identification. In one case, however, enough wood was preserved to identify two fragments of a diffuse-porous angiosperm wood with abundant, singly-arranged vessels.

The non-wood remains, the sum absolute counts[1] of which are presented in Table 17.1, include several poorly preserved fragments of Gramineae that were not identifiable to species, and a single example each of emmer wheat (*Triticum turgidum* ssp. *dicoccum*) and einkorn wheat (*Triticum monococcum* ssp. *monococcum*). Fragments of a hulled variety of barley (*Hordeum* sp.), a small-seeded barley variety (*Hordeum* cf. *murinum*), and a possible example of brome grass (cf. *Bromus* sp.) constitute the remainder of identifiable grasses in the 1997 samples. A modern olive pit (*Olea europaea*), a carbonized nutshell fragment (cf. *Pistacia* sp.), and more than 300 fragments of unidentifiable non-wood carbon were the only other plant remains in these samples.

Since the volume of the samples is unknown, no quantitative conclusions may be drawn from this small data set. In addition, the relative density of plant remains from Building Complex I may not be compared with that of Building Complex II (Table 17.2). The low quantity of plant remains recovered from Building Complex I further limits their interpretive potential, but does demonstrate the potential utility of bucket flotation as a low-cost method for initial testing of plant preservation in archaeological deposits.

## 2. Plant Remains from the 1998 Season.

During the 1998 excavation season, 3,514.5 liters of sediment were processed by water-sieving, according to the methods described above. Of the resulting 207 samples, 42 have been fully sorted, 23 of which have had full quantitative scoring and taxonomic identification and are reported here. These samples all derive from the area of Building Complex II, located in the area of a former olive grove (Garfinkel and Miller, Chapter 2 in this volume). Preliminary analysis of these samples indicates the same level of preservation as noted in the 1997 samples – fragmentary preservation of plant remains and a high frequency of modern rootlets and seeds.

In contrast to Building Complex I (Table 17.1), sampled only by bucket flotation, many small weed seeds were recovered from Building Complex II (Table 17.2). This difference between the two areas likely reflects differences in recovery methodology. Identified crop species include both cereals and pulses. Among the cereals, emmer wheat and hulled barley were both most abundant and most ubiquitous, while einkorn wheat has not yet been identified in this part of the site. The apparent absence of einkorn may reflect the particular samples chosen for analysis rather than a compositional difference between the two areas, however. In addition to the grains of cereals, processing debris was also identified, including rachis segments and nodes, glume bases, spikelet forks, and culm fragments, suggesting that some processing of cereals occurred on site.

Pulse crops are less well represented in these samples than are cereals. Of the pulses, lentils (*Lens* sp.) were most ubiquitous, while fava bean (*Vicia faba*) and bitter vetch (*Vicia ervilia*) occurred in a single sample each. One example of lentil exhibited a pronounced sprouting, suggesting that it may have originated from a stored deposit incompletely protected from humidity, as has been argued for chenopodium deposits from eastern North America (Smith 1992).

In addition to pulses and cereals, several fig seeds (*Ficus carica*), two examples of a pear or apple species (cf. *Pyrus*), and unidentified fruit and nutshell fragments were recovered. It should be emphasized that the total number of fig seeds from all samples represents fewer than the number of seeds in a single fig fruit, and the apparent abundance of fig seeds suggested by the absolute counts is misleading. These items do, however, suggest some use of wild fruit and nut species, all of which were likely to be locally available.

TABLE 17.1. Sha'ar Hagolan 1997, summed absolute counts of all samples (N=15)

| Species | # whole [#frags.] |
| --- | --- |
| Gramineae, indet. species | 3 [62] |
| *Triticum monococcum* | 1 [2] |
| *Triticum dicoccum* | 1 |
| *Hordeum* sp. | [2] |
| cf. *Bromus* sp. | 1 |
| *Hordeum* cf. *murinum* | 1 |
| *Olea europaea* (modern) | 1 |
| cf. *Pistacea* sp. | [1] |
| unidentifiable non-wood | [334] |

[1] Sum absolute counts are presented for the 1997 material due to the absence of information on sample volumes or contexts.

TABLE 17.2. Sha'ar Hagolan 1998, absolute counts (N=23)

| | Square | ? | I44b | G44a | G44a | G44b | G44b | G44b | I44b | H44a | I44b | I44c | I44c | I44d | I44b | G44b |
|---|---|---|---|---|---|---|---|---|---|---|---|---|---|---|---|---|
| | Locus | ? | 41 | 201 | 201 | 210 | 210 | 212 | 218 | 222 | 224 | 225 | 225 | 232 | 233 | 236 |
| | Basket | 852 | 839 | 824 | 826 | 818 | 827 | 832 | 828 | 843 | 867 | 879 | 882 | 866 | | 873 |
| | Context | ? | Wall | Fill | Pit? | Int. Fill | Int. Fill | Pit | Silty Fill | Pit | Sandy Fill | Above floor | Fill | Fill | Mdbrk. | Int. Fill |
| | Sample Vol. L. | ? | 5 | 40 | 4.5 | 70 | 10 | 20 | 20 | 30 | 20 | 30 | 20 | 10 | 10 | 5 |
| | Deposit Vol. L | ? | 20 | 490 | 4.5 | 700 | 130 | 180 | 700 | 30 | 740 | 610 | 480 | 260 | ? | 11 |
| | % Sample | ? | 25% | 8.16% | 100% | 10% | 7.60% | 11% | 2.80% | 100% | 2.70% | 4.92% | 4.20% | 3.80% | ? | 45% |
| **CEREAL CROPS** | **Plant Part** | | | | | | | | | | | | | | | |
| *Triticum dicoccum* | seed | 5 [1] | - | - | - | - | - | 1 | 1 [1] | - | - | - | - | - | - | - |
| cf. *Triticum dicoccum* | seed | - | - | - | - | 1 [2] | - | - | - | - | - | - | - | - | - | - |
| *Triticum* sp. | seed | 1 [4] | - | - | [3] | - | - | - | - | 1 [2] | - | - | - | - | - | - |
| *Hordeum vulgare* | seed | - | - | - | - | - | - | - | [1] | 3 [1] | - | - | - | - | - | - |
| *Hordeum* sp. | seed | - | - | - | - | [1] | - | - | - | - | - | - | - | - | - | - |
| Cereals indet. | seed | 3 [36] | - | - | 1 [15] | - | - | - | [4] | - | 1 [17] | [3] | - | [1] | - | [10] |
| **LEGUME CROPS** | | | | | | | | | | | | | | | | |
| *Lens* sp. | seed | 1 [2] | - | [1] | 1 | - | - | - | - | - | - | - | - | - | - | - |
| *Vicia faba* | seed | - | - | 1 | - | - | - | - | - | - | - | - | - | - | - | - |
| *Vicia ervilia* | seed | - | - | 1 | - | - | - | - | - | - | - | - | - | - | - | - |
| **FRUITS and NUTS** | | | | | | | | | | | | | | | | |
| *Ficus carica* | seed | - | - | 62 | - | - | - | - | - | - | - | 2 | - | - | - | - |
| cf. *Pyrus* sp. | seed | - | - | - | - | - | - | - | - | 3 | - | - | - | - | - | - |
| Fruit, sp. indet. | fruit / seed | - | - | - | - | - | [3] | [2] | - | - | - | - | - | - | - | - |
| Nut, sp. indet | nutshell | - | - | - | - | - | - | [2] | - | - | - | - | - | - | - | - |
| **WEEDS OF CEREALS** | | | | | | | | | | | | | | | | |
| *Lolium* sp. | seed | 1 | - | - | - | - | - | - | - | - | - | - | - | - | - | - |
| cf. *Lolium* sp. | seed | - | - | - | 1 | - | - | - | - | - | - | - | - | - | - | - |
| *Bromus* sp. | seed | - | - | - | - | - | - | - | - | 2 [2] | - | - | - | - | - | - |
| *Hordeum* cf. *maritimum* | seed | - | - | - | - | - | - | - | - | [5] | - | - | - | - | - | - |
| *Avena* sp. | awn | - | - | - | - | - | - | - | - | [1] | [2] | - | - | [1] | - | - |
| **WATER PLANTS** | | | | | | | | | | | | | | | | |
| *Carex* sp. | seed | - | - | - | - | - | - | - | - | - | - | - | - | - | - | - |
| **OTHER WILD PLANTS** | | | | | | | | | | | | | | | | |
| cf. *Adonis* sp. | seed | - | - | - | - | - | 1 | - | - | - | - | - | - | - | - | - |
| *Polygonum* sp. | seed | - | - | - | - | - | - | - | - | 2 | - | - | - | - | - | - |
| *Chenopodium* cf. *album* | seed | 1 | - | - | - | 3 | - | - | - | 2 | - | 1 | - | - | - | - |
| *Chenopodium* sp. | seed | 1 | - | 21 | 1 | 1 | 53 | 2 | 51[2] | - | - | 2 | 7 | - | - | - |
| cf. *Silene / Stellaria* sp. | seed | - | - | 4 | 5 | 11 | 18 [2] | 1 | - | [1] | - | 2 | 1 [1] | - | - | - |
| cf. *Scrophularia* sp. | seed | - | - | 1 | - | - | - | - | - | - | - | - | - | - | - | - |
| cf. *Potentilla* sp. | seed | - | - | - | - | 3 | - | - | - | - | - | - | 1 | - | - | - |
| cf. *Astragalus* sp. | seed | - | - | - | - | - | - | - | - | 2 | - | - | - | - | 1 | - |
| *Medicago* sp. | seed | - | - | - | - | - | - | - | - | 1 | - | - | - | - | - | - |
| *Malva* sp. | seed | - | - | - | 1 | - | - | - | - | - | - | 1 | - | - | - | - |
| cf. *Onobrychis* sp. | capsule | - | - | - | - | - | - | [1] | - | - | - | - | - | - | - | - |
| *Linum* cf. *bienne* | seed | - | - | - | - | - | - | - | - | - | - | 1 | - | - | - | - |
| cf. *Galium* sp. | seed | - | - | - | 1 | - | - | - | - | - | - | - | - | - | - | - |
| *Echium* sp. | capsule | - | - | - | - | - | 1 | - | - | - | - | - | - | - | - | - |
| *Verbena* sp. | seed | - | - | - | - | - | - | - | - | - | 1 | - | - | - | - | - |
| cf. *Lamium* sp. | seed | - | - | - | - | - | - | 1 | - | - | - | - | - | - | - | - |
| *Verbascum* sp. | seed | - | - | - | - | - | - | - | - | - | 1 | 1 | - | - | - | - |
| cf. *Ashphodelus* sp. | seed | - | - | - | - | - | - | - | - | - | - | 1 | - | - | - | - |
| **INDETERMINATE** | | | | | | | | | | | | | | | | |
| Leguminosae, sp. indet. | seed | - | - | - | [5] | [2] | - | - | - | [2] | [1] | - | - | - | [2] | - |
| Compositae, sp. indet. | seed | 1 | - | 1 | - | - | - | 1 | - | - | - | 1 | - | - | - | - |
| Gramineae, sp. indet. | seed | - | - | - | [1] | - | 4 [2] | 1 [1] | [5] | 1 [9] | - | - | - | - | [1] | - |
| Gramineae, sp. indet. | glume base | - | - | - | - | - | [3] | - | - | - | - | - | - | - | - | - |
| Gramineae, sp. indet. | spikelet fork | - | - | - | - | - | - | - | - | [2] | - | - | - | - | - | - |
| Gramineae, sp. indet. | rachis internode | - | - | - | - | [2] | - | - | - | [1] | - | - | - | - | - | - |
| Gramineae, sp. indet. | rachis segment | - | - | - | - | - | [1] | - | - | - | - | - | - | - | - | - |
| Gramineae, sp. indet. | culm | - | - | - | - | - | - | [1] | - | - | - | - | - | [2] | [1] | - |
| Small Gramineae, sp. indet. | seed | 1 | - | - | 1 [1] | 5 [41] | - | - | - | 2 [15] | - | - | - | - | - | - |
| Umbelliferae, sp. indet. | seed | - | - | - | 1 | - | - | - | - | - | - | - | - | - | - | - |
| species indet. | seed | 7 | - | 15 | 2 | 17 | [2] | 16 [5] | 1 | - | - | 2 | 1 | [4] | 7 | 2 |
| species indet. | thorn | - | - | - | - | - | [1] | [4] | - | - | - | - | - | - | - | - |
| non-wood fragments indet. | unknown | [1] | - | [3] | [4] | - | [5] | [31] | [7] | [1] | [70] | [15] | [16] | [8] | [12] | [25] |
| fungal spore, indet. | spore | - | - | - | - | - | - | [1] | - | - | - | - | - | - | - | - |
| wood, sp. indet. | wood | [42] | - | - | - | - | - | [6] | - | - | [46] | [6] | [4] | - | - | - |
| | **TOTAL Whole** | 22 | 0 | 105 | 15 | 41 | 77 | 79 | 53 | 21 | 4 | 11 | 10 | 0 | 8 | 2 |
| | **TOTAL Items** | 108 | 0 | 109 | 44 | 89 | 96 | 133 | 69 | 67 | 140 | 35 | 33 | 15 | 23 | 37 |
| | **# Items per L** | ? | 0 | 2.72 | 9.8 | 1.27 | 9.6 | 6.65 | 3.45 | 2.23 | 7 | 1.17 | 1.65 | 1.50 | ? | 7.4 |

Table 17.2. Continued

| | Square | I44b | I44d | I44c | I44b | I44a | I44b | H46b | I44b | |
|---|---|---|---|---|---|---|---|---|---|---|
| | Locus | 241 | 243 | 246 | 251 | 264 | 271 | 274 | 280 | |
| | Basket | 881 | 938 | 889 | 900 | 924 | 945 | 983 | 969 | |
| | Context | Sandy Fill | Floor? | Mdbrk. | Mdbrk. | Pit | Below grinder | Int. Fill | Sandy Fill | |
| | Sample Vol. L. | 10 | 5 | 5 | 20 | 10 | 10 | 10 | 10 | |
| | Deposit Vol. L | 570 | 20 | 200 | 180 | 150 | ? | 110 | 500 | |
| | % Sample | 1.75% | 25% | 2.50% | 11% | 6.60% | ? | 9% | 2% | |
| **CEREAL CROPS** | **Plant Part** | | | | | | | | | **Totals** |
| *Triticum dicoccum* | seed | - | - | - | 1 [1] | - | - | - | - | 8 [3] |
| cf. *Triticum dicoccum* | seed | - | - | - | - | - | - | - | - | 1 [2] |
| *Triticum* sp. | seed | - | - | - | - | - | - | - | - | 2 [9] |
| *Hordeum vulgare* | seed | - | - | - | - | - | - | - | - | 3 [2] |
| *Hordeum* sp. | seed | - | - | - | - | - | - | - | - | [1] |
| Cereals indet. | seed | - | - | - | - | - | - | - | [1] | 5 [87] |
| **LEGUME CROPS** | | | | | | | | | | |
| *Lens* sp. | seed | - | - | - | - | - | - | 1 | - | 3 [3] |
| *Vicia faba* | seed | - | - | - | - | - | - | - | - | 1 |
| *Vicia ervilia* | seed | - | - | - | - | - | - | - | - | 1 |
| **FRUITS and NUTS** | | | | | | | | | | |
| *Ficus carica* | seed | - | - | - | 4 [1] | 3 | 1 | - | - | 72[1] |
| cf. *Pyrus* sp. | seed | - | - | - | - | - | - | - | - | 3 |
| Fruit, sp. indet. | fruit / seed | - | - | - | - | - | - | - | - | [5] |
| Nut, sp. indet | nutshell | - | - | - | - | - | - | - | - | [2] |
| **WEEDS OF CEREALS** | | | | | | | | | | |
| *Lolium* sp. | seed | - | - | - | - | - | - | - | - | 1 |
| cf. *Lolium* sp. | seed | - | - | - | - | - | - | - | - | 1 |
| *Bromus* sp. | seed | - | - | - | - | - | - | - | - | 2 [2] |
| *Hordeum* cf. *maritimum* | seed | - | - | - | - | - | - | - | - | [5] |
| *Avena* sp. | awn | - | - | - | - | - | - | - | - | [4] |
| **WATER PLANTS** | | | | | | | | | | |
| *Carex* sp. | seed | - | - | - | - | 1 | - | - | - | 1 |
| **OTHER WILD PLANTS** | | | | | | | | | | |
| cf. *Adonis* sp. | seed | - | - | - | - | - | - | - | - | 1 |
| *Polygonum* sp. | seed | - | - | - | - | - | - | - | - | 2 |
| *Chenopodium* cf. *album* | seed | - | 20 | - | 2 | - | - | - | - | 30 |
| *Chenopodium* sp. | seed | - | 8 | - | 1 | - | - | - | - | 147 [2] |
| cf. *Silene / Stellaria* sp. | seed | - | - | - | 2 | - | - | - | - | 44 [4] |
| cf. *Scrophularia* sp. | seed | - | - | - | - | - | - | - | - | 1 |
| cf. *Potentilla* sp. | seed | - | - | - | - | - | - | - | - | 3 |
| cf. *Astragalus* sp. | seed | - | - | - | - | - | - | - | - | 3 |
| *Medicago* sp. | seed | - | - | - | - | - | - | - | - | 1 |
| *Malva* sp. | seed | - | - | - | - | - | - | - | - | 2 |
| cf. *Onobrychis* sp. | capsule | - | - | - | - | - | - | - | - | [1] |
| *Linum* cf. *bienne* | seed | - | - | - | - | - | - | - | - | 1 |
| cf. *Galium* sp. | seed | 3 | - | - | - | - | - | - | - | 4 |
| *Echium* sp. | capsule | - | - | - | - | - | - | - | - | 1 |
| *Verbena* sp. | seed | - | - | - | - | - | - | - | - | 1 |
| cf. *Lamium* sp. | seed | - | - | - | - | - | - | - | - | 1 |
| *Verbascum* sp. | seed | - | - | - | - | - | - | - | - | 2 |
| cf. *Ashphodelus* sp. | seed | - | - | - | - | - | - | - | - | 1 |
| **INDETERMINATE** | | | | | | | | | | |
| Leguminosae, sp. indet. | seed | - | - | - | - | - | - | - | - | [12] |
| Compositae, sp. indet. | seed | - | - | - | - | - | - | - | - | 4 |
| Gramineae, sp. indet. | seed | - | - | - | [75] | - | [1] | [3] | - | 6 [98] |
| Gramineae, sp. indet. | glume base | - | - | - | - | - | - | - | - | [3] |
| Gramineae, sp. indet. | spikelet fork | - | - | - | - | - | - | - | - | [2] |
| Gramineae, sp. indet. | rachis internode | - | - | - | - | - | - | - | - | [3] |
| Gramineae, sp. indet. | rachis segment | - | - | - | - | - | - | - | - | [1] |
| Gramineae, sp. indet. | culm | - | - | - | - | - | - | - | - | [4] |
| Small Gramineae, sp. indet. | seed | - | - | - | - | - | - | - | - | 9 [57] |
| Umbelliferae, sp. indet. | seed | - | - | - | - | - | - | - | - | 1 |
| species indet. | seed | - | 4 | [3] | 3 | 43 | [3] | - | [11] | 120 [28] |
| species indet. | thorn | - | - | - | - | - | - | - | - | [5] |
| non-wood fragments indet. | unknown | [12] | [21] | - | [61] | [16] | - | [9] | - | [317] |
| fungal spore, indet. | spore | - | - | - | - | - | - | - | - | [1] |
| wood, sp. indet. | wood | [4] | [7] | - | - | - | - | - | [1] | [116] |
| | **TOTAL Whole** | 3 | 32 | 0 | 13 | 47 | 1 | 1 | 0 | |
| | **TOTAL Items** | 19 | 60 | 3 | 151 | 63 | 5 | 13 | 13 | AVG = |
| | **# Items per L** | 1.9 | 3 | 0.6 | 7.55 | 6.3 | ? | 1.3 | 1.3 | 3.82 / L |

Preliminary sorting of the heavy fraction yielded only modern botanical remains, suggesting that the more dense items frequently recovered from the heavy fraction (nutshell, legumes, olive pits, etc.) (Pearsall 1989) are here represented in the light fraction. Although the heavy fraction has not yet been fully processed, preliminary scanning suggests that the rarity of legumes and nutshell in the light fraction is not an artifact of the recovery process.

In contrast to the remains from 1997, significantly more small (<1.5 mm.) seeds of weedy and wild taxa are represented in the 1998 samples. This difference likely results from a difference in recovery methodology between the two seasons, such as a difference in mesh size. The few remains of ruderal species such as canary grass (*Lolium* sp.), brome grass (*Bromus* sp.), little barley (*Hordeum maritimum*), and oat (*Avena* sp.) may reflect weeds collected during cereal harvesting. Whether these remains represent human food or animal fodder remains unclear. Future analysis will focus on the ecology and seasonality of the species, and will facilitate interpretation of agricultural practices in use at Sha'ar Hagolan.

**3. Plant Remains from the 1999 Season.** Only six of the 57 flotation samples from the 1999 season have been fully analyzed, but preliminary analysis indicates better preservation and more dense remains in Area H than in Area E, sampled in 1998. This difference may result from a difference in modern land use rather than a difference in area function. Descriptions of the deposits from which the 1999 samples originate are not yet available to me, but a variation in sediment types may be an additional factor in the recovery differences between the two areas.

Among these six samples (Table 17.3), the remains of emmer and einkorn wheats were equally ubiquitous. As in the 1997 and 1998 samples, wheat predominates over barley, and legumes continue to be rare. The diversity of species in this area is much lower than in the 1998 samples. Of particular interest is the rarity of small weedy seeds that were frequent in Area E, such as small chenopods and Scrophulariaceae (e.g. *Silene / Stellaria* sp.). These seeds are generally less than 1.5 mm. in diameter and would be more likely to move within the soil column through bioturbation or seasonal shrinking and swelling

TABLE 17.3. Sha'ar Hagolan 1999, absolute counts (N=6)

| | | AA42B | AA41D | BB42C | Z41B | Z41B | AA41D | |
|---|---|---|---|---|---|---|---|---|
| | Square | | | | | | | |
| | Locus | H141 | H187 | H193 | H164 | H233 | H187 | |
| | Basket | H233 | H466 | H494 | H499 | H504 | H510 | |
| | Context | ? | ? | Jar | Jar #3 | ? | Mudbricks | |
| | Sample Vol. L. | 8 | 8 | 8 | 7 | 6 | 2 | |
| **CEREAL CROPS** | PART | | | | | | | Totals |
| *Triticum monococcum* | seed | - | [2] | - | 4 [2] | [1] | - | **4 [5]** |
| cf. *Triticum monococcum* | spikelet fork | - | 1 [4] | - | [1] | - | - | **1 [5]** |
| *Triticum dicoccum* | seed | - | 1 [2] | - | 1 | [2] | - | **2 [2]** |
| *Triticum* sp. | seed | - | 5 [38] | - | 2 | - | - | **7 [38]** |
| *Hordeum vulgare* | seed | - | - | - | 2 [2] | [1] | - | **2 [3]** |
| cf. *Hordeum* sp. | seed | [1] | - | - | - | - | - | **[1]** |
| Cereals indet. | seed | 2 [6] | - | [1] | 3 [48] | [9] | [2] | **5 [66]** |
| | | | | | | | | |
| **LEGUME CROPS** | | | | | | | | |
| cf. *Vicia / Pisum* sp. | seed | - | - | [2] | - | - | - | **[2]** |
| | | | | | | | | |
| **FRUITS and NUTS** | | | | | | | | |
| *Ficus carica* | seed | 1 | 51 | - | - | 2 | 2 | **[56]** |
| | | | | | | | | |
| **WEEDS OF CEREALS** | | | | | | | | |
| *Lolium* sp. | seed | - | - | - | 1 | [1] | - | **1 [1]** |
| *Bromus* sp. | seed | - | - | - | 1 | - | - | **1** |
| | | | | | | | | |
| **OTHER WILD PLANTS** | | | | | | | | |
| *Galium* sp. | seed | - | - | - | [1] | - | - | **[1]** |
| | | | | | | | | |
| **INDETERMINATE** | | | | | | | | |
| Gramineae, sp. indet. | seed | [12] | 3 [9] | - | 2 [97] | - | [4] | **5 [122]** |
| Gramineae, sp. indet. | spikelet fork | - | - | - | - | [1] | - | **[1]** |
| Small Gramineae, sp. indet. | seed | - | - | - | 2 | - | [4] | **2 [4]** |
| Leguminosae, sp. indet. | seed | - | - | [1] | - | [3] | - | **[4]** |
| species indet. | seed | 3 | - | - | 2 | - | - | **5** |
| non-wood fragments indet. | unknown | [46] | [195] | [5] | [174] | [56] | [14] | **[490]** |
| wood, sp. indet. | wood | - | [4] | - | [10] | [12] | - | **[26]** |
| | | | | | | | | |
| | TOTAL Whole | 6 | 61 | 0 | 20 | 2 | 2 | **91** |
| | TOTAL Items | 71 | 253 | 9 | 335 | 88 | 26 | **782** |
| | # Items per L | 8.88 | 31.63 | 1.13 | 47.86 | 14.67 | 13 | **20.05** |

of clays. Therefore, this difference between the two areas may represent a difference in the integrity of the deposits, rather than areal differences in plant usage. Although these seeds were carbonized, they may be modern examples burned in a recent field fire (Garfinkel 1998, personal communication).

The small number of analyzed samples from the 1999 season precludes the use of ubiquity measures based solely on these remains, assessment of the relative importance of cultivated species in this area of the site, and comparison of this sector of the site with Area E. These issues may only be addressed after additional samples from 1999 have been analyzed.

## IV. TAPHONOMIC FACTORS

In general, the density of botanical remains from the analyzed samples from 1998 and 1999 is quite low, ranging between zero to 47 items per liter. The preservation of material varies across the site, and is better in Area H than in Area E. This difference may be due in part to a difference in land use history between the two areas, with Area E lying below a former olive grove, and Area H lying below a former fishpond. Insect remains and rootlets were less frequently encountered in Area H than Area E, suggesting that bioturbation is less in Area H.

I suggest that the poor preservation results primarily from four taphonomic factors. These are the shallowness of the site, the modern history of land use, the shrinking and swelling tendency of the clay- and silt-rich soil, and bioturbation, as evidenced by the frequent occurrence of

insects and rootlets in the samples. Each of these factors would increase the fragmentation of carbon and diminish the number of identifiable and whole items in the sediment. In addition, some fragmentation of plant remains may have occurred during the water-sieving process itself, particularly when it was necessary to refloat samples of the heavy fraction (Wagner 1988).

Other taphonomic processes may also affect the preservation of botanical remains. For example, wood appears in very limited quantities and only as fragments smaller than 1 cm.$^2$, perhaps reflecting the lack of contexts identified as hearth deposits. Similarly, the species of wood used at Sha'ar Hagolan may be of a type that fractures especially easily (Popper 1988). The behavioral context of floral remains also affects density, fragmentation, and the taxa represented. For example, a primary deposit of cereal processing debris *in situ* should be more dense than secondary deposits of the same material recovered from a swept surface or a mixed trash pit (Dennell 1976). Similarly, various stages in crop processing might be expected to result in different assemblages (Dennell 1974; Jones 1984).

## V. DISCUSSION

In all deposits, cereal remains are both more ubiquitous and more abundant than pulses among the cultivated species (Table 17.4). There is not enough evidence at present to determine any correlation between the location of grinding implements and processing debris, so that the location of these remains in primary or secondary

TABLE 17.4. Ubiquity measures for 1998 and 1999 samples analyzed to date (N = 29, minimum ubiquity measure = 3.5%)

| Group | Species included | Ubiquity |
|---|---|---|
| All Cereals | *Triticum dicoccum, Triticum monococcum, Triticum* sp., *Hordeum vulgare, Hordeum* sp. | 62% |
| Wheats | *Triticum monococcum, Triticum dicoccum, Triticum* sp. | 34% |
| Barley | *Hordeum vulgare, Hordeum* sp. | 21% |
| Small Grasses | *Bromus* sp., *Lolium* sp., *Avena* sp., *Hordeum maritimum,* small Gramineae indet. | 27% |
| Processing debris, grasses | all cereals and grasses | 27% |
| Legume crops | *Vicia / Pisum* sp., *Lens* sp., *Vicia faba, Vicia ervilia* | 17% |
| Fruits | *Ficus,* cf. *Pyrus* sp., fruit frags. indet. | 41% |
| Chenopodium | *Chenopodium* cf. *album, Chenopodium* sp. | 41% |
| Caryophyllaceae | *Silene / Stellaria* sp. | 31% |

contexts remains equivocal. The occurrence of processing debris in several contexts, however, may reflect small-scale processing of cereals as needed, as might be expected in a humid environment. Cereal processing debris appears to correlate with interior spaces. Similarly, B. Hesse (1999; Chapter 18 in this volume) has noted the rarity of faunal remains in street deposits as compared with interior areas at Sha'ar Hagolan. The paucity of botanical remains could equally reflect regular sweeping of plant waste into the streets, but sampling of street deposits is needed to support either of these interpretations.

The low frequency of wood is puzzling, particularly in light of the pronounced evidence of soot noted on several cooking vessels (Eirikh-Rose and Garfinkel, Chapter 7 in this volume) and the absence of burned dung deposits in all excavated deposits. The rarity of wood charcoal (Miller 1984) and the overall low density and high fragmentation of plant remains (Charles 1998) may suggest the use of dung for fuel (Miller 1984), but this interpretation may not be substantiated at present.

The investigation of fuel use, the question of *in situ* burning deposits, and the identification of the botanical remains as food, fuel or fodder will form a significant part of future analysis of material at the site, but at present the evidence is equivocal on these issues. Whether the apparent absence of hearths represents an artifact of excavation and recording or an absence of *in situ* deposits of burning activity will affect future interpretations of the taphonomy of the botanical assemblage. Despite the present limitations of the Sha'ar Hagolan floral data, some initial comparison may be made with the data from other Yarmukian sites with plant remains.

**Sha'ar Hagolan Plant Husbandry in Context.** To date, plant remains have been recovered from only three Yarmukian sites in Jordan and Israel: Abu Thawwab (Kafafi 1988, 1992) and 'Ain Rahub (Muheisen *et al.* 1988) in Jordan, and Sha'ar Hagolan in Israel. At a fourth site in Jordan, 'Ain Ghazal, floral remains were not preserved in the Yarmukian levels (Kafafi 1992; Rollefson and Kohler-Rollefson 1993). The plant remains at these sites have thus far been reported only in terms of presence or absence or as relatively more or less abundant, without quantitative data or information about sampling and recovery methods. In addition, wood charcoal (Neef 1997) is reported only from 'Ain Rahub. Therefore, present data from Yarmukian floral assemblages preclude a clear understanding of agricultural practices and the environment to which they were adapted. Although the data from 'Ain Rahub and Abu Thawwab may not be statistically compared with the data from Sha'ar Hagolan, some general statements of similarities and differences between the sites is possible.

Abu Thawwab is located in the Wadi er-Rummam of northwestern Jordan, adjacent to a perennial spring (Kafafi 1998, 1992). At this site, lentil (*Lens* sp.) and emmer wheat (*Triticum dicoccum*) are reported as predominant in the assemblage (Kafafi 1988, 1993). Cultivated flax (*Linum usitatissimum*) and bitter vetch (*Vicia ervilia*) were also identified (Kafafi 1993). Compared with Sha'ar Hagolan, the Abu Thawwab assemblage is similar in terms of the prevalence of emmer wheat. In contrast to Abu Thawwab, however, lentil and other cultivated legumes are rare at Sha'ar Hagolan. In addition, the single flax seed recovered from Sha'ar Hagolan falls within the dimensions of a wild flax such as *Linum bienne*, as opposed to the cultivated flax identified at Abu Thawwab. While two-row barley (*Hordeum distichum*) was identified at Abu Thawwab, the frequency of barley in the samples from Sha'ar Hagolan is too low to allow this level of precision in cereal identification. Further analysis of the better preserved, more dense deposits from Area H (1999) at Sha'ar Hagolan may allow more precise determination of the type of barley represented.

At 'Ain Rahub, located in the semi-arid environment of the north Jordanian highlands on the west bank of the Wadi ar-Rahub, Neef reports the predominance of emmer wheat and two-row barley in the floral assemblage (Muheisen *et al.* 1988). Among the remains of emmer wheat, spikelet forks, glume bases, and grains are all reported, but the taphonomy of the remains is not discussed (Muheisen *et al.* 1988). As at Sha'ar Hagolan, einkorn wheat is rare (a single occurrence) in comparison with emmer, and no cultivated legumes are reported (Muheisen *et al.* 1988). Neef reports a similar weed assemblage to that from Sha'ar Hagolan, including mallow (*Malva* sp.), medick (*Medicago* sp.), and canary grass (Muheisen *et al.* 1988). Neef has identified all wood charcoal from 'Ain Rahub as tabor oak (*Quercus ithaburensis*) which, in conjunction with relict stands of tabor oak in the area of the site, has suggested the existence of Mediterranean forest in the vicinity during the Yarmukian period (Muheisen *et al.* 1988). It is hoped that identification of the wood species from Sha'ar Hagolan will provide similar evidence of local environmental conditions during the pottery Neolithic.

A separation and specialization of plant and animal husbandry within the Yarmukian agricultural economy has recently been suggested (Rollefson 1997). However, differences between the reported floral and faunal remains from Yarmukian sites suggests that the degree of separation or integration of plant and animal husbandry probably varies between sites. Variations in the agricultural strategies of different Yarmukian sites should be investigated, rather than seeking a single characterization of Yarmukian economy. Further analysis and reporting of

the Sha'ar Hagolan, 'Ain Rahub, and Abu Thawwab botanical assemblages, including wood and non-wood remains, will make a significant contribution to evidence for local environmental conditions and subsistence practices in the later Neolithic of the Levant. Such information is critical for understanding the transition to the Pottery Neolithic and the extent of environmental variation during the later Neolithic.

## VI. CONCLUSIONS

Preliminary analysis of the plant remains, together with information from the faunal assemblage (Hesse 1999; Chapter 18 in this volume) suggests a fully agricultural economy at Sha'ar Hagolan based on both plant and animal husbandry. The plant husbandry system was cereal-based, and likely involved the use of cereals and their by-products for both food and fodder. The presence of cereal grains, weeds and processing debris, together with the high frequency of basalt grinding stones and flint sickles suggests that the Yarmukians of Sha'ar Hagolan were fully engaged in plant producing activities. The presence of fruit and nut species, although rare, suggests that wild plant resources also contributed to the diet.

The taphonomy of the plant remains and the question of fuel resources require further investigation. Future study of the plant remains will focus on these issues as well as the spatial and contextual associations of the recovered taxa, their ecology, and their seasonality. These investigations will provide additional evidence for the functions of areas within the site, the nature of agricultural practices, and the site's environmental context during the sixth millennium BC. In addition, identification of wood charcoal and wild plant seeds from the site may provide a more localized picture of environmental conditions during the later Neolithic than that already provided by regional environmental evidence.

## Acknowledgements
I am grateful to Dr. Y. Garfinkel and Dr. M. Miller for inviting me to undertake study of this material, and to the Israel Antiquities Authority for granting permission to export the 1998 and 1999 flotation samples to Boston University, Boston, Massachusetts, for further analysis in the laboratory. The initial set-up of the water-sieve would not have been possible without the guidance of Dr. J. Hansen and the kind assistance of many members of Kibbutz Sha'ar Hagolan. Sincere thanks are also due to James Hirst, Chris Holmes, Natasha Rakovic, Shalom Sanchez, and most especially to Nick Franchino and Pam Smith for their invaluable help with the water-sieving. For her patient encouragement and careful reading of an earlier draft of this report, I thank Dr. J. Hansen. I retain culpability for any lingering interpretive errors.

## BIBLIOGRAPHY

Banning, E.B., Rahimi, D., and Siggers, J. 1994. The Late Neolithic of the Southern Levant: Hiatus, Settlement Shift, or Observer Bias? The Perspective from Wadi Ziqlab. *Paléorient* 20: 151–164.

Charles, M. 1998. Fodder from Dung: The Recognition and Interpretation of Dung- Derived Plant Material from Archaeological Sites. *Environmental Archaeology* 1: 111–122.

Davis, E.M. and Wesolowsky, A.B. 1975. The Izum: A Simple Water Separation Device. *Journal of Field Archaeology* 2: 271–273.

Dennell, R.W. 1974. Botanical Evidence for Prehistoric Crop Processing Activities. *Journal of Archaeological Science* 1:275–284.

Dennell, R.W. 1976. The Economic Importance of Plant Resources Represented on Archaeological Sites. *Journal of Archaeological Science* 3: 229–247.

French, D.H.1971. An Experiment in Water-Sieving. *Anatolian Studies* 21:59–64.

Hesse, B. 1999. Rethinking the Place of Animals in the Neolithic Period: New Evidence from Sha'ar Hagolan and Ashkelon. Paper presented at the Annual Meeting of the American Schools for Oriental Research, Cambridge, Massachusetts, November 17–20,1999 (Abstract).

Hillman, G.C. 1981. Reconstructing Crop Husbandry Practices from Charred Remains of Crops. In Mercer, R. (ed.) *Farming Practice in British Prehistory*, pp. 123–162. Edinburgh: Edinburgh University Press.

Jones, G.E.M. 1984. Interpretation of Archaeological Plant Remains: Ethnographic Models from Greece. In Van Zeist, W. and Casparie, W.A. (eds.) *Plants and Ancient Man*, pp. 43-61. Rotterdam: A.A. Balkema.

Kafafi, Z. 1988. Jebel Abu Thawwab: A Pottery Neolithic Village in North Jordan. In Garrard, A. and Gebel, H.G. (eds.) *The Prehistory of Jordan: The State of Research in 1986*, pp. 452–471 (B.A.R. International Series 396). Oxford: British Archaeological Reports.

Kafafi, Z. 1992. Pottery Neolithic Settlement Patterns in Jordan. In Hadidi, A. (ed.) *Studies in the History and Archaeology of Jordan* IV, pp. 115–122. Amman: Department of Antiquities.

Kafafi, Z. 1993. The Yarmoukians in Jordan. *Paléorient* 19: 101–113.

Kohler-Rollefson, I. 1988. The Aftermath of the Levantine Neolithic Revolution in Light of Ecological and Ethnographic Evidence. *Paléorient* 14: 87–93.

Kohler-Rollefson, I., Gillespie, W. and Metzger, M.1988. The Fauna from Neolithic 'Ain Ghazal. In Garrard, A. and Gebel, H.G. (eds.) *The Prehistory of Jordan: The State of Research in 1986*, pp. 423–436 (B.A.R. International Series 396). Oxford: British Archaeological Reports.

Kohler-Rollefson, I. and Rollefson, G. O.1990. The Impact of

Neolithic Subsistence Strategies on the Environment: The Case of 'Ain Ghazal, Jordan. In Bottema, S., Entjes-Nieborg, G. and Van Zeist, W. (eds.) *Man's Role in the Shaping of the Eastern Mediterranean,* pp. 3–13. Rotterdam: A.A. Balkema.

Miller, N.F. 1984. The Use of Dung as Fuel. An Ethnographic Example and an Archaeological Application. *Paléorient* 10: 71–79.

Miller, N.F. 1988. Ratios in Paleoethnobotanical Analysis. In Hastorf, C.A. and Popper, V.S. (eds.) *Current Paleoethnobotany: Analytical Methods and Cultural Interpretations of Archaeological Plant Remains* (Prehistoric Archeology and Ecology Series), pp. 72–85. Chicago: University of Chicago Press.

Muheisen, M, Gebel, H.G., Hannss, C. and Neef, R. 1988. Excavations at 'Ain Rahub, a Final Natufian and Neolithic Site near Irbid (1985). In Garrard, A. and Gebel, H.G. (eds.) *The Prehistory of Jordan: The State of Research in 1986,* pp. 473–502 (B.A.R. International Series 396). Oxford: British Archaeological Reports.

Neef, R. 1997. Status and Perspectives of Archaeobotanical Research in Jordan. In Gebel, H.G., Kafafi, Z., and Rollefson, G.O. (eds.) *The Preshistory of Jordan,* II. *Perspectives from 1997* (Studies in Early Near Eastern Production, Subsistence, and Environment 4), pp. 601–609. Berlin: *ex oriente.*

Pearsall, D. 1989. *Paleoethnobotany: A Handbook of Procedures.* San Diego: Academic Press.

Popper, V. 1988. Selecting Quantitative Measurements in Paleoethnobotany. In Hastorf, C.A. and Popper, V.S. (eds.) *Current Paleoethnobotany: Analytical Methods and Cultural Interpretations of Archaeological Plant Remains* (Prehistoric Archeology and Ecology Series), pp. 53–71. Chicago: University of Chicago Press.

Rollefson, G.O. and Kohler-Rollefson, I. 1993. PPNC Adaptations in the First Half of the 6th Millennium B.C. *Paléorient* 19: 33–42.

Simmons, A.H., Kafafi, Z., Rollefson, G.O. and Moyer, K. 1989. Test Excavations at Wadi Shu'eib, a Major Neolithic Settlement in Central Jordan. *Annual of the Department of Antiquities of Jordan* 33: 27–42.

Smith, B.D. 1992. *Rivers of Change: Essays on Agriculture in Eastern North America.* Washington: Smithsonian Institution Press.

Wagner, G.E. 1988. Comparability Among Recovery Techniques. In Hastorf, C.A. and Popper, V.S. (eds.) *Current Paleoethnobotany: Analytical Methods and Cultural Interpretations of Archaeological Plant Remains* (Prehistoric Archeology and Ecology Series), pp. 17–35. Chicago: University of Chicago Press.

# Between the Revolutions:
## Animal Use at Sha'ar Hagolan during the Yarmukian

*Brian Hesse*

## I. Introduction

More than two decades ago Robert Stigler (1974: 106) observed that the millennia which in the Near East separate the early Neolithic from the urban developments of the Bronze Age had received far less attention than had either of the two sandwiching periods. This empirical reality probably found its explanation in the impact on archaeological research agendas of the two-step revolutionary view of later prehistory proposed, elaborated and made familiar through the writings of V. Gordon Childe (e.g., 1934, 1936). The periods of apparently rapid change – the Neolithic Revolution and the Urban Revolution – attracted far more interest, particularly in anthropological circles concerned with understanding "process," than the seemingly "stable" periods that intervened.

This pattern is reflected in the archaeology of the southern Levant as well. Despite the early recognition of the Pottery Neolithic as a distinct phase of development, few excavation projects have targeted its investigation. The lack of effort at the archaeological level is paralleled in the zooarchaeological literature. Extremely few descriptive reports have appeared (see the early work of Ducos [1968], and the more recent surveys of Grigson [1995] and of Hesse and Wapnish [n.d.]) of animal remains from Pottery Neolithic sites. Most of the discussions of faunal remains in the early to mid-Holocene have circled around the evidence of and reasons for the initial domestication of the first herd animals in the southern Levant: sheep and goats. Less energy has been spent documenting the succeeding phases where the competing demands of the various pastoral stock as they were added to the "walking larder" (first incorporating pigs and cattle and eventually, as we reach and enter the historic periods, equids and camels)

interacted with the development of a range of economic objectives to produce a complex, multi-species, multi-objective husbandry system.

Two key empirical goals are to establish the sequence of additions to the pastoral technology and the emergence of differential patterns of access to the production of husbandry. The remains from Sha'ar Hagolan are admirably positioned to contribute to the achievement of these goals. Not only are the bones well dated on artifactual and radiocarbon bases to late in the sixth millennium BC, but they come from an archaeological space with well-delimited architectural elements. The following brief summary lays out the preliminary results of the analysis of the collection.

## II. Condition of the Bone Finds

Preservation of osseous remains at Sha'ar Hagolan is poor. Most of the bone fragments that have been recovered are small and coated with concretions that obscure the morphological details of the specimens. Loss through diagenetic processes seems to have been high. It is likely that these taphonomic factors acted differentially on the deposited sample (see the studies discussed in Lyman 1994; Reits and Wing 1999) to produce the preserved sample we have at hand. Bones of higher bulk density – astragali and distal humeri, for example – are much more likely to have been preserved. The vertebral elements and the late fusing epiphyses of the long bones of herd animals – proximal humeri, femora, and tibiae, as well as distal femora and radii –are less frequently preserved, obscuring to a considerable degree the "real" abundance of carcass parts. Thus, while it may be reasonable to compare the relative frequencies of differ-

ent bone elements within the site, the actual frequency distributions probably cannot be profitably applied to the interpretation to other sites where preservation is markedly better. Further, the differential destruction of "softer" immature elements probably makes the preserved mortality pattern for the various species much "older" than was actually the experience of the herds during the occupation.

Significantly (see below), considering the location of the site on the bank of the Yarmuk River with the Kinneret located only a short distance to the north and the abundance of molluscs recovered, fish and amphibian remains are almost completely absent from the preserved collection. Even the intensive application of water sieving and the careful "picking" of the heavy fraction produced by that technique has not produced significant numbers of bones from aquatic species. After a report about the faunal collection presented at the 1999 American Schools of Oriental Research meetings in Boston, several zoo-archaeological colleagues offered similar stories from their work in the Jordan Valley, and argued that it was preservational conditions that created this result. If true, the scattered microfaunal sample from the site is a poor record of the habitat in which Sha'ar Hagolan was situated during the late sixth millennium BC and analysis will have to depend on the remains of the larger mammals found at the site.

## III. Species Present and Relative Abundance of the Economically Significant Species

A number of categories with different degrees of taxonomic and anatomical uncertainty are used to tabulate the collection (Hesse and Wapnish 1985). The least specific taxon is *Animal*, which includes those fragments that could only be identified as bone. Three categories, *Small/Medium/Large Mammal*, contain up-to-dog-sized, sheep/goat/pig sized, and cattle-sized remains, respectively. *Small Bovid* refers to bones that could be from sheep, goats, or gazelles, but most probably come from the first two of these species. *Carnivore* refers to mustelid/small felid/fox remains while the *Large Carnivore* is probably a dog, though not specifically identifiable as such. Most of the *Bird* remains are shaft fragments from limb bones though a few could, through the kind efforts of Justin Lev-Tov, be identified as ducks (*Anatidae*), geese (*Anser* sp.) and partridges (*Phasianidae*). *Sheep/Goat* contains bone elements either from *Capra* sp. or *Ovis* sp. No specimen was of a size or morphology to be identified as *Capra ibex* though bones from this species could be present, though unrecognized, in the sample. The lone possible *Equid* bone is, if correctly

identified, likely from a wild ass though the possibility that it is a hemione cannot be excluded (Uerpmann 1987).

Along the anatomical scale of uncertainty, *Scrap* refers to items where even the basic part of the skeleton to which a bone belongs could not be recognized. Most of these specimens fall in the *Animal* category. *Long-Bone*

Table 18.1. Distribution of the taxa in the animal bone sample

| Taxon | Count | % age | % age Main Species |
|---|---|---|---|
| Animal | 2293 | 43.1 | |
| Fish | 1 | >.1 | 0.1 |
| Amphibian | 1 | >.1 | |
| Bird | 50 | 0.9 | |
| *Anatidae* | 3 | >.1 | 0.4 |
| *Anser* sp. | 2 | >.1 | 0.2 |
| *Phasianidae* | 1 | >.1 | 0.1 |
| Small Mammal | 18 | 0.3 | |
| Rodent | 2 | >.1 | |
| Carnivore | 4 | >.1 | |
| Large Carnivore | 1 | >.1 | |
| *Canis* sp. | 17 | 0.3 | 2.3 |
| *Felis* sp. | 2 | >.1 | |
| Medium Mammal | 1931 | 36.3 | |
| *Sus scrofa* | 125 | 2.4 | 16.6 |
| Small Bovid | 70 | 1.3 | 9.3 |
| *Gazella* sp. | 27 | 0.5 | 3.6 |
| Sheep/Goat | 364 | 6.9 | 48.2 |
| *Ovis* sp. | 41 | 0.8 | 5.4 |
| *Capra* sp. | 22 | 0.4 | 2.9 |
| Large Mammal | 224 | 4.2 | |
| Equid | 1 | >.1 | 0.1 |
| *Bos* sp. | 81 | 1.5 | 10.7 |
| Total | 5281 | | |

*Shaft Fragment* refers to a splinter of a leg bone. On the basis of cortical thickness most of these fragments are assigned to one of the *Small/Medium/Large Mammal* categories. Most vertebrae and rib fragments are poorly preserved. Thus, they too have been assigned to the *Small/Medium/Large Mammal* categories.

The distribution of the bone finds into the taxonomic categories is presented in Table 18.1. The relative abundance of the main species as estimated by TNF (total number of fragments) is also listed. The estimator TNF is chosen since the other main statistic, MNI, is sensitive to the way elements are grouped spatially (Grayson 1984; Hesse and Wapnish 1985).

Somewhat more than 56% of the sample are the bones of sheep or goats, pigs are the second most abundant taxon at nearly 17%, while cattle are third at about 11%. Among the less abundant taxa, only gazelles, at about 4%, and dogs, at less than 3%, are notable. The near absence of fish, amphibians, and water birds, noted above, is striking but probably not an actual reflection of ancient reality.

**Cattle**: The 81 cattle bones include 20 teeth and tooth fragments, 2 fragments of mandibles, 1 horncore fragment, 1 mandibular and 1 maxillary tooth row, 3 cranial fragments, 1 cervical vertebra, 3 scapula fragments, 5 humerus fragments, 2 radius fragments, 4 ulnar fragments, 1 acetabular fragment, 2 tibia fragments, 2 astragali, 2 calcanei, 1 fibula, 1 naviculo-cuboid, 8 metapodial fragments, and 21 phalanges. Only one of the 10 ageable phalanges is unfused and of the 10 determinable long bones only one is unfused. There were no deciduous

teeth. Though preservational conditions probably worked against the survival of bones from immature animals, this record suggests that the cattle were mostly mature when they died. A few specimens were measurable. The dimensions reported are less accurate than is usual (probably slight over-estimations) because of the concretions which coat the samples. These data are presented in Table 18.2. While benchmark dimensions for the distinction of wild *Bos primigenius* from domestic *B. taurus* have not been established for the southern Levant, the Sha'ar Hagolan measures are substantially larger than early Bronze Age cattle from Yaqush in the Jordan Valley and early Iron Age cattle from Tel Miqne-Ekron in the Shephelah. Whether they are large enough to be referred to the wild morphology is at this point undetermined (see Grigson 1989).

**Sheep and Goats**: Separation of sheep and goat specimens was done through the application of the criteria of Boessneck *et al.* (1963). The 41 *Ovis* sp. bones in the collection include one horncore, 1 distal humerus, 1 proximal radius, 10 astragali, 1 calcaneus, 6 distal metapodia, and 20 phalanges. The 22 *Capra* sp. bones include 4 horncores, 4 scapulae, 1 distal humerus, 1 radius, 1 astragalus, 1 calcaneus, 4 metapodials, and 6 phalanges. The measurable bones are presented in Table 18.3. None of these specimens is of a size to suggest that they derived from wild individuals. No horncore fragments were sufficiently complete to provide a morphological diagnosis of the cross-sectional shape often taken as indicative of domestic stock.

The mortality of the combined sheep and goat sample

TABLE 18.2. Measurements of *Bos* sp. bones. Abbreviations follow von den Driesch (1976)

| | | | | | |
|---|---|---|---|---|---|
| Astragalus | GLl=72.7 | GLm=66.8 | | | |
| " | GLl=70.0 | | | | |
| Metacarpal | Bp=73.8 | | | | |
| Metatarsal | GL=235.0 | Bp=58.5 | SD=36.0 | BT=67.9 | |
| " | | | | | Dd=33.0 |
| Phalanx I | GLl=66.2 | Bp=30.7 | | | |
| " | GLl=60.7 | Bp=34.8 | | | |
| " | GLl=63.6 | Bp=34.2 | | | |
| " | GLl=65.4 | | | | |
| Phalanx III | DLS=80.1 | LD=59.1 | MBS=28.7 | | |

TABLE 18.3. Measurements of *Ovis* sp. and *Capra* sp. bones. Abbreviations follow von den Driesch (1976)

| Scapula | GLpe | LG | BG | | | Metatarsal | Bd | |
|---|---|---|---|---|---|---|---|---|
| Goat | 29.5 | 22.6 | 20.3 | | | Sheep | 25.3 | |
| Humerus | BT | Dd | | | | Phalanx I | GLl | Bp |
| Sheep | | 26.5 | | | | Sheep | 33.3 | 11.0 |
| Goat | 27.4 | 22.6 | | | | " | 38.3 | |
| Astragalus | GLl | GLm | DL | DM | Bd | " | | 11.1 |
| Sheep | | 27.0 | | | 18.4 | " | 33.4 | 10.8 |
| " | | 24.9 | | | | " | 36.5 | 13.6 |
| " | 29.9 | 27.4 | | | 20.2 | Goat | 35.8 | |
| " | 27.4 | 26.3 | 14.7 | 15.4 | 17.3 | Phalanx II | GLl | Bp |
| " | | 25.9 | | | | Sheep | 24.3 | 14.8 |
| " | 29.8 | 28.5 | 17.2 | 17.3 | 19.0 | " | 21.4 | |
| " | | 29.3 | | | | " | 26.4 | 12.4 |
| " | 28.0 | | | | | " | 20.2 | 11.9 |
| Goat | | 27.4 | | | | " | 19.5 | |
| Radius | Bp | Bfp | | | | | | |
| Sheep | 27.9 | 25.7 | | | | | | |

can be estimated by both tooth wear (Payne 1973) and long-bone fusion (Silver 1969). Ten tooth rows and loose teeth could be staged based on the degree of wear. Converting the stages into estimates of mortality following Payne's suggestions produces the results shown in Table 18.4. Mortality based on fusion is presented in Table 18.5 and Fig. 18.1. The two lines on the graph represent the "fat line" robust estimate of mortality (Hesse and Wapnish 1985), that is, the range through which the "true line" is likely to have passed. The fusion data produce a somewhat higher estimate of average age at death and much higher estimates of survivorship for young animals probably due to the poor preservation of the bones of young animals.

However, there is at least overlap in the patterns. A significant number of sheep and goats, about 50% on the basis of tooth wear, somewhat less based on fusion, died before they reached their second year. Coupled with the small size of the animals, it seems clear that they were domestic.

**Pigs**: The 125 Sus scrofa bones include 22 teeth and tooth fragments, 23 mandibular and maxillary toothrows, 8 mandibular and 14 cranial fragments, 1 cervical

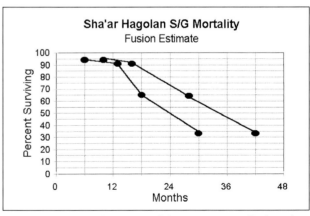

FIG. 18.1. "Fat Line" estimate of sheep goat mortality based on fusion. The "true" mortality is likely to fall between the two lines. Fusion mortality is likely to underestimate the number of animals dying at young ages.

vertebra, 4 scapulae, 7 distal humeri, 4 proximal ulnae, 3 radii, 1 radius/ulna shaft, 4 innominate fragments, 1 proximal femur, 3 proximal tibiae, 1 astragalus, 2 calcanei, 2 fibulae, 11 metapodials, and 14 phalanges. Many of these elements came from immature animals. Ten of the 23 tooth rows contained deciduous teeth, 1 of the 4

TABLE 18.4. Mortality in Sheep and Goats based on tooth wear. Each tooth or tooth row is given a weight of one. This value is distributed across the age categories based on the uncertainty associated with the specimen

| Payne Stage | A | B | C | D | E | F | G | H | I |
|---|---|---|---|---|---|---|---|---|---|
| Mandible | .25 | .25 | .25 | .25 | | | | | |
| " | | .50 | .50 | | | | | | |
| " | | | .50 | .50 | | | | | |
| LM 1/2 | | | .25 | .25 | .25 | .25 | | | |
| " | | | | .25 | .25 | .25 | .25 | | |
| " | | | | .25 | .25 | .25 | .25 | | |
| " | | | | .25 | .25 | .25 | .25 | | |
| " | | | | .25 | .25 | .25 | .25 | | |
| " | | | | .25 | .25 | .25 | .25 | | |
| LM 3 | | | | | | | .50 | .50 | |
| **TOTAL** | .25 | .75 | 1.50 | 2.25 | 1.50 | 1.50 | 1.75 | .50 | 0.0 |
| | 0-1 year 2.50 | | | 1-3 years 3.75 | | 3+ years 3.75 | | | |
| | 25% | | | 37.5% | | 37.5% | | | |

TABLE 18.5. Data for the estimation of mortality based on fusion in sheep/goats

| | Mature | Immature | % Mature |
|---|---|---|---|
| Acetabulum | 15 | 0 | 100 |
| Distal Humerus | 5 | 1 | 82 |
| Proximal Radius | 3 | 0 | 100 |
| Scapula | 7 | 1 | 87 |
| **6–10 months** | **30** | **2** | **94** |
| Phalanx I | 18 | 2 | 90 |
| Phalanx II | 11 | 1 | 92 |
| **13–16 months** | **29** | **3** | **91** |
| Distal Tibia | 9 | 5 | 64 |
| Distal Metacarpal | 5 | 2 | 71 |
| Distal Metatarsal | 6 | 0 | 100 |
| Distal Metapodial | 0 | 4 | 0 |
| **18–28 months** | **20** | **11** | **65** |
| Calcaneus | 2 | 4 | 33 |
| Ulna | 1 | 2 | 33 |
| Proximal Femur | 1 | 2 | 33 |
| Proximal Humerus | 0 | 2 | 0 |
| Distal Femur | 0 | 3 | 0 |
| Distal Radius | 3 | 1 | 75 |
| **30–42 months** | **7** | **14** | **33** |

TABLE 18.6. Measurements of Sus scrofa bones and teeth. Abbreviations follow von den Driesch (1976)

| | M1 GL | M1 GB | M2 GL | M2 GB | M3 GL |
|---|---|---|---|---|---|
| Mandible | 19.8 | 12.3 | | | |
| Mandible | 18.9 | 12.1 | | | |
| Mandible | 18.9 | 12.1 | 22.5 | 15.7 | 37.0 |
| M3 | | | | | 36.0 |

| | |
|---|---|
| Humerus | Bd=39.2 |
| Astragalus | GLm=40.8 |

determinable phalanges was immature as were 5 out of the 6 metapodia. Two out of 4 distal humeri were immature, as was the one ageable proximal tibia. Both calcanei were immature. A few bones were measurable and are presented in Table 18.6. Most of the specimens were small though larger than the early Iron Age pigs from Tel Miqne-Ekron. The dimensions of the teeth fall within the domestic range as estimated by Flannery (1982) though it is probable that the wild pig of the southern Levant was somewhat smaller than the Near Eastern swine he used to establish the criteria. Together, the measurements and the mortality point to domestic stock.

**Gazelle**: The 27 gazelle bones include 1 tooth, 1 maxillary tooth row, 1 horncore fragment, 4 humeri, 2 radii, 1 tibia, 1 astragalus, 1 calcaneus, 1 naviculo-cuboid, 3 metapodials and 11 phalanges. No determination of which of the various gazelles that inhabited the southern Levant (Uerpmann 1987) could be made with the materials at hand. The few measurements are presented in Table 18.7.

**Equidae?**: One bone, a fragment of a lateral or medial metapodial.

**Canids**: Seventeen dog bones were recovered. These include a lumbar vertebra, 2 canines, 1 lower carnassial, 3 mandible fragments, 1 radius fragment, 1 scapula fragment, 1 astragalus, 5 metapodials and 2 first phalanges. Only one element was measureable, the carnassial. Its GL is 21.8 and the GB is 8.8. None of the specimens seem even close to wolf in size. Some could conceivably derive from jackals.

TABLE 18.7. Measurements of *Gazella* sp. bones. Abbreviations follow von den Driesch (1976)

| | GLl | Bp |
|---|---|---|
| Phalanx I | 43.0 | |
| " | 46.4 | |
| " | 43.9 | 10.9 |
| Phalanx II | 20.6 | 7.7 |
| " | | 10.4 |
| " | 23.6 | 9.8 |

## IV. SPATIAL DISTRIBUTION OF THE FINDS

The fact that the excavation has been able to expose a large area of well preserved architecture presents the opportunity to investigate spatial variation in the distribution of the bone finds (see Fig. 18.2). A total of 24 spaces of varying type were defined by the excavators. These include two streets (M and Q), an open area (P) at the intersection of those streets, and three building complexes (I, II, III). Each of the building complexes has spaces of different size and architectural character. Complex I is the most completely exposed. It contains a courtyard (IA), a small round room (IB), three rooms with paved floors (ID, IG, II), and four rooms with unpaved floors (IC, IE, IF, IH). Another three units,

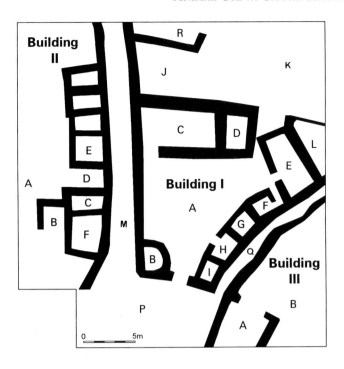

Fig. 18.2. Schematic plan of the main architectural elements

varied to some degree, analysis focused on the relative abundance of various bone categories rather than their absolute values.

Very few articulations (associations of bones that came from an anatomical unit from some individual animal) were recovered in the debris. Two of these were a gazelle ankle (Locus 2, Basket 162) and a pair of sheep/goat mandibles (Locus 2, Basket 104) from Room IIC. A third, a pig mandible/maxilla combination (Locus 8, Basket 327), came from street Q. The fourth, a cow ankle (Locus 96, Basket 403), came from courtyard IA, while the fifth, two articulated sheep/goat digits Locus 183, Basket 740) came from courtyard K. This lack of articulations suggests that much of the sample has been redeposited to one degree or another. Thus, the association between the space a bone fragment is found and the human activity of exploiting the resource the bone represents is probably weak at best.

The initial investigation of variability in these spaces examined the type of bone finds recovered in each space. The three bone categories employed were "Identifiable" – those specimens which could be assigned to a skeletal category, "Long-Bone Shaft Fragments" – splinters of the diaphyses of limb bones, and "Scrap" – otherwise unidentifiable fragments. The distribution of these categories is presented in Table 18.8. Most of the sample was recovered from the street and courtyard areas. Paved rooms produced relatively less material. Exterior courtyards and streets have somewhat higher proportions of scrap, probably the result of trampling. It would be useful to conduct microarchaeological investigations of the sediments in the rooms to see whether micro-bone

outside this building, are also included in the analysis: J, K and L. Further to the north is open area R. Complex II has one courtyard space (IIA) and five rooms (IIB, IIC, IID, IIE, IIF). Complex III has a courtyard (IIIB) and one room with an unpaved floor (IIIA). Since the areas range widely in size and the thickness of the deposit

Table 18.8. Distribution of identifiable, long-bone shaft fragments and scrap in the various architectural zones of the site. Values are presented as both raw counts and percentages (in italics).

| Streets | ID | | LBSF | | SCRAP | | Complex I | ID | | LBSF | | SCRAP | | Complex II | ID | | LBSF | | SCRAP | |
|---|---|---|---|---|---|---|---|---|---|---|---|---|---|---|---|---|---|---|---|---|
| M | 30 | *14* | 51 | *24* | 133 | *62* | B | 9 | *28* | 19 | *60* | 4 | *12* | A | 72 | *22* | 171 | *53* | 80 | *25* |
| Q | 20 | *16* | 69 | *57* | 32 | *26* | A | 193 | *20* | 415 | *44* | 334 | *36* | B | 98 | *26* | 144 | *39* | 130 | *35* |
| | | | | | | | K | 253 | *24* | 286 | *27* | 525 | *49* | C | 26 | *25* | 50 | *49* | 27 | *26* |
| **Open Area** | | | | | | | D | 1 | *9* | 3 | *27* | 7 | *64* | D | 7 | *41* | 7 | *71* | 3 | *18* |
| P | 14 | *14* | 37 | *37* | 48 | *48* | G | 4 | *9* | 17 | *37* | 25 | *54* | E | 0 | *0* | 2 | *100* | 0 | *0* |
| R | 1 | *14* | 3 | *43* | 3 | *43* | I | 5 | *28* | 7 | *39* | 6 | *33* | F | 40 | *19* | 122 | *59* | 46 | *22* |
| | | | | | | | C | 38 | *26* | 64 | *44* | 45 | *30* | | | | | | | |
| | | | | | | | E | 22 | *17* | 71 | *56* | 35 | *27* | **Complex III** | | | | | | |
| | | | | | | | F | 14 | *20* | 33 | *45* | 25 | *35* | B | 77 | *15* | 128 | *25* | 300 | *60* |
| | | | | | | | H | 16 | *19* | 20 | *24* | 48 | *57* | A | 47 | *16* | 48 | *16* | 197 | *68* |
| | | | | | | | J | 31 | *15* | 86 | *42* | 88 | *43* | | | | | | | |
| | | | | | | | L | 61 | *21* | 92 | *32* | 133 | *47* | | | | | | | |

TABLE 18.9. Distribution of the main species, sheep/goat, cattle, and pig in the architectural spaces. Raw courts and percentages (in italics) are presented.

| Streets | S/G | | Bos | | Sus | | Complex I | S/G | | Bos | | Sus | | Complex II | S/G | | Bos | | Sus | |
|---|---|---|---|---|---|---|---|---|---|---|---|---|---|---|---|---|---|---|---|---|
| M | 11 | *69* | 0 | *0* | 5 | *31* | B | 3 | *100* | 0 | *0* | 0 | *0* | A | 31 | *74* | 2 | *5* | 9 | *21* |
| Q | 6 | *50* | 2 | *17* | 4 | *33* | A | 80 | *66* | 22 | *18* | 20 | *16* | B | 39 | *75* | 7 | *13* | 6 | *12* |
| | | | | | | | K | 110 | *65* | 23 | *13* | 38 | *22* | C | 10 | *77* | 1 | *8* | 2 | *15* |
| **Open Area** | | | | | | | D | 1 | *100* | 0 | *0* | 0 | *0* | D | 1 | *33* | 1 | *33* | 1 | *33* |
| P | 3 | *50* | 2 | *33* | 1 | *17* | G | 2 | *100* | 0 | *0* | 0 | *0* | E | 0 | *0* | 0 | *0* | 0 | *0* |
| R | 0 | *0* | 0 | *0* | 1 | *100* | I | 3 | *75* | 0 | *0* | 1 | *25* | F | 9 | *56* | 1 | *6* | 6 | *38* |
| | | | | | | | C | 12 | *67* | 0 | *0* | 6 | *33* | | | | | | | |
| | | | | | | | E | 10 | *71* | 0 | *0* | 4 | *29* | **Complex III** | | | | | | |
| | | | | | | | F | 2 | *40* | 1 | *20* | 2 | *40* | B | 30 | *77* | 3 | *7* | 6 | *16* |
| | | | | | | | H | 5 | *83* | 0 | *0* | 1 | *17* | A | 17 | *57* | 9 | *30* | 4 | *13* |
| | | | | | | | J | 15 | *72* | 3 | *14* | 3 | *14* | | | | | | | |
| | | | | | | | L | 27 | *75* | 4 | *11* | 5 | *14* | | | | | | | |

TABLE 18.10. Distribution of Medium Mammal Carcass Parts in the architectural spaces. The raw count of all MM bones in a space are provided together with the percentage of that total in several anatomical categories: A, ribs and vertebrae; C, crania, mandibles, teeth; F, forelimb from shoulder girdle to metacarpal; H, hindlimb from hip girdle to metatarsal; T, toes.

| Streets | # | A | C | F | H | T | Complex I | # | A | C | F | H | T | Complex II | # | A | C | F | H | T |
|---|---|---|---|---|---|---|---|---|---|---|---|---|---|---|---|---|---|---|---|---|
| M | 23 | *30* | *48* | | *13* | *9* | B | 6 | *50* | *33* | *17* | | | A | 52 | *23* | *42* | *4* | *19* | *11* |
| Q | 15 | *40* | *40* | *7* | *7* | *7* | A | 132 | *24* | *33* | *17* | *17* | *9* | B | 68 | *24* | *32* | *16* | *18* | *10* |
| | | | | | | | K | 194 | *24* | *41* | *11* | *14* | *11* | C | 15 | *27* | *40* | *7* | *13* | *13* |
| **Open Area** | | | | | | | D | 1 | | | | | *A** | D | 3 | | *67* | | *33* | |
| P | 7 | *29* | *29* | *14* | *29* | | G | 2 | | | *50* | | *50* | E | 0 | | | | | |
| R | 0 | | | | | | I | 4 | | *25* | *25* | *25* | *25* | F | 25 | *48* | *40* | | *8* | *4* |
| | | | | | | | C | 27 | *33* | *37* | *15* | *11* | *4* | | | | | | | |
| | | | | | | | E | 17 | *24* | *53* | *6* | | *18* | **Complex III** | | | | | | |
| | | | | | | | F | 7 | *57* | *14* | | | *29* | B | 48 | *36* | *31* | *12* | *12* | *9* |
| | | | | | | | H | 10 | *20* | *40* | *10* | *30* | | A | 28 | *21* | *29* | *18* | *25* | *7* |
| | | | | | | | J | 24 | *21* | *50* | *13* | *13* | *4* | | | | | | | |
| | | | | | | | L | 48 | *31* | *29* | *13* | *23* | *4* | | | | | | | |

*A** = ARTICULATION

distributions provide some indication of differential use of the architectural spaces.

Table 18.9 presents the spatial distribution of the three main species – sheep/goat, cattle and pigs – in the architectural spaces. Cattle are the most variable in their abundance, probably related to the larger size of their bones and the nuisance factor they doubtless were.

Otherwise there is no evidence of differential utilization of the three taxa in the architectural complexes so far surveyed.

Finally, the distribution of carcass parts was examined (Table 18.10). The abundance of axial fragments (vertebrae and ribs), head elements (teeth, cranial and mandibular bones), forelimb (scapula to the distal metacarpal),

hindlimb (innominate to the distal metatarsal) and toes (the three phalanges) of medium mammals (mostly sheep/goat with perhaps a few gazelles and pigs) in the architectural spaces was calculated to consider the possibility that slaughter offal (toes and sometimes head) and butchering offal (ribs, vertebrae and limbs) were differentially discarded. No distinct patterns emerged from this analysis. With the exception that higher proportions of toes seem to be found in the smaller sub-samples, there is no evidence that the carcasses of medium sized mammals are being discarded differentially.

## V. Conclusions

This preliminary evaluation of the faunal remains from Sha'ar Hagolan revealed a community which managed three (sheep, goats, and pigs) or perhaps four (cattle) forms of domestic livestock. Resolving the question of cattle domestication awaits the development of osteometric criteria or the recovery of a sample large enough to estimate the mortality experienced by these animals. The mortality experience by the sheep and goats suggests that they were being husbanded in an effort to provide dairy products and meat. This may hint that wool-producing sheep were not yet a part of the pastoral system. There is little evidence of hunting. Only a few gazelle bones were recovered and several of these certainly came from the same animal. The one possible equid specimen is neither certainly identified nor diagnostic. The nearly total lack of aquatic vertebrates may be a result of preservational bias. The few bird remains are mostly ducks and geese. Finally, an effort to examine the spatial distribution of the remains turned up no evidence of differential access to animal resources. Both the three main species and the medium mammal carcass parts were more or less equivalently distributed across the excavated portions of the site. Nevertheless, these preliminary conclusions should be treated cautiously. Preservation at the site is poor and the sample produced from a number of years of digging is small. It is to be hoped that future excavations plumbing deeper parts of the site will produce more abundant remains.

## Bibliography

Boessneck, J., Müller, H.H. and Teichert., M 1963. Osteologische Unterscheidungsmerkmale zwischen Schaf (*Ovis aries* Linné) und Ziege (*Capra hircus* Linné). *Kühn Archiv* 78: 1–129.

Childe, V.G. 1934. *New Light on the Most Ancient East: The Oriental Prelude to European Prehistory.* London: Kegan, Paul.

Childe, V.G. 1936. *Man Makes Himself.* London: Watts.

Driesch, A. von den 1976, *A Guide to the Measurement of Animal Bones From Archaeological Sites* (Peabody Museum Bulletin 1). Cambridge: Peabody Museum of Archaeology and Ethnology.

Ducos, P. 1968. *L'Origine des Animaux Domestiques en Palestine* (Memoire 6, Publications de l'Institut de Préhistoire de l'Université de Bordeaux). Bordeax: Delmas.

Flannery, K.V. 1982. Early Pig Domestication in the Fertile Crescent: A Retrospective Look. In Young. T.C., Jr., Smith, P.E.L. and Mortensen, P. (eds.) *The Hilly Flanks and Beyond. Essays on the Prehistory of the Southwestern Asia, Presented to R. J. Braidwood* (Studies in Ancient Oriental Civilization 36), pp. 163–188. Chicago: The Oriental Institute.

Grayson, D. 1984. *Quantitative Zooarchaeology. Topics in the Analysis of Archaeological Faunas.* New York: Academic Press.

Grigson, C. 1989. Size and Sex: Evidence for the Domestication of Cattle in the Near East. In Milles, A., Williams, D. and Gardner, N. (eds.) *The Beginnings of Agriculture* (B.A.R. International Series 496), pp. 77–109. Oxford: British Archaeological Reports.

Grigson, C. 1995. Plough and Pasture in the Early Economy of the Southern Levant. In Levy, T.E. (ed.) *The Archaeology of Society in the Holy Land*, pp. 245–268. New York: Facts on File, Inc.

Hesse, B. and Wapnish, P. 1985. *Animal Bone Archeology.* Washington: Taraxacum.

Hesse, B. and Wapnish, P. n.d. An Archaeozoological Perspective on the Cultural Use of Mammals in the Levant. (To be published in a volume surveying the archaeology of animals in the Near East, edited by B. J. Collins). Leiden: Brill.

Lyman, R. L. 1994. *Vertebrate Taphonomy.* Cambridge: Cambridge University.

Payne, S. 1973. Kill-off Patterns in Sheep and Goats: the Mandibles from Asvan Kale. *Anatolian Studies* 23: 281–304.

Reitz, E. J. and Wing, E.S. 1999. *Zooarchaeology.* Cambridge: Cambridge University.

Silver, I. A. 1969. The Ageing of Domestic Animals. In Higgs, E.S. and Brothwell, D.R. (eds.) *Science in Archaeology*, pp. 283–302. New York: Praeger.

Stigler, R. 1974. The Later Neolithic in the Near East and the Rise of Civilization. In Stigler, R. (ed.) *The Old World: Early Man to the Development of Agriculture*, pp. 98–126. New York: St. Martin's.

Uerpmann, H.-P.1987. *The Ancient Distribution of Ungulate Mammals in the Middle East.* Wiesbaden: Dr. Ludwig Reichert.

# Conclusions: The Effect of Population Size on the Human Organization at Sha'ar Hagolan

## Yosef Garfinkel

## I. Introduction

The evidence presented in the various chapters of this book completely alters our previous knowledge concerning Yarmukian culture in general (Garfinkel 1993; Kafafi 1993), and at the site of Sha'ar Hagolan in particular (Stekelis 1951, 1972). It clearly demonstrates that Sha'ar Hagolan was a unique Neolithic settlement in the following respects:

1. large size, making it the largest known Neolithic site in the Near East;
2. large building complexes, each occupying a few hundred square meters;
3. the earliest appearance of courtyard houses, a building concept still prevalent today in traditional societies of the Near East;
4. a planned village with a formal network of passageways, including straight main streets and narrow, curving alleys;
5. a large collection of art objects, including over 200 anthropomorphic figurines, about two thirds of all the prehistoric figurines discovered at all prehistoric sites in Israel.

The explanation that ties all these phenomena together should take into consideration the large population that inhabited the site, or, in other words, scalar stress. Previous studies on population density have concluded: "scalar stress refers to the stresses inherent in large population aggregations, which must be reduced through strategies as diverse as increasingly hierarchical social organization, group fission, and increasing incidence of group ritual" (Carneiro 1967; Johnson 1982; Friesen 1999).

Population pressure has been recognized as a main factor in human evolution (Hassan 1981). While its effect can be examined on the macro-level, such as migration to the New World or the beginning of agriculture, here I would like to explore the effect of population pressure on the micro-level, specifically on the Sha'ar Hagolan community. The inhabitants of this 8,000-year-old village had to struggle with a rather new situation – how to organize a community of a few thousand people living together in the same place. They did not have much relevant background and thus had to find their own original solutions.

Estimating the population size of Sha'ar Hagolan, like any other paleo-demographic reconstruction, is a problematic task. The two main aspects involved are:

1. The specific area of the site that was occupied simultaneously. In other words, were the entire 20 hectares occupied at a given time, or was only part of the entire site occupied at any given time? This problem is relevant to any site. Even in small-scale settlements of approximately one hectare, it is unclear whether the entire area was occupied simultaneously.
2. Population density: how many people lived on one hectare (see, for example, Broshi and Gophna 1984: 41–42).

As the specific size of each of these figures at Sha'ar Hagolan is unknown, only a general estimate of the total population can be made. A simulation of various possibilities is presented in Table 19.1. Concerning site size, four options were considered: the entire area (20 hectares); three quarters (15 hectares); half (10 hectares); or just a quarter (5 hectares) of the site area was occupied. As to population density, three options are proposed: 200; 150; or 100 per hectare. These are rather modest estimates. Kenyon (1957: 65) suggested that the popu-

TABLE 19.1. Simulation of Sha'ar Hagolan population size according to different estimates

| Occupied area (in hectares) | Density (per hectare) | Population size |
|---|---|---|
| 20 | 200 | 4,000 |
| 20 | 150 | 3,000 |
| 20 | 100 | 2,000 |
| 15 | 200 | 3,000 |
| 15 | 150 | 2,250 |
| 15 | 100 | 1,500 |
| 10 | 200 | 2,000 |
| 10 | 150 | 1,500 |
| 10 | 100 | 1,000 |
| 5 | 200 | 1,000 |
| 5 | 150 | 750 |
| 5 | 100 | 500 |

lation of Neolithic Jericho, with an estimated area of 8 acres (3.2 hectares) was c. 3,000 (that is c. 900 per hectare). More realistic estimates, dealing with early urban civilizations have suggested the following population densities per hectare: 200 (Marfoe 1980: 320); 250 (Broshi and Gophna 1984: 41–42); or 300 (Renfrew 1972: 251).

As can be seen in Table 19.1, the population estimates range between 500 and 4,000. The site probably began as a rather small settlement that, through natural growth as well as influx of new individuals, increased over time. Since the entire Yarmukian culture lasted some 600 radiocarbon years (Garfinkel 1999a), it is quite possible that sometimes during that span of time the population of Sha'ar Hagolan attained 3,000 or even 4,000.

Wilson (1988), discussing the effect of the transition to permanent village life, noted:

> The division between the public and the private… is an inherent weakness in such societies that could be self-defeating. Houses and settlements are by nature more permanent than camps and hearth sites. They offer their inhabitants the chance to live with each other in more stable and cooperative groups, and domestication presents the opportunity of a greater and more reliable food supply. But the separateness and privacy of the household is a source of aggravation, stress, and divisiveness. Can this inherent 'contradiction' in domesticated society be countered? (Wilson 1988: 167–168)

The problematic nature of this situation increases tremendously in the later part of the Neolithic period. The creation of large villages with populations of a few thousand living together suppressed the intimacy found in small-scale communities. Society becomes stratified and more formalized. Many individuals feel alienation, as well as competition and suspicion. It becomes necessary to create leadership and decision-making apparatuses and, at the same time, it is essential to tie the community together and strengthen individuals' sense of belonging, so that the community does not disintegrate. Thus, the effect of population density should be examined on two levels: the nuclear family, on the one hand, and the community on the other.

## II. THE EFFECTS OF POPULATION PRESSURE AT SHA'AR HAGOLAN

The data accumulated during the six seasons of excavations at Sha'ar Hagolan make it possible to raise specific issues concerning the effect of population pressure on human organization. These issues can be taken as working hypotheses, which we would like to test against more data. As mentioned above, the effect of population pressure should be examined on two levels: that of the nuclear family and that of the community. The following aspects seem to be relevant on the nuclear family level:

**1. Kinship Reorganization.** Usually in Neolithic villages we see the houses scattered in the village without any clear pattern. It seems that each nuclear family ran its own household (Fig. 19.1: a). This village infrastructure indicates two levels of social organization: the community and the nuclear family (Fig. 19.2: a). The situation is different in the large, well-planned village of Sha'ar Hagolan. Here the basic dwelling unit is a large courtyard structure. Were these structures used by one nuclear family or by a few such families? So far we have only one completely excavated building but careful analysis of its architecture reveals an interesting pattern (Fig. 19.3). There is a basic unit composed of two rooms: one with beaten earth floor and a doorway; adjacent to it is a second room without any doorway but with carefully laid stone paving. There are three such units around the courtyard (No. c–d, f–g and h–i). Two additional rooms appear in the building (No. b and e). This data indicates that three nuclear families lived it this house. Living in such proximity indicates close kinship relations, i.e. an extended family. The other two rooms could serve other members of this extended family. In the other partially excavated houses at Sha'ar Hagolan, a similar arrangement is apparent. Thus, the village infrastructure indicates three levels of

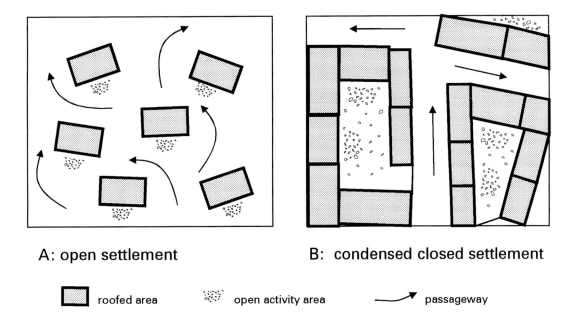

A: open settlement          B: condensed closed settlement

□ roofed area     ⠿ open activity area     ➤ passageway

FIG. 19.1. Various types of Neolithic sites

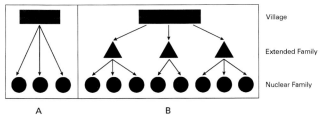

FIG. 19.2. Social organization in Neolithic villages: A. two levels of hierarchy; B. three levels of hierarchy

social organization: the community, the extended family, and the nuclear family (Fig. 19.2: b).

Ethnographic observation and analysis presented recently by Friesen (1999) indicates a similar pattern of behavior among the Inuit tribes of North America:

> …other means were necessary to reduce scalar stress in the large Mackenzie Delta beluga hunting camps. This, I believe, was a factor in the development of the large and elaborate Mackenzie Inuit cruciform house, which held greatly expanded households averaging six families. These expanded households existed in both winter and summer, as indicated by the composite multi-family tents… With the household serving as the basal unit in Mackenzie Inuit society, a much reduced number of units was present in each settlement and cluster. Scalar stress was reduced, and a powerful symbol of unity and relatedness was created for each household. (Friesen 1999: 33)

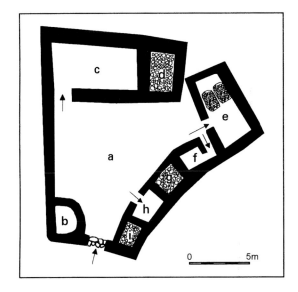

FIG. 19.3. Schematic plan of Building Complex 1, Area E

**2. Enclosedness.** Usually in Neolithic villages, the open areas between the houses were used for cooking, storage in pits, and various other household activities (Fig. 19.1: a). At Sha'ar Hagolan, however, the open area was integrated into the house as an enclosed courtyard. This placed the open area under tight control, limiting access only to approved persons (Fig. 19.1: b). Personal belong-

ings, the accumulation of wealth, and women are protected in the enclosed courtyard to this day in some parts of the Near East (Watson 1979). In these traditional societies, the women are barred from public areas, and their main activity areas are closed courtyards.

**3. Food Supplies and Storage.** Evidence for food supplies include animal bones and the various botanical remains collected through systematic flotation. As demonstrated by the analysis of the rooms of Building Complex I, each nuclear family had a dwelling room and adjacent storage room with paved floor. This indicates that each nuclear family was responsible for its own storage. The introduction of pottery, the first evidence for which appears in the Yarmukian culture, created new storage facilities: jars are excellent vessels for storing liquids; pithoi, in the form of large holemouth jars, up to 300 liters in volume, are suitable for grain storage. Such large vessels were usually buried below the floors, as discovered in Area H at Sha'ar Hagolan (Garfinkel and Miller, Chapter 2 in this volume) and at Munhata (Garfinkel 1992, Fig. 60: 1). The burial of the pithoi under the floors, creating underground storage installations, has various advantages: constant temperature, isolation from insects, saving dwelling space and protecting the vessel from breakage. Large pithoi were also found buried below the floors at later, protohistoric sites in the Jordan Valley, such as Tell Dalhamiya, Tel Kitan and Abu Hamid (Tsori 1967; Eisenberg 1993; Dollfus *et al.* 1988, Fig. 7; Garfinkel 1999b: 249–251).

**4. Food Processing and Cooking.** The site of Sha'ar Hagolan is characterized by the number of large mortars and grinding slabs. The local farmers have found many of these over the years. Whenever mortars and grinding slabs have been discovered *in situ* in our excavations, they occurred in the open courtyards rather than in rooms. This context indicates that grinding was done on the extended family level, and not in the individual household. Another aspect that should be examined by further research is the size of the grinding tools at Sha'ar Hagolan in comparison to the size of the same tools at other Neolithic sites. If the Sha'ar Hagolan items prove significantly larger, it would further support the above conclusion.

It is also possible that the introduction of pottery in the Yarmukian culture, the earliest appearance of pottery in the region, is another response to population pressure. Pottery vessels can be placed in open fire, enabling quick or slow cooking. This invention opens new horizons in human nutrition, making possible more effective use of food resources. Marginal foodstuffs can now be included in the diet. The new cooking technique also makes possible more effective use of combustibles, such as grasses and dung.

**5. Accumulation of Wealth.** Families that have produced more than they consume may begin to accumulate wealth. They may have bigger fields or flocks. In the material culture such households might be indicated by the larger size of their dwellings, as well as the presence of exotic items such as obsidian, seashells, beads and alabaster vessels. Even daily commodities in such houses can be larger and more elaborate in shape and decoration.

The following aspects are relevant at the community level:

**6. Settlement Density.** The various structures abut one another, creating a condensed settlement, not leaving open areas between the buildings. A higher percentage of the site is covered by roofs, indicating growing intensification of land use within the settlement.

**7. Formalized Passageways.** At Sha'ar Hagolan, evidence for hierarchic systems of streets has been uncovered in the form of a wide, straight street and a narrow, curving ally. Movement in the village consequently occurs through formalized passageways. The existence of such passageways indicates the existence of a certain degree of settlement planning.

**8. Communal Maintenance Works.** The main street at Sha'ar Hagolan was resurfaced from time to time with small river pebbles and mud plaster. The street is clearly a communal place; thus its maintenance reflects organized communal effort. This phenomenon raises various questions concerning public decision-making: Who organized the work? How often were the streets repaired? Who carried out the work and who supervised it?

**9. Center and Periphery.** The center of the village can be used for functions of a more communal nature, and by the more important families of the village. This can be the location of cult structures. In order to verify that aspect, we must compare the center of the village and an area in the periphery. So far, our excavations have concentrated only on the center (Area E). In the future, we would like to excavate an area on the site periphery and compare various aspects of the two areas including: building size and function, obsidian and seashell distribution, the presence of elaborated pottery, art objects, etc.

**10. Communal Rituals.** Approximately 200 anthropomorphic figurines have been found at Sha'ar Hagolan. By way of comparison, at all the other Natufian and Neolithic sites put together only 100 figurines have been found (Yizraeli-Noy 1999). In addition, zoomorphic figurines and incised pebbles have been found in large numbers at Sha'ar Hagolan. This data clearly indicates extensive symbolic/cultic activity. It has been recognized that

...religious ritual played an important role in social and ecological regulation during a time in human history when the arbitrariness of social conventions was increasing but it was not yet possible for authorities, if they existed at all, to enforce compliance. (Rappaport 1971: 38)

It has also been noted that while band societies are characterized by *ad hoc* rituals (rites of passage, successful hunting and healing ceremonies), calendrical rituals are performed in the more complex social organizations of tribes and chiefdoms (Flannery 1972: 411–412, Fig. 1). I have specifically dealt with two such rituals: burial of cultic objects and dancing (Garfinkel 1994, 1998). Sha'ar Hagolan produced a very large collection of art objects, the richest prehistoric assemblage ever discovered at any site in the Levant, and one of the richest in the Near East. The intensification of artistic activity can be related to population pressure (Johnson 1982: 406; Hays 1993). As discussed, for example, by Hays, using cross-cultural examples from Europe, the Near East and North America, prehistoric population aggregation in non-state agricultural societies is accompanied by an increase in the amount and kind of labor invested in artistic activities. This indicates increased competition and social stress due to changing organizational scale. Thus, a major task of the Sha'ar Hagolan excavations is to obtain more data on the context of these objects in the Neolithic community and their role in social organization.

**11. Central Storage and Redistribution.** One of the mechanisms for controlled storage and redistribution in the ancient Near East is sealing. Prehistoric evidence attesting to this activity has been found at various sites, such as 200 bullae discovered in a single room at Tell Sabi Abyad (Akkermans 1996) and 619 bullae and seals from Levels XII–VIII at Tepe Gawra (Rothman 1994). No public storage facilities or concentrations of bullae have been found at Sha'ar Hagolan so far, but a few seals were found on the site surface (Beck 1993; Garfinkel 1999c). It is noteworthy that while such items have not been reported from other sixth millennium BC sites in the southern Levant, these few examples were found at Sha'ar Hagolan, where they were apparently associated with controlled storage and redistribution. We hope to uncover relevant data on this aspect.

**12. Formalized Cemeteries.** Usually in Neolithic villages, burial was carried out within the houses, under the floors, or in pits. In Sha'ar Hagolan only two burials have been found so far. Relative to the large excavated area, this is a very low number. It is possible that the burial ground moved from the living area into cemeteries in the village vicinity, that is, from the nuclear family to the community level.

**13. Craft Specialization.** Another possible aspect of the life in a very large community is the process of specialization. Evidence for this may include flint knapping, woodworking, art production and elaborated pottery production (production of highly decorated vessels or large storage jars).

**14. Trade.** While few examples of exotic items have been reported from sites of the Pottery Neolithic period, if at all, at Sha'ar Hagolan, evidence for trade has been found, including alabaster vessels, Mediterranean sea shells and Anatolian obsidian. The trade is concentrated at this large site, indicating that it was hierarchically structured and not a simple "down the line" trade system (Renfrew 1982).

The creation of a new human environment, the very large community, has direct influence upon many aspects of human organization: social structure, kinship organization, dwelling house, village structure, specialization, economy, land use and cult.

## II. SUMMARY

Much scholarly attention has been paid to the beginning of agriculture and quite a number of early Neolithic sites, 10,000–9,000 years before present, have been excavated in the Near East. The later phases of the Neolithic period, 8,000–7,000 years before present, have been largely neglected. Thus, very little is known concerning their settlement patterns, social organization or economic base. In the southern Levant this gap in our knowledge has been traditionally understood as one in the settlement history, or as culture decline. The site of Sha'ar Hagolan has completely altered this picture. It has emerged as one of the most advanced Neolithic centers in the ancient Near East. The very large community living there can be used as a case study for revealing and understanding the strategies used by Neolithic people when agglomerating into very large communities. It seems that this process had fundamental effects at the level of the nuclear family, as well as on the community level. The most important of all is kinship reorganization with the rise of the extended family. This unit combines a number of nuclear families into a larger and stronger social unit. The rise of the extended family is a response to population pressure. It has a direct influence on the dwelling unit and the village plan. A new type of structure – the courtyard building – was introduced.

Sha'ar Hagolan presents a unique example of a mega-settlement in the Neolithic period. How did this large, densely inhabited community, adopt to the demographic situation? We would like to examine this question at both

the level of the nuclear family: kinship reorganization, enclosedness, food supplies, food processing, and accumulation of wealth; and of the community: settlement density, formalized passageways, communal maintenance works, center and periphery, rituals and craft specialization. What should the research strategy be in order to produce the best understanding of these aspects? Excavating the entire village is an impossible task. At the present pace, 700 years would be required, as during the seven seasons conducted so far, only 1% of the site has been unearthed. I think that three different parts of the village should be examined: the center (Area E), the northern part (Area H) and the western extremity (not yet excavated). In each area, two structures should be completely uncovered. According to this strategy, the dwellings of six extended families, from different parts of the village would be available for analysis. This sample would provide a sufficient database to test the effect of population pressure on various aspects of human organization. Probably five or six excavation seasons are still required in order to complete this task.

## BIBLIOGRAPHY

Akkermans, P.M.M.G. 1996. *Tell Sabi Abyad. The Late Neolithic Settlement*. Istanbul: Nederlands Historisch-Archaeologisch Instituut.

Beck, P. 1993. A Note on a Neolithic Stamp Seal from Sha'ar Hagolan. *Mitekufat Haeven (Journal of the Israel Prehistoric Society)* 25: 189–191.

Broshi, M. and Gophna R. 1984. The Settlements and Population of Palestine during the Early Bronze Age II–III. *Bulletin of the American Schools of Oriental Research* 253: 41–53.

Carneiro R. 1967. On The Relationship between Size of Population and Complexity of Social Organization. *Southern Journal of Anthropology* 23: 234–243.

Dollfus, G., Kafafi, Z., Rewerski, J., Vaillant, N., Coqueugniot, E. and Neef, R. 1988. Abu Hamid: An Early Fourth Millennium Site in the Jordan Valley. In Garrard, A.D. and Gebel, H.G. (eds.) *The Prehistory of Jordan: The State of Research in 1986* (B.A.R. International Series 596), pp. 567–601. Oxford: British Archaeological Reports.

Eisenberg, E. 1993. Kitan, Tel. In Stern E. (ed.) *The New Enncyclopedia of Archaeological Excavations in the Holy Land*, Vol. III, pp. 878–881. Jerusalem: Israel Exploration Society.

Flannery, K.V. 1972. The Cultural Evolution of Civilizations. *Annual Review of Ecology and Systematics* 3: 399–426.

Friesen T.M. 1999. Resource Structure, Scalar Stress, and the Development of Inuit Social Organization. *World Archaeology* 31: 21–37.

Garfinkel, Y. 1992. *The Pottery Assemblage of the Sha'ar Hagolan and Rabah Stages of Munhata (Israel)* (Les Cahiers du Centre de Recherche Français de Jérusalem No. 6). Paris: Association Paléorient.

Garfinkel, Y. 1993. The Yarmukian Culture in Israel. *Paléorient* 19: 115–134.

Garfinkel, Y. 1994. Ritual Burial of Cultic Objects: The Earliest Evidence. *Cambridge Archaeological Journal* 4: 159–188.

Garfinkel, Y. 1998. Dancing and the Beginning of Art Scenes in the Near East and South-East Europe. *Cambridge Archaeological Journal* 8: 207–237.

Garfinkel, Y. 1999a. Radiometric Dates from Eighth Millennium B.P. Israel. *Bulletin of the American Schools of Oriental Research* 315: 1–13.

Garfinkel, Y. 1999b. *Neolithic and Chalcolithic Pottery of the Southern Levant* (Qedem 39). Jerusalem: Institute of Archaeology, Hebrew University.

Garfinkel, Y. 1999c. *The Yarmukians, Neolithic Art from Sha'ar Hagolan*. Jerusalem: Bible Lands Museum.

Hassan, F.A. 1981. *Demographic Archaeology*. New York: Academic Press.

Hays, K.A. 1993. When is a Symbol Archaeologically Meaningful? Meaning, Function, and Prehistoric Visual Arts. In Yoffee, N. and Sherratt, A. (eds.) *Archaeological Theory: Who Sets the Agenda?*, pp. 81–92. Cambridge: Cambridge University Press.

Johnson, G. 1982. Organizational Structure and Scalar Stress. In Renfrew, C., Rowlands, M. and Segraves, B. (eds.) *Theory and Explanation in Archaology*, pp. 389–421. New York: Academic Press.

Kafafi, Z 1993. The Yarmukians in Jordan. *Paléorient* 19: 101–114.

Kenyon, K. 1957. *Digging up Jericho*. London: E. Benn.

Marfoe, L. 1980. Book Review of R. Amiran, Early Arad I. *Journal of Near Eastern Studies* 39: 315–322.

Rappaport, R.A. 1971. The Sacred in Human Evolution. *Annual Review of Ecology and Systematics* 2: 23-44.

Renfrew, C. 1972. *The Emergence of Civilization*. London: Methuen.

Renfrew, C. 1982. Alternative Models for Exchange and Spatial Distribution. In Earle, T.K. and Ericson, J.E. (eds.) *Exchange Systems in Prehistory*, pp. 71–89. New York: Academic Press.

Rothman, M.S. 1994. Sealing as a Control Mechanism in Prehistory: Tepe Gawra XI, X and VIII. In Stein, G. and Rothman, M.S. (eds.) *Chiefdoms and Early States in the Near East* (Monographs in World Archaeology 18), pp. 103–120. Madison: Prehistory Press.

Stekelis, M. 1951. A New Neolithic Industry: The Yarmukian of Palestine. *Israel Exploration Journal* 1: 1–19.

Stekelis M. 1972. *The Yarmukian Culture of the Neolithic Period*. Jerusalem: Magnes Press.

Tsori, N. 1967. On Two Pithoi from the Beth-Shan Region and the Jordan Valley. *Palestine Exploration Quarterly* 99: 101–103.

Watson, P.J. 1979. *Archaeo-Ethnography in Western Iran*. Tucson: University of Arizona Press.

Wilson, P.J. 1988. *The Domestication of the Human Species*. New Haven and London: Yale University Press.

Yizraeli-Noy, Y. 1999. *The Human Figure in Prehistoric Art in the Land of Israel*. Jerusalem: Israel Museum and the Israel Exploration Society (Hebrew).

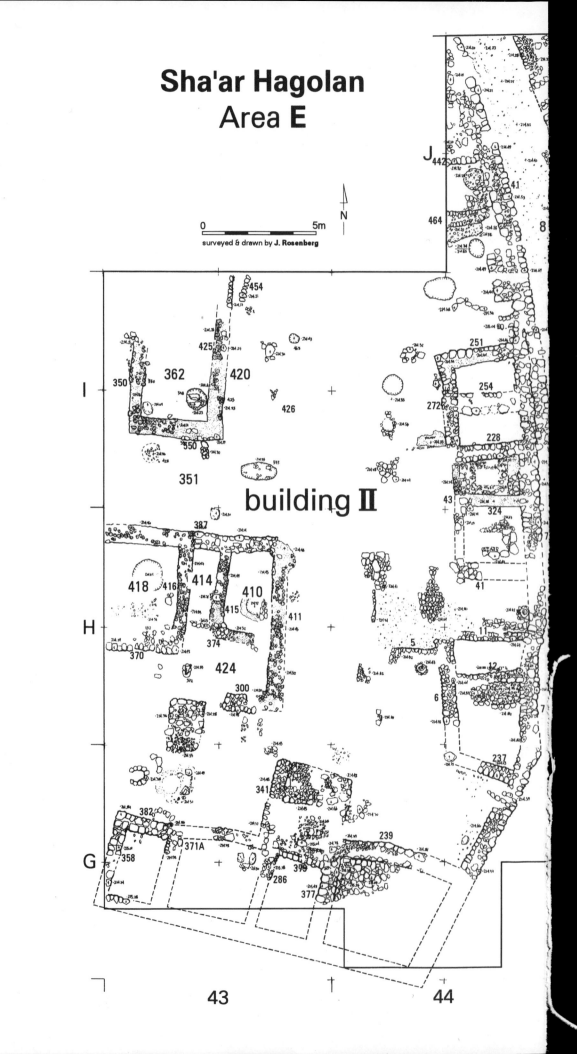

# Sha'ar Hagolan
## Area E

0      5m   N↑

surveyed & drawn by **J. Rosenberg**

building **II**

J 442

464

41

251

254

272

228

43

324

41

350   362   420   425   454

351   350

426

387

418   416   414   410   415   411

370   374

424

300

341

382

371A

358   239

286   399

377

5   11   12   6   237

G

H

I

43      44